CW00326931

WOMEN'S POLITICAL REPRESENTATION AND EMPOWERMENT IN INDIA

A Million Indiras Now?

Women's Political Representation and Empowerment in India

A MILLION INDIRAS NOW?

EVELIN HUST

MANOHAR
2004

First published 2004

ISBN 81–7304–575–5

Published by
Ajay Kumar Jain for
Manohar Publishers & Distributors
4753/23 Ansari Road, Daryaganj
New Delhi 110 002

Typeset at
Digigrafics
New Delhi 110 049

Printed at
Lordson Publishers Pvt Ltd
Delhi 110 007

It is not merely that more justice must be received by women, but also that social justice can be achieved only through the active agency of women. The suppression of women from participation in social, political, and economic life hurts the people as a whole, not just women.

The emancipation of women is an integral part of social progress, not just a 'women's issue'.

DRÈZE and SEN (1999: 178)

Contents

PART I
Politics of Presence, Empowerment, and the
Socio-Cultural Framework: Theoretical Foundations

PART II
Political Presence, Power, and Empowerment
of Women: Case Study

8 *Contents*

Illustrations

Tables

Abbreviations

AWARE	Action for Welfare and Awarening in Rural Environment (NGO based in Hyderabad)
BDO	Block Development Officer
BJD	Biju Janta Dal
BJP	Bharatiya Janta Party
BSY	Ballika Samrddhi Yojana
CEO	Chief Executive Officer
CDP	Community Development Programme
CM	Chief Minister
CPI (M)	Communist Party India (Marxist)
CPI	Communist Party India
CYSD	Centre for Youth and Social Development (NGO in Bhubaneswar)
DK	Don't Know
DRDA	District Rural Development Agency
DSS	Darbara Sahitya Sansad (NGO in Balipatna)
DWCRA	Development of Women and Children in Rural Areas
EIC	East India Company
GDI	Gender Development Index
GKY	Ganga Kalyan Yojana
GP	Gram Panchayat
GPO	Gram Panchayat Officer
GSR	Gania Sishu Raija (NGO in Gania)
GUC	Gania Unnayan Committee (NGO in Gania)
IAS	India Administrative Service
IAY	Indira Awaas Yojana
INC	Indian National Congress
IRDP	Integrated Rural Development Programme
ISED	Institute for Socio-Economic Development (NGO in Bhubaneswar)
JD	Janta Dal
JGSY	Jawahar Gram Samrddhi Yojana
JMM	Jharkhand Mukti Morcha
JRY	Jawahar Rozgar Yojana
MLA	Member of Legislative Assembly
MLALAD	MLA Local Area Development Scheme
MP	Member of Parliament
MSY	Mahila Samrddhi Yojana
MWS	Million Wells Scheme
N	Number

NA	No Answer
NGO	Non-governmental Organization
OAP	Old Age Pension
OAS	Orissa Administrative Service
OBC	Other Backward Class
PHC	Primary Health Centre
PRI	Panchayati Raj Institutions
PS	Panchayat Samiti
Rs	Indian Rupee
SC	Scheduled Caste
SFC	State Finance Commission
SGSY	Swarnjayanti Gram Swarozgar Yojana
SIRD	State Institute of Rural Development
SITRA	Supply of Improved Toolkits to Rural Artisans
ST	Scheduled Tribe
TRYSEM	Training for Rural Youth for Self-Employment
UNDP	United Nations Development Programme
ZP	Zilla Parishad

Acknowledgements

THE present study is the revised and updated version of a dissertation in Political Science of South Asia that was accepted by the University of Heidelberg, Germany, as a Ph.D. in the philosophic-historical faculty in May 2001. The research was financially supported by scholarships granted by the German Academic Exchange Service (DAAD) for the two field studies in Orissa in 1998–9 and 1999–2000, and for my maintenance in Germany by the Landesgraduiertenförderung of the State Baden-Württemberg, 1999–2001.

As usual, such a study could not have been completed without the support of numerous individuals and institutions. Foremost I want to express my immense gratitude to the women and men in Balipatna and Gania Block, who patiently answered my relentless questions and made themselves available although time is a very precious resource for them. I am especially indebted to the 14 female members of the Panchayati Raj Institutions, who showed great patience and frankness during my qualitative inquiries. They did this with great humour and tolerance for my inquisitiveness in quite sensitive issues. Since they gave me their opinions in good faith I am not mentioning them here personally, and also in the study their names have been changed. I am even more grateful that they interacted with me after the calamity of the super-cyclone had upset their lives and threatened their livelihood in Balipatna and in the face of enormous economic hardships which is the usual condition in Gania. I feel furthermore honoured that they gave me a unique glimpse into their lives and did not only share their thoughts but also their food with me.

In Gania, the fieldwork could not have been carried out without the support of the NGO Gania Unnayan Committee (GUC), who helped me in organizing meetings, identifying resource persons, provided mobility, and shared their work and insights into the problems of this area with me. Inexpressible appreciation is due to the family of Parikhit Pattnaik who provided me a home away from home and treated me as their family member. Especially Usha Pattnaik, who was my most able and reliable research assistant, deserves my grateful thanks!

In Balipatna, I am thankful to Lina Mohanty, who was my research assistant during the quantitative survey in 1998–9. A special thanks goes to the Fishery Extension Officer Sri Mahapatra in Balipatna, who also supported me during the first round of research. During the qualitative phase I was aided by my research assistant Lita Mohapatra. For this phase my major thanks are due to the members of the NGO Darbara Sahitya Sansad (DSS), who created a space in their office for me to stay and sacrificed precious time, in spite of being extremely busy in the relief efforts after the

cyclone. They also arranged meetings with the women's groups they have organized, and helped me with their experience to understand many things better.

In Orissa, I got academic support from S.P. Das of the St. Xaviers Institute of Management, who rescued me out of a difficult situation and brought me in contact with Parikhit Pattnaik and the GUC. Further support was extended by members of the Political Science as well as the Public Administration Departments of Utkal University, Bhubaneswar, especially Amareshwara Mishra, S.N. Mishra, and Bijoyni Mohanty. I also had numerous interesting discussions with P.K. Nayak of the Department of Anthropology, Utkal University, in particular about the caste structure in Orissa. Several individuals from NGOs in Bhubaneswar were also helpful, like Balaji Pande of the Institute for Socio-Economic Development (ISED), and S.S. Mohapatra from OSCARD.

In Delhi, during the research for the dissertation, I had useful discussions with George Mathews, Bidyut Mohanty, and G.K. Giri of the Institute of Social Sciences (ISS), Imtiaz Ahmad and Sudha Pai of the Jawaharlal Nehru University (JNU), and S.N. Mishra of the Indian Institute of Public Administration (IIPA). V.B. Singh of the Centre for the Study of Developing Societies (CSDS) helped me with the first draft of the questionnaires. I also benefited from workshops organized by the Friedrich-Ebert Foundation, the ISS, the Konrad-Adenauer Foundation and the Indian Social Institute (ISI) between 1998 and 2000. Furthermore, I had interesting discussions with members of the Centre for Women's Development Studies (CWDS), the Society for Participatory Research in Asia (PRIA), the Indian Institute of Public Administration (IIPA), the Indian Social Institute (ISI), the Indian Social Studies Trust (ISST), and the Women's Studies and Development Centre (WSDC), University of Delhi.

In Germany my special thanks are due to Michael Mann (FernuniHagen) for the many lively lunch discussions and for his useful comments on the first draft of the dissertation; to Hanna Büttner and Susanne van Dillen (South Asia Institute, Heidelberg) for their constructive comments on the case study; and to Harald Fischer-Tiné (Humboldt University, Berlin) for comments on the chapter on Orissa's history. A major thanks goes to Peter Park (UCLA, Los Angeles) for proof-reading and correcting the 'German'–English syntax of the final draft of the submitted dissertation, which does vary, however, from the present book. As regards the quantitative dataset I also took advice from ZUMA (Zentrum für Umfragen, Meinungen, Analysen, in Mannheim).

Last, but not the least, my thanks are due to my supervisor Subrata K. Mitra of the South Asia Institute. He encouraged me to take up Orissa as a case study, provided me with support in also many non-academic ways, and was additionally very tolerant towards my personal approach to the subject.

Further thanks are due to numerous individuals with whom I have discussed the topic in the two years that have gone by since the completion of the first draft. They helped me to sharpen my arguments and to mould the manuscript into the present form. I am unable to name all of them and I also

could not take up all their suggestions. Thus, obviously all shortcomings in the present book are entirely mine.

Important input came from Anne Phillips, who was so kind to read through the manuscript and give her useful comments. I also want to thank Paricia Jeffery who gave extensive comments on an earlier draft. In addition, I benefited enormously from remarks by the audiences of talks I delivered on this subject at the 16th European Conference of Modern Asian Studies in Edinburgh, at the Max Müller Bhavan in Delhi, at the Delhi School of Economics and the Political Science Department of the University of Delhi, and at the Political Science Departments of the Universities of Goa and Warangal, Andhra Pradesh. Furthermore, my arguments also benefited from more casual discussions with numerous individuals at the JNU, the CSDS, the Centre de Sciences Humaines (CSH), and the India International Centre (IIC), all in Delhi, which is my home now. Special thanks are due to J.P. Bhatti of the Himachal Pradesh University in Shimla, who provided the opportunity for a scholarly retreat to work on my manuscript.

On a more personal note, I am very grateful to my parents, who always supported me in my academic quest though my choice of interest—India and its fascinating people and culture—is very remote for them, and to my friends and my sister Isabell for their emotional backing in both good and bad times. Among my friends I want to mention especially Siddharth, who gave me the first introduction into Orissa and mobilized his family to support me during my stay in Orissa.

Delhi, August 2003 EVELIN HUST

Introduction

We are happy to be wardmembers
Because we get prominence now
And have more prestige.
Actually we would like to have
100 per cent Mahila seats!

We will never elect a woman
If we are not forced to do so!
Women are not used to going out,
And this is our tradition.
We won't change.
And if the women change
— Who will do the work?

*F*EMALE WARDMEMBERS articulate their pride and demand to get their fair share or even more in local politics whereas male villagers voice their utter rejection of granting women a public role, coupled with fears of losing their traditional way of life. These two remarks, recorded during my field study in Orissa from 1998 to 2000, essentially capture the female and male sentiments on women's newly acquired presence in rural local politics in India. These observations are not restricted to the eastern state of Orissa. Men in Maharashtra, for example, also feel threatened that the traditional division of labour will be upset because of women's political activities, while female wardmembers in Haryana were equally proud to be addressed with reverence, as one can gather from the revealing book titles '*And who will make the chapatis?*' (B. Datta 1998) and *They call me member saab* (MARG 1998). Apparently, the Indian country-side is witnessing an unprecedented challenge to customary gender behaviour. While politics in India's villages was traditionally an exclusive male affair and women had hardly any presence in the public realm, this situation has changed now!

The novel large-scale presence of women in local rural political bodies that is seen today was decreed by the 73rd Amendment to the Indian Constitution, introduced in 1992. This Amendment formulated the basis for a three-tier system of local government, the Panchayati Raj, and reservation of seats for women of no less than 33 per cent as well as a proportional quota for other marginalized social groups (GoI 1993).[1] These bodies of rural local

[1] Similar provisions for the municipal bodies were implemented through the 74th Amendment. They will not be dealt with here. For the legislative structure of the Indian Union, see Fig. 2.1.

government—if they had not been defunct in any case—had up to then literally been manned by the male elite. In this respect, the 73rd Amendment is definitely a revolutionary document for India's democracy: it not only strengthens the institutions of local government but gives a constitutionally secured voice to social groups hitherto de facto excluded from the political decision-making process.

Yet, the 'male' viewpoint gives already a succinct indication of the obstacles faced by the new entrants into public life. Women in rural local politics encounter a male stronghold that is not really convinced that it could gain from women's participation in politics. The self-esteem and pride of the female wardmembers, on the other hand, shows that the quota offers rays of hope and opens up a space for 50 per cent of the population that so far had no role to play in rural politics. The introductory remarks represent two extremely opposed estimations of the women's quota in India: women's joy and over-abundant confidence contrasted with men's complete rejection. It goes without saying that there are many shades of grey between these poles of opinion, and one cannot pit the 'male' against the 'female' view as if they were essential categories. Nevertheless, the following analysis will show that gender has without doubt significance for political life, although culture, caste, class, or location are central as well.

In comparative perspective it seems remarkable that India, which has been frequently labelled as a 'developing' or 'backward' state in respect of the status of women, is at the forefront with regard to the inclusion of women into the institutional political process. This effort towards legally guaran-teeing the presence of women in the local political institutions was mainly justified in terms of gender equality and justice. Additionally, many advocates of the quota propose that it will also lead to women's empowerment in India. Yet, one wonders how the latter is coming about in a social environment that can still be portrayed as predominantly patriarchal. Without doubt, women in the rural areas in most Indian states face severe obstacles against performing in politics due to structural discrimination, most evidently exposed in the practice of *purdah*, or female seclusion. This culturally ordained separation of the male and the female world has effectively debarred most women from becoming politically active. During the field research women clearly stated that: 'There was no scope for women in politics. So why should we have been interested?'

This rather unfavourable setting has induced many opponents of the quota to argue that the elected women will be mere proxies of influential males, that the reservation will not lead to any gains for women's empowerment, or that the improvement will only accrue to the elite. Thus one wonders what kinds of changes are really taking place as a result of the women's quota. Will women's political presence indeed lead to their empowerment—or will nothing change? Will the quota create local institutions occupied by women representatives working for women's interest—or will the ranks be filled by proxies?

The evidence from studies in various Indian states so far is rather mixed. In

the north-western Hindi-speaking belt, many female representatives still remain in *purdah* and sign the registers at home. In the southern regions the situation looks better, although there too women face many obstacles in performing well in their new public role.[2] It is obvious that the processes resulting from the women's quota are determined by the specific setting, especially since features of structural discrimination vary across localities. Additionally, the Panchayati Raj Institutions (PRI) are not uniform throughout India, although the constitutional Amendment provides a steel-frame. Even so, the federal states have some autonomy in designing the actual system of local government, and the devolution of finances differs substantially from state to state.[3] Yet, the processes are also comparable, as the introductory quotes and their resonance in experiences from Maharashtra and Haryana show. How does one then assess and position the differing experiences?

This volume argues that any analysis of the processes emanating from women's political presence must be context-sensitive, paying due respect to the distinctive features of a particular locale. However, every study needs also to be informed by a theoretical framework in order to be able to compare the singular experiences with results from elsewhere. Furthermore, as mentioned above, supporters of the quota argue that women's political presence will lead to women's empowerment. Conceptual arguments on how the one will actually lead to the other are, however, remarkably absent in most studies. Considering this, a comprehensive theoretical discussion on the justification of a women's quota and its expected gains seems necessary.

The theoretical and normative considerations are delineated in Chapter 1 of this volume. For arguments supporting quotas for women in politics I draw mainly on Anne Phillips' *Politics of Presence* (1995). Her representation is supplemented by insights from other scholars like Pippa Norris, Joni Lovendusky, and Drude Dahlerup. Because the women's quota supposedly leads to women's empowerment, this concept needs to be defined. Since the most conspicuous element of the term 'empowerment' is power, I also discuss

[2] Most of the existing studies dealing with women in the institutions of local government in India are case studies of a single Indian state; few have been comparative between two or three states. For studies on women in Panchayati Raj after the 73rd Amendment, see, for example, Athreya and Rajeswari (n.d.) [the study was conducted in 1998 in Tamil Nadu]; Bhaskar (1997) [Kerala] (for a critique of this study, see Mathew 1997); Ghosh (1995, 1997) [West Bengal]; Gowda, et al. (1996) [Karnataka]; ISED (1998) [Angul District, Orissa]; Kanango (1996) [general overview]; Kaushik (1997) [Haryana]; MARG (1998) [Haryana]; Mukhopadhyay (1996) [West Bengal]; Pai (1998) [Uttar Pradesh]; Santha (1999) [Haryana, Kerala, Tamil Nadu]; for studies on women in the local government prior to the 73rd Amendment, see Bhargava and Vidya (1992) [Karnataka]; D' Lima (1983) [Maharashtra]; Manikyamba (1989) [Andhra Pradesh]; Mohapatra (1995) [five districts in Orissa]; OSCARD (1993) [Orissa]; Panda (1995b, 1997, 1998, 1999) [Ganjam District, Orissa]; Rajput (1993) [Punjab]; and Vidya (1997) [Karnataka].

[3] For a good overview on the particular organization of the rural political bodies in all Indian states see Mathew (1995b).

the relevant debates on this concept, drawing, for example, from Foucault, Lukes, and Kabeer. In the final part of Chapter 1, the concepts of political presence and empowerment are operationalized for the case study. The potential process of empowerment flowing from a quota in politics is divided into four stages: the moving into formal positions of power; the exercise of power; the empowerment of the elected female representatives; and the empowerment of women as a group. These four areas of empowerment provide the frame for the arrangement of the three main chapters of the empirical study, namely Presence, Power, and Empowerment.

Orissa was chosen for investigation because it is one of the most 'underdeveloped' regions of the Indian Union in economic and social terms.[4] Orissa has a politically rather unstable system, and in the Oriya heartland we encounter a male biased sex-ratio and fairly patriarchal social values. The rationale of this selection was to see what kind of changes happen in a rather difficult environment. If one can find positive developments under bleak circumstances, it seems fair to assume that changes in more favourable settings should be even greater. Another reason for this choice was also the fact that Orissa provides a kind of paradox. Orissa was the first state in India to hold elections with 33 per cent seats reserved for women already in 1992, under regulations passed in 1991.[5] However, the institutions were dissolved in 1995 itself, and fresh elections were held in 1997 only.

Even though the study of a single state was seen as advantageous to pay respect to the regional context, a comparative approach can yield important insights into the processes of women's political presence and empowerment. Thus, two regions in Orissa were identified—one in the coastal area (Balipatna Block in Khurda District) and one in the hinterland (Gania Block in Nayagarh District)[6] that differ in various features like political history, economic development, and the status of women, while at the same time avoiding the tribal factor. Orissa has in fact a large tribal population that is located mainly in the western and northern hinterland. Yet, the position of women in tribal society differs sharply from the one in 'Hindu' civilization. The tribal factor was hence excluded since it would overshadow other factors like political history or economic infrastructure. And all these factors are believed to influence women's empowerment and the general democratic process and thus need to be spelled out as background information.

[4] Orissa was ranked the poorest state of India in terms of per capita income and persons below the poverty line in 1996 (Haq 1997: 32); for Orissa's 'backwardness' in social and political terms, see Mohanty (1990) and Pathy (1988). The methodological device to select a difficult setting for the empowerment process led to the investigation of the rural bodies of local governance. In the municipalities, the environment for women's political presence and empowerment is believed to be more conducive.

[5] As will be discussed later, other Indian states (Karnataka and Andhra Pradesh) had provided for a reservation for women even earlier than Orissa, but the amount was below 33 per cent.

[6] Please refer to the maps for the location of the study regions provided in Chapter 2.

In Chapter 2, the relevant institutional, cultural, historical, and political framework is specified.[7] Knowledge about the institutional context is important, since it demarcates the space that has opened up for women. As we shall see, the PRI are rather powerless, which obviously limits the overall changes that could be introduced through a women's quota there. The cultural setting concerning female role models in Hinduism, the specific socio-cultural context in Orissa, and macro-social indicators on the well-being of women in Orissa serve to illustrate the limits women face for being active in the rural political sphere. Spaces are highly segregated, which severely compromises the independence and autonomy of women to act. This again has obvious repercussions on the scope of women's empowerment through a quota in rural politics. The final part of Chapter 2 describes Orissa's political history, the structural feature of regionalism, and the local caste-structure. The selection of the two study regions is explained in greater detail, and their socio-political and economic structure also delineated. Chapters 1 and 2 comprise Part I of the book in which theoretical and normative arguments as well as relevant background information is given.

Part II presents the *quantitative* and *qualitative* findings of the field research that was conducted between 1998 and 2000. As we have seen, elections to the PRI in Orissa had taken place in January 1997 only, and thus the representatives were two to three years into their term of office. This short incumbency is one limiting factor for major changes to happen, as we will see later. Here I want to draw attention to the specificities of the methodological approach employed. In the social sciences, one normally finds a preference for either quantitative or qualitative research.[8] Both have their merits as well as drawbacks. Quantitative studies help us to detect the general patterns, give us a bird's-eye view on a complex reality, and enable us to arrive at comprehensive conclusions. Quantitative research is, in addition, especially meaningful for comparative studies. A survey was moreover regarded as necessary since hardly any quantitative data was available on women in the local government in Orissa after the 1997 election.[9] However, quantitative results often lack depth and remain inconclusive, since not all relevant information for the analysis of complex social processes can be gathered and not every component of a given process is quantifiable. Furthermore, not much attention can be paid to arguments and information

[7] For the importance of the cultural setting for political processes, especially in regard to the so called 'civic culture', see Almond and Verba (1989). The authors have, however, concentrated on the national level only, disregarding the differences that exist at local levels in a given nation.

[8] For a classical article on methodology in political science, see Driscoll and Hyneman (1955). For recent discussions on methodology and concerning the design of case studies in particular, see King, et al. (1994) and Stake (1995).

[9] Among the studies on Orissa mentioned in fn 2, only ISED (1998) was conducted after the 1997 election. This study provides quantitative data on women elected in Angul District. No men were interviewed.

that come up from the interrogated persons themselves, as pre-designed questions are asked and answered. In many respects, quantitative survey techniques thus prevent us from really hearing the voices of the people concerned, and the statistical interpretations remain rather 'bloodless'. The problem of drawing from quantitative sources only was aptly captured in an article on 'Women in Local Governance: Macro Myths, Micro Realities' (Banerjee 1998).

Purely qualitative research of a single case, on the other hand, often lacks the breadth for arriving at broader conclusions. One also does not know whether the insights gained are exceptional, or if they comply with a larger pattern. Yet, such methodology takes the informant and his or her setting more seriously, and thus usually facilitates a more context-sensitive understanding. Qualitative research also helps to conceive the relative uniqueness of each case and prevents us from making sweeping generalizations without paying tribute to the fact that reality is after all very complex. Thus, an eclectic approach combining quantitative and qualitative research was adopted for the present empirical study.[10] The analysis will expose the general patterns that emerged from the quantitative data, but will also give due respect to the voices of selected female representatives, members of their constituencies, and other people concerned.

Existing studies on women in Indian local government are predominantly quantitative in nature, providing only scant qualitative evidence. Usually they offer survey data on the elected women's socio-economic background and relate some success-stories or problems faced by individual elected women. Women as a group have hardly been the focus of investigation, and if the question of empowerment was dealt with at all, it had been mainly looked at in regard to the mandate holders only. Furthermore, the social and political setting is often taken for granted, thus no particular context-sensitive analysis is provided. The studies have moreover been mainly conducted at the state or district levels, paying no attention to the actual setting at the village or block level, where most of the representatives are located.

Another factor which distinguishes the present work from other studies is the employment of a gender-approach in its full sense. 'Gender literature' is often a misnomer for studies that concern themselves exclusively with women, while disregarding men as objects of analysis. Thus, in most other studies on women in local government men do not feature much—exclusively female representatives have been interviewed and comprise the sample of the quantitative surveys, and the perception of men plays a role mainly in polemical or 'generally-speaking' phrases. There is no recent study on women in the PRI in which quantitative data has been generated on men as well. This deficiency leaves the readership rather clueless in understanding to what extent the situation of the women really differs from that of the men, or in more analytical terms, what results can really be attributed to gender and

[10] For the justification of an 'eclectic' approach, especially in comparative politics, see the stimulating debate by Kohli et al. (1995).

what to other factors? In this study it will become obvious that the neglect of men as objects of analysis is a serious methodological fallacy.

The comparison with male incumbents shows clearly that some features that have been attributed to women only concern men to a certain extent as well, like political family background, insufficient knowledge, or lack of autonomy in decision making. The regional comparison is illuminating as well, and generally women in the Balipatna, the 'forward' block, appear to have gained more from their inclusion into politics than their colleagues in Gania, the 'backward' locality. However, in both areas the evidence indicates that the quota has indeed opened up a space that is now occupied and used by some female representatives who have considerably gained from their inclusion. Furthermore, their presence has also led to a certain empowering impetus for women as a group. Nevertheless, it also became clear that the process has just been started. There are still many obstacles on the way to women's full empowerment which will not be removed by women's political presence alone. A set of hurdles working against women's empowerment that result from the specific framework are summarized in Chapter 6. Among these are structural deficiencies of the PRI, such, as the mode of reservation or the lack of financial resources, and problems that result from women's status, most importantly their lack of autonomy and the absence of effective women's groups. Apart from stating the problems, some policy recommendations are also made. The book concludes with a summary of the main results and a reassessment of the theoretical framework of women's political presence and empowerment.

PART I

Politics of Presence, Empowerment, and the Socio-Cultural Framework: Theoretical Foundations

CHAPTER 1

Political Representation, Power, and Empowerment

REPRESENTATION in political decision-making bodies and the empowerment of marginalized groups are two distinct concepts. However, if one follows the Indian debate on the inclusion of women in political bodies, one frequently finds that these notions have been combined in such a way as to suggest that political representation of women will also lead to women's empowerment. This tendency becomes quite obvious when we look at several studies on women in the Panchayati Raj Institution (PRI).[1] Some authors have been more cautious and qualify the hope concerning a kind of 'general' empowerment through political representation by limiting expectations to the 'political' empowerment of women as a result of the reservation policy.[2] In most of the works it remains quite obscure in what way the one will lead to the other, which has mainly to do with a lack of theorizing and conceptualization. That is not to say that the concept of empowerment or, for that matter, of reservation policy has not been critically dealt with, but it seems that the theoretical as well as empirical ramifications, especially if we postulate that the one will somehow lead to the other, have been widely ignored. Furthermore, neither the concept of political representation nor the concept of (political) empowerment has been scrutinized in most of the given studies, and the link between the two remains ambiguous. To discuss the two concepts and to theoretically explore their relationship is the theme of this chapter. It sets the agenda for the empirical study, in which the theoretically derived insights will be confronted with the results from the field.

Readers may think that a theoretical discussion is not very relevant for this analysis since a 33 per cent quota for women in the local political bodies has already been introduced in India. However, one problem that can be perceived in regard to the academic as well as activist debate in India is precisely that there have not been many theoretical deliberations as to why India should opt for a reservation for women in the first place. Such a comprehensive discussion is important to understand and foresee the

[1] See, for example, Athreya and Rajeswari (n.d.); Datta (1998), especially Chapter 4: 'Women in Panchayats', pp. 39–56; Gopalan (1993, 1994); Jayalakshmi (1995, 1997); Lelithabhai (1998); Meenakhshisundaram (1995); Mohanty (1995); Oommen (1996), especially pp. 26–37; Pal (1999).

[2] Bhargava and Subha (1999); Kaushik (1993, 1999); Mohanty, Bidyut (1996); Mohanty et al. (1996); Panda (1997, 1998, 1999); Pattanaik (1996); Vidya (1997).

manifold implications a quota for women has for the political system and the polity as such, as well as for an estimation of the likely outcomes of the reservation. Surely, there are several arguments for a women's quota and many against it, but a broad theoretical discussion is lacking, at least concerning the reservation for women in the PRI.[3]

There is also not much deliberation on the specific nature of political representation, which is quite distinct from political participation; the historical development of representative democracy in contrast to direct democracy; and the logic behind a claim for quotas for women. None the less, this debate would be very much relevant in Western democracies, where affirmative action as such—be it for women, ethnic, racial, or religious minorities—is still politically a highly contested issue, while many constitutions are framed in a way which makes the introduction of a quota for marginalized groups extremely difficult.[4] Furthermore, if we take a close look at the Indian scene this assertion actually holds as well, especially when we contrast the passage of the 73rd and 74th Amendments, which was smooth, with the passing of the Women's Bill for the introduction of a women's quota in the National Parliament and the State Assemblies, which was heatedly debated and for various reasons delayed. Thus, we have to ask: Why was there no discussion when the quota for women was introduced in the PRI, but is erupting now concerning the extension of quotas for women to the national and state level as well? The same issue—at least from a theoretical point of view—of the introduction of a quota for women in the Legislative Assemblies and in the Parliament is very controversial at present.

I do not propose that I shall be able to answer all these questions here since the recent discussion on the Women's Bill in Parliament is very complex and would require a separate study to do justice to all the different strands of the argument. However, I shall give a possible explanation as to why the issue for reservation for women as such was not contested in the case of the panchayats and why the debate in the National Parliament is not about a quota for women *per se*, but more about whether this quota should have sub-quotas for Other Backward Classes (OBCs) or Muslims.[5]

[3] More discussions started to take place after the Women's Bill for 33 per cent reservation for women in the National and State Parliaments was not passed three times. For a short background on the debate, see Sharma (1998), and for a bibliographic compilation on this issue, CWDS (1998).

[4] See, for example, the case of France. In 1982, the socialist government under Francois Mitterrand wanted to implement a promise made during the election campaign by adopting a law to secure a 25 per cent quota for women in the municipal elections. In 1983, the French Constitutional Council declared quotas to political elections unconstitutional (Siim 2000: 63). However, later developments have led to a change of two articles of the French Constitution in 1999, and in 2000 a law of parity to be secured in various ways for the national, regional, local, and European elections was passed (Mossuz-Lavau 2003). Similar developments at the constitutional level took place in Belgium, whereas in Germany various political parties have adopted women quotas.

[5] The proposed Women's Bill in the Indian Parliament does envisage sub-quotas for SC- and ST-women. Reservations for these two groups already exist in general. The bone

Reasons for the lack of debate and of a wide-ranging discussion on the reservation policy as such at the time when the 73rd and 74th Amendments were passed should be found in the particular history of the Indian State. Quotas in politics for marginalized groups have been existent right from the inception of India as an independent state, although it was initially perceived as a transitory measure. The need was seen at the time of independence to constitutionally secure the political representation of the Scheduled Castes (SCs) and Scheduled Tribes (STs). This was in order to rectify a historically unjust and unbalanced distribution of power, which might lead to political instability. The Indian Constitution was framed in such a way so as to do away with discrimination, on the one hand, but allow affirmative action to promote marginalized groups, on the other. Thus, the present reservation for women in the PRI in India or the demand for it in the Parliament and the State Assemblies could be seen as a logical extension of the already granted reservation for SCs, STs, and OBCs. And this might not call for intensive theoretical discussions on a regime of 'positive discrimination' as such. The issue of affirmative action in favour of historically marginalized social groups seems to be much less politically divisive in India than in the established democracies of the West. Again, this is not to say that there was never a debate on reservation policy in India, or that there are no critics against it for that matter, but by and large the population and the major political parties have accepted this device of 'social engineering' as a legitimate policy to reach the stated goals of the Indian Constitution.

That women also became included into the category of historically disadvantaged groups that are in need of promotion in the political realm is definitely partly due to the pressure exerted by the women's movements in India. However, one should also not forget to recognize changes in the political landscape, which induced politicians like Rajiv Gandhi to sponsor this issue. This can be understood as an outflow of realpolitik, which has compelled various political parties to take a positive stand.on the issue of reservation of seats for women in elected bodies. The historical development of the demand for a quota for women and how the 73rd Amendment was actually passed will be discussed in detail in Chapter 2.

Still, even though a theoretical argument for the political representation of marginalized groups seems to be less relevant in India where far-reaching measures have already been introduced, I argue that it is still very much needed, especially in regard to the reservation for women, who form a rather

of contention is an additional sub-quota for women of the OBC-category, and Muslims, because there are no general quotas for them in the National Parliament yet. It is also more difficult to provide them, although not impossible, from a constitutional point of view. For a short examination on the constitutionality of the proposed Women's Bill, and concerning the various sub-quotas in particular, see Desai (2000); see Bhattacharya (1997) for arguments favouring a reservation for women in the Parliament, but opposing sub-quotas for Muslims and OBCs. Also see Dhagamwar (1997) who is against reservations in the Lok Sabha, but favours the reservation for women in the PRI.

special group of 'minority'. This becomes obvious when we look at the recent evaluation of the impact of the reservation for women in the PRI, but also for the related debate on a similar reservation for women in the higher political bodies.

Firstly, theoretical deliberations are necessary to derive a perspective on what one can legitimately expect as practical consequences from a reservation for women. Following the debate in India, one gets the feeling that at least the strong promoters of reservation for women might cherish too many unrealistic hopes about the positive effects that this reservation might bring to women as a group, or to society as such, and this may be followed by a severe disillusionment. It is exactly this disillusionment resulting from high-flying hopes that might lead some critics to conclude that one should do away with the quotas. Secondly, reservation of women is still an open case for the Parliament and State Assemblies, which definitely needs serious thinking and theoretical ammunition for realization; and thirdly, during the field research I came across a lot of criticism regarding the already realized reservation for women in the PRI. This means that the issue is not that uncontested as the smooth passing of the 73rd Amendment might lead an outside observer to believe. Last, but not least, the case study of Orissa should give relevant insights into the process of the workings of a quota for women at the level of the PRI. This could be interesting for other states of the Indian Union, but also for democracies in the West, although the setting is undisputedly very different. Thus, theoretical deliberations make the Indian case more comparable to situations elsewhere, and also help us to identify the important differences.

THE 'POLITICS OF PRESENCE'

Representation for women in political bodies through a quota system has been identified as one important means of achieving gender equality in India as elsewhere. Those countries that have enhanced the presence of women in their national parliaments have usually achieved this through reservation for women, be it through legislative action or self-imposed regulations by political parties (IDEA 2001).[6] Furthermore, empirically those countries that have multi-member rather than single-member constituencies, offer more favourable conditions for women politicians (IFES 2001). In spite of this, the inclusion of women into political decision-making bodies, especially if implemented through affirmative action such as a quota, is still politically highly contested and theoretically debated. Remarkably, a quota for women is an area in which those engaged in its practice have gone beyond its theoretical foundations. Anne Phillips, on whose deliberations in her *Politics*

[6] For the positive impact of quotas on women's enhanced political presence, see also Bunagan et al. (2000), Pintat (2001), and the webpages of the International Institute for Democracy and Electoral Assistance (IDEA), Gender Section at *www.idea.int/gender/index.html*.

of Presence (1995) I will mainly draw for the theoretical background, believes that this fact is mainly due to party-competition, where one party introduces a quota (as in Germany or the Nordic countries) and the other parties have to follow because otherwise they fear to be punished at the ballot box. The same argument also holds for the Indian case where no party can now openly oppose a women's quota as such, although resistance especially for the parliamentary level is very much there. However, in India the quota was not introduced at the level of party (as in most of the democracies in the West), but through the reservation of rotating single-member constituencies. To my knowledge this is unique in political history, but also leads to specific problems that are not so salient when the quota is operating through a party-system; I shall discuss the difficulties of this specific political setting in Chapter 6. Furthermore, the fact that the decentralization of political power and the inclusion of marginalized social groups were imposed by the most central instrument available, namely a constitutional amendment, deserves special attention. We shall see later that the lack of combined struggle for women's rights in the countryside limits the impact of the women's quota considerably.

Although there seems to be a surprising degree of consensus that women are indeed under-represented, there are various critical points raised against a reservation for women. Phillips states that arguments against other forms of group-based representation are mainly concerned with social divisiveness, whereas critics of gender-quotas normally oppose affirmative action as such and refer to women's lack of experience. In the West, this claim has been empirically refuted and it has furthermore been questioned whether male politicians have been necessarily elected on merit basis. However, one definitely faces a different situation in rural India than in the established democracies in the West. In the Indian countryside, most women undeniably lag behind men: women are less educated, less exposed, more dependent, and command lesser capabilities than men, whereas women in the West are more or less at par with men in these respects. Yet, all this only proves the existence of structural discrimination that has relegated women into the private realm and hindered them in developing the required skills. The quota is exactly a means to open up a space where women can acquire the necessary expertise that has been denied to them. And we will see later how some women really use this new public space. Additionally, the point whether the male incumbents are always chosen on merit is very valid in the Indian case as well. During my field research I encountered a dominant discourse where men's lack of capabilities was seen in a completely different light than women's deficiencies, which will be discussed in detail in Chapter 6. A further problem is that nobody really knows what the qualifications of a politician are supposed to be. There seem to be more objective criteria of qualification for jobs in general than those concerning serving in a political office. Still, Phillips reminds the reader that becoming a representative is not a matter of an individual right—thus one has to ask about the grounds on which a quota in politics can be defended.

Phillips' argument for a quota for women is couched in terms of an advocacy for a 'politics of presence' in contrast to a 'politics of ideas'.[7] In traditional liberal democracies, difference is regarded primarily as a matter of ideas. Representation is considered to be more or less adequate depending on how well it reflects the opinions or preferences of the voters. Such an understanding of representation does not pay much attention to the personal characteristics of the representative—gender, race, or other social attributes are not important. Historically, there was a shift from direct to representative democracy[8] in response to the larger mass of enfranchised citizens, and this has shifted the emphasis from 'who' the politicians are to 'what' (policies, beliefs, preferences) they represent. Thus, accountability to the electorate became the most important concern. Where such processes to enhance accountability are successful, it seems unimportant who the representative is.

However, the marginal political position of several social groups (such as women and ethnic or racial minorities) has become a major source of concern in democracies, and the above stated argument does not address this felt sense of exclusion. Phillips makes the case that the subordination of 'who' to 'what' is to be represented should be questioned and an alternative politics of representation should be sought. The novelty of this claim is not the emphasis on difference as such, but diversity has only been perceived as differences in beliefs or opinions. These differences might originate from a variety of experiences, yet they are considered in principle as detachable from them. Phillips poses a crucial argument against this view:

> Once difference is conceived, however, in relation to those experiences and identities that may constitute different groups, it is far harder to meet the demands for political inclusion without also including the members of such groups. Men may conceivably stand in for women when what is at issue is the representation of agreed policies or programmes or ideals. But how can they legitimately stand in for women when what is at issue is the representation of women per se? (Phillips 1995: 8)

This argument offers also an explanation as to why the Women's Bill that was to introduce a quota for women in the Parliament of India has so far not been successful. One might see the lack of a substantial number of women Members of Parliament at the time of tabling the Bill as one crucial explanatory factor for its failure.[9]

[7] The following paragraphs delineate the arguments Phillips makes in Chapter 1: 'From a Politics of Ideas to a Politics of Presence' (1995: 1–26).

[8] It should be noted that it is not that clear what the differences between direct and representative democracy really are. There is even more confusion about what 'direct' and 'representative' actually mean. However, the problem will not be dealt with here. There is the commonsensical notion that representative democracy implies that not all citizens share the power of decision-making directly, but via representatives chosen through election. For this discussion, the historical development, and different forms of representative democracy see Manin (1997).

[9] In the 1998 Lok Sabha, 43 of the total 543 MPs are women or a mere 7.92 per cent. For this and women's representation in the Indian Parliament from 1952 to 1998, see

Another extremely contested issue is here touched upon, which was always a major source of tension in the development of feminist theory and politics, namely, who can really speak on behalf of another?[10] In the Indian setting, people wonder as to what extent a Brahmin can speak for an SC; an urban, middle-class woman for a rural one; a Hindu for a Muslim. This is the overt rationale for political actors to argue for sub-quotas in the women's quota as well. The Indian women's movement has been chastened for its elite character by the OBC political forces and for not accepting a sub-quota for OBC-women. The OBC forces believe that a reservation without a secured presence

Table 1 in Narayan et al. (2000). It should be noted, however, that the Women's Bill has serious flaws, which is also why Narayan et al. (2000) have presented their Alternative Women's Bill. The procedure of the implementation of the women's quotas leads to various problems, which will be discussed in Chapter 6. The same problems that are identified for the quota in the PRI would also hold for the quota in the Parliament and State Assemblies. In this respect, one should maybe try to forge consensus on revising the Bill before tabling it again, instead of trying to push through the present one which has some flaws (though I do not consider the absence of an OBCs' or Muslims' sub-quota as flaw, but rather the delineation of constituencies, the rotation, etc., as shown in Chapter 6).

[10] The question of who can legitimately represent women is extremely important for our discussion. Therefore a short excursus on the development of the feminist debate on this point is provided here. A major corpus of feminist theorizing centred on the question of equality and difference between men and women in the beginning. Only later, the issue of differences between women emerged as an important issue. One can see a historical development of arguments, but it is also rewarding to classify the theoretical debate according to different types of feminism. A good overview over *liberal* feminism can be found in Evans (1995). Nicholson (1986) gives a good background on *radical* feminism. Both schools propose a universal suppression of women who are treated as a homogenous group and identify specific causes for this oppression. *Radicals* see the main explanation in the omnipresent patriarchy, and the *liberals* in the unequal chances of women in education and jobs. Women of colour or women from Third World countries challenged both views from the 1970s onwards. These critics argued that the *radical* and *liberal* assumptions are based on experiences of Western, white, heterosexual, and middle-class women. Thus, these assumptions do not hold universally. Feminists of colour argued that ethnicity is an important factor in identity formation. They propose that women of non-white racial origin have a different socialization and experiences, which lead also to different behaviour and preferences. Class came back on the agenda as well, especially through feminists with a Marxist point of view. For the Indian case, Patricia and Roger Jeffery (1996) have found that the experiences of women in rural Bijnor do differ from that of men. But there are also differences between the women that result from belonging to different caste, religion, ethnicity, and position in the life cycle. The issues of caste and religion are also the stumbling block for the introduction of the quota for women in the Indian Parliament. Thus, the homogeneity of women as a group got severely challenged, culminating in post-modernist writings *à la* Judith Butler (e.g. 1990). Butler wants to do away with a binary construction of men and women per se. Even though many feminists regard Butler as too radical, the differences that exist between women are a more or less accepted fact. It is important, however, to point out that though women are divided by social cleavages, they also do have distinct differences towards men of their own class or religion, and women also share some commonalities across class and caste, like limited freedom of movement, discrimination for the mere fact of being a woman, etc.

for OBC-women would lead to a weakening of the disadvantaged castes and classes, since mainly women from an elite background would fill the 33 per cent quota for women.

These considerations are very important and tend to resurface time and again. However, recent contributions to the debate have redirected the question of authenticity into the direction of achieving an equality of presence. Phillips refers to the controversy on who can legitimately speak about rape within Aboriginal communities and whether it is appropriate for white feminists to enter this supposedly internal debate. She cites Anne Yeatman who argues that it is less a matter of silencing the white women contributing to the discussion, but more the matter of ensuring that 'those who could contest our representations . . . are present to undertake that contestation' (Yeatman 1993: 241, cited in Phillips 1995: 10). Thus, the presence of those who could have a different point of view becomes important, whereas the search for pure authenticity has been largely discredited. The inclusion of previously excluded voices and the changes this implies in political and other institutions is the dominant theme. In respect to the heated debate about the sub-quota for OBCs in the women's quota in the Indian Parliament, this means that one would need to prove that OBC-women would not be able to capture seats without a reservation for them.

The main concern nowadays centres also on specifically political mechanisms that associate adequate representation with political presence and also emphasize changes at the political level. All such measures insist that deliberate intervention is necessary in order to break the link between social structures of inequality or exclusion and the political reflection of these in levels of participation and influence. Political mechanisms are seen in this line of thinking as the precondition for longer-term social transformation. Thus, they challenge the standard radical alternative that has focused its attention on prior economic and social change.

One encounters arguments in India such as women should first be educated before they can stand for election from academics and journalists, but not surprisingly such remarks were also frequently voiced by general villagers during the field study. Women's lack of capabilities is used to argue against their political involvement, but the criticism is normally not accompanied by a commitment to remove the obstacles that deny women the development of these capabilities. Even the women's movements in India have been divided on the issue of giving priority to women entering politics for quite a while, and some have held the view that women's oppression is mainly a social, and not a political, question (CWDS 1995: 20). As will be discussed below, the 'original' empowerment approach too envisions a kind of psychological empowerment—awareness-raising—as precondition, which would then lead to the empowerment of women in other areas as well.

However, structural transformations are slow to happen, as has been witnessed in India as well as in the rest of the world. Thus, the focus has shifted more to institutional mechanisms and the quota can be seen as a device to accelerate the pace of change. A further argument is that the range

of ideas and preferences is severely constrained by the characteristics of the people who convey them.

In a more traditional base–superstructure model, one were advised to concentrate first on generating social conditions for equal citizenship, then to enjoy the political equalization that flows from this. Such an approach treats policy choices more straightforward than they really are, underestimating the extent to which strategies (even those devised for equality) will reflect the limits of those currently in power. When policies are worked out *for* rather than *with* a politically excluded constituency, they are unlikely to engage with all relevant concerns. (Phillips 1995: 13)

These considerations finally lead to the demand for a more fair representation of hitherto excluded groups. But what is a fair representation? The notion that a just representation implies proportionate is rather controversial. One has to note that there is a crucial difference in regard to the philosophical roots and practical implications between the demand for political parity and arguments for a quota system. Whereas the demand for a parity of women and men in political bodies is grounded in biological differences between them, the rationale behind a quota system is women's historical marginality in politics and the effects it has had on the political system (Siim 2000: 69). In fact, the discussion nowadays is more centred on the concept of a 'critical mass' to safeguard minority interests (Lovenduski and Karam 2001).[11] This 'critical mass', necessary to give voice to marginalized groups, can be less than the proportional share, but can also be more. However, there is still the need to make a case for why there should be a representation according to social characteristics at all.[12] What is to be gained if one argues for a 'politics of presence'? Phillips establishes the normative basis for any kind of political presence.

She starts with the need of *symbolic recognition*. Phillips argues that the under-representation of certain categories of people is in one sense just an empirical fact and does not itself present a normative case for their equal or proportionate presence. But it does provide the basis for the first part of the argument of political presence, which relates to symbolic recognition. That most of the political decision-makers are men relegates women to the category of a 'political minor', and 50 per cent of the population gets infantilized. In this respect claims on political representation are one of the

[11] The 'critical mass' is a concept originally derived from nuclear physics and refers to a quantity needed to start an irreversible chain reaction. Its basic tenet in our context is that a certain number of women must be present in order to be able to effect change. However, it is difficult to give a specific number, and often a percentage exceeding 30 per cent is given. Drude Dahlerup (1988) believes that it is more important to look at critical acts in contrast to critical mass in the sense that in social reality we should not expect mechanical irreversible chain reactions, but she still maintains that the size of a minority is important to effect change.

[12] For the three main arguments against a quota, namely the fear of undermining social cohesion, the problem of accountability, and the turn to a more deliberative democracy contemplated in major developments in recent political theory discussion, see Phillips (1995: 22–4; 46–56).

many avenues of challenging the existing hierarchies of power. It is important
to note that symbolic recognition as such carries an independent value:
'Including those previously excluded matters *even if* it proves to have no
discernible consequences for the policies that may be adopted' (Phillips 1995:
40, emphasis hers).

The elected women can furthermore serve as role models—an argument
that is discounted by Phillips, but which seems important for the Indian case,
especially in the rural environment. India has a history of women in
important political positions, such as Prime Minister Indira Gandhi, and
Nandini Satpathy, who twice served as Chief Minister of Orissa. At the rural
level, in contrast, such role models are missing, and many women do not
believe themselves to be capable of performing well in politics. When more
women become present in rural politics they could serve as role models and
inspire others to come forward as well. Still, apart from the benefits of
symbolic recognition, an additional expectation is that a fuller inclusion of
previously excluded groups will also alter the direction of policy or the
content of the decisions that are made as well as the way politics is done.

Thus, a further key argument of Phillips is the need for a *more vigorous
advocacy on behalf of disadvantaged groups*.[13] Anne Phillips does not
propose that representatives only promote their own interests. In the West,
most politicians are elected on party commitments, which might include a
number of policies relating to sexual or racial equality. Hence, says Phillips,
the relevant question is whether, in the case of there being a clear mandate
for such policies, it really matters who these politicians are. Would it not be
better to put the effort in establishing commitments, rather than bothering
about the characteristics of the people who implement them? Part of the
answer to this refers back to the issue of symbolic representation. Most
democracies accept that marginalized groups should be promoted, but do
not promote the disadvantaged as the right people to carry this through. The
other part of the argument is based on scepticism about binding mandates.
Phillips argues that sometimes new issues emerge alongside unexpected
constraints. In the ensuing evaluation of interpretations and priorities it can
matter a lot who the representatives are, because in fact they have con-
siderable autonomy in decision making.

Interestingly, the notion that the presence of specific groups should be
secured in political bodies was accepted in India at Independence, and thus
much earlier than in many other democracies. However, before Independence
the articulation of specific groups was limited. The most visible groups were
the two major religious communities—Hindus and Muslims—and also the
SCs, and later the STs. As the Constitution of India made secularism a basic
tenet, representation was not accepted on the basis of religion, but members

[13] Phillips actually proposes four key arguments. The second is the need to tackle those
exclusions inherent in a party packaging of political ideas. However, since there are no
parties operating at the two lowest tiers of the Orissa PRI, this argument was not seen as
very relevant for the analysis.

of the SCs and STs were granted reserved seats according to their proportional share right from the outset. But in India, as elsewhere, a further process of differentiation and articulation of newer 'identities' who claim their share of power has taken place, women being among them.

Feminists argue that women occupy a distinct position in society. In rural India, most women are confined to the home, to unpaid family work or lower paid outside work, to gathering fuel and drawing water for the home, and to caring for the young and needy (for a fuller discussion, see Chapter 2). Phillips argues that from these particular experiences of women, specific needs, preferences, or concerns do arise that are not adequately addressed in male-dominated politics. Apparently, the equal right to vote is not strong enough to deal with this problem—there should also be equality among those elected to office (1995: 66).

However, there is a serious challenge from those that wonder whether women do indeed have distinct and specific interests. In how far are women really a unified category? For the Indian case, Lele claims that women do indeed form a constituency because there are a range of concerns that are common to all women by virtue of their being women.

Thus the first argument for reservation concerns their needs on account of their gender linked priorities, for instance the enormous violence perpetrated against women—both sexual and physical—and therefore the need for legislation to provide safety and ensuring the execution of that legislation. The second issue concerns women's needs and demands on account of the economic/social/political status they occupy in the Indian society, for instance property laws, right to divorce, right to positive discrimination in areas of education and health and other areas of 'development'. (Lele 2000)

All this might not be enough to establish a set of interests shared by all women—in fact, there are individual differences based on class, caste, religion, or location. If interests are understood as the way in which women express their priorities, there is definitely considerable disagreement among women, as has been established by recent feminist theory.[14] Phillips argues instead that the variety of women's interests does not refute the claim that interests are gendered, as argued also by Lele (Phillips 1995: 68). Phillips maintains that the fact that some women do not bear children does not make pregnancy a gender-neutral event. That women do occupy such different positions in the occupational hierarchy does not mean that they have the same interest as their male class members. In this respect, the argument from the perspective of interests does not depend on establishing a unified interest of all women; it rather depends on establishing a difference between interests of women and men.

The last key argument is the importance of *a politics of transformation in opening up a fuller range of policy options*. Here, Phillips stresses again the importance of those ideas, which have not been included in the political agenda yet. 'The problem of representation is not just that preferences refuse

[14] Compare fn. 10.

to cluster around a neat set of political alternatives, or that the enforced choice between only two packages can leave major interest groups without any voice. There is an additional problem of the preferences not yet legitimated, the views not even formulated, much less expressed' (Phillips 1995: 44).

If the voters have only the choice between packages offered by political parties it appears that there is not much scope for further development and expansion of political issues. Citizens can indeed pressure political parties to take up new issues and once these issues are on the agenda they can use the ballot box to punish those who still ignore them. The problem is that disadvantaged groups might not be able to formulate their preferences or new issues if they are not first drawn into the political process, especially when a history of political exclusion has made it difficult even to articulate group concerns. The more fixed the interests, the less significance seems to be attached to who is representing them. Thus, if women's interests had a more objective quality there might be no particular case, apart from a more vigorous advocacy, that the representatives should also be women. Changing the composition of decision-making bodies is especially important because women's interests are not precisely demarcated and might only be developed and formulated once women are also drawn into the political process.

Yet, will women really represent women's interests? The question of accountability is still open. At an intuitive level, an increase in the number of women elected seems likely to change both the practices and priorities of politics, increasing the attention given to matters of child care, for example. But what does it mean in terms of political representation? Elections are typically organized by geographical constituencies, which hardly ever co-incide with concentrations of women or men. In the case that elections are held on a party basis (that is what Phillips assumes for democracies in the West and the national level, but as I have argued already, is not valid for the two lower tiers in the PRI in Orissa), the candidates are assumed to represent a party's interests. In what sense then can the women elected through this process carry the additional responsibility to represent women?

Yet, there is already some empirical evidence from Western democracies that female legislators do indeed promote women's issues, though this evidence is sometimes contested. Wängnerud (2000) has argued that studies conducted by men normally declare gender differences among politicians to be insignificant, whereas female researchers found that women did indeed make a gender-specific contribution to policies.[15] Dahlerup, who studied the effect of women's increased presence in Nordic politics, came to the conclusion that though it is difficult to isolate the effect of the growth in

[15] Wängnerud refers to studies on women politicians in Great Britain (Norris and Lovenduski 1995), Sweden (Esaiasson and Holmberg 1996), Australia (McAllister and Studlar 1992), and the United States (Thomas 1994). Female researchers, pointing out the female contributions, did the studies on Great Britain and USA whereas males, who saw only a small difference between male and female politicians, carried out the other two studies.

women's political representation from the general social development, certain changes can be directly attributed to the increase in women's political representation. Among these are a lessening of the stereotyping of women, the creation of new role models of women in public life, a change in some social conventions (though the main features of the political culture remain untouched), and the removal of open resistance against women politicians (Dahlerup 1988: 295). Furthermore, Lena Wängnerud (2000) has empirically tested that women do represent women's interests (defined as the recognition of women as a social category; the acknowledgement of the unequal balance of power between the sexes; and the occurrence of politics to increase the autonomy of female citizens) more than their male colleagues in the Swedish Riksdag. Empirically, this was measured by female *v.* male attitudes and behaviour in areas such as gender equality and social welfare policy. Pippa Norris and Joni Lovenduski (2001) got a similar result from a survey carried out in the British Parliament after the introduction of 'Blair's Babes' in 1997.[16] They found that on the scales related to women's interests, namely affirmative action and gender equality, women and men differed significantly across party lines. Concerning other issues like free market economy or stand towards the European Union, however, party affiliation proved to be more significant than gender. Sarah Childs (2001) has excluded the party factor, but found in a qualitative survey of 33 newly elected Labour women MPs in the 1997 British Parliament that more than two-thirds are 'attitudinally feminist'. Also in Norway several studies since the mid-1980s have indicated a consensus among the political leadership that gender makes a difference in politics. A series of issues were specified where women differ from men, which included representational politics, labour market politics, body politics, and care politics. However, also in Norway, party alliances are maintained as the primary political identification (Skjeie 2001). Thus, there is empirical evidence that some women's interests are more likely to be pursued by women than by men in politics, though on established political issues gender might not be the decisive factor. However, it is not so easy to know beforehand whether and where party loyalty or the autonomy of the representative might succeed, especially when we look at polities across different cultures.

In India, party loyalty is an issue as well and might hold also for women in the PRI, as for example in West Bengal, where they are elected on a party basis.[17] In Orissa, it appears that allegiance to a party programme should not be a concern, since there are no political parties operating at the two

[16] In the 1997 election that returned Tony Blair as the British Prime Minister, the number of women MPs doubled to 120 out of which 101 were from the Labour Party. These Labour MPs were soon called 'Blair's Babes' in the British Press with obvious sexist undertones. They were mainly portrayed as only dancing to Tony Blair's tunes without developing a (pro-women) profile of their own.

[17] Allegiance to the party programme was voiced by women representatives from West Bengal in a National Workshop on 'Women in Panchayati Raj' held on 27–8 April 2000, organized by the Konrad Adenauer Foundation and the Indian Social Institute in Delhi.

lower tiers of the PRI. Thus, the autonomy of the representative is in principle much greater, even if representatives are party members, since party discipline is usually less than in Western democracies. Yet, critics argue that women in the rural countryside are not autonomous in their decision-making to begin with. They are portrayed as proxies, dependent on the wishes of influential males. As the concept of autonomy is deeply rooted in Western notions of individualism, many might claim that this kind of autonomy does not exist in India in any case.[18] This argument was found to be valid to a certain degree, though there is a recognizable regional variation. Furthermore, the lack of sovereignty also holds for males who in certain settings are dependent on the traditional village elite. We shall have a close look at the question of autonomy in the course of the empirical study. Furthermore, in Orissa, representatives at the lower levels are not necessarily independent from party politics, which became quite obvious during the empirical investigations (see especially Chapter 4).

The above sections have mainly discussed whether women politicians would also promote women's interests. In connection with the argument for the transformation of politics, some feminists have argued from a completely different direction. They argue against the dominance of interest group politics and believe that this would be challenged by the inclusion of women. They expect women politicians to introduce a different set of values and concerns. This view has a long-standing tradition in feminist thought, and is also seen in recent developments. In the West, this is captured by, for example, the concept of a 'politics of care'.[19] This belief is grounded in assumptions that the traditional role of women and the socialization of girls as caretaker of the family, as nurturer and guardian of dependants, be it children or the elderly, leads to a different way of dealing with politics. Women are supposed to be more concerned about the common good; their style of doing politics would be less aggressive. Some believe that women are more co-operative and concerned about the environment for sustaining the community. In India, Vandana Shiva most notably puts forward this view in her notion of 'ecofeminism' (e.g. Shiva 1993; Mies and Shiva 1993). Furthermore, it is also voiced in India that women possess moral power (*shakti*) which renders them not, or less, corrupt and women would thus introduce cleaner politics. Since this is a widely held assumption in India, it was imperative to have a close look at this issue in Chapter 4.

Anne Phillips is rather unconvinced by those types of arguments that propose a female superiority in moral terms, and she was proved right at least in the study's investigation concerning corruption. One reason is that

[18] This point emerged in a discussion of the paper on women in Rajasthan held by Sumi Madhok (SOAS, London) in the panel on 'Rethinking Indian Political Institutions' at the 16th European Conference of Modern South Asian Studies in Edinburgh, 5–9 September 2000.

[19] See especially the political scientist Jean Bethke Elshtain, who has focused on the implication of motherhood and caring for women's political roles (see Elshtain 1990 and 1993).

this expectation overburdens the elected women representatives with a responsibility that only very few see themselves able or willing to shoulder. Furthermore, in my opinion it is not advisable to base the argument for an inclusion of women into politics on premises that they will be 'better' politicians than men. Are such arguments really necessary? Why do women need to be better than men to qualify for a political office? It does not mean that women will not introduce changes in the political process, but we cannot know beforehand what these changes will look like. One should also be cautious concerning the magnitude of these changes. As mentioned above, Dahlerup had pointed out that though changes occurred because of a greater number of women being present in Scandinavian politics, the basic political culture has not changed (1988: 295). There are definitely social differences between men and women that do result from their different responsibilities and social locations, and one can expect that these also translate into different approaches to politics and power. But Phillips makes us aware that '[t]hese initial differences may be far outweighed by the common experiences men and women will later share in making their way through political life. I incline to the view that politics is more formative than sex, and that the contrast between those who get involved in politics and those who do not is deeper than any gender difference between those who are elected' (Phillips 1995: 75).

This down-to-earth view is much more appealing and should be taken seriously if we do not want to get severely disappointed. It is important to take into consideration the formative power of the political system in which the women have to act. Summing up, there is no guarantee that women's needs or interests will be addressed when the gender composition of political bodies will be changed. Phillips gives a rather sober statement on what one can legitimately expect to be the effect of a quota for women:

It is possible—if highly unlikely—that assemblies composed equally of women and men will behave just like assemblies in which women have a token presence; it is possible—and perhaps very likely—that they will address the interests of certain groups of women while ignoring the claims of others. The proposed change cannot bring with it a certificate of interests addressed or even a guarantee of good intent. In this, as in all areas of politics, there are no definite guarantees. (Phillips 1995: 82)

This should be a warning that adequate representation cannot be achieved overnight and can also not be guaranteed in advance. The shared experiences of women are likely to lead to common concerns, but there is no obvious way of establishing strict accountability for women as a group. Furthermore, it will be seen that in the Indian setting some women representatives might feel more accountable to the dominant male villagers, who were instrumental for their election, than towards the female constituency, who hardly had a say on who should become elected to the PRI. Thus, changing the gender composition of elected political bodies is mainly an enabling condition and does not come with a warranty.

The stress that a quota is more a facilitating rather than an ensuring condition provides the link to the discussion, of whether the inclusion of

women into the PRI will also lead to their empowerment. As argued above, discussions concerning the reservation for women in the PRI in India are often combined with the hope that this will lead to women's empowerment. Lele (2000) proposes that there are two main arguments behind the Bill to introduce a quota for women in Parliament (which are, in principle, not different from the arguments for a reservation at the local level). First, it will give representation to women who constitute around 50 per cent of the population. Thus, it is in keeping with gender equality, in her opinion. Second, the very process of standing for elections and performing the subsequent responsibilities will 'empower women and bring about gender justice'. The first implication has been dealt with in the preceding part of the chapter. The assumptions of the second argument will be scrutinized below. Before we turn to the definition of empowerment, the most conspicuous concept incorporated in the very term, namely the notion of power, will be discussed.

THE CONCEPTUALIZATION OF POWER

The most salient feature of the term empowerment is that it contains the word 'power'. Power is one of the most distinct but also contested concepts in social–scientific theory. Interestingly the term empowerment, which is so closely connected with the term power, has been largely ignored by mainstream political science so far (Rai 1999: 84). It is not possible to give all conceivable views on power, as basically every major social scientist has developed some conceptualization of this important concept. Hence, I shall mention here only some major developments that took place from the 1970s onwards and have influenced feminist thinking.

There is not one view of power, as argued by Steven Lukes in his seminal short treatise *Power: A Radical View*. He argued that the view of power is 'ineradicably evaluative and "essentially contested"' (Lukes 1974: 9). Naila Kabeer (1994), referring to Lukes' work, distinguishes between different understandings of power that are important to the concept of empowerment. She makes a contrast between possessing the 'power to', 'power over', and 'power within'. To have power in the sense of 'power to' is closely connected with liberal ideas on decision-making processes, where power is seen as the ability of an actor to influence the outcome of a situation against the wishes of other actors (Kabeer 1994: 224).[20] In this understanding, power is analysed only in respect to individual decision-making, but the structures and processes in which this decision-making actually takes place are neglected. In contrast, to hold power as in 'power over' does not focus on the decision-making process alone, but deals also with the question of who is deciding on what to decide upon. 'This "power over" (as Lukes terms it) inheres in the implicitly accepted and undisputed procedures within institutions which, by demarcating decisionable from non-decisionable issues,

[20] This is also the Weberian notion of power.

systematically and routinely benefit certain individuals and groups at the expense of others' (Kabeer 1994: 225).[21]

In the understanding of power as 'power to' as well as 'power over', the analysis of only those conflicting interests takes place which are identifiable and articulated. The meanings of power as in 'power within', however, stress the fact that some conflicts of interest are not only excluded from the decision-making processes, but are also not elevated up to the level of consciousness. Thus, not only how conflicting interests are dealt with is socially and culturally structured, but also what kinds of interests are perceived. This reminds us of the problem pointed out by Phillips above that many group-based interests have not been articulated yet and maybe never will, unless the bearers of these interests also get included in the decision-making process. 'Power within' thus encompasses the notions to have the power to decide on the rules of the game, to have control, to decide upon issues, and to make decisions. In Chapter 4 we will look at the question of whether women have gained the power to change the rules of the game and to make decisions.

Jo Rowlands (1998) proposes a slightly different definition of the concept. She argues that the dominant perspective of empowerment held by Western development-experts and by the 'Women in Development'[22] approach is to give women 'the chance to occupy positions of "power", in terms of political and economic decision-making. . . . The difficulty with this view of "empowerment" is that if it can be bestowed, it can just easily be withdrawn. In other words, it does not involve a structural change in the power relations' (Rowlands 1998: 12).

Rowlands' warning concerning the lack of change in the power relations is very important for the present case, even though the question of whether such legislation can be withdrawn easily might be a function of time: The longer women get used to holding positions of power, the more difficult it will be to deny them again. Nevertheless, one problem is that rural women have not really struggled for their right to stand for elections to public

[21] Bachrach and Bachratz (1963) introduced this point of view to political science literature in their seminal article.

[22] The *Women in Development* approach was formulated as a reaction to Esther Boserup's seminal work (Boserup 1970). She had argued that a gendered division of labour does exist in all countries, but women are not necessarily relegated to housework. In Africa, for example, women are very active in agriculture. Boserup also established a correlation between the status of women *vis-à-vis* men, and their respective roles in agrarian production. The situation of women deteriorated under colonial and post-colonial agrarian policy. Because of the Eurocentric promotion of men's productive role in agriculture, and their training in modern technologies in particular, the position of women was weakened. Thus, Boserup argued to give women better education and not to ignore their productive role in society. The neglect of women's productive role had actually occurred in many development projects. The term '*Women in Development*' was coined by women working for the Society for International Development, Washington, DC Chapter in the beginning of the 1970s. It was appropriated a little later by the United States Agency for International Development (USAID) [Moser 1993: 2].

office—it was bestowed on them by the constitutional amendment. In this respect, it is imaginable that if the quota would be withdrawn again the protest would be rather slim, although presumably only at the early stages. Rowlands argues that the above notion of empowerment stems from the dominant understanding of power as being 'power over', in the sense of command and control over resources and values. This 'power over' corresponds with Naila Kabeer's 'power to' and 'power over'. Power as perceived in this way is in finite supply, and empowerment of one group, i.e. women, is seen to be at the expense of the other group, i.e. men, which might lead to a backlash or at least protest of the latter. That means that the struggle for power by marginalized groups is seen as a zero-sum game. 'Men's fear of losing control is an obstacle to women's empowerment, but is it necessarily an outcome of women's empowerment that men should lose power or, crucially, that a loss of power should be something to be afraid of? With a "power over" view of power, it is hard to imagine otherwise' (Rowlands 1998: 13). To counter this fear, she proposes a different understanding of power, which focuses more on the process than on a particular set of results. She refers to Hartsock who contrasts the obedience definition of power with an 'energy' definition of power. 'This is power which does not involve the domination of "power over", but is a power which is generative, for example, "the power some people have of stimulating activity in others and raising their morale"' (Rowlands 1998: 13).[23]

These recent developments in the conceptualization of power do owe much to Foucault's studies on the regimes of power and knowledge. He identified a non-economic form of power that is, in his view, part and parcel of the micro-processes of social life. The exercise of such power requires no external surveillance or coercion. He sees the individual as constituted through power, and the exercise of power can occur through a process of self-discipline or self-regulation. Moreover, the exercise of power is implicated in the mechanisms and procedures for producing knowledge, and hence, in knowledge itself.

Rowlands also refers to Foucault. She argues that in his conceptualization, power is not a finite entity that can be located, but is relational and constituted in a network of social relationships among subjects who have some agency. It includes the understanding that where there is power, there is also resistance. However, she believes that the problem which gets neglected by this view is the effect of structural oppression, such as the effects of male violence against women, which conditions women's experience and might disable them to resist this domination. Thus, Rowlands argues for a 'feminist model of power', which draws on the Foucauldian notion of power as productive and bound up with knowledge and thus not finite, but which is enhanced by a gender analysis of power 'of how "internalised oppression" places internal barriers to women's exercise of power, thereby contributing to the maintenance of inequality between men and women' (Rowlands 1998:

[23] Rowlands cites Hartsock (1985: 223).

14). This notion corresponds with Kabeer's perception that some interests are not at the level of consciousness; this means that there is no awareness on the working of domination, and culturally and socially constructed internal barriers operate against the articulation of such interests. It remains an open question whether women comply to the dominant ideology and accept their unequal status in society because they have internalized it through the process of socialization, as Kabeer and Rowlands seem to suggest, or because they believe they have no other options. As we shall see later, non-complying behaviour can be punished by character assassination or violence. In any case, cultural norms and how society structures gender relations becomes a very important framework for analysis that will be outlined in Chapter 2.

THE DEFINITION OF EMPOWERMENT

The different views of power are important for the understanding of the multi-layered nature of empowerment, and they have to be distinguished when one attempts to characterize the concept. The problem with the term is that it has been defined in various ways, and in many instances it has not been defined at all. The concept originated from debates on education in Latin America in the 1970s, especially in the works of Paulo Freire (1970, 1973, 1985). He proposed that the poor could be enabled to challenge the power structure and take control over their lives through the method of consciousness-raising. Social movements then appropriated 'empowerment', later it became the buzzword of the development agencies, but it was also a central point of the feminist definition of politics (Bystydziensky 1992: 3).[24] While initially the term indicated a view of politics from below, from outside the state-agencies, located at the grass-roots level, it was recently expanded to include institutional strategies also. The term has gained high visibility in the context of development policies and discourses, and this is where most of the definitions stem from.

Kumud Sharma gives a comprehensive definition of empowerment as seen from the grass-roots level:

The term empowerment refers to a range of activities from individual self-assertion to collective resistance, protest and mobilization that challenge basic power relations. For individuals and groups where class, caste, ethnicity and gender determine their access to resources and power, their empowerment begins when they not only recognise the systemic forces that oppress them, but act to change existing power relationships. Empowerment, therefore, is a process aimed at changing the nature and direction of systemic forces which marginalize women and other disadvantaged sections in a given context. (Sharma 1991–2: 29)

Sharma presents the more original understanding of empowerment, which stresses awareness—the understanding of the systemic forces—as the beginning of empowerment. In contrast to power, which can be possessed or

[24] For a very critical assessment of the concept of empowerment see Mohanty (1995).

denied, empowerment is seen as an encompassing process aiming for restructuring power-relations. While the goal is the end of oppression and subjugation of marginalized groups, no explicit reference is made to the gaining of formal power in the political institutions.

Chandra, who also argues mainly from a developmental point of view, gives the following definition:

Empowerment in its simplest form means the manifestation of redistribution of power that challenges patriarchal ideology and male dominance. It is both a process and the result of the process. It is a transformation of the structures or institutions that reinforces and perpetuates gender discrimination. It is a process that enables women to gain access to, and control of, material as well as informational resources. (Chandra 1997: 395)

Here empowerment is seen as the process and the goal of changing the structures of oppression as well, mainly understood as patriarchal ideology. The mentioning of a redistribution of power indicates that the author views power rather as a zero-sum game—and she is not alone, when we recount the introductory statement by the male villagers. Like Sharma, Chandra does not mention the gaining of formal power explicitly, but what is important in this definition is the stress on the gain and control of informational resources. This is in line with Foucault's thinking, that power is intimately linked to information and knowledge. This makes clear why gaining access to information is an important part of the empowerment process.[25]

Batliwala points out that the process of empowerment begins from women's consciousness, from the beliefs about herself and her rights, capacities, from her self-image and awareness of how gender and other sociological and political forces are acting on her (Batliwala 1993: 9). The moving into positions of power is not seen as the beginning of the process of empowerment in this view of the term, and the process is understood to happen from the bottom-up instead of the top-down. However, it is also mentioned by Batliwala that empowerment is the process of gaining control over the self, over ideology and the resources that determine power (Batliwala 1993: 8). In this very broad definition, to acquire formal political power could be seen as one way to gain control over resources.

Another definition that refers to politics and the different aspects of power in a more direct way is the one by Bystydziensky. She defines empowerment as

a process by which oppressed people gain some control over their lives by taking part with others in development of activities and structures that allow people increased involvement in matters which affect them directly. In its course, people become enabled to govern themselves effectively. This process involves the use of power, but not 'power over' others or power as dominance as is traditionally the case; rather, power is seen as 'power to' or power as competence[26] which is generated and shared by the disenfranchised as they begin to shape the content and structure of their daily

[25] The question of knowledge will be examined in Chapter 4.
[26] Bystydziensky refers to Carroll (1972: 604).

existence and to participate in a movement of social change. (Bystydziensky 1992: 3)

The author makes the distinction, already discussed above, between 'power over' and 'power to'. Apparently she disclaims that to move into positions of 'power over' should be the focus of the process of empowerment. However, if one wants to establish a link between political presence and empowerment, the moving into positions of 'power over' is an obvious binding element. The reluctance to use the concept of power as dominating decision-making or becoming part of institutional politics has a long-standing tradition in feminist thought. It is grounded in ideas mainly proposed by radical feminists, that women have a different morale, are more co-operative and non-hierarchical, and are more caring and nurturing. It also has to do with a different conceptualization of politics as such, where politics includes people's everyday experiences of oppressive conditions, the recognition of the injustice of power differences, and the various attempts to change the power relation-ships at all societal levels, and is not only reserved for institutionalized politics.

Notwithstanding, one might wonder how a transformation of society will take place if the marginalized do not also claim the seats of 'formal' power. Bystydziensky acknowledges at a later stage that the election of a substantial number of women who are supported by a strong women's movement outside the existing system could be an effective means for empowering women, whereas just the election of a few more women into parliaments is not considered to be a successful strategy (Bystydziensky 1992: 5). Rowlands favours a combination when she says that '[e]mpowerment, then, is not restricted to the achievement of the "power over" form of power, but can also involve the development of power to, with and from within' (Rowlands 1998: 15). She proposes that to get into positions of power is one step, but the attainment of other forms of power is very important, especially in order to restructure the power-relations which subordinate women.

What is common to most definitions of empowerment is that they are context-sensitive. The people who are supposed to become empowered have to become aware about the structural forces, that have relegated them into the more or less powerless position. The analysis of these structural forces (social, cultural, economic, and political) is one of the prerequisites for understanding the process of empowerment. Empowerment is not necessarily restricted to groups—individuals can become empowered as well—but normally a group approach is formulated, as, for example the empowerment of the poor, of women, and so on. Looking at the definitions that stem from the tradition of empowerment as taking place from the grass-roots, awareness raising is the beginning of every process of empowerment. The latter is normally understood as an all-encompassing process, which will restructure power-relations at all levels—political, economical, and social. However, there is no overall agreement on which strategies are best suited to promote the process of empowerment, whether strategies operating at different levels should be phased or happen simultaneously, how these strategies should be designed, and who should implement them. In this respect, one can definitely

argue that bringing women into formal positions of power could be one path leading to their empowerment.

THE LINK BETWEEN POLITICAL REPRESENTATION AND EMPOWERMENT

One common feature is that both concepts are based on the assumption that the marginalization and subordination of women as a group is the result of structural forces operating at the level of culture, society, economy, and politics. They further explicitly or implicitly suppose that the present division of labour between the sexes is not natural and that it can and should accordingly be rectified. Thus, in both concepts the examination of the structural forces that have marginalized women is a necessary precondition for any further analysis. This analysis has to be context-sensitive, because these structural forces differ between different regions, castes, classes, religions, and cultures. The relevant contextual framework will be given in Chapter 2. Both approaches affirm that women are indeed a group who have substantial interests in common, although it is acknowledged that gender is not the only factor, and might not even be the most important one, for identity-formation. Religion, culture, class, caste, and position in the life cycle also play a major role and work on the preferences and ideas of individual women.

The most obvious link between the demand for political representation and empowerment is the dimension of bringing women into formal positions of power. Power is what politics is all about, the power to define what to decide upon, the power to influence decisions, the power over who gets what, how, and when—the power over values, ideas, and resources. Power is also the most conspicuous ingredient of the term empowerment. The normative argument for bringing women into positions of power and to empower them in a more general sense lies in the assessment of structural barriers that have historically marginalized women in politics, society, and the economy. To bring women into the political decision-making bodies corresponds with Rowlands' notion of women moving into positions of 'power over' as being one part of women's empowerment. However, the link goes even further. During the discussion on the arguments for a quota for women I have made the distinction between a demand for parity between the genders and the demand for a threshold presence. The rationale behind the latter is that the presence of women is supposed to lead to a transformation of politics. In this respect the claim for the political representation of women is one of the various avenues to challenge existing hierarchies of power. The aim of a quota is to subvert and reform, to introduce new issues and also different ways of doing politics. In this respect there is also the notion that women will gain productive power—power to change the rules of the game and also to negotiate the gender relations. And this is exactly the stated goal of empowerment.

What gets rather neglected by proponents of empowerment via quota is

that there is no guarantee that the elected women will really work for the benefit of women in general. As already noted, Bystydziensky believes that political representation could be a strategy only when the numbers are sufficient (however, she does not give a definite number of what would be sufficient), combined with the strong support of a women's movement which is operating outside the corridors of institutional politics. Yet, such women's movements do not exist everywhere, and in the case where they are in place it does not necessarily mean that all members of the movements share the same opinions and can successfully influence female politicians. As Phillips has argued, there is no easy solution to make the elected women accountable to their constituency. In this respect, the path to women's empowerment via political representation is abundant with uncertainties, and if one wants a guarantee for success, one definitely has to look for other and/or supplementary strategies.

A further corresponding feature is the belief that disadvantaged groups might not be able to formulate their preferences for several reasons like internalized oppression or diversity of interests between individual members of such groups. Proponents of a quota for women suppose that women might not be able to really formulate these interests and needs if they are not drawn into the political process. Here is a basic tension to the traditional empowerment approach, which focuses on awareness-raising methods as a prerequisite to understanding the structural forces and becoming conscious of one's interest. Thus, the empowerment approach is somehow ambiguous on whether the inclusion of women into the political process will really lead to empowerment in case there was no prior awareness-raising, or if it is not coupled with strategies to make the representatives gender-sensitive. However, again there is no universally accepted strategy that would provide for such a new consciousness. To sum up, the reservation for women in political bodies can only be an enabling condition since it opens up a space for a larger project of women's empowerment.

Generally speaking, a top-down and elite approach such as the reservation for women in politics is not really believed by many proponents of the empowerment approach to be sufficient or even the most successful strategy for leading to women's empowerment (e.g. Narasimhan 1999a: 45f).[27] We should also keep in mind Anne Phillips' argument that finally gender might be less formative than the political career and that the inclusion of women will not serve all women in the same way. But the hope remains that it will make a difference to the lives of women in general and thus could be a step towards their empowerment.

Apart from defining it, the term empowerment needs to be operationalized in order to serve as a framework for analysis. Drawing on the deliberations above, I distinguish four successive stages of empowerment that are linked to the inclusion of women in political decision-making bodies.

[27] Narasimhan argues that the women representatives elected to the PRI lack awareness. She concludes that the reservation policy may not be sufficient for women's empowerment. For a short version of her main arguments, see also Narasimhan (1999b).

The first two stages are concerned with the issues of political presence and the exercise or possession of power in a more conventional sense (as 'power over' and 'power to'). I suggest that they constitute the basis of that kind of empowerment resulting from women's inclusion into politics, as contrasted to empowerment that might flow from other strategies.

1. The first stage to be examined is whether women really moved into positions of power, and who these women are. This is the issue of political presence. The main questions are: Has the quota been implemented to the required degree? Who are these women in socio-economic terms? How did they come to be elected to the political institutions? Where and to what degree are they present? This will be examined in Chapter 3, 'Political Presence'.
2. The second stage to be analysed is if the women who have moved into the political positions are actually exercising power. At this level of analysis, power is mainly viewed as a static property. The main issues are: Do women have the relevant knowledge to exercise power? Are they autonomous and do they participate in the decision-making? Do they have the power to change the way of doing politics? Do they introduce new issues? These questions will be examined in Chapter 4, 'Power'.

The last two stages are about empowerment as understood in the more conventional sense, namely, as a process providing enabling conditions for exercising more control over one's life. Here the focus lies on the changes that have been introduced into women's lives because of their political presence. This question will be dealt with mainly in regard to the perceptions of the women concerned and focuses on issues that are assumed to be crucial for the process of empowerment. It seems important to distinguish between the changes taking place in respect to the women present in the institutions, and the ones remaining outside. This distinction has mostly been neglected in the literature on women in the PRI so far. Both will be discussed in Chapter 5, 'Empowerment'.

3. The third stage is to see if the women serving in the political institutions are getting empowered. The main questions are: Have they gained knowledge and interest in politics? Have they gained status and visibility at home and in public life? Have they gained a new conscious-ness and confidence? Have they gained gender-awareness?
4. The last stage is whether the reservation for women really leads to the empowerment of women as a group. This will be analysed through the perception of village women on what they have gained from the inclusion of women into politics so far and from the perception of men.

Before I analyse these issues in the case study, I shall describe the context in

which women are placed in Orissa, as well as the political institutions, in which they have to act. As stated above, the study of the structural determinants of the social and political framework in which the women have to perform is very important for further analysis. The status of women and the design of the PRI set the framework in which the empowerment of women can take place. I shall first describe the evolution of the PRI, how the 73rd Amendment came about, and the specific structure of the PRI in Orissa, and then provide an overview of women's status in India and Orissa. The purpose is to analyse the structural factors that have marginalized women in the region and also show their current position. In another sub-chapter, the setting of the case study will be given, which is the state of Orissa and specifically the blocks Balipatna and Gania where the field research was conducted. The issue of how this specific socio-cultural framework impinges on the process of political representation and empowerment of women will be summarized in Chapter 6.

CHAPTER 2

The Framework

As ARGUED, the context is very relevant to the analysis of the process of women's political presence and empowerment. Firstly, one has to examine whether women's marginal status is really due to historical processes and social structures and not to 'natural' properties. Secondly, the structure of the political institutions, as well as women's social, economic, and political status, influences the representative's 'room to manoeuvre',[1] and also sets the framework in which social change towards women's empowerment takes place. Theoretically I position myself here mainly in the tradition of Giddens and his 'structuration theory'.[2] Giddens attempts to bridge the gap in social sciences between structure and agency. Agency here is understood as the power of the agent to make a difference and to change a given course of events—in other words, be an agent of his or her destiny. Structure refers to rules and resources that are recursively implicated in social reproduction. The institutionalized features of a given society, Giddens argues, have structural properties that ensure that relationships are stabilized between time and space. These structural properties also express forms of domination and power. Giddens develops a concept of the 'duality of structure' that basically proposes that action (re)produces structure (re)produces action (re)produces structure and so on. Thus, the social agent reproduces but also produces structure, and hence has the power to make a change. In this respect, Giddens opposes determinism or structuralism, and opens the space for social change—for agents to make a difference. The scope for change, however, is very much influenced by the structure the agent is positioned in— that is, the agent is not completely independent—as the structure opens or forecloses certain opportunities. In other words, the social and institutional structure makes certain avenues of action more or less likely. In this respect, the analysis of the structural framework is very important and is the pre-condition for any meaningful analysis of social change. Regarding women's empowerment in local government, the Panchayati Raj Institutions (PRI), women's status, and the regional environment are important determinants of the framework.

[1] I took up this term from Mitra (1991). He coined the phrase of the 'room to manoeuvre in the middle' in his analysis of the important role of the local political elites.

[2] Giddens' 'structuration theory' has been developed over time. It is most concisely described in Giddens (1984). For a critical assessment of his thinking, see Bryant and Jary (1997). See also Bourdieu (1997); he introduces the concept of the 'habitus' to bridge the gap between agency and structure.

THE INSTITUTIONS OF LOCAL GOVERNMENT

The Background of the 73rd Amendment Act

In the year 1993, the 73rd Amendment of the Indian Constitution, which formulated the basis for the introduction of a three-tier system of rural local self-governance in all Indian states, was passed. This system is called Panchayati Raj, and after its initial introduction in the 1950s it lay dormant in most of the states. With the passing of the 73rd Amendment it became mandatory for all states to hold elections to these bodies of governance.[3]

The main interest for our topic is the provision for the reservation of seats and posts (such as sarpanch, samiti chairperson,[4] and zilla parishad chairperson) for women of not less than 33 per cent, as well as a proportional representation for the Scheduled Castes (SCs) and Scheduled Tribes (STs), also in the women's quota (GoI 1993).[5] Since the elections in Bihar in April 2001 there are around 7,60,000 elected female representatives in the institutions of local government.[6]

The history of the development of the institutions of local government in India is a chequered one. Mahatma Gandhi especially promoted them. He could, however, succeed only to get them incorporated in Art. 40, Part 4 of the Constitution of India (Directive Principles) that left the initiative to the state governments.[7] However, most of the states did not bother to enter

[3] For the position of PRIs in the political set-up of the Indian Union see Figure 2.1.

[4] In most of the literature and official documents one finds chairman. Since now many of these offices are occupied by women as well, I shall refer to this office as chairperson. However, during the interviews most people referred to chairman, and I left this nomenclature in the citations.

[5] The relevant Sections are: '243 D (2) Not less than one-third of the total number of seats reserved under clause (1) shall be reserved for women belonging to the Scheduled Castes or, as the case may be, the Scheduled Tribes. (3) Not less than one-third (including the number of seats reserved for women belonging to the Scheduled Castes and the Scheduled Tribes) of the total number of seats to be filled by direct election in every Panchayat shall be reserved for women and such seats may be allotted by rotation to different constituencies in a Panchayat. (4) The offices of the Chairpersons in the Panchayats at the village or any other level shall be reserved for the Scheduled Castes, the Scheduled Tribes and women in such a manner as the Legislature of a State may, by law, provide. . . .'

[6] In 1997, there were 7,16,234 elected female members in India, excluding Bihar and Jammu & Kashmir, where elections had not taken place at that time (ISS, *PRU*, February 1997: 7). The Bihar election has added roughly another 45,000 women to this score. For the number of seats reserved for women in Bihar see *www.pria.org/cgi-bin/lsg/activity.pl?ac_id=13*.

[7] Article 40 (4) reads: 'The State shall take steps to organise village panchayats and endow them with such powers and authority as may be necessary to enable them to function as units of self-government', Constitution of India, as amended. For a brief description of the evolution of the Panchayati Raj from pre-independence till today, see Mathew (1995a: 1–14). The literature on several aspects of the Panchayati Raj in India is prolific. For a good overview on studies conducted at different levels of the Panchayati

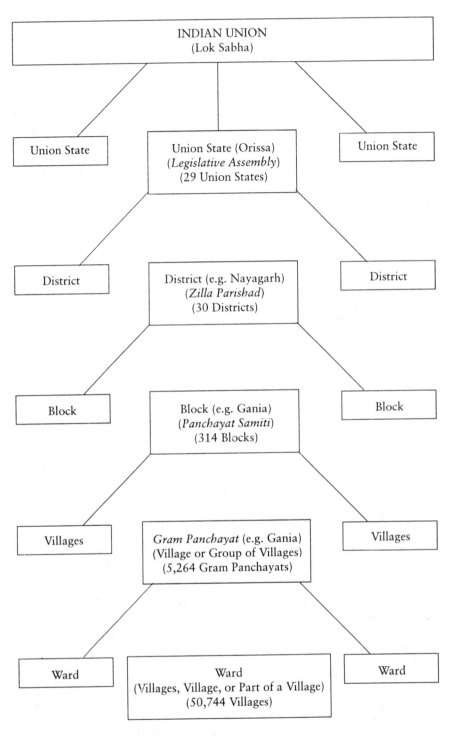

FIG. 2.1: Legislative structure of the Indian Union.

upon a system of local governance seriously. The first influential document addressing this malady was the so-called Balwantrai Mehta Report of the Team for the Study of Community Projects and National Extension Service, 1957 (GoI 1957). It was constituted to evaluate the work of the Community Development Programme that had been started by the government in 1952 to carry out the integrated rural development work, and of the National Extension Service established in 1953. Additionally, it should conduct some special investigation into the reorganization of the district administration, following the recommendation of the Second Five Year Plan 'that village panchayats should be organically linked with popular organisations at a higher level and that . . . democratic bodies should take over the entire general administration and development of the district of the sub-division . . . ' (GoI 1957, Vol. 1: ii).

Under the Community Development Programme the administration at the district and lower levels had been reorganized. The posts of the Block Development Officer (BDO), the Extension Officers, and the Village Level Workers had been created as development bureaucracy, and the block had emerged as the central unit of planning and development (Reddy 1977: 6). One found that the main problem with this arrangement was the absence of local initiative and interest, now seen as the *conditio sine qua non* for rural development. The committee thus recommended the set-up of a three-tier structure of elected self-governing institutions—the Panchayati Raj Institutions. As regards rural women, it was argued that they should not just be beneficiaries of development, but also contributors to it. The conditions of women were considered, and the conclusion was reached that they should be assisted to find ways to increase their incomes and improve the condition of their children (GoI 1957, Vol. 1: 47). The committee was also particular about the fact that women should be represented in the rural political institutions, and recommended the co-option of two women members to the Panchayati Raj Institutions (GoI 1957, Vol. 1: 127).[8]

The next landmark in the development of the PRI was the Report of the Committee on Panchayati Raj Institutions, 1978, popularly known as the Ashok Mehta Report (GoI 1978). The committee was set up by the Janata government in 1977 to look into the working of the Panchayati Raj System in various states, because the situation was perceived to be unsatisfactory.

Raj Institutions and a categorization of these studies, see Sharma (1994: 7–35). For a select reading, apart from the ones that will be mentioned elsewhere, see AVARD (1962) on the discussions in the Constituent Assembly about Panchayati Raj; Maddick (1970) for a detailed description of the background and the system, as well as interesting reflections on various issues like financial problems or relationship between officials and non-officials; Khanna (1994) on developments of the Panchayati Raj in several states (but not Orissa); and Mukherjee (1994) on recent developments of the PRI.

[8] This is recommendation 15, 2.28: 'The constitution of the panchayat should be purely on an elective basis with the provision for the co-option of two women members and one member each from the Scheduled Castes and Scheduled Tribes. No other special groups need be given special representation.'

With regard to women, the report laid special emphasis on the need to strengthen their decision-making capacities and managerial roles. Apart from measures to improve the economic standing of women, the team focused on the effective organization of *Mahila Mandals* (women's groups) as an important component of rural development programmes.[9] It recommended that seats be given to the two women who secured the highest number of votes in the panchayat elections, and to co-opt them in case they did not come through elections (GoI 1978: 179f).[10] It also proposed the establishment of a Committee of Women

to operate and look after specific programmes which largely concern women and children. This would ensure that they do not become victims of the processes of change and that decisions are made by women themselves on priorities and choices involved in their programmes. Such a Committee should have the powers of the Mandal Panchayat with reference to the programmes specifically assigned to them. (GoI: 1978: 199)

A major departure from the Balwantrai Mehta Report was the suggestion for the creation of a two-tier instead of a three-tier structure (GoI 1978: 178). It is interesting to note, that the participation of women in the institutions of rural governance was advocated by both commissions—mainly to secure that 'women's interests', understood as being concerned with social welfare and children, should be heard and paid attention to. Apparently the framers had no problems in acknowledging the presence of women's interests.

The discussion about the reservation of seats for women in political bodies started already before independence. Everett distinguishes two phases in the Indian campaign for women's political representation: the first phase (1917–28) witnessed the struggle for female enfranchisement and eligibility for the legislatures, and in the second phase (1928–37) the salient issues were liberalization of the terms of enfranchisement and increasing female representation in the legislatures.[11] Already in 1917, enfranchisement and eligibility for the legislatures for women was demanded before the Montagu–Chelmsford Committee. Male politicians also supported the proposals of the women's movement, and finally both the British government and the Indian political elite accepted the principle of women's right to vote and to their representation in the legislatures. The basis of enfranchisement under the Montagu–

[9] See GoI (1978: 140–2) for the 'Role of Women'; a list of recommendations concerning the issues above follows later, on p. 199 (recommendations 111 and 112).

[10] GoI (1978: 179) for zilla parishad, and p. 180 for panchayat samiti. This idea was inspired by a provision in the *Punjab Panchayat Samitis and Zilla Parishad Act, 1961*; ibid.: 141.

[11] For this and the following, see Everett (1979), especially Chapter 6: Women's Movement Campaign for Political Representation, pp. 101–40. On the women's movement and its role for the empowerment of women in India, see Calman (1992); for short overviews on the development of Indian women's movements, see Agnihotri and Mazumdar (1995); Akerkar (1995); Kumar (1989); Menon (2001); and Saxena (1994). For the politics of the contemporary women's movements, see also Palriwala and Agnihotri (1996).

Chelmsford reforms of 1919 was based on property and income qualifications—a major handicap for women, as only few had property in their own names. Thus, the potential female electorate was much smaller than the male electorate. Accordingly, the women's movement was interested to enlarge the basis of the female electorate. However, in this issue, as well as in the question of a reservation for women in the legislatures, the women's movement was divided into two distinct camps: the 'equal rights' and the 'women's uplift' faction.

In the early 1930s, members of the latter group testified before the Simon Commission and demanded enfranchisement of literate women and reservation of seats for them. It was believed that enlightened female legislators would work for the cause of all women and that without reservation women would not be able to capture seats in the legislatures. The equal rights faction, on the other hand, argued for universal adult franchise. It was hoped that it would create a progressive electorate, and because it would not be constituted only of the propertied and landed elite, it would thus elect a reformist legislature. This faction was against a reservation of seats, as equal treatment of men and women was preferred (hence the name of the faction). The Simon Commission finally recommended reservation of seats for women under limited franchise, and the 1937 Provincial Assembly Elections took place with 1 per cent to 4 per cent of the seats reserved for women (Everett 1979: 136, Table 10). After independence, the ideas of the equal rights faction became entrenched in the Constitution that gave suffrage to all adults and opened public offices to everybody irrespective of gender, sex, caste, and race. But no special reservation of seats for women was provided for. It is important to emphasize, however, that reservations for the SCs and STs were introduced in different areas including politics, which shows that reservation as a means of social engineering was accepted by the framers of the Constitution. Over the years the population too became very used to the principle of quotas for the advancement of specific marginalized groups.

Parallel to the committees on the PRI, important investigations into the situation of women in India took place. A pioneering and very influential document was the *Report of the Commission on the Status of Women in India* (CSWI) from 1971 to 1974 (GoI 1974; for a short version see ICSSR 1988). The commission was set up to review and evaluate the changes in the status of women that had taken place since independence. Chapter 7 of this report deals with the political status of women. Even though it was observed that some positive developments had occurred, especially an increase in the turnout of female voters, it was felt that a lot remained to be desired.

Reservation of seats was proposed by women delegations as well as by social scientists, and it is interesting to note that the figure of 30 per cent for the reservation for women in the legislative bodies was already mentioned in this early document (GoI 1974: 303). However, political parties voiced strong opposition and most women legislators as well as the writers of the report found themselves finally unable to recommend a system of reservation to the State Assemblies and the Parliament (ibid.). Instead, they handed over the

burden to the political parties who 'should adopt a definite policy regarding
the percentage of women candidates to be sponsored by them for elections
to Parliament and State Assemblies', and the figure of initially 15 per cent
was given (GoI 1974: 305). As regards the Panchayati Raj Institutions, the
Committee argued that the necessity for the representation of women in the
local self-governing bodies had already been accepted, and a system of co-
option or nomination in these bodies existed in most State legislations.
However, the report valued it as mere 'tokenism', and argued that the views
of the women were neglected in the Panchyati Raj Institutions (GoI 1974:
304).

The main recommendation regarding strengthening women's role in local
politics was the 'establishment of statutory women's Panchayats at the village
level with autonomy and resources of their own for the management and
administration of welfare and development programmes for women and
children, as a transitional measure, to break through the attitudes that inhibit
most women from articulating their problems and participating actively in
the existing local bodies' (ICSSR 1988: 114f.).[12] Reservation of seats was
only advocated as a transitional measure at the level of municipalities (GoI
1974: 305). Thus, the reservation for women in legislative bodies was dis-
cussed already in the mid-1970s, but opinions were split and the quota was
finally neither recommended nor implemented (GoI 1994: 354-7).[13]

The recommendations concerning women in local governance remained
unheard in the decade that followed. The *National Plan of Action 1976*,
which was the major outcome of the CSWI Report, hardly mentioned the
subject of the political participation of women (GoI 1988: 153). However,
the need for greater efforts for the emancipation of women was felt especially
after 1975, the International Women's Year, and a chapter on Women and
Development was included in the Sixth Five Year Plan (1980–5).[14]

In 1985, the Congress government under Rajiv Gandhi indicated that it
wanted to give greater priority to women's issues (The President's Address to
the Parliament, January 1985).[15] Prompt activities started, among them the
constitution of a core group to prepare a long-term policy document for the
empowerment of women. The result was the *National Perspective Plan for
Women, 1988–2000 A.D.*, where Chapter 7 deals with 'Political Participation
and Decision Making' (GoI 1988: 153–70).

Concerning women in local government, the Committee came to the con-
clusion that the co-option of women as recommended by the Ashok Mehta
Report had not brought any perceptible impact on women's participation

[12] For the longer version, see GoI (1974: 304f.).

[13] Phulrenu Guha and Maniben Kara were against the reservation recommended for
the municipalities, whereas Lotika Sarkar and Vina Mazumdar argued for a principle of
reservation in all legislative bodies.

[14] For detailed information on state initiatives to better the position of women, see GoI
(1995).

[15] Referred to in Mazumdar (1997: 15); for Rajiv Gandhi and his promotion of the
Panchayati Raj, see Lal (1994).

in the bodies of local governance (GoI 1988: 156). As positive examples of enhanced representation Karnataka and Andhra Pradesh were named which supposedly had introduced a reservation of women of 25 per cent and 30 per cent respectively.[16] Thus, the Commission recommended:

* Reservation should be made of 30 per cent seats at the panchayat to zilla parishad level and local municipal bodies for women. Wherever possible, higher representation of dalits/tribals, women of weaker sections should be ensured.
* 30 per cent of executive heads of all bodies from village panchayat to district level and a certain percentage of chief executives of panchayati raj bodies at lower, middle and higher levels must be reserved for women (GoI 1988: 164f.).[17]

Rajiv Gandhi followed the recommendations of the National Perspective Plan in the formulation of the 64th Amendment Bill of 1989. In this document, the reservation for women at all levels for 'as nearly as may be' 30 per cent, including in-built quotas for the Scheduled Castes and Scheduled Tribes, was provided for (GoI 1989).[18] It was left to the states to reserve the offices of chairpersons also.[19] The Bill could not pass the Rajya Sabha for various reasons, which were, however, not related to the question of the reservation for women.[20] The Bill re-emerged after three years in a slightly modified form as the 73rd Amendment and was enacted under the

[16] However, I could not find any information on a 30 per cent reservation in Andhra Pradesh; the last Act before the 73rd Amendment was the *Andhra Pradesh Mandala Praja Parishads, Zilla Praja Parishads and Zilla Pranalika Abhivrudhi Sameeksha Mandals Act, 1986* which reserved 9 per cent of seats for women in the Mandala Praja Parishad, and 2 out of 22 chairpersons of the Zilla Praja Parishad (Mathew 1995a: 24f); at the level of Gram Panchayats, a number of seats were reserved for women in the *Andhra Pradesh Gram Panchayats Act, 1964* as amended till the mid-1980s, which amounts to a reservation between 22 and 25 per cent (Manikyamba 1989); in Karnataka, a reservation of 25 per cent for women in the Zilla Parishad and the Mandal Parishad (Karnataka had a two-tier system) was enshrined in the Act of 1983. Elections under this Act took place in 1987 (Mathew 1995a: 98f).

[17] Mazumdar (1997: 16) narrates that the first draft of the document had put a proviso that this quota may be filled by nomination or co-option in the initial years. This proposition was rejected by major national women's organizations and was deleted from the final document.

[18] Government of India, *The Constitution (Sixty-Fourth Amendment) Bill, 1989* as introduced in Lok Sabha on 15 May 1989; the relevant sections are: '243C (2) As nearly as may be, thirty per cent of the total number of seats reserved under clause (1) shall be reserved for women belonging to the Scheduled Castes or, as the case may be, the Scheduled Tribes . . .; (5) As nearly as may be, thirty per cent (including the number of seats reserved for women belonging to the Scheduled Castes and the Scheduled Tribes) of the total number of seats to be filled by direct election in every Panchayat shall be reserved for women and allotted by rotation to different constituencies in a Panchayat.'

[19] '243C (3) Nothing in this part shall prevent the Legislature of a State from providing for the reservation of the office of Chairpersons in the Panchayats for the Scheduled Castes, the Scheduled Tribes and women.'

[20] The main problem was that the non-Congress state governments felt that the Bill vested too many powers in the Governor and the National Government (Chandrashekhar 1989). For further details on the 64th Amendment Bill, see also Ghosh (1989).

government of Narasimha Rao on 22 December 1992, just about two weeks after the demolition of the Babri Masjid. With the attention of the public thus occupied elsewhere, the Amendment was quietly ratified without much discussion by the Parliament in April 1993, with the provision that the states had to introduce or amend their existing Panchayati Raj Acts accordingly till 24 April 1994.

It is interesting to note that the provision for the reservation of seats for women and the in-built quota for SC- and ST-women did not lead to major debates in the late 1980s and early 1990s, when the 64th and 73rd Amendment Bills were tabled, whereas it emerged as a bone of contention in discussions about the reservation of seats in the Parliament and State Assemblies. One might wonder how the reservation of 33 per cent for women in the Panchayati Raj made it into legislation at all. Women activists claim that it is due to the prolonged struggle of the women's movement (e.g. Nanivadekar 1998), whereas others see it as an election gimmick initiated by Rajiv Gandhi to attract women's votes. A further reason for the missing debate in Parliament, one could speculate, is the fact that the reservation of seats at the lowest level of government does not endanger the prospects of the sitting MLAs and MPs, the majority being male, whereas a reservation of seats for women in the State Legislatures and Parliament will limit their chances very much if their constituencies were to become reserved for a woman.

Panchayati Raj and Reservation for Women in Orissa

Like elsewhere in India, the evolution of the PRI in Orissa occurred in ups and downs. Before Orissa emerged as separate province in 1936, the region of the present state was partly under the Bengal Presidency (later Bihar–Orissa Province), the Madras Presidency, Sambalpur District and other Princely States, which merged in 1948–9 to form the present state of Orissa. Hence, various laws applicable in the different Presidencies, Provinces, and Districts regulated rural self-government in these regions that constitute Orissa today.[21]

In the three coastal districts forming British Orissa from 1803 onwards, urban local self-government was introduced for the Municipalities under the *Bengal Municipal Act III of 1884* and after the creation of the Bihar and Orissa Province under the *Bihar and Orissa Municipal Act VII of 1922* (Rout 1988: 25–60). Rural local government in the three coastal districts initially followed the *Bengal Local Self-Government Act of 1885*, which was brought under this Act from 1887 onwards (Rout 1988: 61–87). Three district boards were formed, and below them local boards at the sub-district level. The government nominated all the members, including the chairperson. Following the suggestions made by the Simon Commission in 1909, and the

[21] For example, the *Bihar Local Self-Government Act, 1885*; *Bihar and Orissa Village Administration Act, 1922*; *Madras Local Boards Act, 1920*; *Sambalpur Local Self-Government Act, 1939*.

Montagu–Chelmsford Report in 1918, the *Bihar and Orissa Local Self-Government Act of 1922* was passed, which introduced the elective system to all the self-governing institutions and established Union Boards consisting of several villages. However, the area covered by these institutions was very large and the operation of district boards was quite confined. 'These boards did provide for limited popular participation through periodic elections under limited suffrage. These bodies were, however, apologies for democratic institutions and the British themselves regarded them as training schools of democracy, rather than as full-fledged autonomous institutions' (Rao 1977: 197). Taking into consideration that in most princely states no rural governments on a representative basis were operating at all, the base for popular rural self-government was rather weak.

However, after independence, Orissa acquired the distinction of being the first state in India to introduce village panchayats through the *Orissa Grama Panchayat Act, 1948*. By 1950 the merger of the feudatory states was complete and gram panchayats were gradually established in these areas as well. The *Orissa Grama Panchayat Act, 1964*, passed in 1965, later replaced the *Grama Panchayat Act of 1948*. This Act consolidated all laws pertaining to gram panchayats in Orissa.[22]

Apart from setting up gram panchayats very early, Orissa was also quite innovative as regards schemes for rural local self-government at higher levels. The *Land Revenue and Tenure Committee* headed by Nabakrushna Chaudhury (a Bhoodan leader who subsequently became Chief Minister) in 1949 made interesting suggestions concerning the decentralization of authority through the formation of 'Anchals', that were, however, never implemented (GoO 1949).[23] 'It is evident that this scheme was an attempt to evolve a comprehensive system of local self-government in Orissa, which

[22] For the Panchayati Raj System in Orissa, see Samal and Bhargava (1999), published also slightly modified as Bhargava and Samal (1998) (the article was written after the election in 1997, the book chapter before); Bhargava and Samal (1993); Jena (1995); and Deb (1985).

[23] The Terms of Reference of the Committee were actually concerned with the abolition of the zamindars and the shaping of the future revenue set-up. Still, the committee also came up with a scheme for the decentralization of authority to facilitate an appropriate revenue administration and development activities in the rural areas. For this purpose the province was to be divided into administrative units called 'Anchal', every Anchal having an administrative authority called 'Anchal Sasan' consisting of an 'Anchal Sabha' and the 'Anchal Adhikari'. The Anchal Sabha would be a body of members elected by the gram panchayats, Notified Areas, and municipalities comprising the Anchal, and the Anchal Adhikari would be a permanent officer from the State Administrative Services. The Anchal Sasan would be a body corporate with its own funds from land revenue, fees, tolls, cesses, and taxes that could be imposed and collected by and for the Sasan. The Anchals were constituted under the *Orissa Estates Abolition Act, 1951*. However, the *Orissa Anchal Sasan Act, 1955*, which sought to give full shape to the plan, and which was assented to by the Governor in March 1956, was never implemented (Rao 1977: 198; Deb 1985: 250f.; Rath 1985: 287). Jena (1995) also mentions the *Anchals*. Interestingly he claims that the Act was really in place while the other three authors claim that the Act was never implemented.

was to undertake development function too. However, this scheme was overtaken by the on-rush of events culminating in the Balwantrai Mehta Committee recommendations' (Rao 1977: 198).

In place of the proposed scheme, a full-fledged but short-lived three-tier system as envisaged by the Balwantrai Mehta Committee came into being through the *Panchayat Samiti and Zilla Parishad Act, 1959*, implemented on 26 January 1961. Former Community Development Blocks were converted into Panchayati Raj Blocks, counting 314, and zilla parishads were set up in all of the then 13 districts, replacing the former district boards. The already existing gram panchayats were organically linked up with the two higher tiers.

The fulcrum of the administrative level for rural development was the block, which was inherited from the Community Development Programme.[24] The main functions of the second tier—the panchayat samiti—were thus concerned with the execution of development in the block. The zilla parishads as a higher level were not only entrusted with powers of coordination, but also with powers of supervision over the execution of the works and programmes by the panchayat samitis and the power to approve their plans and budgets. Nevertheless, they were abolished by the newly elected Swatantra/Jana Congress coalition through the *Orissa Panchayat Samiti and Zilla Parishad (Second Amendment) Act, 1967* in 1968 after six years of existence as being 'superfluous' (Rath 1985: 289). The zilla parishad was substituted by the District Advisory Council (DAC), which was heavily dominated by the District Collector. Thus the Panchayati Raj System in Orissa became effectively reduced to a two-tier system. This instance shows already that the PRI were often used by the parties in power at the state level for their ends. The Swatantra-led government had good reasons to dissolve the zilla parishads, for the Congress party dominated them at this time. In this set-up of 1959 the position of women was negligible as elsewhere in the Indian Republic. There were provisions for the nomination of one woman in case there was none returned through the general election to the panchayat samiti and zilla parishad. This rule obviously followed the recommendations of the Mehta Committee for the nomination of women.[25]

[24] For some general information on administration in Orissa, see Rout (1991). For an interesting study of the relationship between block administration, elected representatives, and citizens conducted in Atgarh Block of Orissa, see Rath and Panda (1993).

[25] Devi (1988) has gathered data on the women's position in the previous elections. Elections to the gram panchayats were held in 1970, 1975, and 1983–4. Data on the 1970 election is not available. In the 1975 election, out of 2,962 sarpanches 20 were women (0.68 per cent), and out of 56,720 ward members 103 were women (0.18 per cent). In the 1984 elections, only 11 women were elected as sarpanches out of 3,384 (0.33 per cent), and 125 out of 67,002 as ward-members (0.19 per cent) (Devi 1988: 46, proportional calculations mine). Election to the panchayat samitis took place in 1961, 1965, 1970, 1975, and 1984. There was a provision to reserve one seat for women. Therefore, in every election a minimum of 314 women should have been elected; however, allegedly no data on these elections is available anymore (Devi 1988: 45).

After the abolition of the zilla parishads not much development in the PRI took place. Elections were not held regularly, and political parties at the state level misused the PRI for political mileage. In 1983, for example, elections to the PRI took place under the J.B. Pattnaik-led Congress government, which was accused of utilizing official machinery, money, and coercive power for securing the seats (Bhargava and Samal 1998: 101).

A major rejuvenation of the Panchayati Raj System in Orissa took place under the Janta Dal Government led by Biju Patnaik, which was voted into power in 1990. It is interesting to note that the PRI had flourished in the early 1960s also under Biju Patnaik's stewardship, and there seemed to be a genuine concern for devolution of power ingrained in his thought, however, only as long as it served his political interests as well. Without much loss of time, three important Acts, namely the *Orissa Grama Panchayat (Amendment) Act, 1991*, the *Orissa Panchayat Samiti (Amendment) Act, 1991*, and the *Orissa Zilla Parishad Act, 1991* were passed. These three Acts contain many revolutionary provisions and ushered in a new era for local rural self-government in Orissa. Unlike the Acts of 1959 and 1964, the newly amended Acts made detailed provisions for the reservation of marginalized groups, such as Scheduled Castes, Scheduled Tribes, and women. The Orissa Act 9 of 1991,[26] for example, which amended the *Grama Panchayat Act, 1964*, gave the provision for a reservation of no less than one-third for women.[27] Thus Orissa was the first state to introduce a reservation of no less than 33 per cent for women.[28] In 1992, another novel and progressive provision only found in Orissa was enacted. It reads that in case the sarpanch happens to be a man, the naib-sarpanch has to be a woman.[29] The provisions for reservation for women in the other two tiers were formulated likewise.

The Amendments were of a very progressive nature not only in regard to the strong reservation for women, SCs, and STs. Experts on the Panchayati Raj praised also the following initiatives taken by the government:

The amendment made with regard to the direct election of the members of all the PR bodies was a 'radical step' taken to make the PRIs more democratic and responsible. Devolving more and more powers and functions to the PRIs in the field of rural reconstruction and development, and the provision for the constitution of a state level Finance Commission to look into the financial position of PRIs showed the government's interest in the PR system. (Bhargava and Samal 1998: 102)

[26] Published in Orissa Gazette Extraordinary, Act 502, dated 9 May 1991; see for the original Act of 1964 and Amendments till 1997, Samal and Samal (1998).

[27] Reservation for women is given in clause 10 (3) (b) (ii) for the seats reserved for the Scheduled Castes and Scheduled Tribes, and in clause 10 (4) for the general seats.

[28] It was already mentioned that Karnataka reserved 25 per cent of seats for women, and Andhra Pradesh 9 per cent, but the implementation of a reservation to the extent of 33 per cent was a novelty. Biju Patnaik obviously followed the recommendations of the 73rd Amendment, which had already been discussed at this time.

[29] This provision was inserted in Clause 14 (1) of the *Grama Panchayat Act of 1964* by Orissa Act 25 of 1992 (GoO 1994a: 8). Unfortunately, an exact date of the Act is not given, but it must have been ratified prior to the PRI-elections in May–June 1992.

Elections to the two lower tiers (gram panchayats and panchayat samiti) and the local urban bodies took place in May–June 1992 on a non-party basis. Unfortunately the election was marred by violence, which hints at the importance of these institutions in the political fabric of the state (Beuria 1992). In the 1992 election, 480 women representatives were returned in 94 municipalities and 28,068 women representatives in the rural panchayats.[30] Among them were 14 sarpanches, 5,237 naib-sarpanches, 1,841 members of the panchayat samitis, 15 chairpersons, and 301 vice-chairpersons of the panchayat samitis (OSCARD 1993: 49).[31]

Apart from holding elections very soon after the assent of the amended Acts, the government also organized a nationally well received Panchayati Raj Convention on 5 March 1993 in the Kalinga Stadium in Bhubaneswar, and the day, not incidentally the birthday of Biju Patnaik, was declared as the 'Panchayati Raj Divas' (Panchayati Raj Day) to be celebrated every year. These episodes show that the Janta Dal government might have been really interested in devolution of power. These developments led to the enthusiastic remark by George Mathew that Orissa was 'leading the way' in the strengthening of the PRI and the empowerment of women (Mathew 1995b: 73–8).[32]

However, the same government delayed elections to the zilla parishads, which would have taken place after a gap of 23 years. This adjournment was partly due to political bickering, but a genuine reason was the reorganization of the 13 districts, which was an important task especially in light of their unwieldy size hampering efficient administration. They were first increased to 17 districts, and from 1 April 1993 onwards 28 districts started functioning. Since 1994 there have been 30 districts in Orissa. The Chief Minister announced elections to the zilla parishads for April 1994 to be held on party basis, which were later deferred to November and again to December 1994. Controversy arose over the manner of the demarcation of the zilla parishad

[30] For the number of women in the Municipal Bodies, see ISS (*PRU*, January 1994: 3) and Bhargava and Samal (1998: 102). The number of elected women in the Panchayati Raj Bodies is given by the ISS as 25,000, and by Bhargava and Samal as 35,000. The number given above which seems to be the correct one is taken from OSCARD (1993: 42). It is also given, with the difference of one digit (28,069) by Jena (1995: 162). Generally speaking, it is extremely difficult to get corresponding numbers from different sources. Even a single author gives sometimes conflicting statements, like Jena (1995). He states on p. 161 that there are 5,264 gram panchayats, while on p. 162 the number is given as 5,267. I have found numbers ranging from 5,261 to 5,267 and have settled with 5,261 as given by the State Election Commission of Orissa (1997: 2).

[31] Jena (1995: 162f) gives the following numbers for women: 14 sarpanches, 5,237 naib-sarpanches, 1,841 samiti members, 17 chairpersons, and 302 vice-chairpersons.

[32] This is the title of Chapter 10: 'Orissa Leads the Way' in Mathew (1995b: 73–8), which was originally published in *The Hindu*, 27 March 1993 as 'Panchayats: Orissa Leads the Way'. For another positive assessment of Biju Patnaik's move, see also Pujari and Kaushik (1994). For empirical accounts on Orissa as a whole, see OSCARD (1993); for empirical accounts on women in the PRI elected in Ganjam District in 1992 see Panda (1995b, 1997, 1998, and 1999).

constituencies and the identification of the reserved constituencies. It was alleged that political calculations were the main consideration, instead of a just and rational routine. Finally the State Election Commission, due to 'non-availability of ballot boxes', postponed the elections, then scheduled for 20 December 1994. A revised programme was only planned to be drawn up after the State Assembly elections, which were due in the spring of 1995. Biju Patnaik claimed that this cancellation was nothing short of a conspiracy (ISS, *PRU* November 1994: 2).

In the following State Assembly elections in March 1995, the Janta Dal lost its majority and the Congress (I) under the leadership of J.B. Pattnaik came to power in Bhubaneswar. Clearly the Panchayati Raj and municipal bodies were seen with suspicion and as the legacy of the Janta government. Not too surprisingly, the new government thus decided to dissolve them. The Notification No. 673/95 of 1 August 1995 gave as the reason for the dissolution that the law under which the elections had taken place in 1992 did not conform in some points with the 73rd Amendment (Samal and Samal 1998: 55). As a pivotal problem the lack of a provision for the reservation of the offices of sarpanch or chairperson for SCs, STs, and women as provided by the 73rd Amendment in Article 243-D (4) was cited. However, the dissolution of previously elected bodies that did not comply with the regulations laid down by the Constitutional Amendment was not mandatory, though possible. Article 243 N of the 73rd Amendment Act concerning the continuance of existing laws and panchayats reads: 'Provided that all the Panchayats existing immediately before such commencement *shall continue till the expiration of their duration*, unless sooner dissolved by a resolution passed to that effect by the Legislative Assembly of the State (emphasis added).'

Hence one can argue that the premature dissolution of the bodies was constitutional, but most likely politically motivated. The lack of interest and reluctance towards a meaningful devolution of power by the Congress-government in Orissa can also be seen in the deferment of elections until January 1997, although they were constitutionally due six months after the dissolution, or until 2 February 1996. The pretexts were first that the constituencies had to be newly delimited, and a routine procedure for the reservation of the constituencies had to be developed. This happened through an Amendment in December 1995, as well as a reservation of not less than 27 per cent for OBCs.[33] The government also said that it would set up a Finance Commission, Orissa being the last state that had not constituted one until February 1996 (ISS, *PRU* February 1996: 3). The State Election Commission announced polls for June and July 1996, but because of a joint appeal by all recognized parties to put them off considering the onset of the rainy season, they were cancelled (ISS, *PRU* May 1996: 4). In October 1996,

[33] *Orissa Act 18 of 1995, The Orissa Grama Panchayat (Amendment) Act 1995*, 12 December 1995, see point 5: Amendment of Section 10 (3) (b-1) for the reservation of 27 per cent of seats for OBCs, and 4 (b) for the procedure of the selection of reserved constituencies, in Samal and Samal (1998: 34).

the Supreme Court promulgated an ordinance that the elections were to be held without further delay, notwithstanding the pending writ petitions in the High Court (ISS, *PRU* October 1996: 4). On 20 November 1996, the State Election Commission finally issued notification of holding elections to all the three-tiers of the PRI in January 1997, and the nominations had to be filed in December 1996 (ISS, *PRU* November 1996: 5). Yet, the government tried again to postpone the polls in view of severe drought conditions prevailing in some parts of the state. It made a plea to the Court, guided by a resolution taken by the State Assembly on 28 November. The Assembly was of the opinion that the elections would affect the drought relief measures, since the administration would be busy with the preparation and carrying-out of the election (ISS, *PRU* December 1996: 5f.). However, the appeal was of no avail, and the elections took place at last from 11 to 15 January 1997, one and a half years after the gram panchayats and panchayat samitis had been dissolved. The election to the zilla parishads took place after a lapse of 30 years.

Like the elections in 1992, these also were marked by violence in 19 districts of coastal Orissa, claiming 9 lives and leaving 200 injured (Bhargava and Samal 1998: 103). Re-polls were ordered in 597 booths because of violence, snatching of ballots, and other incidences, and the elections were completed in all respects including elections to chairpersons and vice-chairpersons by 25 February 1997 (State Election Commission of Orissa 1997, also for the following information). Elections were held in 30 districts having 854 zilla parishad constituencies for 5,260 panchayat samiti constituencies in 314 blocks, and in 5,261[34] gram panchayats having 81,077 wards. The total number of electors was 1,93,93,602. Computing the data given by the State Election Commission concerning the reservation of seats for the various offices shows that 35.27 per cent of the wardmembers (28,595), 35.39 per cent of the sarpanches (1,862), 35.55 per cent of the samiti members (1,870), 36.31 per cent of the samiti chairpersons (114), 34.43 per cent of the zilla parishad members (294), and exactly 33.33 per cent of the zilla parishad presidents (10) have been reserved for women.[35] Thus, 32,745 positions have been reserved for women.

All in all, elections took place for 92,452 offices, out of which 35,290 (38.17 per cent) officeholders were elected unopposed, and for 4,548 offices (4.92 per cent) no nominations were filed. Unfortunately there is no information on whether these have been predominantly seats reserved for women. The remaining 52,604 offices,[36] however, were contested with an

[34] There is no explanation given for why there are 5,261 gram panchayats, but only 5,260 panchayat samiti constituencies. As per the rule, every gram panchayat should elect one samiti member.

[35] The figures slightly exceeding 33 per cent are due to the fact that 'not less than one-third' of the seats have to be reserved for women. This effectively means that, for example, in case a gram panchayat consists of 16 wards, six seats, or 37.5 per cent, have to be reserved for women, as five would be less than one-third.

[36] 10 offices have been countermanded in addition to the unopposed and vacant offices.

average of 3.65 contestants. It is not too astonishing, as will become clear later, that the position of the sarpanch was the most highly contested with an average of 7.58, followed by zilla parishad members (4.7), panchayat samiti members (4.11), and wardmembers (3.1).[37] The election for the zilla parishad was conducted on a party basis. Out of 854 seats, 444 went to the Congress party, 191 were won by the Janta Dal, 119 by the Bharatiya Janata Party (BJP), 11 by the Communist Party of India (CPI), 4 by the Communist Party of India (Marxist), 17 by the Jharkhand Mukti Morcha (JMM), 12 by the Samajwadi Janata Party (SJP), and 56 by Independents.

Structure of the Panchayati Raj Institutions in Orissa

In order to be able to judge how much room to manoeuvre the representatives of the PRI have and to understand the functioning of the Panchayati Raj as such, one ought to discuss the structure and functions of the different levels of the Panchayati Raj System in Orissa. Even though the 73rd Amendment led to a more or less uniform system all over India through the Amendments of the various State Acts, differences remain in the nomenclature and also in several features in which the states have the freedom to lay down specific rules. Orissa has presently a three-tier arrangement, with the zilla parishad as the apex body at the district level, the panchayat samiti at the block level, and the gram panchayats at the village level. There are two more distinct general bodies at the village level, namely the 'grama sabha' and the 'palli sabha'.[38] As the system is, theoretically speaking, supposed to be a 'bottom-up' system concerning planning mechanisms, I analyse it here also from the lowest tier, namely the gram panchayat, upwards.

The Gram Panchayat. As noted earlier, the gram panchayat is not only the lowest tier located at village level, but also the oldest. The first village panchayats were already constituted under the *Orissa Grama Panchayat Act of 1948*. The *Orissa Grama Panchayat Act, 1964*, which is still valid with modifications up to now, replaced the former Act. The *Grama Panchayat Act* is very elaborate, having 154 Sections with multiple sub-sections, and one Schedule giving the vehicle tax rates. In the Act, the constitution and function of the gram panchayats is laid down as well as the definitions for 'grama', the 'grama sasan', the 'grama sabha', and the 'palli sabha'. I will explain these terms in more colloquial language and will add some observations made during the field study that are the result of specific regulations in the Act.

A 'grama' in Orissa consists either of a big village or of several contiguous villages, declared and notified by the state government in the gazette as a 'grama'.[39] It comprises a population of not less than 2,000 and not more

[37] These percentages are calculated from data given by State Election Commission of Orissa (1997: 17).

[38] For an overview of the PR Structure in Orissa see Figure 2.2.

[39] *Orissa Grama Panchayat Act*, 1964, 3(1). In case not mentioned otherwise the given sections refer to the *Orissa Grama Panchayat Act, 1964*, Orissa Act 1 of 1965, as modified up to 31 December 1994 (GoO 1994a).

Zilla Parishad
(District Level)

Members: (1) *Non-Official: President and Vice-President* elected from among themselves, one directly elected member from each Block (on party basis); *ex-officio*: all Panchayat Samiti Chairpersons of the District, every MP and MLA representing constituencies which comprise wholly or partly the area of the Parishad, every member of the Council of States who is registered as elector within the area of the Parishad; (2) *Official*: District Collector is the CEO, Project officer of DRDA is ex-officio Secretary (both have no right to move a resolution or to vote).
Meetings: at least once every three months.

Panchayat Samiti
(Block Level)

Members: (1) *Non-Official: Chairman and Vice-Chairman* elected from among themselves, one directly elected member of each Gram Panchayat; *ex-officio*: all Sarpanches, every MP and MLA representing constituencies which comprise wholly or partly the area of the Samiti, every member of the Council of States who is registered as elector within the area of the Samiti; (2) *Officials*: Block Development Officer is the CEO; other officers (like Revenue Divisional Commissioner, Collector, Sub-Divisional Officers) can take part and speak in the Samiti meetings (officials have no right to vote).
Meetings: at least once every two months.

Gram Panchayat
(Village Level)

Members: (1) *Non-Official*: directly elected *Sarpanch and Naib-Sarpanch* elected among themselves, one person elected from each ward (a Gram Panchayat consists of 11–25 wards); (2) *Official*: Panchayat Secretary (no right to vote).
Meetings: at least once in a month.

Grama Sasan/Grama Sabha
(Village Level)

Members: *Grama Sasan* is composed of all persons registered in the electoral role of the *Grama* (village or group of contiguous villages having population between 2,000 and 10,000).
Meetings: there shall be at least two meetings of the *Grama Sasan* (February and June) called *Grama Sabha*; since April 1999, four additional dates have been introduced (26 January, 1 May, 15 August, and 2 October); the quorum of the *Grama Sabha* is one-tenth of the *Grama Sasan*.

Palli Sabha
(Ward Level)

Members: composed of all persons on the electoral role of the ward (villages, village, or part of a village).
Meetings: once a year (February).

FIG. 2.2: Panchayati Raj structure in Orissa.

than 10,000 people, but a village should never be divided. Thus, the 'grama' is very big. Rao had criticized much earlier that '[t]he Orissa Gram Panchayats . . . are rather unwieldy in size. Taken together with the fact that the communications in the State are relatively poor, the size of the Gram Panchayat is bound to tell upon their efficient functioning' (Rao 1977: 199). This assessment holds true till today and is especially consequential for the newly elected women members. Since they are limited in their freedom of movement and need male chaperons, especially when they have to cover long distances, the big size of the panchayats impinges on their autonomous participation. That became evident especially in the hinterland block, where women sometimes have to cover distances of 10 km through difficult terrain, or where a wardmember has to serve up to four villages which are dispersed over a fairly large area. In such a framework it is difficult for women to pursue their work without male support.

The 'grama sasan' is the electorate situated in the area of the 'grama'; this means all persons on the electoral roll for an Assembly Constituency in this area.

4 (2) The Grama Sasan shall be a body corporate by the name of the Grama to which it relates, having perpetual succession and common seal, with power, subject to the provisions of this Act and the rules made thereunder, to acquire, hold and dispose of property and to contract and may by the said name sue and be sued.

There used to be at least two meetings of the members of the grama sasan, one in February and the other in June, and these meetings are called grama sabha, but since 1999 four more dates have been introduced. The quorum for these meetings is 1/10 of the members of the grama sasan. In case the quorum is not met, the meeting will stand adjourned to a future day and no quorum is needed for the second meeting.

During the case study it became visible that this leads to the predicament that the PRI representatives are not necessarily very eager to motivate the villagers to participate in the grama sabha. They do not have to bother with the interference of the electorate if the required number does not turn up and can decide on priorities and financial transactions without popular assent and transparency. The problems encountered in regard to the grama sabhas will be more fully discussed in Chapter 3 where I discuss the workings of grass-roots democracy.

At the grama sabha held in February the programmes and works to be undertaken by the gram panchayat for the ensuing year and the annual budget for the grama for that year in regard to the recommendations of the 'palli sabhas' (see below) are discussed, and recommendations are given to the gram panchayat. At the grama sabha in June, the sarpanch submits the report of the programmes and works undertaken by the gram panchayat, and their progress during the preceding year along with the annual audit report. Proposals for the levy of taxes, rates, rents, and fees, the organization of community service, and the drawing up and implementation of agricultural production plans can be brought forward in any of the grama sabhas.

When a grama consists of more than one village, for every village the state government shall constitute a 'palli sabha'. Provided that a ward (constituency for the election of the wardmember) consists of more than one village, only one palli sabha will be constituted for this ward. The electorate and the meetings of the electorate of a ward are called palli sabha. The palli sabha is supposed to meet once a year in February, and no quorum is required. The duty of the palli sabha is to give recommendations to the grama sabha regarding development works and programmes that might be taken up during the ensuing year in the ward and concerning the annual budget estimate submitted by the gram panchayat. Consequently, the meetings of the palli sabhas should take place before the grama sabha. Many villagers, especially in the hinterland block, complained that they are asked to participate in two separate meetings to basically discuss the same matters. They do not appreciate the double burden and often were of the opinion that participation in the institutions of grass-roots democracy is basically a waste of time.

If one could call the grama sabha the 'village parliament', then the gram panchayat could be called the 'village government'. A gram panchayat has to be established as the executive authority for every grama sasan. For the constitution of the gram panchayat the grama has to be divided into several 'wards' by the District Collector, and the total number of wards shall not be less than 11 and not more than 25. These wards form the smallest constituencies in the Indian electoral system. Every gram panchayat shall be composed of a sarpanch, who is directly elected by the grama sasan, a member elected from each ward, and a naib-sarpanch, who will be elected from among the wardmembers. The fact that the sarpanch is directly elected strengthens his/her position *vis-à-vis* the gram panchayat.

Wards are reserved for the SCs and STs as far as possible proportionally according to their strength in the population of that area as follows (Bhargava and Samal 1993: 196):

$$\frac{\text{Seats to be reserved for SC/ST}}{\text{Total no. of seats}} = \frac{\text{Total SC/ST population}}{\text{Total population of the gram panchayat}}$$

If the SC- or ST-population is not sufficient for the reservation of any seat, one seat shall be reserved for them. Not less than one-third of the seats are reserved for women, including one-third of the seats reserved for SCs and STs. If only two seats have been reserved for SCs or STs, one of them has to be filled with a woman. The reserved wards shall be allotted by rotation. Since the reservation is done in single-member constituencies, the legislators did not want to block certain constituencies for consecutive elections. That is why they decided that the reserved seats should rotate in every election, so that each constituency gets reserved for a woman again only after 10 years.[40] The quite complicated procedure of the reservation of wards and offices of

[40] The provision for proportional reservation for SCs and STs and for one-third for women has been introduced by Orissa Act 9 of 1991. However, the regulation as given above was introduced through Orissa Act 6 of 1994. The difference regards the procedure of the reservation of wards and the matter of rotation.

sarpanch for the specific groups was inserted through the *Orissa Grama Panchayat (Amendment) Act, 1995* (Orissa Act 18 of 1995) after the PRI had already been dissolved by the Congress government.[41] The main consideration was to make the reservation procedure a rational and not arbitrary one; otherwise it could be easily used for political gains. In the same Amendment Act, the provision that additionally not less than 27 per cent of the wards are reserved for OBCs, also in the women's quota, was inserted.

The offices of the sarpanches shall be reserved for SCs and STs as far as possible according to their proportion in the state, and not less than one-third of the total number of sarpanches in gram panchayats shall be reserved for women. No reservation is provided for Other Backward Castes (OBCs). The state government makes the reservations of the offices of the sarpanches by rotation among different gram panchayats. As mentioned earlier, the naib-sarpanch position is reserved for a woman in case the sarpanch is a man.

Anyone who has attained the age of 21 years, is able to read and write Oriya, and is not contesting any other position in the PRI is eligible for the office of sarpanch and wardmember.[42] The provision in regard to literacy, however, has been pragmatically adapted in reality: members are required to be at least able to sign their name—without this adjustment it would be difficult to find enough qualified candidates. Otherwise, most of the disqualifications are meant to secure that the candidate is mentally and bodily fit, that s/he does not hold more than one political post at the same time, that no criminal can stand for election, and that the candidate is not an employee of the state or Central government.

The sarpanch is the main executive of the gram panchayat, acting under its authority. S/he has the responsibility to convene and preside over the meetings, conduct, regulate, and be responsible for the proper maintenance of the records of the meetings, and other records relating to the grama sasan. The sarpanch has to execute documents relating to contracts, is responsible for the proper working of the panchayat, exercises control over the acts and proceedings of all officers and employees of the panchayat, and can discharge certain duties. The naib-sarpanch can exercise such powers, discharge such duties, and perform such functions as the sarpanch may from time to time delegate to her/him. S/he will also perform as the sarpanch if the post falls vacant until a new sarpanch is elected, and in absence of the sarpanch the naib-sarpanch presides over the gram panchayat meetings and attends the samiti meetings.

The important official at the gram panchayat level is the panchayat secretary, whose duty is to maintain the records of the proceedings of the meetings and to remain in custody of all records, documents, cash, and

[41] Insertions were done in Section 10, (4) (a)–(d) [reservation of wards] and (6) (a)–(b) [reservation of office of sarpanch)]. The Act is given in Samal and Samal (1998).

[42] Section 25 sub-sections (a) to (v) give several disqualifications for becoming a member or sarpanch of the gram panchayat, among which is the much-disputed two-child norm [Section 25 (v)].

valuables. He is often the most knowledgeable person at this level, as he is doing his job for longer periods, whereas the non-officials can change more frequently and are often novices, especially since the introduction of the reservation. Thus, the newly elected members are often dependent on his guidance.

Meetings of the gram panchayat shall take place at least once every month, and when circumstances so require, emergency meetings can be held. The Collector or some other officer deputized by the state government can attend the meeting, but has no right to vote. There is also a provision that Standing Committees should be constituted for the efficient discharge of the duties, but apparently they do not function in many gram panchayats. The regular term of office is five years from the date appointed for the first meeting.

The powers, duties, and functions of the gram panchayat are rather extensive nowadays.[43] The first sections of the Act attribute to the gram panchayats, among others, the responsibility for infrastructure like the construction, repair, maintenance, alteration, and improvements of public streets, the drainage system, and water supply. The gram panchayat also has to care for health issues such as the prevention and control of pests (for example, scavenging, removal and disposal of rubbish), for the registration of births, deaths, etc., and maintenance of other records (e.g. cattle and population census), supervision and regulation of fairs, weekly markets, etc., and assistance to the samiti in the realm of primary education. This was the catalogue from the Act of 1964. Rao argued rightly in the 1970s that developmental functions did not figure very prominently among the obligatory functions of the gram panchayats (1977: 202). At this time the main responsibility for development rested with the panchayat samiti. However, this has changed radically with the *Orissa Grama Panchayat (Amendment) Act, 1991*, where the following functions have been included in the list:

(44) . . .
(w) Minor forest produce;
(x) Small Scale Industries including Food Processing Industries;
(y) Rural housing;
(z) Poverty alleviation programme;
(z-1) Women and child welfare;
(z-2) Social welfare including welfare of the handicapped and mentally retarded;
(z-3) Public distribution system

Thus, nowadays the gram panchayats have a major responsibility for executing development programmes.

A look at this list of obligatory functions raises the question concerning the financing of these works. Gram panchayats can collect, among others, vehicle tax, water and lightning rate, drainage tax, fees on markets, cart-stands, slaughter-houses, and animals brought for sale, fees for the use of

[43] See Section 44 (1) (a)–(z-4) for obligatory functions, and Section 45 (a)–(y) for discretionary functions of the gram panchayats.

buildings such as shops owned by the gram panchayat, and licence fees on brokers and commission agents. Interestingly, the District Collector can require the gram panchayat to impose a tax when he feels that the gram panchayat fund is unbalanced and its income insufficient for the discharge of the obligatory functions (Section 91). Sections 93 to 100-A of the Act deal with the finances. It is stated that a grama fund has to be constituted, where all proceeds of any tax, toll, fee, fine, or rate imposed shall be placed, as well as all sums received as loan, gift, grant, and contributions, and all income from various assets owned by the grama sasan. This fund has to be deposited in a bank. The problem is that generally the funds from own resources are very slim, and that the budget is mainly constituted out of state-sponsored programmes, where the money is tied to specific undertakings. Thus, the financial position of the gram panchayats is precarious and money for the pursuit of local initiatives is basically nil. In Orissa, only very few financial resources have been devolved to the PRI and the power of taxation is very meagre if one regards the precarious financial position of the citizens of which a high proportion lives below the poverty line. The implications of this will be discussed in Chapter 6.

It is the duty of the sarpanch to prepare a budget estimate showing the probable receipts and expenditures and place it before the gram panchayat, which in turn will place it before the palli- and grama sabhas for consideration. This is to ensure transparency of financial dealings, which, however, does not really take place since the institutions of grass-roots democracy are not functioning in the desired way as we will see in Chapter 3. This (revised) budget then has to be placed before the samiti for approval, and the samiti has the power to modify it. Accordingly, the samiti has a supervisory function in respect to finance. Apart from financial supervision, the gram panchayat is also under the control of the District Collector, and sections 109–20 deal with control over the gram panchayat executed by the District Collector, samiti chairperson, or MLA. The Collector holds the greatest powers. He can even suspend or remove a sarpanch, naib-sarpanch, or wardmember, if he thinks the person is violating provisions under this Act or the further continuance in office would be detrimental to the interest of the gram panchayat. Thus, the position of officials is very strong in the PRI of Orissa.

The Panchayat Samiti. The second tiers in the Panchayati Raj system in Orissa are the panchayat samitis. They are situated at the block level and 'have emerged as the Principal units of developmental administration in the state having regard to the volume of responsibility presently assigned to them', writes Mr Chinmay Basu, the Secretary of the Panchayati Raj Department of the Government of Orissa in June 1998 (GoO 1998: 1). However, this is not really a new development, since the block became the fulcrum at the administrative level for rural development already under the Community Development Programme of 1952; and therefore the panchayat samiti was most important in this respect right from the beginning.

Interestingly, when compared with the *Orissa Grama Panchayat Act of*

1964, the *Orissa Panchayat Samiti Act of 1959* is quite slim and regulates the constitution, conduct, and business of the samiti in only 58 sections with various subsections. However, there are several separate rules that regulate comparable procedures which are directly incorporated into the *Grama Panchayat Act*.[44] The main features of the Act will be discussed below.[45]

The state government divides each district into local areas known as 'blocks'. For every block, a Block Development Officer (BDO) is appointed by the state government, and in every block a samiti has to be constituted consisting of the following members:

Section 16 (1):
(a) the Chairman and the Vice-Chairman, elected from among the members given under (b),
(b) one member directly elected from every constituency within the Block,
(c) all sarpanches of the Gram Panchayats situated within the Block,
(d) every MLA and MP representing constituencies which comprise wholly or partly the area of the Samiti,
(e) and every member of the Council of State (Rajya Sabha) who is regarded as an elector within the area of the Samiti.

All members named above have the right to vote. It is quite interesting to note that this was only established through the *Orissa Panchayat Samiti (Amendment) Act, 1994*, Orissa Act 7 of 1994 (Samal and Samal 1998). Before, only the directly elected members from the constituencies had the right to vote, whereas the ex-officio members (sarpanches, MLAs, MPs, and members of the Council of States) could only take part in the discussions and proceedings of the meeting without voting rights.[46] This gives the sarpanches maximum power in the two-lower tiers, whereas the samiti members have been effectively reduced to the electorate of the samiti chairperson. It also gives undue power to higher level politicians who might use it to interfere with local level politics. In a samiti meeting that was observed in Balipatna on 16 March 2000 the newly elected MLA from this region was obviously calling the shots, reducing the samiti chairperson more or less to a ceremonial head of the session. This rather offsets the rationale for decentralized politics in case higher level politicians can use it to further their ends.

The rules for the reservation of seats are basically the same as for the gram panchayats. Seats are reserved for SCs and STs in every samiti proportionally

[44] These rules are the *Orissa Panchayat Samiti Budget Rules, 1969*; the *Orissa Panchayat Samiti (Conduct of Business) Rules, 1969*; the *Orissa Panchayat Samiti Elections Rules, 1991*; the *Orissa Panchayat Samiti (Removal of Chairman and Vice-Chairman from Office) Rules, 1987*; the *Orissa Panchayat Samiti (Constitution of Standing Committees) Rules, 1993*.
[45] In case not mentioned otherwise, the sections are given according to the Orissa Panchayat Samiti Act, 1959, Orissa Act 7 of 1960, modified up to 31 December 1994, given in Government of Orissa (1994b). The Rules mentioned above are also found in this document.
[46] See for this the *Orissa Panchayat Samiti Act, 1959*, 18 (3) as amended until 1991, in Samal and Samal (1998).

to the population in the samiti area (compare with the formula given above), allotted by rotation to different constituencies in the samiti area. As in the case of the gram panchayats, new provisions for the reservation of 27 per cent of the seats for the OBCs were inserted through the *Orissa Panchayat Samiti (Amendment) Act, 1995*. Offices of the chairperson are also reserved for SCs and STs according to their proportional population in the state, and one-third of the total number of offices of chairperson in the samitis has to be reserved for women. Again, as in the *Grama Panchayat Act*, no provisions have been made for the reservation of the office of the chairperson for OBCs, and like the naib-sarpanch, the vice-chairperson has to be a woman, in case the chairperson happens to be a man.

In addition to the non-official members of the samiti given in Section 16 (1), several officers like the Collector or Sub-Divisional Officer have the right to speak or take part in the meetings of the panchayat samiti or in the standing committees. These officials, however, have no right to vote. The chairperson of the samiti is the executive authority, and the BDO is the executive officer of the samiti, functioning under the control of the former. Thus, the elected representative is in fact the superior of the official, which is resented by some. One reason is that the officials are normally highly educated, whereas the local level politicians usually have less formal education. As a result of this, the officials feel uneasy to be supervised by 'uncouth' villagers, who are seen rather as obstacles for the development process.

The catalogue of the powers and functions of the samiti is much smaller than that of the gram panchayats. However, it is more general in nature, and subsumes many functions under one subsection. Thus, subsection (1) (a) of Section 20 states the function of the samiti as 'planning, execution and supervision of development programmes, schemes and works in the Block relating to Community Development including those pertaining to "Tribal Development Blocks" for the time being recognised by Government as such and of such other programmes, schemes and works as Government may from time to time by general or special order direct in respect of any Samiti . . .'.

With this rule the samiti has been made the prime agent in rural development, which is mainly financed and regulated through several state sponsored development schemes, e.g. the SGSY. Additionally, the panchayat samiti is in charge of the management, control, and spread of primary education in the block, management of trusts and endowments under orders of the government, supervision of enforcement of laws relating to vaccination and registration of births and deaths, and most importantly supervisory powers over the gram panchayats within the block. The chairperson and every other non-official member have the power to supervise all works undertaken by the samiti and all institutions under control of the samiti. Like the gram panchayats, the panchayat samiti shall constitute 'standing committees' for the efficient discharge of the duties. The chairperson has to convene and conduct the meetings of the samiti, and s/he has the power to

inspect and supervise all works undertaken by the samiti. The function of the vice-chairperson is formulated like the one for the naib-sarpanch.

The Zilla Parishad. The highest tier of the system of local government is the zilla parishad, constituted at the district level. As already discussed, the history of the zilla parishad in Orissa is not an exemplary one. Before elections took place in January 1997, zilla parishads had existed only once for seven years, constituted under the *Zilla Parishad Act of 1961* and abolished already in 1968. Thus, after a lapse of nearly three decades, zilla parishads were constituted again in Orissa. During the field research the zilla parishad was not the focus of attention, as only the two lower tiers were analysed. Hence, only the most important details are given below.

One of the major exceptional features of the zilla parishad that distinguishes it from the lower bodies of the PRI is the provision that elections are to take place on a party basis, whereas the other bodies are supposed to be partyless.[47] Among those contesting for zilla parishad seats one can find former MLAs and even ex-ministers.[48] The positions on the zilla parishad bodies were, next to the sarpanches, the most highly contested. The zilla parishad is at the apex of the PRI, and its functions will be given as delineated in the *Orissa Zilla Parishad Manual, 1994* (GoO 1994c), which is, not incidentally, the thinnest of the three manuals printed by the Panchayati Raj Department.[49]

The functions of the zilla parishad are given in chapter 3 (3) (i-xiii); the most general listing of functions is given in the first paragraph of this Section:

3. (3) Every Parishad shall have the power to—
(i) undertake schemes or adopt measures including giving of financial assistance relating the development of agriculture, social forestry, live stock, industries, co-operative movement, rural credit, water-supply, distribution of essential commodities, rural electrification including distribution of electricity, minor irrigation, public health and sanitation including establishment of dispensaries and hospitals, communications, primary, secondary and adult education including welfare and other objects of general public utility.

As one can see, it is a very general listing, leading to the problem that the distribution of functions between the three-tiers is not clear-cut. Concerning the relationship between the three-tiers, Article 3 (3) (xi) states that the zilla parishad shall 'coordinate and integrate the development plans and the

[47] For the arguments in the long-standing Indian debate on the merits and drawbacks of parties operating in the PRI, see Bhargava (1979). The discussion today follows basically on the same lines.

[48] Personal communications with Mr Chinmay Basu, Secretary, Panchayati Raj Department, and Mr D.P. Dhal, Deputy Secretary, Panchayati Raj Department, 16 December 1998.

[49] The *Orissa Zilla Parishad Manual, 1994* has 52 pages while the *Orissa Grama Panchayat Manual, 1994* has 204 pages, and the *Orissa Panchayat Samiti Manual, 1994* has 126 pages.

schemes prepared by the Samiti in the district'. Thus, it is also a supervisory body for the panchayat samitis.

The idea is that the micro planning from the lower tiers gets coordinated by the higher tier, and the zilla parishad and the parallel executive body of the District Rural Development Agency (DRDA) will devolve the funds accordingly. The DRDA was created in 1982 for the purpose of allocating money and implementing projects under the Integrated Rural Development Programme (IRDP) and other Central and state sponsored schemes. The District Collector is the chairperson and members are the heads of various functional government departments. Before the constitution of the zilla parishad, the DRDA acted more or less independently, and was the main body for rural development. Generally speaking, at the highest level the officials appointed by the state government have great influence which reduces the impact the decentralization of political power to the PRI could have.

THE STATUS OF WOMEN

In this section the socio-cultural background that influences the status of women in India and more specifically in Orissa will be portrayed. It will also be seen how this translates into macro-indicators on the well-being of women, like sex-ratio, life expectancy, literacy rates, and political participation. I shall first analyse some cultural concepts, which influence the special status presently occupied by women in India. The place they hold in society is a very important determinant of the scope women have to become politically active. Their status also structures to a certain degree the extent and direction of their involvement.

One must be careful not to essentialize the gender-categories. The post-modernist feminist writers have made this point, and also women of colour have argued that the 'woman' in most feminist writings appears to be white, heterosexual, and middle-class. Some writers conclude that we do not know what really constitutes womanliness, or maleness, for that matter. Obviously there are differences among women, which originate from various social cleavages. The *Report of the Committee on the Status of Women in India* formulated it as follows:

While it is true that the status of women constitutes a problem in almost all socie-ties . . . we found that sex inequality cannot in reality be differentiated from the variety of social, economic and cultural inequalities in Indian society. The inequalities in our traditional social structure, based on caste, community and class have a very significant influence on the status of women in different spheres. Socially accepted rights and expected roles of women, norms governing their behaviour and of others toward them vary among different groups and regions. They are closely affected by the stage and methods of development, and the position held by the group in the social hierarchy. All this makes broad generalisations regarding women's status unrealistic. (GoI 1974: 3)

In the Indian context, factors other than gender, such as caste, class,

religion, and region, are very important, and one's gender might not even be the main structural factor for identity formation. However, there is no reason to underestimate the fact that there are certain differences between men and women, regardless of their social or regional location: Only women can bear children, mainly women are victims of rape or domestic violence, women are seen as less capable to perform certain jobs, they are less paid, and last but not least most women do have to act in a hierarchical structure which subordinates them in most walks of life. In India, the strict gender-segregation found in many areas (even though the extreme form of this—*purdah*—is mainly practised by high-status families) also leads to different life-realities and concerns for women in comparison to men. Additionally, a great part of the oppression faced by women is meted out to them only because they are women, no matter what their education, class, religion, or descent is.

The deprivation faced by poor women especially is strongly linked with sexual discrimination (like early marriage, physical exploitation by landlords, no education, no inheritance rights, lesser pay for work, etc.), whereas for better-off women the excesses meted out to them might take a different form, e.g. women of the middle class especially are victims of dowry-torture. Hence, the feature of middle-class discrimination differs from that faced by poor women, but it is still safe to maintain that all women face this treatment for the mere fact of being women. Women also nearly everywhere have to cope with a male biased discourse that belittles their contributions to society and judges their behaviour in a different light than the male one. Furthermore, women's freedom of choice is heavily curtailed.[50] Thus, critique regarding the empirical value of gender-categories as such and scepticism about 'universalism' might be important to alert us that structures of inequality vary across cultures and social classes, but should not confuse us about the possibility of making general arguments as well. Nussbaum, for example, criticizes post-modern feminist theory to have reached a stage of abstraction that turns the focus away from reality and does not serve to understand women's lives better. In contrast, she maintains in her capabilities approach that it is important to understand the subjugation of women, in universal terms, especially in order to be able to compare cross-culturally and develop a philosophical and political framework to address the pervasive problems faced by most women. She offers a feminist philosophy that is strongly universalistic without being insensitive to difference. Focusing on human capabilities, she also argues that women should be treated as an end in themselves, and not in their functions as reproducers or caretakers of the family, as often focused on in the development discourse (Nussbaum 2000: 7–11).

[50] However, also men are victims of this discourse, and ideas of 'manly' behaviour restrict their choice as well. Still, they face less discrimination in the public space and the value system is usually shaped in a way that the choices available to men carry a higher prestige than those available to women. This should be the reason why men might not be compelled to work for a society that gets rid of gender-ordained roles and liberates both men and women to live their lives according to their preferences.

In this chapter, I shall thus focus on the ideological determinants that circumscribe women's room to manoeuvre, and these hold for most women, regardless of caste or location, even though the emphasis will be laid on structures relevant for the case of Orissa. This chapter looks especially at the features that influence the position women can occupy in the public sphere. This is, however, intimately related to the role they are expected to perform in the household sphere. It would be pure hubris to claim to be able to analyse all factors affecting women's status in India or Orissa, as they are manifold, complex, and dynamic, but the attempt will be made to summarize the most latent features.

The Cultural Framework

Since Orissa is mainly populated by Hindus, and most persons dealt with in the case study are Hindus as well, I shall concentrate only on 'Hindu' cultural norms.[51] Outside observers of India or even South Asia as a whole have been puzzled by the fact that generally speaking women do occupy a very low position in public and family life and that many grievous atrocities are committed against women, like sati, dowry death, and female infanticide, on the one hand, and the fact that most South Asian countries were headed at least once by powerful women politicians, on the other. Women do also occupy positions in public life as professionals, be it in medicine, arts, or science. The status of women in India is apparently ambiguous and it seems promising to look at the role models for women provided in Hinduism to find an explanation for this pattern.

Susan Wadley (1999a) in her classic article on 'Women and the Hindu Tradition' analyses the symbolic duality of women in Hindu ideology as it emerges from the classical texts as well as from the oral traditions. She asserts that this dualism is responsible for the situation in India today. This duality, she argues, stems from the dual presentation of women in Hinduism as fertile and benevolent—the bestower—on the one hand, and as aggressive, malevolent—the destroyer—on the other. Two facets of femaleness relate to this duality, where the female is first of all *shakti* (power/energy)—the energizing principle of the universe, and also *prakriti* (nature)—the undifferentiated matter of the universe. The man is *purusa* (cosmic person) and the differentiated spirit, as opposed to undifferentiated matter, and he is comparatively inactive.

Uniting these two facets of femaleness, women are both energy/power and Nature; and Nature is uncultured. . . . Uncultured Power is dangerous. The equation 'Woman=Power+Nature=Danger' represents the essence of femaleness as it underlies

[51] The Census 1991 shows that 94.67 per cent of Orissa's total population are Hindus, 1.83 per cent are Muslims, 2.1 per cent are Christians, 0.05 per cent are Sikhs, 0.03 per cent are Buddhists, and 0.02 per cent are Jains (Directorate of Census Operations, Orissa 1996: 4). I do not want to enter the debate of what constitutes 'Hindu' society. Such a discussion would deserve a separate thesis. I shall refer to 'Hindu' civilization or 'Hindu' society in contrast to mainly Christian and Muslim practices, as well as to Buddhist and Jain practices, which are, however, in most works subsumed under 'Hindu' culture.

Hindu religious belief and action about women. The equation summarizes a conception of the world order that explains the woman/goddess as the malevolent, aggressive destroyer. . . . [H]owever, the Hindu view of woman is not only of danger—Woman is also the benevolent, fertile bestower. . . . One possible explanation for female benevolence is that woman is capricious, therefore she sometimes uses her Uncultured Power for human benefit. Recent studies have provided a sharper insight: 'good females—goddess or human—are controlled by males; that is Culture controls Nature'. (Wadley 1999a: 114)

Wadley further maintains that understanding the dual character of Hindu female's essential nature (namely, power and nature) provides the backdrop for understanding the rules and role models for women in Hindu society. 'A central theme of the norms and guidelines for proper female behaviour . . . is that men must control women and their power. . . . [T]he dual character of the female Hindu emerges definitely, and is seen most clearly in the roles of the wife (good, benevolent, dutiful, controlled) and mother (fertile, but dangerous, uncontrolled)' (Wadley 1999a: 116f).

While the wifely role is pre-eminent in Hinduism, the most critical other female role is the woman as mother. The norms for mothers are more implicit than those for wives, and in contrast to the 'good wife', there is no prime example for the 'good mother'. But it is the goddess as mother, rather than as wife, who is the guardian of the village, and the mother is the topic in many folklore and vernacular traditions.

Concerning religious activity, Wadley shows that Hindu women have a considerable involvement, even though mainly as 'non-specialists' who are not visible because most of their observances take place in the domestic sphere. Women's religious role is also not textually sanctioned, but if one looks at the actual folk religious practice, women and low-caste men are the prime actors. Women alone perform numerous yearly calendrical rituals and also many life-cycle rites, most being part of the 'little' tradition. This observation holds very much for rural Orissa where women tend to be religiously very involved. Thus, besides a sexual division of labour and the existence in different worlds—*purdah* being the symbol for this, there is also a religious division of labour between the sexes in Hindu India.

Summing up, one can find a deep-seated fear of women aligned with recognition of their power in Hinduism. Analysing Indira Gandhi's role as prime minister, Wadley proposes that the powerful position held by a woman was not a contradiction to most Indians. Indira Gandhi—the epitome of the independent woman politician—was seen as the mother goddess, also portrayed as riding a tiger, like the goddess Durga.[52] Thus, Indira Gandhi's active and powerful role could be accepted in Hindu cultural terms, much more than we could expect from a Western perspective. 'Thus, Hindu beliefs about the nature of the female and corresponding religious role models (but not the ideal type—the wife), do contain an ideology that can and seemingly

[52] A further article by Susan Wadley on a 'Village Indira' (Wadley 1999b) captures the symbolic relevance of Indira Gandhi as a woman politician.

does provide a meaningful code for women actively involved in non-wifely roles' (Wadley 1999a: 128).[53]

In the following study we will see that so far the role model of the mother has not been applied to the women who became active in rural politics in Orissa. It is much more the wifely model that is employed which leads to specific problems for the women concerned. If the elected women act according to the ordained ideal of the chaste wife, they are blamed for being ineffective in their political role. If they dare to act otherwise, they are chastened for 'unwomanly' behaviour and become victims of character assassination. This dilemma is not easily resolved but is without doubt a major obstacle for women's role in politics and will be discussed in greater detail in Chapter 6. Let us now turn to the cultural context for women in Orissa.

While describing women's socio-cultural status, I will pay attention to its change during a woman's life-cycle, which holds for most castes in Orissa.[54] As will be discussed in greater detail later, Orissa is placed in the border-region between north and south India, between the Aryan and Dravidian culture. However, Orissa has become more and more 'Aryanized' in its social practices, being visible in customs like patrilocal marriage, patrilineal descent and inheritance, dowry, no widow remarriage, etc. (Berreman 1993: 368).[55] Furthermore, the case study is located in non-tribal Orissa, which was always more influenced by the Aryan kinship model and similar role models and myths are *en vogue* like in the rest of north India. Sita and Sabitri[56] are the female role models to be emulated and during my field research I did not come across specifically Oriya female role models. There are female village deities, but many villages do have temples where Jagannath, the omnipresent god of Orissa is worshipped.[57]

As in the rest of north India, and in patriarchal societies in general, also in non-tribal Orissa too sons are favoured over daughters. As reasons for this

[53] It appears that women in India who occupy powerful roles have actually more potential for acceptance than powerful women in the West. See for example, Margaret Thatcher, the 'iron lady', who was criticized for her 'unwomanly' behaviour. However, as mentioned, the powerful woman as epitomized by Indira Gandhi is not an ideal to emulate. Such a female role is not actually promoted by Indian society, but is approved when it is a matter of fact. One could speculate, on the other hand, that control over females is even more rigid in India than in the West exactly because of the potential danger powerful women pose to the predominant wifely ideal.

[54] For women's status in Orissa in a historical perspective, see Nayak (1999), who gives a very detailed account. Her rather well researched work stands in stark contrast to the mediocre book by Barai (1994).

[55] Compare for this also Agnihotri (2000: 172–209). He sees Orissa as a case of not full integration into the Aryan 'male-centred' kinship system, which is recognizable by the large number of tribals. However, if one sets aside the tribal regions of Orissa, the coastal and 'Oriyanized' areas show definite signs of progressing 'Aryanization', although the situation is still not as 'male-centred' as in the Hindi-belt.

[56] In Orissa, 'v' is normally pronounced as 'b'.

[57] For the cult of Jagannath and the regional tradition in Orissa, see Eschmann (1978).

Altekar states that from ancient times the son was a permanent economic asset to the family, whereas the daughter migrated to her in-laws; that a son perpetuated the name of his father's family; that he offered co-operation to his family in the case of warfare; and that sons alone were regarded as eligible for offering oblations to the ancestors during the *shraaddha* ceremony (Altekar 1991: 3f).[58] Today, the practice of distributing sweets when a son is born is still found in Oriya villages, whereas nothing happens for a girl. Many rituals are performed for the birth of a son or for the well-being of the sons and the husband, but there are no rituals for the well-being of the daughter. During my second field research in 2000 I had the chance to observe the *Mangalvara-Puja* in a village in Gania block. Mothers perform this *puja* to secure the well-being of their sons. It took place on several Tuesdays in January/February, since a mother has to perform a *puja* for every son separately. All village women donned their best saris and went with coconuts, vermilion, fruits, jaggery, and money to sacrifice them in a ceremony that took place outside the village at a road crossing. It was a very important event for the village women.

This preference for sons can also be seen in the fact that most families aspire to beget at least two sons. The medical officer of Gania Primary Health Centre said 'Sterilisation, if done at all, usually takes place after the birth of three or four children, or after the second son has been born. Families still aspire for two sons. They believe that having one son is like having only one eye: If this is lost, one is blind, thus, it is better to have two eyes' (personal communication, 6 February 2000). Also the sarpanch of Gania voiced her dismay that she has given birth to two daughters only, and has no son to perform her last rites and care for her when she will be old.

Still, daughters are normally treated very affectionately by their parents, and often grow up in the happy security of their home. Before marriage the young girl is the *gaanjhia*, the daughter of the village. She can move freely as a child, can have social intercourse with the village boys, and can often be assured of affection from her extended family. Still, girls are often treated not as well as boys, who are normally better fed, get more health-care, and education. One reason for this is the fact that in patrilocal societies girls will leave the family and take part of the family wealth with them as dowry. This is amply put by the following Oriya proverb: '*Jhia, ghia para patarare dia*' which translates as 'daughters and ghee [you have in order to] put on other people's plates'.[59]

While growing up, girls learn that they should segregate from males who do not belong to their family. Most village girls are usually taken out of school—if they attend one at all—before they reach puberty. They are then trained to become good daughters-in-law. Moving around freely is now considered bad behaviour, and is attributed as low social status. A decent girl does not do this, and if she dares to do so, she has to fear for character

[58] For the rite of *shraaddha*, see Basham (1991: 157).
[59] I am grateful to Subrata K. Mitra for mentioning this proverb to me.

assassination. Girls and women are hardly seen travelling alone, and a village woman of good mores should only travel when she has an approved purpose to do so. However, she is still relatively free to move around in her native village and have social intercourse with fellow villagers, as compared to the restriction on a woman's mobility when she leaves her native village to marry, which is the usual practice in patrilocal and village-exogamous marriage patterns. This cultural concept of *gaanjhia* versus *bahu* in regard to mobility and social intercourse was found to have a specific impact on the election process in the PRI as we will see later.

Earlier, women were often married before reaching puberty so that the parents could be on the safe side. Usually the marriage was not consummated before the girl reached puberty, and nowadays the age of marriage tends to rise.[60] An unmarried girl is considered to be a disgrace and danger to the family, and most women in Orissa would consider it as very bad fate not to be married when they are in the respective age. Free choice of the partner is rare, and girls are often not consulted for the selection of the groom.[61]

When a woman marries her status changes tremendously; wearing sindoor, bangles, and the sari signifies her new status. High-status women in rural Orissa may also stop eating chicken and egg after marriage. Hence, food intake for women is often less than for men, and certain nutritious foodstuffs are denied to them after marriage. Also some women only eat after they have served the husband and the other family members.[62] The life of the husband, on the other hand, does not change much and there is nothing that outwardly signifies his married state. Apart from some religious festivals, he is not required to take a special diet. Frequent dieting by women, on the other hand, is very common. Women are involved in different rituals, which are, as mentioned above, mostly performed at home. Most of the *pujas* imply certain dietary regulations and so women often fast more than three days out of a month. I interviewed many women who were fasting at that time for one or other reason: women fast when their children go astray, for the health of their husbands, and for the general well-being of their family.[63]

[60] In 1971, the mean age of marriage for girls in Orissa was 17.29 years and for males 22.57 years, whereas in 1981 it was 19.04 years and 24.17 years respectively (Agarwala 1985: 224). The women I interviewed more intimately married when they were between 13 and 18 years of age.

[61] In a survey on the 'Status of Women in Orissa' conducted by the Xavier Institute of Management (XIM), Bhubaneswar in various districts, the team found that in Khurda District (where Balipatna block is situated) 85.2 per cent of the women were not free to select their mate, out of which 86.2 per cent were also not consulted by their parents (XIM 1996a: 58). In Nayagarh (where Gania is situated), 90.1 per cent had no say in the selection of the husband, and 84.4 per cent were not even consulted (XIM 1996b: 57).

[62] In Khurda, 42.5 per cent women do not take their meal with the other family members, out of which 96.4 per cent take their food after them (XIM 1996a: 73). In Nayagarh, 41.6 per cent women do not take their meal with the family members, out of which 96.1 per cent take it later (XIM 1996b: 72).

[63] The prevalence of dieting is also mentioned to be very high in XIM (1996a: 73) and XIM (1996b: 72).

The greatest change in the life of the young married woman, besides the ones described above, is that she will leave her parental family to move in with her in-laws, into a house of strangers, which was found in the study region to be up to 15 km away from her native place. She leaves back her secure home and mostly her right to inherit her ancestral land. It is well known that though the daughter has inheritance rights to landed property, she might forfeit it, since especially in patrilocal and village-exogamous marriage patterns it is difficult for her to care for this land when she is too far away.[64] She often does not want to sour the relations with her brothers, who might be her only refuge if the marriage turns bad. Hence, though legislation on inheritance state otherwise (see *Hindu Succession Act 1956*), most women have still no land in their name. This has serious consequences for women's autonomy, since they remain economically dependent on others.[65]

In the new village she is the young *bahu* and is not allowed to meet her elder brother-in-law, or the brothers of the father-in-law, except when she is veiled. Since in the countryside of Orissa many other respected persons get addressed with uncle or other relational nouns, these restrictions also hold for the social intercourse with them.[66] This obviously curtails female mobility to a major degree and thus impinges on women's political work as we will see later. It is a cultural trait that is applicable to all rural women across caste and class affiliations though SCs and women from lower social and economic background are less inhibited. But they too face restrictions on their mobility and are not completely free to decide about their movements. Thus it is safe to claim that nearly all women in the countryside are limited in their movements and have no right to loiter in the public.

The *bahu* becomes a member of her husband's lineage, and is considered auspicious (*sumangal*), because she lives together with a husband. Her relationship to the mother-in-law or her husband's sisters is often strained, and frequently women told me that they looked forward to visiting their natal family. A young *bahu* is given the most arduous household tasks, ridiculed when she does not fulfil them properly, and she is only allowed to venture out of the house with a purpose and has to cover her face with the end of her sari. Kakar explains this treatment and the husband-wife relationship as follows:

[64] Since marriage patterns prove to be quite decisive, it is important to mention that in coastal Orissa the marriage pattern appears mainly patrilocal and village-exogamous. Though Agarwal (1994: 327) has classified Orissa as allowing village endogamous marriages, she cites only evidence from tribal Orissa. As we shall see, village endogamy is also practised in the study region, but to a very minor degree.

[65] For the tremendous significance to have landed property in the name of women, see Agarwal (1994). For flaws in the legal position, i.e. in the *Hindu Succession Act*, see ibid: 215-23.

[66] Compare this with the observations made by Jacobson (1999: 35) in a north Indian village, where the social practice was exactly the same. Also her other extremely interesting ethnographic accounts from north and central India resemble very much the situation found in Orissa.

[T]he new bride constitutes a very real threat to the unity of the extended family. She represents a potentially pernicious influence which, given family priorities, calls for drastic measures of exorcism. The nature of 'danger' can perhaps be best suggested by such questions as: Will the young wife cause her husband to neglect his duties as son? As a brother? . . . Will social tradition and family pressure be sufficient to keep the husband–wife bond from developing to a point where it threatens the interests of other family members? . . . Any signs of a developing attachment and tenderness between the couple are actively discouraged by the elder family members by either belittling or forbidding the open expression of these feelings. (1988: 63)

The harsh treatment towards young daughters-in-law is also partly due to the practice of dowry. In Orissa, the bride's family pays dowry, and expectations can be very high, depending on the position of the husband. The contemporary payment of dowry can be seen as a further indication of the 'Aryanization' of Oriya society. Earlier the practice of bride price seems to have been common—at least among Brahmins—since it is the topic of the short story 'The Bride-Price' by Fakir Mohan Senapati (1998).[67] As regards dowry today, the medical officer in Gania stated:

The system of dowry is prevalent here, but the sums are not as high as for example in Rajasthan. However, relatively speaking it is quite substantial. Like an IAS officer will ask for 5 lakh, and even among the SC-communities it will be around Rs. 5000, which can easily be the cash-income of one year. Dowry deaths occur here, but the statistics may report too high. The rule laid down by the Government of India is that every death of a daughter-in-law in the house of the in-laws up to seven years after marriage will be treated as a dowry death if the parents of the woman file a case. However, the death might also be due to other reasons, like jealousy etc. The main problem of dowry is that the parents of the bride commit something at the wedding, but do not give it later. (personal communication, 6 February 2000)[68]

The inability to keep the promise often leads to so-called dowry torture, even though it might not result in the death of the woman. In my presence no woman complained of dowry torture, but it was found by the study group of the Xavier's Institute of Management, that 42.1 per cent of women in Nayagarh experienced torture at the hands of the in-laws (XIM 1996b: 59), and in Khurda 36.1 per cent of the women mentioned such incidences (XIM 1996a: 61).

In rural Orissa, chastity and fidelity of the wife, following the role model of Sita, are considered to be the ideal, even though adultery or illicit relationships are not really uncommon. However, blame always falls on the family of the woman. There was, for example, a case in a neighbouring village, where a girl eloped with a married man. The village imposed social boycott on the family of the girl, called *basanda* or *ekgharkiya* (the single house) in Oriya. No villager is allowed to speak to this family and whoever defies this rule will get fined Rs. 500. It is not possible in an Indian village to

[67] Fakir Mohan Senapati (1843–1918) tells the story of a greedy Brahmin who was asking such a high bride-price for his daughter that nobody was willing to pay.

[68] For individual case studies of dowry torture and also on rape in Orissa, see Pati (1993b).

survive without the cooperation of your neighbours, and it is also not easy to move to another village. In order to be taken back into the village community, the villagers asked the family to pay Rs. 15,000—a very big amount for a family of agricultural labourers. As a consequence, women are guarded very closely. As in north India in general, many persons in Orissa told me that the '*jhia* (daughter) and *bahu* are the *izzat* (honour) of the family'. If they go astray, the whole family has to suffer. They are thus prevented from going alone and may only leave the house for necessary tasks like drawing water, fetching fuel, or tending the cattle. The situation is different for women earning money outside the home, mainly those who come from poor families or SC-households. Yet, they also normally go back home as soon as their work is finished. There is hardly any public space for women to talk about their problems, apart from areas where they go together to the water-tank to bath or to a well to draw water. But modernization and developmental efforts have ensured that now often tubewells are in the vicinity of the house, and the better-off families have their own wells. As the *bahu* is isolated by restrictions on her movement, she is also unable to visit her neighbours freely and it is difficult for her to form friendships even with women in her husband's village. Her only confidante in the new village is often her husband's younger brother.

A tremendous change in the wife's position among her in-laws takes place when she becomes pregnant. She is fed better now, the women of the household treat her well, and often the bride returns to the emotional security of her natal family a few month's before her delivery. 'This unambiguous reversal in an Indian women's status is not lost on her; moreover, the belief that pregnancy is a woman's ultimate good fortune, a belief that amounts to a cultural reverence for the pregnant woman, is abundantly broadcast in the favourite folk-tales and familiar myths of Hindu tradition' (Kakar 1988: 66).

While becoming a mother and getting older, the restrictions on the woman's activities diminish, but not until she is very mature and becomes a senior woman in her household is she free to visit her neighbours or attend social functions and work outside according to her wishes. The relationship between the partners also gradually changes. Generally speaking, her relation to the husband is marked by reverence towards him, and, in particular, in the areas of the case study women do not address their husbands by name.[69] The title for husband used in Oriya is 'swami', literally master. Many women have imbibed the cultural values of being a dutiful wife towards their husband—to be a real *pativrata*. As noted earlier, an intimate relationship between husband and wife is normally curbed by the in-laws, and develops only later in married life.

[69] I interviewed a woman whose husband's name was the same as the name of the MLA I was asking her for. She was quite distressed, because even though she knew the name of the politician, she could not utter it. Finally she nodded at her husband and looked at me, hoping for my understanding. My assistant finally explained her behaviour to me. See for this practice, Rajan (1993: 83–102).

Ideally, parenthood and the shared responsibility for the offspring provide the basis for intimacy, rather than the other way around in the West. This postponement of intimacy is encouraged by the family, for in the years of middle age the husband–wife bond no longer seems to threaten the exclusion of other family members, but incorporates or rather evolves out of the responsibility to take care of the next generation. Thus, it is not antithetical to communal and family solidarity, but, in its proper time, a guarantor of it. (Kakar 1988: 64)

The woman's status changes again tremendously when she becomes a widow. Whereas the married woman is auspicious, the widow is most inauspicious and is somehow made responsible for outliving her husband. She is not allowed to wear colourful saris, jewellery, and is also not invited to religious functions. Very few widows are economically independent and they often have to endure harsh treatment by the very family they are dependent upon.[70] An old widow selling vegetables frequented the household where I lived, even though she was very frail and trembling from age. She told me that her son regards her as a liability, and in order to evade his criticism she tries to contribute some money to the household. Another widow from a neighbouring house also came quite often, sometimes weeping, because her son did not treat her well and even beat her up. However, these widows do not have many opportunities to change their fate, and widow remarriage is not very frequent.

The status of a woman clearly changes in the course of her life-cycle. Still, for most stages of life a woman experiences that she is less welcome than a son, that she has less freedom and opportunities, and that she often has to bear a greater burden than males. How does this socio-cultural status affect the self-perception of women and the gender-relations? The answer to this question is very important for estimating in what kind of psychological framework the empowerment of women can take place.

Kakar argues that as in other patriarchal societies one would expect the preference for sons and cultural devaluation to be reflected in the psychology of Indian women (Kakar 1988: 48). It could lead one to conclude that this kind of inequity would lead to heightened female hostility towards males, or in case the resentment could not be shown to men, to redirect this hostility against male children. However, in India it is found that aggression occurring between members of the same sex is significantly greater than with members of opposite sex. As a third possibility, Kakar proposes that girls and women will turn the aggression against themselves and imbibe feelings of worthlessness and inferiority because of the cultural depreciation in a patriarchal social environment. That feeling of inferiority is what has been labelled before as 'internalized oppression'. This pattern does exist in India but is at least partly mitigated by two factors.

[70] XIM (1996a: 69) mentions that 80 per cent of the widows are economically dependent, mainly on their sons, in Khurda, and XIM (1996b: 68) gives the dependence of widows in Nayagarh as 58.8 per cent.

In the first place, for the cultural devaluation of women to be translated into a pervasive psychological sense of worthlessness in individual women, parent's and other adult's behaviour and attitudes towards the infant girl in their midst—the actualities of family life—must be fully consistent with this female depreciation. Secondly, the internalization of low self-esteem also presupposes that girls and women have no sphere on their own, no independent livelihood and activity, no area of family and community responsibility and dominance, no living space apart from that of men, within which to create and manifest those aspects of feminine identity that derive from intimacy and collaboration with other women. (Kakar 1988: 49)

Both these conditions do not exist in India, where many adults of their natal household treat girls affectionately and where women do have a specific female sphere of their own. However, even if women might not internalize a general feeling of low self-esteem it seems quite likely that many girls and women internalize their worthlessness and lack of capabilities to perform in the public sphere, especially if they follow the wifely role model offered to them. In my view, they are also likely to internalize that they are dependent on their husband, and that their worth depends on him and on producing preferably male offspring. The question remains as to why more aggression is levelled against the own sex, as Kakar found, and not against men.

Quite enlightening in this respect is Chitnis (1988), who gives a personal account of how she experiences the difference between Western feminism and the Indian women's point of view. She draws attention to the differing social and ideological context. Even though gender discrimination in India might be even more severe than in the West, it takes place in a very different setting. Chitnis sees three areas where a large number of Indian women seem to diverge from those of the Western-influenced feminists: 'By far the most conspicuous of these is the average Indian women's disapproval of feminist anger. The second is their somewhat mixed and confused reaction to the feminist emphasis on patriarchy, and particularly on men as the principal oppressors. The third is their relative inability to tune in to the demands for equality and personal freedom' (1988: 82).

The anger of Western feminism, Chitnis argues, is rooted in the hypocrisy of the respective culture that accords centrality to the value of equality and individual freedom but denies equality to women. The situation in India is different to the extent that it has always been highly hierarchical. But '[t]he harshness and oppressiveness of all these hierarchies [in the family or community] is somewhat relieved by a strong sense of deference to superiors, a sense of mutuality, a series of behavioural codes which bend superiors to fulfil their obligations to their inferiors and, above all, by a philosophy of self-denial, and the cultural emphasis on sublimating the ego' (Chitnis 1988: 83).

The concept of equality was introduced to India via Western education, and when it was accepted, it granted equality to women and men alike at the point of drafting the Constitution. Thus, women in India have not had the experience of the need to bridge the gap between a proclaimed ideal and contrary state action. The women's cause was also largely taken up by men

in India, like Rammohun Roy, Phule, or Ranade, who tried to abolish practices detrimental to women and promoted female education. Also, Gandhi declared that the equality of women should be central to his political programme and stressed the moral power of women (*stree shakti*). This could be communicated to the masses because of the above mentioned concept in Hinduism of female power, which also stresses the complementarities of male and female, at least in the version of the role model of wifely devotion.

As equality between the sexes and the promotion of marginalized social groups became ingrained in the state policy (even though implementation often lags behind), Chitnis argues that women in India do not feel, as compared to Western women, that they have been neglected by the state. Chitnis sees the main problem in the fact that women in India do not really use the favourable legal situation: She believes that this is due to non-awareness of these rights, the remoteness of bureaucracy, and women's low level of political awareness and sense of political efficacy (1988: 89). The main problem, however, is seen in the value system by which women abide. 'Women are conditioned to revere the father, and to serve the husband as a devotee serves God. Devotion of the husband is cultivated among girls of all religions, but it is particularly idealized and firmly institutionalized in the Hindu concept of *pativrata*.' (1988: 90). Thus, Chitnis argues that the problem is not that women do not have rights in India, but that they do not use them for several reasons.

However, apart from unawareness or 'internalized oppression', a big hurdle lies also in the fact that the favourable legal position is seldom implemented. Martha Nussbaum (2000: 54) rightly argues that '[a]ll women in India have equal rights under the Constitution; but in the absence of effective enforcement of laws against rape and Supreme Court guidelines on sexual harassment, and in the absence of programs targeted at increasing female literacy, economic empowerment, and employment opportunities, those rights are not real to them'. Since women have not been empowered in the above named areas, they hardly have fall-back options and a rather weak bargaining position to claim their rights, even if they were aware of them.

Still, Chitnis makes another interesting point. She argues that the feminist message misses the mark when it names men as oppressors. She believes that the mass of Indian women is unlikely to make the distinction between sorrow and oppression. Sorrow is there, and it is experienced among others as hunger, poverty, or free use of their bodies through powerful landlords. They also experience it as the impotence of their husbands or other male kin to protect them if this happens. The author thus proposes that feminists must make a special effort to indicate how sorrow is compounded by oppression. The second point is that even though Indian society is undeniably patriarchal, patriarchy is only one among several hierarchies that oppress women, including hierarchies of age, ordinal status, and relationship by marriage.

Conceptually and analytically some of these may be seen to be mere extensions of patriarchal oppression, but it is important to recognize that they are not experienced

as oppression by male. Most women in India experience family violence as the cruelty of the mother-in-law or the husband's sisters. . . . Even in cases in which the husband has been held guilty of a crime against his wife, the victims have generally named his mother or sisters as abettors. (Chitnis 1988: 92)

As also mentioned above, men in Indian history have often stood out as facilitators for the advancement of women, and many women who have managed to come forward and enter male spheres were mainly supported or actively helped by a husband, father, or brother. Additionally, the young *bahu* in the new household has sometimes only the younger brother of her husband as confidante, not the sister. Thus, she experiences males not necessarily as oppressors, but often as supporters as well.

Chitnis' final point is that the very aggressiveness of Western feminism and the criticism towards males strikes a discordant note in the Indian ethos. She believes that this is rooted in the difference in which contradictions and conflicts are dealt with in the two cultures. 'In the West there is a compulsion for a logical resolution of conflict to confrontation and categorical choice. In contrast, the Indian culture places greater value of compromise on the capacity to live with contradictions and to balance conflicting alternatives' (Chitnis 1988: 93). Thus, in order to promote the status of women in India she proposes to co-opt men for the movement of women's empowerment. It remains a moot point as to how far men really wish to become co-opted in this movement, since they might perceive a threat from women's empowerment—as we could see in the introductory quote. One also wonders, considering the present value system, if women and men will actually work together for women's emancipation and a different relationship between the genders.

Ashis Nandy, for example, proposes that the mother-son relationship is the basic nexus of gender-relations in India, whereas the conjugal one is less important. This fact has led him to conclude that '[t]o make the issues of emancipation of woman and equality of sexes primary, one needs a culture in which conjugality is central to male-female relationships. One seeks emancipation from and equality with one's husband and peers, not with one's son. If the conjugal relationship itself remains relatively peripheral, the issues of emancipation and equality must remain so too' (Nandy 1980: 41).

All the issues mentioned above will be examined with respect to how far they impinge on women's empowerment through political presence in the PRI in the case study. But first I shall show how the cultural framework described above translates itself into macro-social indicators for the status of women in Orissa.

Macro-Social Indicators for Women's Status in Orissa

The status of women in Orissa can also be exemplified through macro-social indicators, like sex-ratio, life expectancy, or participation in the workforce. For some indicators the relative position of Orissa in comparison with that of India as a whole will be given.[71]

As regards the sex-ratio one might expect that the proportion of women to

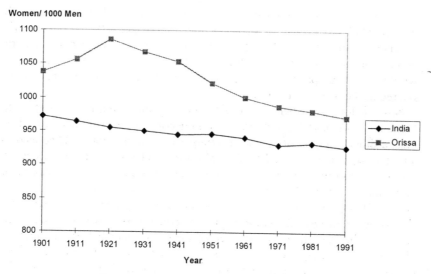

FIG. 2.3: Sex-ratio in India and Orissa (1901–91).

TABLE 2.1: SEX-RATIO IN INDIA AND ORISSA (1901–91)

Year	1901	1911	1921	1931	1941	1951	1961	1971	1981	1991
India	972	964	955	950	945	946	941	930	934	929
Orissa	1037	1056	1086	1067	1053	1022	1001	988	981	972

Source: Director of Census Operation, Orissa (1991: 13f.).

men in the population should be roughly equal; however, empirically this is not the case everywhere. Several factors work in the direction of a higher proportion of females. In the industrial market economies these factors have resulted in ratios of about 95 to 97 males per 100 females.[72] In case there are no other dominant sex-specific features like war or migration, a female/male ratio significantly below 100 can be interpreted as reflecting the effects of discrimination against women. There is evidence that the low female/male ratio is due to a higher female to male mortality (Visaria 1971), which is in turn an effect of discrimination against females in terms of nutrition or health care (Miller 1981).

With two exceptions there was a steady decline in the Indian sex-ratio, and it was unfavourable for women right from the beginning. In Orissa, the sex-ratio was initially favourable to women, reaching its peak in 1921, and was then steadily declining and becoming unfavourable for women from the

[71] For a broad-based assessment of the present status of women in Orissa, see Mohanty, Bedabati (1996). The quality of the chapters is not always satisfying, but many issues like economic, political, and social status are touched upon.

[72] For a discussion on the sex-ratio, see Momsen (1991: 7–27), Drèze and Sen (1999: 140–78), and for latest insights, Agnihotri (2000).

1960s onwards. However, one has to mention the fact that an unnaturally high female/male ratio is actually an indicator of poverty, since in health-adverse environments male infant mortality tends to be higher than female infant mortality (Agnihotri 2000: 127ff.). Thus, a 'healthy' female/male ratio would be around parity, and major deviations to both sides should be considered as a cause for concern.

Nevertheless, it is obvious that also in Orissa more and more women are 'missing' in the last decades, and it is quite convincing that this trend does indeed show a neglect of females as compared to males and could be seen as a further sign of the spread of 'Aryan' kinship culture. There are, however, significant internal differences between the districts in Orissa, where, in particular, the tribal districts normally have a sex-ratio where women are in excess. This pattern can partly be explained through working migration, where men migrate to the more prosperous coastal areas, urban centres, and areas of industrialization, leaving behind their wives and children in the poor hilly districts.[73] However, as mentioned above it is also an indicator of the neglect of tribal development and the stark poverty that exists there. The coastal districts, in contrast, show a sex-ratio that starkly favours men and thus indicates the discrimination of women.

The adverse environment for women's health can also be seen in another indicator, namely, life expectancy, which in most industrialized countries is higher for women than for men. In India too, women do outlive men nowadays (59.1 years for women *v.* 58.1 years for men in 1988–91). In contrast, men enjoy a longer life than women in Orissa and the life expectancy figures for the same period are 57.13 years for men and 55.15 years for women (EPW Research Foundation 1994: 1304).

Education is another important indicator of the status women occupy in a society, and it is also important for their participation in public life. Orissa is one of the educationally backward states of India. The combined literacy rate in 1991 was 48.55 per cent, placing Orissa at rank 18 out of the 25 states of the Indian Union (EPW Research Foundation 1994: 1305).[74] Literacy of males was 62.37 per cent (rank 17) and 34.4 per cent for females (rank 19) in 1991 (ibid.).[75] The lower literacy for women is due to lesser school enrolment and higher dropout rates of girls.[76] The development of

[73] For the development of the sex-ratio in the various districts of Orissa during 1941–91, see Senapati (1993: 27); for the effect of urbanization and industrialization responsible for male migration, see ibid.: 28f.

[74] Lower combined literacy rates are only found in Andhra Pradesh, Arunachal Pradesh, Bihar, Madhya Pradesh, Meghalaya, Rajasthan, and Uttar Pradesh.

[75] Only Andhra Pradesh, Arunachal Pradesh, Bihar, Madhya Pradesh, Rajasthan, and Uttar Pradesh have lower female literacy rates.

[76] For the exact figures and the development from 1978 to 1986, see Pandey (1992: 31). For the different enrolment figures of boys and girls for the years 1983–4 till 1991–2, see Rath (1995: 6), and for the dropout rates for 1990–1 till 1992–3, Rath (1995: 8). The latter table indicates that dropout-rates for girls are around 50 per cent in primary school, and around 75 per cent for middle school; for boys it is around 43 per cent and 69 per cent, respectively.

literacy rates shows that in 1961 female literacy in Orissa was nearly nil (0.86 per cent) and then has been rising proportionally to the female literacy in India as a whole, but has remained always lower (34.4 per cent in Orissa *v.* 39.42 per cent in India as a whole in 1991). The literacy rate for males in Orissa, starting from 24.7 per cent in 1961 reached 62.37 per cent in 1991, which is only slightly below India as a whole at 63.86 per cent (EPW Research Foundation 1994: 1304). Thus, whereas in average 9.41 per cent literates per decade were added to the males, it was only 8.38 per cent for females

Concerning economic indicators, Orissa is one of the poorest states of the Indian Union. In terms of per capita income (Rs. 3028 per annum) and persons below poverty line (55 per cent), Orissa was even ranked as poorest in 1996 (Haq 1997: 32). With regard to women's status, the relevant economic indicators are their participation in the workforce, their wage earnings as compared to men, and their share of earned income. The distribution for India and Orissa is given in Table 2.2.

Women make up a much lower portion of the measured economically active population and their wage earnings are also considerably less than those of men. The contrast between the Rupees earned per hour for women *v.* men is sharper in Orissa than in India as a whole, and in all other indicators women's status is less in Orissa than in India as a whole.

With respect to gender-sensitive development indices, the Gender Development Index (GDI) as used by the UNDP (which is calculated from the share of earned income, life expectancy at birth, and adult literacy rates) for Orissa is 0.329 only (Kumar 1996: 892).[77] Alternative indicators for development in respect to gender have also been developed, in which Orissa is always ranked very poorly. Hiraway and Mahadevia (1996) have computed alternative indices, using 33 variables for their GDM-1 Index, and 14 variables for their GDM-2 Index. In GDM-1, Orissa ranks lowest out of the 15 states of the sample, and in GDM-2 it ranks 12. In an Empowerment Index, which is composed out of women's political activities and atrocities committed against them, Orissa is ranked 13 out of 15 Indian states (Hiraway and Mahadevia 1996: WS-92). This low Empowerment Index can be

TABLE 2.2: ECONOMIC INDICATORS OF WOMEN'S STATUS IN INDIA AND ORISSA

	Share of economically active population (1991) (per cent)		Regular non-agricultural wage rate earnings per day (1987–88) (Rs)		Share of earned income (per cent)	
	Female	Male	Female	Male	Female	Male
Orissa	0.273	0.727	19.43	30.87	0.191	0.809
India	0.286	0.714	26.28	34.90	0.232	0.768

Source: Data taken from Parts of Table 4 in Kumar (1996: 891).

[77] The higher the index, the better is the status. Kerala, for example, scores 0.565 and India as a whole 0.388. If one places Orissa in a world scale of 130 countries, it occupies rank 109 (comparable to Sudan), while Kerala occupies rank 72 (comparable to the Syrian Arab Republic), and India as a whole ranks 99 (Kumar 1996: 893).

TABLE 2.3: VOTES CAST IN THE ASSEMBLY ELECTIONS OF ORISSA (1967–80)

Year	Votes polled (per cent)	
	male	female
1967	28.13	15.83
1971	27.14	16.19
1974	30.56	21.34
1977	25.27	16.11
1980	28.43	18.53

Source: Table 12 in Rath (1995: 17).

understood better if one turns to women's political participation, which forms one part of this index.

The political status of women can be measured with their participation in institutional state politics, such as exercising their vote and serving in political bodies.[78]

Women exercise their voting right to a much lesser degree than men, and the percentage of votes polled in the Legislative Assembly elections is quite low for both sexes. The participation of women increased over time, reaching its peak in the 1974 election, and then went down again (see Table 2.3). However, the overall disparity between men and women has been decreasing over time as well. More political involvement than just casting a vote is needed for participating in electoral politics as candidates.

Table 2.4 shows that women's participation as candidates is abysmally low in Orissa state politics, and the highest proportion of women candidates was reached in the 1957 election with 2.95 per cent. Thus, female participation in high-level politics is considerably lower than male participation. How successful were the women candidates in getting elected to office?

Women's participation in the Legislative Assembly in Orissa is very low, reaching its peak in 1985 and 1990 with more than 5 per cent. The average percentage of representation from 1952 to 1990 is 3.52 per cent (Table 2.5). For comparison, the average proportion of women legislators in the Lok Sabha from 1952 to 1998 is 5.91 per cent.[79] It is interesting to note, on the other hand, that the success rate of women to get elected is very high. In the first election, 3 out of 4 women candidates were elected, and apart from the 1971 and 1974 elections, their success-rate was always very substantial. This indicates that while the general participation of women in institutional politics at the state level is very low, the population does indeed elect women if given the choice.

[78] There are not many accounts on women in politics in Orissa. For recent qualitative studies on women and politics in Orissa see Panda (1990, 1992, 1995a); for information on women in the freedom struggle in Orissa, see J. Mohanty (1996); for issues introduced by women legislators during British Rule, see Raju (1996); and for the social background of women members in the Orissa Legislative Assembly during 1937–85, see Devi (1986).

[79] For the number of women MPs in the Lok Sabha from 1951 till 1998, see Table 1 provided by Narayan et al. (2000). For the political profile of women in the national parties, see Roy (1999).

TABLE 2.4: MALE AND FEMALE CANDIDATES IN THE ORISSA ASSEMBLY ELECTIONS (1952–80)

Year of election	Total female candidates	Total male candidates	Women candidates as percentage of total candidates
1952	4	433	0.92
1957	15	493	2.95
1961	10	523	1.88
1967	11	592	1.83
1971	12	823	1.44
1974	15	710	2.07
1977	17	587	2.81
1980	16	720	2.17

Source: For figures in rows (1) and (2), see Rath (1995: 18); proportional calculations are mine.

Note: Rath provides us with a calculation of the proportion of female to male candidates. I could not figure out the mathematical procedure through which she arrived at the figures given. Compare the figures provided here with the ones given by Parija et al. (1988: 407), which vary considerably. As the latter authors do not give their source, I rely on Rath, who has consulted the Home (Election) Reports issued by the Government of Orissa for the various elections. By-elections have not been taken into account.

TABLE 2.5: NUMBER OF WOMEN LEGISLATORS IN THE ORISSA ASSEMBLY (1952–90)

Year	No. of women legislators	Percentage of total strength of the house	Success-rate (proportion of women legislators to candidates) (per cent)
1952	3	2.14	75.0
1957	5	3.57	33.3
1961	5	3.57	50.0
1967	5	3.57	45.5
1971	1	0.71	8.3
1974	4	2.71	26.7
1977	7	4.76	41.2
1980	5	3.40	31.3
1985	8	5.44	N.A.
1990	8	5.44	N.A.

Source: For rows (1) and (2), see Das (1994: 5). Row (3) was calculated by me.

Note: The strength of the house was 140 legislators till the 1971 election, and from 1974 onwards 147. Compare again with Parija et al. (1988: 407), who give different figures in two incidents: for the year 1961 they give only one women legislator, and in 1972 Nandini Satpathy was elected in a by-election and became Chief Minister. She was incorporated in this table for the 1971 Assembly.

Another important question is whether the elected women are present in the cabinet—in the most important decision-making body. Only two Cabinets were headed by a woman so far (Nandini Sathpathy was Chief Minister in 1972 and 1974), and either no or only one woman was present in the Cabinet, and mostly in the lower rank of a Deputy Minister, apart from the Cabinet of 1985, where one woman was a Minister of State and two were Deputy Ministers (Rath 1995: 20). Women were mainly represented in the Health Ministry, Ministry of Education, and Ministry of Community

Development and Rural Reconstruction (Das 1994: 7f). Apart from state level politics, women of Orissa were only twice present in the Lok Sabha from 1937 to 1990 and only six times in the Rajya Sabha during the same period (Das 1994: 8).

In conclusion, one can say that the status of women in Orissa as seen from macro-social indicators is rather bad in Orissa, and in many areas also considerably lower than in India as a whole. It is certainly fair to argue that Orissa indeed provides a very difficult environment for women's empowerment.

THE LOCAL SETTING

The State of Orissa

It is out of the purview of this study to give a thorough description of the evolution of the state of Orissa and her political history. Some political and institutional developments have already been mentioned in the preceding analysis. Here, I shall be more concerned with a perusal through Orissa's history, focusing mainly on developments after the British conquest in 1803, which is important for comprehending the political situation today. It is also consequential for understanding the structural feature of regionalism in Orissa, which forms the backdrop for the selection of the two study regions. Additionally, the description of the caste-structure in Orissa is provided as important background information for understanding the social processes and the environment in which these processes take place.

Orissa is located in the east of the Indian subcontinent and forms a bridge between north and south India (see Map 2.1). Different Hindu and tribal dynasties ruled here and Orissa was several times invaded and witnessed foreign rule.[80] A territorial dismemberment of Orissa had already begun before the rule of the Mughals, and by the time of Akbar (1556–1605) the territories were organized into five *sarkars*. Those *sarkars* were included in the *subah* of Bengal and were referred to as *Mughalbandi*. The hill territories were known as *Garjats* whose rulers were recognized as Mughal feudatories, and they paid annual tribute to the Emperor. When the Mughal Empire began to disintegrate, Orissa passed under the rule of the Nawabs of Bengal. Frequent raids from the Marathas brought the largest part of Orissa again under their rule (from the mid-eighteenth century until the beginning of the nineteenth century).

In 1803, the East India Company (EIC) conquered the Provinces under Maratha rule—Cuttack, Balasore, and Puri—and subsequently 18 *Garjats* also came under its control. The principal concern of the EIC after the conquest of Orissa was the collection of revenue (Rout 1988: 23 ff.). In 1829, the Orissa District was split up into three Regulation Districts of

[80] For more detailed information, see Mahtab (1960) and Sahu (1956). For Orissa's history from the British conquest in 1803 onwards, see Patra and Devi (1983).

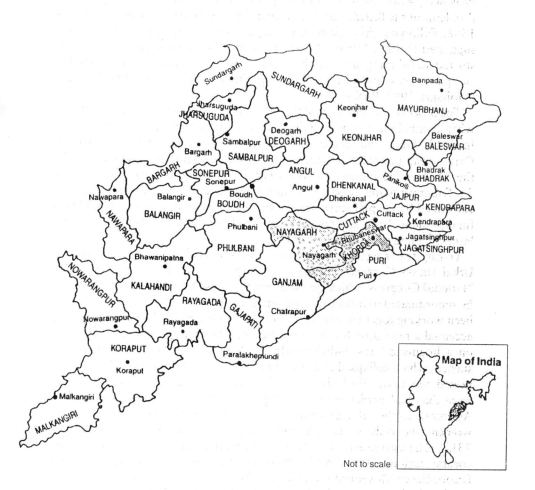

Source: Adapted from Sahu (1997: xxiii).

MAP 2.1: Orissa after the Reorganization of Districts in 1994.

Cuttack, Puri, and Balasore and the 24 non-Regulation Tributary States. These areas, which constituted British Orissa in the nineteenth century, formed a part of the Bengal Presidency. The rest of the Orissa *Garjats* including Sambalpur were placed under the administration of the Central Provinces, while Ganjam and Koraput were under the Madras Presidency. Problems of the British administration led to the catastrophic famine in June 1866. Following this calamity, the separation of Orissa from Bengal was suggested (Mishra 1984: 33). At about this time a national consciousness started developing among the Oriya-speaking elites and a systematic campaign was initiated to bring the Oriyas under one administration (Mohanty 1982; Padhy 1995).

The process of integration of the Oriya-speaking territories began in 1905, when Sambalpur region including seven *Garjats* were united with Orissa. In 1912, Bihar and Orissa was constituted as a new province, but the Oriya-speaking tracts of Ganjam, Koraput, and Sambalpur remained with the Madras Presidency and the Central Provinces respectively, and the 24 Tributary States remained under their respective rajas, supervised and controlled by the political agents of the British government. In 1936, Orissa finally emerged as a separate province, the first one to be established by and large on a linguistic basis in India.

During the struggle for a united Orissa the local political forces like the Utkal Union Conference increasingly came into conflict with the Indian National Congress, which believed that the cause for a united Orissa should be subordinated to India's independence. In the beginning the two forces had been working together, and in the Nagpur Session in 1920 the Congress had accepted a resolution for the formation of Provincial Congress Committees on a linguistic basis. Subsequently the Non-Cooperation Movement was started, which collapsed after two years.[81] From 1930 to 1934, Orissa witnessed the Civil Disobedience Movement that was linked with the salt issue that had earlier been taken up in the Bihar and Orissa Legislative Assembly. In the salt-*satyagrahas* in Puri and Cuttack the participation of women who violated the salt laws was an important feature (Pati 1993a: 73).[82] The participation of women, however, remained confined to the coastal region. After the Gandhi–Irwin Pact in March 1931, the Civil Disobedience Movement gradually declined.

After the formation of the Province, the Utkal Union Conference expressed its loyalty to the British government, which was considered by the Congress, in contrast, as the main enemy. The first election after the creation of Orissa

[81] For the rise of mass movements from 1920 to 1950 in Orissa, see Pati (1993a).

[82] For the role of women in the struggle of independence in general one should refer to the illuminating work of Chatterjee (1993). He argues that in the nationalist struggle 'woman' was equated with 'nation'. Since women were the true representatives of India, they were invited to participate in this struggle, but only as long as this did not threaten the prevailing models of femaleness. In this respect, women could not break away from their ordained roles and did not become empowered. When the struggle was over, they retreated back into their homes.

as a separate state was held in January 1937 and the Congress party won 36 out of 40 seats. The government introduced several reforms and welfare measures, like opening temples to the untouchables, and setting up primary and secondary schools. During this reign the Congress also introduced several policies favouring the poor peasants, which alienated the zamindars, who were mainly present in the political opposition.[83] Additionally, the government supported the *prajamandal* leaders in the feudatory states in their struggle for liberation from the rule of the kings.[84] These peasant and tribal movements, especially in the early 1940s, led to the consolidation and depth of the national movement, but at the same time there was a virtual retreat of women from it. The space women had gained during the Civil Disobedience Movement seems to have been altered in this phase. Women figured mainly as victims of terror or as refugees from the Princely States. Although two women held leadership positions[85] it was only a token presence. 'Thus, they [women] remained outside the mainstream of the mass movements which was no longer perceived as an acceptable sphere for women's participation' (Pati 1993a: 130).

After the war was over an election under limited franchise was held, in which the Congress party secured the majority of seats (Mishra 1985: 18). Under Congress rule lasting until 1950 the feudatory states were integrated into Orissa. Twenty-five states merged on 1 January 1948, the state of Mayurbhanj acceding a year later. Obviously this merger had consequences for Orissa's political landscape. The ex-rulers, having lost their political power, social status and material wealth, were interested in joining state politics and several rajas formed the Ganatantra Parishad Party.[86]

So far Orissa has had 11 Assemblies, and the 12th Assembly was elected in February-March 2000. The political scene of Orissa after independence was characterized by great political instability, although the Congress party was able to rule frequently. But due to inter-party factionalism these ministries proved not to be very stable in many cases (Mohapatra 1985). Between 1952 and 1977 there were twelve ministries, the average life-span of a ministry being only about two years (Mishra 1984: 199). The state also came under

[83] See, e.g. the *Madras Estates Land (Orissa Amendment) Bill*, which proposed changes in the assessment of revenue in Ganjam and Koraput Districts; the *Orissa Tenancy (Amendment) Bill, 1937*, or the *Orissa Money Lenders Bill, 1938* (Mishra 1985: 11f.).

[84] For the *prajamandal* movements, see Pati (1993a: 60ff.) and Pradhan (1984) for several movements in various states of Orissa; for the analysis of the *prajamandal* movement in one major feudal state, namely Mayurbhanj, see Praharaj (1988).

[85] These were Malati Chaudhury in the Kisan Sangha, and Sarala Devi in the Legislature.

[86] This party is blamed by some authors for the injection of regionalism, to be dealt with below, in Orissa politics at the time of the 1952 parliamentary election because they commanded the vote of many *adivasis* (Mishra 1985: 24). For a more informed and differentiated view on the Ganatantra Parishad, see Mishra (1984: Chapter 6), and Banerjee (1988).

President's Rule at various times.[87] Important for the case study is the Janata Dal government of the 10th Assembly (1990–5) headed by Biju Patnaik as the Chief Minister, who introduced the important Panchayati Raj Acts. Under Patnaik's office, the reorganization of Orissa's Districts also took place. In the 11th Assembly (1995–2000) the Congress party was voted to power led by J.B. Pattnaik, who had been Chief Minister twice before. He dissolved the elected PRI, as referred to earlier, and introduced new legislations, especially concerning the reservation for OBCs and a routine procedure for the reservation and rotation of constituencies. Following various scandals, J.B. Pattnaik was succeeded by Giridhar Gamang, who was in charge when Orissa was devastated by the cyclone in October 1999, and then by Hemanant Biswal as Chief Minister. The 12th Assembly is led by a BJP/BJD government under Naveen Patnaik, the son of Biju Patnaik. The local political setting and the Assembly Election 2000 will be described in detail in Chapter 4. One can say that Orissa has a rather unstable political system: Politicians are changing parties frequently, inner-party factions prove sometimes fatal to ministries, and coalitional support gets withdrawn.[88] All this has obvious repercussions on the precarious economic position of Orissa.

Another important feature of Orissa is the incidence of regionalism. This particular structural feature of Orissa's regionalism has various causes. The first element is that geographically speaking Orissa is not a homogenous state.[89] It has four distinct physical regions, namely the Coastal Plains, the Eastern Ghats, the Central Table Land, and the Northern Plateau. The 'old' (before reorganization in the 1990s) districts of Balasore, Cuttack, and Puri, and parts of Ganjam, constitute the Coastal Plains. Since the region is formed by the delta of three rivers, it is highly fertile. Undivided Puri District, where the research-area is located, has two distinct physiographical divisions, namely a plain alluvial tract in the south and south-east and a hilly tract in the north and north-west. The plains, where Balipatna of today's Khurda District is located, have an extensive irrigated area and well co-ordinated embankment systems, and extensive areas are double cropped, having the highest yield rate per unit of land in Orissa (Mishra 1984: 55).[90] The situation in the north and north-western parts of Puri District, where Gania of today's Nayagarh District is situated, is akin to the one in the Eastern Ghats—a

[87] See for President's Rule in Orissa, Table 3: 'Tenure of Ministries in Orissa' in Das and Pradhan (1988). For the problems of coalitions in Orissa, see Chapter 7: 'The Patterns of Coalitional Politics' in Mishra (1984: 198–214), and Nanda (1979). For the different state governments, periods of President's Rule, and the caste composition of ministries, see Jena (1994).

[88] For further information on the political processes in Orissa, apart from the works already mentioned, see Asthana (1988) for the party system; Jena and Baral (1989) and Misra (1989) for electoral politics and voting behaviour; and Tiwari (1994) for politics in Orissa 1961–71.

[89] For this and the following, see Mishra (1984), especially Chapter 3: 'Orissa: A regional profile' and Chapter 4: 'Origins of Regionalism'.

[90] For general information on Puri District, see GoO (1977).

region composed out of Phulbani, Koraput, and a part of Ganjam Districts. This region is marked by dense forests, where the hill ranges in the West slope into a plateau containing some fertile valleys. In this respect, the two study regions reflect the regionalism of Orissa, while at the same time evading the tribal factor. The Central Table Land consists of the districts of Sambalpur, Bolangir, and Kalahandi. The plains and river basins are suitable for agriculture, and paddy is the main crop. Finally, the Northern Plateau is hilly and thickly forested, comprising the districts of Mayurbhanj, Keonjhar, Dhenkanal, and Sundargarh.

If the four regions based on physical features are also categorized according to their level of development, it appears that on the basis of some common characteristics Orissa can broadly be divided into two regions: the coastal plains and the highland or the inland region, in which the northern part of the state forms a distinctive sub-region. The differences that characterize the two regions are not merely geographic in nature, but are due to specific historical (*Mughalbandi v. Garjat*), social, economic, cultural, and political factors (Mishra 1984: 57).

The coastal area, comprising around 25 per cent of the total area of the state, is well suited for intensive cultivation. It is the most densely populated part and produces the major portion of agricultural output. As mentioned above, this area came under British Rule in 1803, which has to some extent led to the growth of prosperity through the expansion of irrigation, transport systems, and education facilities. Many canals were built. The region was also connected to important places through the Orissa Trunk road (finished 1825) and the Bengal-Nagpur Railway (1899).[91] English schools were opened and the Ravenshaw College, a major centre of higher education even today, was inaugurated in 1868. This college had political significance in the freedom struggle, with many political leaders both in the pre- and post-independence period having graduated from here.[92] Additionally, the earlier experience with developmental and bureaucratic administration led to the formation of a powerful educated middle class, which provided the necessary manpower for post-independence Orissa. The coastal plain has a higher rate of urbanization, and the cities have served as the centre of socio-political activities from the nineteenth century onwards. Moreover, the major industries are located here. The higher number of factories led to a higher concentration of trade unions.

[91] It is important to mention that the development of communication systems took place mainly on a north-south axis. That was according to British needs and their interest in connecting Calcutta with Madras. The local and regional infrastructure, on the other hand, followed the natural courses of valleys and rivers, mainly on a west-east axis. These were the traditionally important trade and pilgrim routes from today's Maharashtra via Madhya Pradesh. The British activities actually intensified the regionalism, because the hinterland was effectively closed off from the coastal areas. Information given by Ravi Ahuja in a personal conversation, September 2000.

[92] Mishra (1984: 62) notes that eight out of ten Chief Ministers serving between 1952 'and 1978 were students of Ravenshaw College.

In contrast to this, the highland region as a whole constitutes the socially and economically most backward part of the state, although internally it is quite diversified. As seen above, the region does not have a common history, as it comprises the former Princely States that were ruled by different independent rajas. In most of these states, the absence of bureaucratic rule resulted in the absence of a large middle class, from which the pioneers in social and political movements usually emerge. Thus, the national movement here was never as broad-based as in the coastal area, and the participation of women was also negligible. The common socio-economic features of this area are higher dependence on a poorly developed agriculture, a large proportion of STs and SCs, lack of urbanization, and inadequate infra-structure. All this has contributed to a high activity rate in agriculture, low-income levels, and low levels of education. Most importantly, it also led to a lesser participation in state politics. The representation of the regions in successive councils of ministers since 1952 has hardly been proportional to the population of the regions, making the highland region less influential in the state.

A final feature of Oriya society that is important for background informa-tion is the caste-structure.[93] Unfortunately, only very few ethnographic accounts of caste-groups in Orissa are to be found.[94] One exception is the very interesting and thorough work of Bailey (1958) on the changes intro-duced in a village through economic processes and penetration through the administration of the colonial and later independent Indian state, and the repercussion it had on the local caste-structure. However, Bailey conducted his research in the early 1950s in a village of central Orissa in Phulbani District, and thus his analysis is limited. Due to the varied pattern of the caste-structure in Orissa it is extremely difficult to give a description of definite features that are valid throughout the state.

The major watershed can again be drawn between the caste-structure in the coastal plains and the one in the northern and western hinterland of Orissa. This is also due to the high number of *adivasis* in the latter region.[95] However, to get an idea about the hierarchical set-up one has to differentiate even between the sub-regions since the relational status of caste-groups may change from locality to locality.

As already argued, Orissa was divided mostly into small principalities until the British conquest in 1803 and even afterwards. The local 'little' kings or rajas had the obligation to maintain the caste order as fulfilling their

[93] I use the term caste-'structure' in contrast to caste-'system', since it is difficult to talk about a caste-'system' in India or Orissa. Rothermund (1993: 67) has argued that caste constitutes a system only in the interpretations of the Brahmins. In practice, it is a loose pattern of ranking several social groups who live in a certain region, and sets them in relationship to each other.

[94] For a more general discussion on the role of caste, class, and power in rural Orissa from a leftist point of view, see Pathy (1982).

[95] *Adivasi* is the Indian term for its tribal or aboriginal population. I use the term tribal and *adivasi* interchangeably.

spiritual function of upholding the dharma (Mahapatra 1984: 42). However, the raja always needed the consent of Brahmins, and he was also dependent on their services to legitimize his rule since he claimed Kshatriya status. According to legends, even the kings of coastal Orissa had to import thousands of Brahmins to perform certain important rituals. It seems that there was also scarcity of functional castes in some areas, who then either had to be imported from elsewhere or had to be 'created'.[96] The same holds true for rajas of the states of central and western Orissa. Brahmins normally legitimized functional castes as well as the claim of Kshatriya status for the rajas, since it also secured their own position in the hierarchical set-up of society. In this respect the hierarchical position of caste-groups has changed through time and differs from locality to locality:

[T]he same caste or sub-caste may be having different caste status as between two principalities. In other words, the kingdoms were not only autonomous political groupings, but also rather exclusive social groupings, with slightly distinctive caste hierarchies and patterns of interaction among castes, which might deviate not only from the neighbouring political (and social) regions, but also from the regulations and interpretations of the *Shastras*. (Mahapatra 1984: 45)

Another important feature of the caste-structure (not only in Orissa) is the existence of caste councils—the traditional caste panchayats—at various levels. All caste-groups, barring the Brahmins, Kshatriyas, Karans, and the Khandayats, had or still have these caste councils. Apart from villages, where a sizeable number of households belonging to particular castes are found, the local caste panchayat at the lowest level was in most cases an institution encompassing several villages. In some cases, as with the milkmen or potters, there might be a higher-level caste council catering to the needs of a large number of households scattered in a region, which is smaller in area than the principality concerned (Mahapatra 1984: 47–50).[97] The councils were invested with the powers of excommunication or other sanctions towards caste-members who transgressed certain rules. They also decided regulations, for example, concerning the marriage ceremony or educational matters. These caste-councils are still in operation in many villages of Orissa, and also at the regional and state level. These traditional caste panchayats are an exclusively male affair, and women do not participate in the deliberations. Nowadays also political issues, such as whom to vote for, get decided by these bodies. *Basanda* or social boycott is also still practised against caste-

[96] It heightened the status of the king when he had several functional castes (like barbers) in his kingdom, because he could show that he is able to perform all important rituals. This information was given to me by Prof. P.K. Nayak, Professor of the Department of Anthropology, Utkal University, Bhubaneswar, Orissa in one of the numerous talks we had on issues concerning society and culture in Orissa. I want to thank him for his friendliness and patience to spend so much of his scarce time for discussions with me. All misrepresentations, however, which might have crept into the above description, are entirely mine.

[97] For examples of the organization of caste panchayats of several caste groups or agendas of caste-council meetings, see Bose (1960).

members who have transgressed caste rules. Cases brought before the council often concern 'improper' inter-caste marriages or elopements of young couples.

The caste councils had several officials, who were either recognized by the raja or could also be appointed or replaced by him. The title for this mostly hereditary office was usually 'Jati Behera'. Thus, one finds today several families who bear the title 'Behera' instead of their caste name. Accordingly, it is not possible to know the caste or the ritual position of the household by only knowing that a certain family is called Behera, as this title was used by several caste-groups, touchable and untouchable. The same holds true for other titles such as Pradhan, Das, Patra, and Naik or Nayak (leader). However, in other cases, the surname does unmistakably indicate a certain occupational caste-group, like Muduli (potter) or Sahu (oilmen).[98] The ritual hierarchy of specific castes is not a clear matter in all cases and differs from region to region. It is also not fixed eternally in specific localities. As in other parts of India, the dividing line between clean castes and untouchables seems to be insurmountable, but the ranking of the 'clean' castes is and was always a matter of contestation.[99]

If there is a problem of a clear ranking of castes already encountered at the local level, one can easily imagine that it becomes even more complicated at the state level. One case in point is the caste-group of Keutas (who are either fishermen or prepare *chuda* for sale). They have somehow been included in the SC-category in Orissa, although they are regarded as touchable in some areas and even occupy a rather high ritual status, for example in Gania Block.[100] We shall come across this caste-group in the case study. Another

[98] G.K. Lieten (1996: 101) acknowledges the same fact in his study of Ramnagar Block in West Bengal which is adjacent to Orissa and populated by a majority of Oriyas: 'The space between the Brahmins and the Scheduled Castes . . . is occupied by a limited number of castes which are internally divided along the entire class spectrum and which have opaque position in the caste hierarchy. The problem is compounded with the fact that the common surnames in the area (Das, Patra, Bhowmick, Koron, Maity, Giri, Jana, Bera, Bhuyia) are associated with practically all castes and various social and economic status groups.'

[99] This is amply shown in the study by Bailey (1958). He analyses how economic change in a village in highland Orissa (Kondmals) was used by several castes to aspire for a higher rank in the caste hierarchy in a single village. Whereas a touchable caste group succeeded with a combination of prosperity and sanskritization, an untouchable caste group, who tried the same avenue, failed. For the 'Sanskritisation Theory', see Srinivas (1987, 1989).

[100] For information on a *Keuta* council, see Patnaik (1960: 175–8). Unfortunately I could not find out when and why this group was included in the SC-category. In the article mentioned above, the matter of untouchability does not come up, thus it seems safe to assume that the Keutas were not included in the SC-category before the 1960s. Bhattacharya, who wrote about Hindu castes at the end of the nineteenth century, mentioned the Kaibarttas (another name for Keutas) in a specific subdivision called Contai and argued that this caste group qualified as 'local aristocracy' if they were zamindars or substantial tenants, whereas they were considered 'unclean' if they were poor (Bhattacharya, 1973 [1896]: p. 223; referred to in Lieten 1996: 102).

contested issue is the ritual status of the Karan (Kayastha). This caste-group mainly bears the titles Patnaik or Mahapatra, and the latter are ranked below the former. Normally the Karans are ranked highly in the caste-hierarchy and claim Kshatriya-status, whereas they are also sometimes labelled as Shudras, even though in this case they occupy a higher rank than Shudra cultivators (Bose 1960: 103). However, when one looks at the list of influential politicians in Orissa, one frequently comes across the name Patnaik (Pattanayak, Pattnaik). Thus, today many people claim that actually only the Brahmins and Karan are 'general' castes, whereas the other caste-groups, who are neither SCs nor STs, belong to the OBC-category in Orissa. In the study I followed this categorization, as the Brahmins and Karans in most cases do occupy a high social status, whereas the ranking of the numerous middle castes is extremely difficult to ascertain and would call for detailed village studies, which stood outside of the scope of this project.

An important feature of the village communities connected with caste—the pattern of settlement—holds true for most parts of Orissa. This is very important for the following analysis. In most cases, caste-groups are clustered along streets (in Oriya, *sahi*). In most villages one will find a potter street (Muduli *sahi*) or an oilmen street (Sahu *sahi*), which is mainly or exclusively inhabited by this occupational caste-group. This holds generally for the old parts of a village, or older villages. In new villages, or in newer parts of the village, one can find multi-caste settlements, where no caste-group enjoys the majority. The *sahis* of the untouchables are often located at the fringe of the villages where they do not have to be crossed by the 'clean' castes. Nowadays, the untouchables often have built their own temples and have their own community halls. Ritual interaction between them and the touchable castes hardly takes place. It is normally easy to spot the Harijan *sahi*,[101] as generally the streets are more congested, and in electrified villages often their *sahi* is without electricity. In some cases the SCs do live in hamlets that are rather separated from the village proper and are sometimes regarded as a different village. However, in most cases the villages were and are organic bodies, with linkages between the different castes. Only in matters of social and religious functions, such as inter-dining, marriage, and *puja*, caste segregation was and is important. In other cases the villagers dealt with each other and were connected with each other through various economic and political relations.

Even though casteism is still prevalent in the villages of Orissa, important changes have been taking place. Children of various caste backgrounds sit together in school; 'clean' caste members do enter the untouchable *sahi* when they have some business there, and in some cases SCs now get invited to certain functions, even though they still often sit apart from the 'clean' castes. Bailey (1958: 214) had observed a distinctive generation gap in the interaction between clean castes and untouchables in the 1950s, where the younger generation was more open in its interaction than the older ones, and this process has further intensified over the last decades.

[101] In the study region this term was used for the SCs or dalits.

Generally speaking, the older the village, the more caste-groups will be present.[102] There can be villages, in which 20 caste-groups reside, but only few caste-groups might occupy newer villages. Nowadays, these *sahis* are often congruent with the delineation of wards, the constituency from which the wardmember gets elected. Only in some cases is a *sahi* divided, or if the population is small, several *sahis* form one ward. We shall come to the implications of this when we look at the role of caste in the election process for the PRI.

The Study Area

A comparative approach was seen as most fruitful for a case study on political presence and women's empowerment, and, hence, two blocks were selected. It was decided to conduct the study at block level because at this level most planning takes place, state development programmes get implemented, and it is also the unit of the second and most important tier of the PRI, the samiti level. Another reason is that a district can contain large socio-economic variations, and thus the unit of district is too big for a comparative research. Furthermore, the block is the lowest level for which macro-economic data is readily available.[103]

The main criterion for the selection of Balipatna and Gania was to pay tribute to the feature of regionalism in Orissa. Both blocks used to be part of undivided Puri District before the reorganization of the districts under the government of Biju Patnaik, and shared the same administrative history from independence until 1993. However, the historical background prior to independence and the socio-economic situation today is very different. Balipatna of today's Khurda District is located in one of the politically most active regions of the former *Mughalbandi* area, whereas Gania, part of the feudal state of Daspalla at that time, was a sleepy place hardly cleared from the mighty jungle and pretty much cut off from the turmoil in other parts of Orissa. On 1 January 1948, the ex-states of Ranpur, Nayagarh, Khandapara, and Daspalla were added to Puri District, and after the reorganization of the districts they came to constitute Nayagarh District.[104] Thus, there was no political connection between Balipatna and Gania for most of the time, even though they were part of the same district for 45 years. Hence they are distinct in the historical evolution of local self-government and political culture. The two blocks also represent the two divergent features of old Puri District. As mentioned above, the north and north-western area of undivided Puri District where Gania is situated is more akin to the situation of the

[102] This information was given to me by Professor P.K. Nayak, Department of Anthropology, Utkal University.

[103] See for this the District Statistical Handbooks, which give aggregated district and block level data.

[104] For some general information on the two districts (like infrastructure, important monuments, economic position, etc.), see Bhat (1997). Information on Khurda is to be found on pp. 672–6, and on Nayagarh on pp. 724–7. Some historical information is given under the chapter on Puri on pp. 741–4.

Eastern Ghats, thus the two blocks do represent the regionalism in Orissa while at the same time avoiding the tribal factor.[105]

To date, there is also a marked variance in economic development, infrastructural facilities, and indicators on the position of women. In all aspects, Balipatna could be labelled as relatively forward when compared to Gania. Additionally, exposure to urban life is much higher in Balipatna, as it is situated only 30 km from Bhubaneswar, whereas in Gania, 100 km away from the capital, some of the gram panchayats are inaccessible by car or even motorbike. The comparison between the two regions should help us to assess which patterns of the processes taking place after the implementation of the quota might be attributed mainly to gender and which are at least partly dependent on the specific local setting. This enables to draw conclusions on the relevant structural properties of the process. That is why the tribal factor was excluded, since the status of women there is arguably so different to that in Hindu society, that the relevance of other factors, like the specific historical, economic, social, and political context, would be overshadowed by this factor only.

Balipatna block is situated towards the south-east of the state capital Bhubaneswar. It is shaped like a triangle with the north-west side bordering Balianta block of the same District, the north-east side bordering Jagatsinghpur District, and the south bordering Puri District (see Map 2.2). Balipatna is only the name of a crossing of the street going to Nimapada and the road leading to the headquarters of Balipatna, which are located in the village Garedi Panchana, 23 km away from Bhubaneswar and 52 km away from the District Headquarters Khurda. Near the block office there is also a police station. The commercial centre of the block is not the headquarters panchayat but a small market town with the name Banmalipur, situated in the gram panchayat Bakhara Sahi. The distance to the coastline is around 30 km from the nearest tip of the block.

The block is irrigated by several canals, which originated mainly from British times and the area of 140.79 sq. km has a population of 92,394, and is thus densely populated (GoO s.d.a: 7). The population lives in rather big villages (average 1087 persons in each of the 85 inhabited villages), and nearly every village has a water-tank, often covered by water hyacinth—a very beautiful but harmful pest here. There is a high percentage of SC-population (26.5 per cent); the number of STs, given as 13 persons, is negligible. According to the 1991 Census, 7799 Muslims do live in this area, or 7.3 per cent of the total population (Director of Census Operation, Orissa 1996: 155).[106]

[105] In Gania there is actually a sizeable ST-population from the tribe of the *Kandhas* (10.57 per cent). However, they are 'Oriyanized' in most of their social customs, and speak Oriya nowadays instead of their ancestral language Kui. Furthermore, they are mainly located in the Gram Panchayat Badasalinga, in which the PRI election was boycotted. Thus, tribals do not have a major part in the study.

[106] The total population of Balipatna Block is given as 1,06,525 (as compared to 92,394 in the District Statistical Handbook); the census figure was used as basis for the

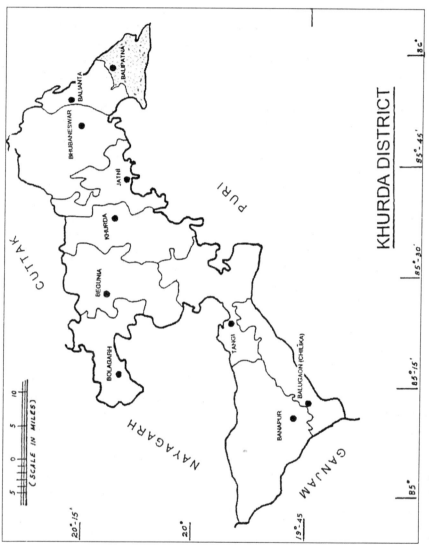

Source: Adapted from OVHA (1995: 61a).

Map 2.2: Balipatna Block in Khurda District.

Most villagers (71.8 per cent) earn their livelihood from agriculture.[107] The next sizeable occupational group is engaged in trade and commerce (8.7 per cent) and the rest are in other services (8.6 per cent) (GoO s.d.a: 10–3). The net area sown is 7,644 hectares, which is 54.5 per cent of the whole area (all the following is calculated from data given in GoO s.d.a). The main crop is paddy and because of the good irrigation facilities it is possible to have three crops a year. However, most of the farmers settle with one crop in the cold season, while a few sow paddy also in the rainy and post-monsoon months.

Apart from fair agricultural facilities, the general infrastructure is also quite good. 92.9 per cent of the villages were supposed to be supplied with electric power until the end of the year 1994. However, 10 per cent of the villages did not have drinking water facilities until the end of 1993. The poverty line was Rs. 11,000 per annum as per the 1992 survey (that is, around Rs. 15,000 in prices of 2000), and 11,755 out of 25,096 families fell under this line, or 46.8 per cent of all families.

There are 144 primary schools (that means more than one school per village, and they are located in several hamlets), 25 middle schools, 14 secondary schools, and one college. The enrolment of girls is declining through the hierarchy from 47.6 per cent in primary schools to 26.5 per cent in the college. One has to keep in mind that the enrolment rates do not necessarily give the number of regularly attending pupils—this figure is lower to quite a substantial degree. That obviously has repercussions on the literacy rates which are (excluding the age group 0–6 years) 80.64 per cent for males and 51.55 per cent for females, making a total of 66.26 per cent, which is, however, quite above the average literacy rates in Orissa (63.09 per cent for male and 34.68 per cent for female, total 49.09 per cent). The demographic position of women in Balipatna is generally speaking worse than the men's position. There is an unfavourable sex-ratio of 970 females per 1000 males; among the SCs it is 968. Women's total work participation rate is given as 4849 out of 28,025 total workers (17.3 per cent of total workers), where 3832 are main workers out of a total of 26,747 (14.3 per cent of the main workers), 1017 out of a total of 1278 are marginal workers (79.6 per cent of the marginal workers), and 40,633 out of 64,369 are labelled as non-workers (63.1 per cent of the non-workers).

In terms of population, Balipatna forms a big block, comprising 12 gram panchayats with 212 wards. The number of wards per gram panchayat ranges from 12 to 23, and a ward normally comprises several *sahis* in a big village, or several villages, if the villages are small. There are 238 PRI-representatives in total, namely 212 wardmembers (including 12 naib-

calculation of the percentage. It is generally quite annoying that corresponding figures are hard to find in different sources. Interestingly enough, all claim to be based on the census figures. This truism holds for nearly all statistical figures. However, their accurateness is sufficient for the arguments made here.

[107] Out of 26,747 main workers, 10,140 are cultivators and 9054 are agricultural labourers.

sarpanches), 12 sarpanches, 12 samiti members (including the samiti chairperson), and one zilla parishad member. 75 positions for wardmembers have been reserved for women (35.4 per cent); 4 for sarpanches (33.3 per cent); 4 for samiti members (33.3 per cent), out of which the office of the samiti chairperson is reserved for an SC-woman. The zilla parishad seat is also reserved for a woman, adding up to 84 seats reserved for women in the PRI in Balipatna (35.3 per cent).

As referred to, there is a high percentage of SCs living in Balipatna, and the MLA constituency of Balipatna, comprising the two blocks Balianta and Balipatna of Khurda District, has been reserved for an SC-candidate since the creation of this constituency in 1961 (Singh and Bose 1987). The present MLA elected in February 2000 is Ragunath Ch. Sethy from the Biju Janata Dal (BJD), who already served once as MLA for the Indian National Congress (INC) from 1985–90. The sitting MLA before Sethy was a member of the Janata Dal. He was MLA when the Congress party headed the government, thus many villagers complained that the state government neglected them, as their representative hailed from the opposition party. Generally speaking, this constituency seems to be fairly politicized, as MLAs get up-seated in nearly every election.[108]

Important for the setting of the case study is the fact that this area was heavily devastated by the super-cyclone that hit the coast of Orissa from 27 to 30 October 1999. In this catastrophe, 10,000 or more people died, the cattle stock was depleted to a major degree, and millions of houses were destroyed—making innumerable people homeless. Balipatna belonged to the most severely devastated areas of Khurda District. It was not hit by the tidal waves which destroyed the neighbouring District Jagatsinghpur to a much greater extent, but due to heavy winds and rain,[109] 86 lives were lost, a lot of cattle died, many houses had collapsed completely or partially, and nearly 80 per cent of the trees which used to cover this area were destroyed. The damage was estimated to be around 96 lakh of rupees.[110] It was a rather difficult setting to conduct the qualitative research of the second round— people were still busy mending their lives, and many had lost their means of livelihood and shelter. In this respect it was much more difficult to get access to the informants, because of their lack of time due to their preoccupation with more important undertakings then answering my questions. This led to the problem that less qualitative data could be gathered in the coastal area, which, however, proved to be still sufficient for the present analysis. However, despite the human misery and tragedy of the cyclone it also gave an impetus

[108] Several parties managed to win seats in various elections. In 1961, 1971, 1985 the constituency was won by the Indian National Congress, in 1967 by the Jana Congress, in 1974 by the Utkal Congress, in 1977 by the Janta Party, and in 1980 by the Indian National Congress (Indira). See (Singh and Bose 1987). In the 1995 election, it was also won by the Janata Dal. Compare this to the situation in Gania.

[109] In the three days from 29 to 31 October 1999, 380 sq. mm were measured. Information gathered from Block Office in Balipatna Block on 10 January 2000.

[110] The BDO of Balipatna on 10 January 2000 provided this information.

to the Panchayati Raj Institutions. All PRI members became much more active and in some cases solidarity was created between opposing factions of the gram panchayats in light of the calamity. Thus, we have to keep in mind that part of this research was conducted under very special circumstances that are quite distinct from the normal situation.

The second block is the economically and socially comparatively 'backward' Gania[111] Block in Nayagarh District. Gania block headquarters is 62 km from the district headquarters-town Nayagarh, and about 100 km from the state capital Bhubaneswar. Since Nayagarh belonged to the former Puri District it is considered by most of the people as part of the 'coastal' and, therefore, fairly developed part of Orissa. However, the ground reality is different. As mentioned, Gania belonged to the *Garjat* area of Orissa. The block is bordered to the north by the biggest river of Orissa, the Mahanadi, which often causes sand-casting in the dry season, to the west by the tribal District Boudh, to the south by the blocks Daspalla and Nuagaon, and to the south-east by the block Khandapara (see Map 2.3).

The topographical and sociological features are also more comparable to the interior than to coastal Orissa. One gram panchayat is completely inhabited by *adivasis* of the Khandha Tribe. They describe themselves as Hindu; they speak not their ancestral language Kui, but Oriya, and their social customs are also fairly 'Oriyanized'. They are situated in inaccessible hilly jungle with no proper road leading there. Since the PRI elections were boycotted there, only few interviews were taken in this area.[112] Most of the villages and hamlets in Gania are located in undulating terrain, surrounded by degraded forest, punctuated by a number of hilly streams, which become wild and render the area inaccessible during rainy seasons. Because of the rolling terrain, narrow valleys amid the hills, and poor soil quality in certain pockets, the villagers have limited choice in developing land for cultivation. Sand casting, soil erosion, and gully erosion are some of the major problems.

[111] The local explanation for the name Gania, which is the name of the headquarters village and gave the name for the block, was narrated to me by Mr P. Patnaik on 10 January 1999 in Belpadapatna, Gania Block. The word 'Gania' is etymologically close to the Oriya word for 'counting'. The village Gania is situated at the old Jagannath road where pilgrims from central India used to pass through on their way to Puri. It was the place where the pilgrims stepped out of the dense jungle—which was during these times even more inhabited by wild animals like tigers and elephants—and counted the heads to find out how many people had been lost on the way.

[112] This is the gram panchayat Badasilinga, which is area-wise quite big, but only 2,712 people live in an area of 27.45 sq. km, or 98.8 people per sq. km. Data collected from a non-governmental organization (NGO) operating in this area: Gania Unnayan Committee, Belpadapatna, 752085 Distr. Nayagarh, Orissa. People in Badasilinga protested against the neglect of the state government which had promised to build a street long time ago, but so far has not fulfilled its promise. The reason given is that the area is a reserved forest and a proper street would lead to increase in the already rampant smuggle of timber. As a consequence, the inhabitants of this gram panchayat boycotted the Panchayat Elections in 1997. However, the husband of the present sarpanch did not withdraw the nomination, and the other members were then appointed by the Collector.

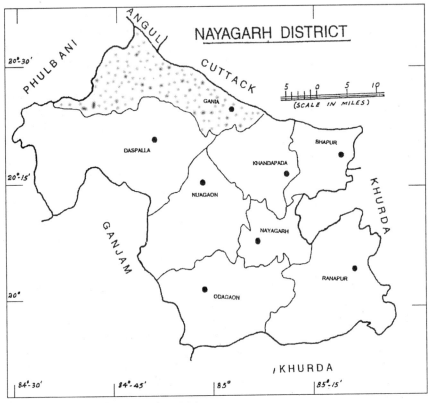

Source: Adapted from OVHA (1995: 66a).

MAP 2.3: Gania Block in Nayagarh District.

Only in some pockets some cash crops are cultivated, while the rest is mainly used for subsistence agriculture. When Gania was still under Puri District, officials regarded the block as 'punishment area' because of its backwardness and lack of facilities.[113]

Gania, incidentally the smallest block of Orissa in terms of population, comprises only seven gram panchayats with a total population of 31,317 living in an area of 162.17 sq. km (this and the following data are given in Government of Orissa s.d.b). Thus, it is rather sparsely populated with an average density of 193 people per sq. km. People live in small villages that are less than one-third the size of the villages in Balipatna.[114] The SC-population is 23.16 per cent, and the ST-population is 10.57 per cent. Of the working population, 80.6 per cent is engaged in agriculture, other sources of income in descending order being other services, manufacturing, fishing and hunting, trade and commerce. The net area sown is 6535 hectares, which constitutes 41.5 per cent of the whole area. More than 10 per cent of the area

[113] Information gathered in an interview with the Medical Officer, Gania, 6 February 2000.

[114] Average density being 323 people per one of the 97 inhabited villages.

is covered by dense jungle. The main crop is paddy, but, whereas in Balipatna basically the whole net area sown is devoted to paddy cultivation, it is only a bit more than half of the area in Gania. The reason for this is the lack of adequate irrigation facilities, and, thus, most of the paddy-harvest is the rainfed winter crop. Other major products are mung, black gram, horse gram, chickpeas, mustard, til, and groundnut; while vegetables for marketing and sugar cane as cash crop are cultivated only in a few pockets. Thus the agricultural situation is marked by low soil quality and lack of irrigation facilities. The sources which were supplementing the production and income from landed property such as forest produces and fishing from the rivers have been substantially depleted over the last two decades: The forests have been cut and resources squandered, and the fishing area has been reduced because of a crocodile project up the Mahanadi River.[115]

The infrastructure is comparatively poor. Only 51.5 per cent of the villages were to be electrified until the end of the year 1994, and 28.4 per cent of the villages have no safe source of drinking water facilities. However, even villages that are counted as electrified do not have electricity as the wires are frequently stolen and not replaced. Additionally, villages with tube-wells still take their water from the rivers since in some areas the iron-content of the groundwater is too high for consumption.[116] The number of families under the poverty line of Rs. 11,000 as per the 1992 survey is a stunning 99.3 per cent (5,904 families out of 5,944)!

There are only 42 primary schools (i.e. more than half of the villages do not have a primary school), 14 middle schools, 5 secondary schools, and 2 colleges. As in Balipatna, the higher one goes in the educational hierarchy, the less are girls present (going down from 45.2 per cent in primary school to 13.7 per cent in the colleges), and the gap between girls and boys is considerably higher in Gania. The output of the educational system as measured in literacy rates is 71.54 per cent for males and 37.17 per cent for females, amounting to a total of 54.94 per cent literate, which is considerably lower than in Balipatna, but still above the Orissa average.

The sex-ratio in Gania with 943 females per 1,000 males is worse than in Balipatna (970). The sex-ratio among the SC-population is 940, and among the ST-population 960. The total work participation for women is given as 2,077 out of 10,837 for all workers (19.17 per cent as compared to 17.3 per cent in Balipatna), 1,140 out of 9,751 are main workers (11.69 per cent as compared to 14.3 per cent in Balipatna), 937 out of 1086 are marginal workers (86.28 per cent as compared to 79.6 per cent in Balipatna), and 13,119 out of 20,480 are labelled as non-workers (64.06 per cent as compared to 63.1 per cent in Balipatna). Thus, the work participation of women as enumerated in the Census is slightly higher for women in Gania as compared to Balipatna, but this is due to their higher prevalence in the category of marginal workers, whereas they figure less in the category of

[115] Information given by GUC; the crocodile project in Tikapada, however, has been closed a couple of years ago.

[116] Personal communications with villagers.

main workers. Thus, one could argue that there is not a substantive difference in this respect between the two blocks, at least when calculating from the official figures.

As noted above, Gania is the smallest block in Orissa, comprising only seven gram panchayats. There are 112 wards, the gram panchayats ranging from 11 to 21 wards. Since the density of population is low, a ward often comprises several villages, which also might be quite dispersed. All in all, there are 127 PRI-representatives: 112 wardmembers (including 7 naib-sarpanches), 7 sarpanches, 7 samiti members (including the samiti chairperson), and one zilla parishad member. In total 40 positions of wardmember have been reserved for women (35.7 per cent), 3 for sarpanch (42.8 per cent), 3 for samiti member (42.8 per cent), out of which an SC-woman has to be elected samiti chairperson, adding up to 46 positions reserved for women in the Gania PRI (36.2 per cent). Two positions of wardmembers reserved for women have not been filled—in one ward, voters did not go for election as they boycotted the SC-woman who had been nominated, while the other ward is in the tribal gram panchayat where the elections were boycotted in general.

Gania belongs to the MLA constituency Daspalla, which is a general seat since the 1974 election (Singh and Bose 1987).[117] The present MLA is Harihar Karan from the INC, who has already served in the 1974, 1977, 1980, and 1985 Legislative Assembly and was also elected in the by-election in 1997. In 1974 and 1997, he was elected as an Independent, but later joined the INC again. Thus, the political situation here is much more stable than in Balipatna. The MLA returned in the Assembly election of 2000 was again Harihar Karan from the INC.

However, this 'stability' is not necessarily positive, since it is rather an indicator for Gania's peculiar political culture, which is due to the feudal history of the region: The state of Daspalla was arranged in seven so-called *praganaths*. One *praganath*, consisting of several villages was administered by a *sardar*. The *sardar* was nominated by the raja of Daspalla and was paid for his services. In the villages there were jagirdars, the so-called *sarbarakars*. They were responsible for the collection of land revenue in their village, and got land as remuneration for their services. These feudal structures are still prevalent in the political set-up today as we shall see later. The former *sardars* and *sarbarakars* are very influential in the local power-structure, since they are still the biggest landowners and are also respected due to their elevated social position. Apparently they are still quite influential in organizing vote-banks.[118]

[117] Daspalla Constituency was reserved for an SC-candidate in the 1961, 1967, and 1971 elections. With the exception of 1967, when the seat went to the Swatantra Party, the INC or an Independent, who later re-joined the INC, always won it.

[118] For information on the feudal state of Daspalla, see Cobden-Ramsey (1982: 158–62); for a more detailed description of Gania's history as told by senior inhabitants, see the Appendix in this volume.

PART II

*Political Presence, Power, and
Empowerment of Women: Case Study*

Political Presence

IN THE CHAPTER on political representation and empowerment I argued that women moving into positions of 'power over' could be seen as a first step for women's empowerment in the political realm. In this chapter I shall first give an overview of the socio-economic characteristics of the elected representatives—women and men alike—to lay the foundation for further analysis.

The social characteristics of representatives have always been standard fare for classical political participation studies (e.g. Lipset 1959; Verba et al. 1971). Age, education, family status, and economic position have been established as being important factors for participation in politics. In the Indian context, caste plays a special role as well. However, the present case study is not a classical participation analysis. Political participation analyses were mainly concerned with finding out what types of citizens are more likely to participate in politics or to be elected as representatives and how socio-economic status influences the political behaviour of individuals. In the present case study, the situation is a little different.

In traditional participation analysis, one normally does not deal with quota regimes, which restrict the voters' choice and limits considerably the selection of candidates. Persons who might wish to run for a political office are not allowed to participate in the election as candidates if the constituency from which they come is reserved for a social group they do not belong to. On the other hand, representatives get elected who would presumably not be holding political office without the device of affirmative action. Thus, the specific socio-economic profile of the present representatives cannot serve as prima facie evidence for the preferences of the voters, or as definite factors which have influenced the representatives to participate in the election, at least not among the women.

WHO IS PRESENT?: SOCIO-ECONOMIC BACKGROUND

Although the socio-economic characteristics of the present representatives do not tell us directly what the preferences of the voters really were, or what might have been crucial for the election of specific candidates, it is still very important to have a close look at them. One has to establish first if the quota has been adequately implemented. Did enough women come forward to fill the seats reserved for them? Second, the social characteristics of the incumbents are also part of the structural determinants, as age, education,

and economic standing as well as caste are seen as influencing the election and performance of the representatives. Third, it is interesting to see if and at which points men and women differ substantially in their socio-economic characteristics, and if and at what points there are regional variations. It is also important to examine to what degree new persons have been introduced into the Panchayati Raj Institutions (PRI) or if the representatives are still recruited from the traditional political elite. Prior to the election under the 73rd Amendment there were also many deliberations regarding the type of candidates that would become elected under this Act, and we shall scrutinize whether these expectations have been verified or not.

The Sample and Methodology

During the quantitative survey 105 women and 80 men were interviewed in the two blocks between December 1998 and March 1999. All 19 gram panchayats (12 in Balipatna and 7 in Gania) were covered. 101 women at the level of the gram panchayat (82 wardmembers, 7 sarpanches, and 12 naib-sarpanches) and 4 at the samiti level (2 samiti members and 2 samiti chairpersons) were interviewed, representing a more or less full sample of women elected in these two blocks. In Balipatna, the much larger block in terms of representatives in the PRI, 100 per cent of the female sarpanches (4), the only samiti chairperson, and 76 per cent of the female wardmembers (57 out of 75, among which seven are naib-sarpanches) were interviewed; in Gania, all but one of the elected women in both lower tiers—the gram panchayats and panchayat samiti—were interviewed (3 sarpanches, 32 ward-members, 5 naib-sarpanches, 2 samiti members, and the samiti chair-person). Thus, the sample in Balipatna consists of 62 women, and in Gania of 43 women.

Additionally, 80 men, 40 in each block, were interviewed. In Balipatna 6 sarpanches, 33 wardmembers, and 1 naib-sarpanch, and in Gania 3 sarpanches, 34 wardmembers, 2 naib-sarpanches, and the vice-samiti chairperson were interviewed. In Balipatna, the sample of men constitutes 26 per cent of all men present in the PRI; in Gania, it is 49.4 per cent. The men were either interviewed on the way to the female incumbents, or in the panchayat and the block office. Thus, there was no purposeful selection, apart from the fact that most sarpanches were interviewed. With them also general discussions took place, and they sometimes accompanied my research assistants and myself to the representatives, since it was often difficult to find our way to their wards. However, they were not present when the members were interviewed. Generally, we tried to interview the respondents alone but did not succeed always. At home, the husbands were sometimes present, sometimes only children or curious villagers, but usually there was not much interference. In three cases, women refused to be interviewed at home while their husbands were absent. In the panchayat office, we normally got a room where we could talk to the interviewed person alone, and the sarpanches were mostly very helpful in this respect.

The qualitative semi-structured interviews were conducted a year later,

covering the months of January through April 2000. The following procedure was more or less followed in both blocks: In the beginning, a meeting of all female members of two gram panchayats in each block was conducted. These were the headquarters panchayat and one remote panchayat. The rationale behind this selection was that distance to the administrative headquarters matters for participation. In the remote panchayats, interaction with the bureaucracy or with representatives at the samiti level is more difficult because of the distances that need to be covered. The bad communication is an impediment especially for women. In the all-women meetings, the female incumbents were asked about the developments during the previous year, and the women for further interviews were selected on the basis of the information provided by the survey and their willingness to spare some time. These were normally the more active women. Others were too shy to contribute much to the discussions and were less eager to co-operate with us for a longer time, which is, after all, a prerequisite.

The visits to the selected women had a very informal character, mostly taking place in the backyard of the house, the living room, the kitchen, or in the fields. Sometimes the women were busy with work. Most of the interviews took place around noon. At this time, women in rural Orissa have normally finished their cooking and can spare some time. Some interviews took place in the evening between 6 and 8 p.m., when most women have again some time to spare. Time is a precious resource for village women and we always signalled that we are following their time schedule. The interviews were conducted in Oriya and were translated every five minutes or so by the respective assistant. After some time, I could follow most of the discussions in Oriya and could directly instruct my assistant to ask follow up questions. If the respondent was very talkative, intervening questions were rare, since one interest was also to see what kind of problems or issues the women wanted to talk about. If the women were not very outspoken, the conversation had more the character of a structured interview: questions were asked and answers given without much additional contribution by the interviewed person. The women who were more informative were visited more frequently. The women were visited up to four times each and in all, 14 women were interviewed in greater detail. Their names have been changed, since they gave a lot of information in good faith, like on corruption, their political inclinations, their domestic situation, etc.

With the help of the non-governmental organizations (NGOs) [Gania Unnayan Committee (GUC) in Gania and Darbara Sahitya Sansad (DSS) in Balipatna] village-meetings were conducted in the constituencies of the women. In Gania, the meetings took place normally in the evening after the work on the fields was done. The meetings were attended only by men. In Balipatna, it was more difficult to conduct meetings. The villagers were still busy with reconstruction work after the cyclone, and it was also planting season. Many persons were also busy in the evenings, and men spent their time in the bazaar. Thus, only few village meetings took place in Balipatna, and here too only men turned up. The villagers were asked why they had

elected the specific representative and whether they were satisfied with her work. In Balipatna, the DSS also conducted one meeting for me with several women's groups, and I attended two women's groups meetings which took place anyway. Apart from village and women's groups meetings, other people also were interviewed, such as neighbours, dignitaries, ordinary villagers, and bureaucrats. The interviews with the officials were conducted in English and mostly without the help of assistants.

In addition to the questionnaires and semi-structured interviews, observations played a crucial role for primary data collection. Also during the first survey the observations during the interviews (Was the women shy or confident? Did she wait for a sign from her husband before answering?) were noted at the back of the questionnaire. These observations helped a lot in interpreting the quantitative data later. Directly connected with the research on the PRI was the observation of gram panchayat meetings, the grama sabhas (village councils), and one panchayat samiti meeting in Balipatna.

Age

Before elections took place under the new legislation, there was the widespread belief that mainly old women past their reproductive age would come forward. That opinion was built upon the rationale that older women have lesser household duties because their children are more mature or they already command daughters-in-law (*bahus*), who care for the bulk of household responsibilities. The second reasoning was that they have a different status in the village community than young women, which gives them greater freedom of movement and decision-making, as discussed in Chapter 2. Higher age also stands for experience and maturity, which is valued very much in rural society; additionally, the position of a mother of sons and mistress of *bahus* further elevates a woman's status. In view of this it is surprising that in Orissa, as well as in most other studies, it was found that rather younger women came to the fore.[1]

Table 3.1 shows that the majority of women are still in the 'reproductive

TABLE 3.1: AGE-STRUCTURE OF RESPONDENTS

	21–5	26–30	31–40	41–50	51–60	61+	Total
Female B	9 (14.5)	9 (14.5)	25 (40.3)	10 (16.1)	7 (11.3)	2 (3.2)	62 (59)
Female G	5 (11.6)	9 (20.9)	19 (44.2)	5 (11.6)	4 (9.3)	1 (2.3)	43 (41)
Total	14 (13.3)	18 (17.1)	44 (41.9)	15 (14.3)	11 (10.5)	3 (2.9)	105 (100)
Male B	2 (5.0)	8 (20.0)	9 (22.5)	15 (37.5)	4 (10.0)	2 (5.0)	40
Male G	2 (5.0)	5 (12.5)	14 (35.0)	6 (15.0)	11 (27.5)	2 (5.0)	40
Total	4 (5.0)	13 (16.3)	23 (28.8)	21 (26.3)	15 (18.8)	4 (5.0)	80 (100)

Note: Percentage in rows for Balipatna (B) and Gania (G) are calculated for each sample separately.

[1] For socio-economic data of other samples, see: Kaushik (1997: 11ff.); Manikyamba (1989: 58ff.); MARG (1998: 38ff.); Rajput (1993: 34ff.); Santha (1999: 40ff.); Vidya (1997: 102ff.).

age', the largest group with nearly 42 per cent is in the age group of between 31 and 40 years, when household responsibilities are still quite pronounced; more than 62 per cent are younger than 41 years of age. The mean age of women is 37.7 years.[2] It could be seen as a positive fact that only very few women above age 61 years have been elected as compared to the findings, for example, in Haryana.[3] The standard of living in Orissa is much lower than what one is used to in the West, people waste away much faster, and people above the age of 60 years are often already more handicapped in respect to their eyesight, hearing-capabilities, and physical as well as mental mobility. Thus, one could argue that people of this age are normally no longer capable of becoming very active in politics. Interestingly, the males tend to be older than the women, even though the difference is not too pronounced; only 50 per cent are younger than 41 years of age; however, here also the largest group is of age between 31 and 40 years (28.75 per cent), but a nearly equally large group is aged between 41 and 50 years (26.25 per cent). Their mean age is 41.30 years, and, thus, the men tend to be in average 2.6 years older than the women.

Apart from age, other important social characteristics are the marital status of the representatives, the number of children, family size, and family arrangement such as joint or nuclear family. It is especially interesting in the case of women representatives to know if they are married, if they have children and if they live in a joint family. Such information helps to get an idea of whether there is potential support from other family members or whether female representatives are tied up with small children in nuclear families.

Family Status

In rural Orissa, a girl child is raised with the purpose of eventual marriage. Getting married normally means to leave the place of birth, move to the husbands place, and taking over household responsibilities at the in-law's house. It also means giving birth to children as procreation is seen as the main purpose of marriage. Thus, women in the age group of their late teens until their mid-thirties tend to be very busy with young children and household responsibilities. On the other hand, in cases where the women are not married, it is very difficult for them to be effective in the political local bodies. One problem is that unmarried women are easy victims of character assassination if they dare to move around without male company. The second factor is that for work to be conducted in the evenings in their official capacity, women normally need male support. Thus, as found in other states as well, most of the female representatives are married (91.4 per cent). Three female incumbents are not married, and it is not by chance that all of them hail from Balipatna, the more 'progressive' block. Normally it is unthinkable that women of marriageable age, who are not married, can yet move around

[2] Not all women could give their age precisely. In these cases, either present relatives were asked, or when the answer was, for example, 'between 35 and 40' it went into the calculation as 37.

[3] See Kaushik (1997: 11).

in village councils. Two of the three unmarried women are very young, one is a sarpanch and the other one is the samiti chairperson, and both were 24-years-old in 1999; the third one is also a sarpanch, but 61-years-old. She was never married and lives in her brother's family. Only five widows have been elected (4.8 per cent), a figure, which is normally higher in the Hindi-belt.[4] Two women are divorced; one is the samiti chairperson of Gania Block, while the other one is a wardmember who was deserted by her husband. It is interesting to note that apparently the single women are normally found in the higher positions, where they have to devote more time, which is often difficult for them to do if they have to run a household. However, among the sarpanches, there are also women with small children.

Most of the males are married as well; there are no widowers, since they normally remarry, especially if they have children. However, a higher number of the men are unmarried (10, that is 12.5 per cent), which has to do with the higher age of marriage for men. The ten bachelors are in the age group between 21 and 30 and have presumably not married yet. We have seen that most of the women are married, and also most of the men. How many children do they have?

The majority of female representatives have between three to four children (44.8 per cent) or even more, while only six women (5.7 per cent) do not have children, three in each block. In Balipatna, the three childless women are the unmarried ones; in Gania, they comprise the divorced samiti chairperson and two other women. Interestingly, Balipatna, considered to be the more 'developed' block, shows a higher percentage in the category five to six children (19.4 per cent in Balipatna, and 4.6 per cent in Gania). The mean number of children in Balipatna is 3.3 and in Gania exactly 3. Thus women in Balipatna do tend to have more children. One may assume that this rather high number of children is quite a burden on the time-budget of female representatives, at least if the children are younger. Many women are in an age group where the children are still infants or young adolescents, and arguably this puts quite a structural strain on women's intense participation in politics.

That there are more men without children (14, that is 17.5 per cent) in the institutions partly corresponds with the greater number of unmarried men; if we set them apart, the distribution is quite similar and also in this case Balipatna shows more families with children numbering five to six than in Gania. And again the mean number of children for males in Balipatna with exactly 3 is higher than for the men in Gania, which is 2.25. However, in the case of men, children normally do not feature very much as a kind of constraint as female household members tend to take care of the offspring.[5]

[4] One can presume that these widows do act as mere proxies of influential men, because usually widows still have a very low social position in rural India.

[5] The fact that the representatives in Balipatna have a higher number of progeny seems to be a bit counter-intuitive. Usually higher economic prosperity is supposed to contribute to a smaller family size. Maybe the threshold for the income, which leads to lesser children, lies higher. We shall see later that the income of the representatives is not very substantial in any case.

It is also interesting to have a look at family size. The number of household members ranges from one (a bachelor) to 23 (a female wardmember living in a joint family). The average size of a household is seven members for both genders. Whereas the family size in Balipatna is slightly bigger, which is a consequence of a higher number of children, the tendency towards a nuclear family in the female sample is greater (40.3 per cent in Balipatna *v.* 27.9 per cent in Gania). Looking at the female sample, one could get the impression that the higher incidents of nuclear families is due to the fact that Balipatna Block is more 'developed' or 'modern'. Joint families are regarded as a more traditional social institution. However, if the males and females are taken together, Balipatna does not have more nuclear families as compared to Gania.

There is the notion that females are freer to move in a nuclear family, where they are not under the sharp eyes of the mother-in-law. However, we should not forget that in a nuclear family there are no other daughters-in-law with whom to share the household duties, which could be an important resource for women elected to the PRI. Female representatives themselves mentioned this fact. Nalini, an Other Backward Class (OBCs)-wardmember in the remote gram panchayat of Gania Block, said for example:

I used to live in a joint family together with my husband's six brothers. But there was not enough space in this house, so the other families moved away and we stayed on. I prefer to live in a joint family, there is always somebody to talk to and the wives of my husband's brothers also helped with the children and the household work. My husband does not help me in the household work—men do not do this. So I have to care for everything alone.

A similar remark was made by Mina, an OBC-wardmember in the remote gram panchayat of Balipatna Block. She was talking of a fellow wardmember who is living alone with her husband and little children. Mina claimed that this woman is not attending the meetings regularly since she often has no time.

I myself do attend all meetings and do a lot of work because I live in a joint family and my sister-in-law is doing many household chores when I am busy with my panchayat work. In my gram panchayat only those women come regularly who live in a joint family or have older daughters who help them in the household.

In Gania, women are less likely than men to live in a nuclear family. And despite the arguments given above, women are more likely to come from a nuclear family than men, and one can assume that it is rather an advantage than a drawback. Normally the freedom of movement is more circumscribed for young *bahus* in their in-law's house. In any case, laborious household duties and the caring for small children is a heavy burden on their time budget for efficiently working for the PRI. The marital status, number of children, and type of family are important structural components, especially for women. Another important factor is social status, which is still mainly dependent on caste.

Caste

Caste plays a major role in Indian politics and no analysis is complete without a close look at the caste composition of the political bodies. Seats are reserved for Scheduled Castes (SCs) and Scheduled Tribes (STs) proportionally, and 27 per cent of the seats, but not the positions, are reserved for OBCs in the Orissa PRI. In this respect, one can assume that the caste composition of the institutions does reflect the distribution of caste in the localities, at least for the SCs and STs. Unfortunately, I could not get information for which caste specific seats had been reserved. The block personnel could provide only the category of reserved seats for women, but not for caste. Only in some cases could the sarpanch give information about seats, which had been reserved for OBCs. Thus, one cannot see whether SCs, STs, or OBCs were also successful in getting seats not reserved for them. During the survey I came across one SC lady in Gania who had contested a general women's seat. She was successful because the SC-population formed the majority in her ward, and no woman from a general caste was nominated. During the more intensive interviews, I talked with one husband of an SC-member. I asked him if he would contest also a seat not reserved for SCs in the next election. He was interested in running for the position of the sarpanch, which is currently held by a Brahmin. He told me that he would not contest this position unless it is reserved for SCs since he will otherwise not have a chance. We shall see in the next sub-chapter that some men from the reserved castes are also reluctant to contest general seats. Still, it is important to see what the caste composition of the present sample looks like (see Table 3.2).[6]

There is a higher percentage of general castes in the male than in the female sample. This substantiates the assumption that high-status families are more reluctant to let their womenfolk participate in politics. The reason should be seen in the greater seclusion of women in well-to-do or high-status

TABLE 3.2: CASTE OF REPRESENTATIVES—PERCENTAGES ACCORDING TO GENDER

	General (Brahmin and Karan)	OBC	SC	ST	Shia	Total
Female B	5 (8.1)	34 (54.8)	19 (30.6)	-	2 (6.5)	62 (59.0)
Female G	2 (4.7)	19 (44.2)	16 (37.2)	6 (14.0)	-	43 (41.0)
Total	7 (6.7)	53 (50.5)	35 (33.3)	6 (5.7)	4 (3.8)	105 (100.0)
Male B	8 (20.0)	25 (62.5)	6 (15.0)	-	1 (2.5)	40 (50.0)
Male G	-	28 (70.0)	8 (20.0)	4 (10.0)	-	40 (50.0)
Total	8 (10.0)	53 (66.3)	14 (17.5)	4 (5.0)	1 (2.3)	80 (100.0)

Note: Percentage in rows for Balipatna (B) and Gania (G) are calculated for each sample separately.

[6] In local terms, 'caste' is used for all social and religious groupings—thus also Muslims or STs are referred to and refer to themselves as constituting a caste group. I followed the regional nomenclature, except for the category of OBCs, which is not used by the population but is important because of administrative compulsions.

families. It might be disturbing that in Gania no men from the general castes are present in the sample. One could take this as an indication that the sample is not very representative. However, generally speaking the general castes are found less in the hinterland of Orissa, while more Brahmins live in the coastal areas of Orissa. It is furthermore a problem of classification, which becomes evident when we look at the high percentage of OBCs. I was told by several informants that in Orissa all castes, which are neither Brahmin nor Karan, nor SC and ST, are actually labelled as 'backward' and are included in the OBC category. However, the category of OBC is no reality in daily life and most Khandayats, for instance, do not consider themselves at all as backward. It is an administrative category, which has a meaning in states such as Bihar where several castes have been mobilized on this platform, but in Orissa many people have never heard about OBCs and would not label themselves as 'backward'. Thus, they called themselves Chasa (cultivator), Gauda (cow keeper), or Teli (oilman), and they have been classified by me and my assistants as OBCs.[7]

Apart from the high proportion of OBCs there is a notably higher than average proportion of SCs in the female sample as compared to the male sample. Part of the answer lies in the fact that in both blocks several positions had been reserved for SC women, e.g. the two samiti chairmanships. However, at least one SC woman has won a general women seat, and it seems that more low caste women have been promoted. If one supposes that the male sample is also more or less representative, percentages for the different caste groups should add up roughly to the distribution of percentages of caste groups in the region (see Table 3.3).

TABLE 3.3: CASTE OF REPRESENTATIVES—PERCENTAGES ACCORDING TO BLOCK

	General (Brahmin and Karan)	OBC	SC	ST	Shia	Total
Female B	5 (4.9)	34 (33.3)	19 (18.6)	-	4 (3.9)	62 (60.8)
Male B	8 (7.8)	25 (24.5)	6 (5.9)	-	1 (1.0)	40 (39.2)
Total	13 (12.7)	59 (57.8)	25 (24.5)	-	5 (4.9)	102 (100.0)
Female G	2 (2.4)	19 (22.9)	16 (19.3)	6 (7.2)	-	43 (51.8)
Male G	-	28 (33.7)	8 (9.6)	4 (4.8)	-	40 (48.2)
Total	2 (2.4)	47 (56.6)	24 (28.9)	10 (12.0)	-	83 (100.0)

Notes: 1. Percentages are given according to distribution of caste group in the region.
2. B: Balipatna; G: Gania.

[7] As noted already, the caste structure is very complex, and the status of castes differs from locality to locality. I also mentioned that, apart from the Brahmins, Karans, and Khandayats, the caste groups had or have their caste councils. Many castes today do bear a title instead of a surname, such as Behera. One cannot deduct the caste from the surname alone, which is partly possible in other states of India. It is, therefore, very difficult to label castes and determine their ritual and social status without close investigations in the villages.

The *District Stastical Handbook* with data on Balipatna (GoO, s.d.a) gives the percentage of SCs as 26.5 per cent, the percentage of STs as negligible, and 7.3 per cent for Muslims. The number of OBCs is not given in the Statistical Handbooks, but we have learned that 27 per cent of the seats (except the positions) are reserved for them. However, OBCs are more present than the share reserved for them. Castes labelled as OBCs normally do not hesitate to contest general seats, and several people whom I knew to have contested from an OBC-seat were not aware of it. They responded that they have contested a general seat. The reservation for OBCs in Orissa seems to be mainly a political move, which was perhaps not really necessary to secure sufficient representation for them in the institutions. How does this sample correspond with the information on the other caste groups? The sample of the SC category in Balipatna adds up to 24.5 per cent. The difference of 2 per cent is understood to be in the range of sampling and does not give major cause for concern. It might have to do with a little bias in the sampling in so far as proportionally more sarpanches have been interviewed in the male sample. That there are no STs in the Balipatna sample mirrors the actual absence of STs in this region. The only group which could give some basis for worry is the category of Muslims. In this sample, the percentage of Muslims is only two-thirds than that actually present in the population (4.9 per cent as compared to 7.3 per cent in the overall population). This could either be due to the fact that no seats are reserved for Muslims according to their proportion, and if they live dispersed they will not be able to elect a member from their community. The other reason is that their numbers are very small; and two to three more Muslims interviewed would have rectified the problem, if it actually were a bias.

In Gania, there are 23.16 per cent SCs, 10.57 per cent STs, and no Muslims (GoO, s.d.b). The near absence of general castes was discussed above. The proportion of SCs in our sample is around 5 per cent higher than the distribution in the population. This gives some cause for concern that there could be an unintended bias in the sample. However, the high number of SCs has partly to do with the fact that some of the positions were reserved for SC women, such as the sarpanch of Gania and the samiti chairperson. Additionally, there cannot be a mistake of sampling, since the high proportion of SCs in Gania is mainly due to the high proportion of SC women. Since I have interviewed all but one woman present in the Gania PRI, the female sample gives the actual distribution of castes among the women representatives. Thus, the problem could be the small number of PRI-members in Gania, where one person counts more proportionally than in Balipatna. We have also seen that at least one SC woman won a general seat. Considering all these arguments, one can conclude that the sample is sufficiently representative in order to allow the drawing of substantive conclusions. It is also rewarding to have a look at the caste composition of different positions to see whether and in which positions caste groups are over- or under-represented despite the reservation policy.

I shall name here only the most striking cases of over- or under-

representation, as minor differences are due to the size of the sample. In Balipatna, there are more sarpanches from the general castes as compared to their percentage in the overall sample (30 per cent as compared to 12.7 per cent). Due to this, there are less OBCs and SCs in this position. Scheduled Castes are found more often in the category of wardmember (60.2 per cent as compared to 24.5 per cent of their overall strength). In Gania, the SCs got more than their proportional share in the category of sarpanch, samiti member, and samiti chairperson, which is due to reservations for SC women in these positions. Accordingly, the OBCs are underrepresented in the category of sarpanch.

The non-proportional presence of SCs in certain categories is mainly due to the practice of reservation and the sample size. Thus, the only 'imbalance', which can be solely attributed to the decision of the electorate, is the over-representation of general castes among the sarpanches in Balipatna. One can only speculate how the sample would look like without the reservations for specific groups, but I think it is safe to assume that it would be much different from the sample presented here.

Occupation

Occupation is a denominator of social status and has been traditionally linked with caste. Additionally, occupation also tells us something about economic standing, which will be shown in greater detail in the next sub-Section. The categories for occupation are not always sharp—sometimes people followed different occupations (for example, being a 'salaried' samiti member but also busy in cultivation). In these cases, the main occupation indicated by the respondent was coded (see Table 3.4).

Only very few women describe themselves as cultivators.[8] The majority of the male representatives are cultivators, complying with the general occupational pattern of rural society in Orissa. However, the percentage of 57.5 is less than in the general population, which is between 70 and 80 per cent. The category of self-employed comprises shopkeepers, petty traders,

TABLE 3.4: MAIN OCCUPATION OF RESPONDENTS

	Culti-vator	Self-employed	Wage worker	Casual labour	Salaried in PRI	Salaried outside	Unpaid family worker	Non-worker	Total
Female B	2 (3.2)	-	2 (3.2)	6 (9.7)	5 (8.1)	2 (3.2)	45 (72.6)	-	62 (59)
Female G	6 (14.0)	6 (14.0)	2 (4.7)	5 (11.6)	3 (7.0)	-	20 (46.5)	1 (2.3)	43 (41)
Total	8 (7.6)	6 (5.7)	4 (3.8)	11 (10.5)	8 (7.6)	2 (1.9)	65 (61.9)	1 (1.0)	105 (100)
Male B	22 (55.0)	11 (27.5)	1 (2.5)	-	2 (5.0)	1 (2.5)	-	3 (7.5)	40 (50)
Male G	24 (60.0)	11 (27.5)	-	-	2 (5.0)	-	-	3 (7.5)	40 (50)
Total	46 (57.5)	22 (27.5)	1 (1.3)	-	4 (5.0)	1 (1.3)	-	6 (7.5)	80 (100)

Note: Percentage in rows for Balipatna (B) and Gania (G) are calculated for each sample separately.

[8] Cultivators are people working on their own fields, on rented fields, or on both.

artisans, and fishermen. In Gania, most of the women who were labelled as
self-employed were artisans (bell-metal works and making of images) or
basket weavers, drawing only a very small cash income. Wage-workers are
agricultural workers and workers in other sectors—they are normally rather
poor. Only few women do earn wages; casual labourers are persons who hire
out their labour not permanently (like the wage-workers), but work in the
fields during the planting season, for example. They are mainly women from
the Scheduled Castes. There are no male representatives working as casual
labourers. Representatives describing themselves as salaried in the PRI are
sarpanches, samiti chairpersons, or even naib-sarpanches, drawing a monthly
'salary' between Rs. 300 to 1,500. However, not all persons holding these
positions understood themselves as salaried in this respect or they felt that
income from cultivation was more important. The two women who are
salaried outside the PRI are employed as Anganwadi Workers for the mid-
day meal scheme and draw a cash income between Rs. 150 and 200 per
month. Unpaid family workers are women working on their own fields and
in the household without getting cash income. It is often a matter of
perception that some women working on the family fields respond that they
are cultivators and others respond as not working outside the household.
The latter have been coded as unpaid family workers. Non-workers are
mainly older representatives who have other household members working or
some unemployed youth who often turn to politics as a source of income.

It is important to note the differences between the occupational patterns of
women in the two blocks. Substantially more women in Gania are working
outside their homes in some way or the other than in Balipatna. The category
of unpaid family workers in Balipatna comprises nearly 73 per cent, whereas
in Gania 46.5 per cent belong to this category. It has been noted frequently
that female work participation enhances their social standing because of
independent cash income. Furthermore, work outside the home is supposed
to have useful 'educational' effects (Drèze and Sen 1999: 160). Also Bina
Agarwal (1994: 68ff.) argues that outside work raises the status and self-
esteem of women and improves their standing in the family.

In Gania, the higher participation rate of women is mainly the result of
poverty. In Balipatna, women come from richer households, as we shall see
below, where females are more secluded. However, some of them are
members in women's groups, and thus also contribute financially to the
household. In this respect it seems that women in Gania are not much better
off because of their outside work than the female representatives in Balipatna.
The gain seems to be offset, which might be due to the kind of work, where
women do not have much public exposure after all, but return home
immediately when their work is done.

Since a majority of women representatives were labelled as unpaid family
worker, one cannot gain much knowledge on their socio-economic status.
Thus, the married women were asked in addition to give the main occupation
of their husbands.

If the figures in Table 3.5 are compared with the ones of the male

TABLE 3.5: MAIN OCCUPATION OF RESPONDENT'S HUSBANDS

	Culti-vator	Self-employed	Wage worker	Casual labour	Salaried outside PRI	Non-worker	Total
Balipatna	17 (30.3)	5 (8.9)	6 (10.7)	4 (7.1)	8 (14.3)	7 (12.5)	56 (59.0)
Gania	9 (23.1)	8 (20.5)	5 (12.8)	3 (7.7)	5 (12.8)	1 (2.6)	39 (41.0)
Total	26 (27.4)	13 (13.7)	11 (11.6)	7 (7.4)	13 (13.7)	8 (8.4)	95 (100)

Notes: 1. Percentage in rows for Balipatna and Gania are calculated for each sample separately.
2. (n=95) since widows and deserted women did not give their husband's occupation.

representatives in Table 3.4, there are considerably fewer husbands busy in agriculture (27.4 per cent as compared to 57.5 per cent). More husbands are self-employed (but mainly as artisans), wage-workers, or even casual labourers. Among the salaried husbands is a teacher, others are just peons without much income. The occupational pattern of the husbands as compared to the male representatives seems to point to the direction of lesser economic status of the households from which the female representatives are drawn. In order to prove this assumption we look at the income and landholding of the households.

Economic Position of Representatives

Economic standing is always considered as having importance in political matters. Traditionally, the PRI were literally manned by the propertied and landed elite. Everybody believes that for the elections to higher positions money is needed for the entertainment of voters, bribes, etc. However, cash income is very difficult to assess in rural Orissa, as most households are not fully drawn into the cash economy. Often women do not have much of an idea about the cash position of the household, and frequently the answer was given by the husband or was calculated through knowing the assets of the family. Thus, the income given (Table 3.6) does also take into account the landed property that is separately given in Table 3.7.[9]

The Indian poverty line was Rs. 11,000 per annum in 1992[10] and was around Rs. 15,000 in the year 2000. If the latter amount is taken, 59.9 per cent of the female sample is below poverty line. This is quite remarkable when one considers the notion that the rural elite traditionally dominated the PRI. As expected, there is a difference between the economic positions of women in the two blocks. In Gania, more than 72 per cent of the women are below poverty line, and in Balipatna around 59 per cent are below poverty line. Recall that the figures for the total households under poverty line were

[9] The figures for cash income cannot be taken as absolute figures. There is a tendency especially in the richer segment to give a lower income. There is also a tendency in the poorer segment to understate their income since they are conscious about the official poverty lines. They state an income below the poverty line to be eligible for certain benefits. However, this table still gives a good enough idea about the financial position of the households in relative terms.

[10] That is the figure for the 1992 survey (GoO s.d.a.: 71). At the time of this survey 1 US$ was equivalent to Rs. 42.

TABLE 3.6: Total Family Income per Annum of Respondents in Rupees

	<5000	5000–<10,000	10,000–<15,000	15,000–<20,000	20,000–<30,000	30,000–<50,000	50,000–<1,00,000	1,00,000 and more	Total
Female B	12 (22.2)	9 (16.7)	11 (20.4)*	2 (3.7)	10 (18.5)	6 (11.1)	3 (5.5)	1 (1.8)	54 (55.7)
Female G	6 (14.0)	22 (51.2)	3 (7.0)	4 (9.3)	3 (7.0)	2 (4.7)	1 (2.3)	2 (4.7)	43 (44.3)
Total	18 (17.1)	31 (29.5)	14 (13.3)	6 (5.7)	13 (12.4)	8 (7.6)	4 (3.8)	3 (2.9)	97† (100)
Male B	-	9 (22.5)	8 (20.0)	7 (17.5)	5 (12.5)	6 (15.0)	1 (2.5)	4 (10.0)	40 (50)
Male G	3 (7.5)	14 (35.0)	9 (22.5)	4 (10.0)	5 (12.5)	1 (2.5)	2 (5.0)	2 (5.0)	40 (50)
Total	3 (3.8)	23 (28.8)	17 (21.3)	11 (13.8)	10 (12.5)	7 (8.8)	3 (3.8)	6 (7.5)	80 (100)

Notes: *Percentage in rows for Balipatna(B) and Gania(G) are calculated for each sample separately.
† (n=177), since eight women could not give their financial position and other family members were not available. Thus, they have been deleted from the sample.

46.8 per cent in Balipatna and 99.3 per cent in Gania in 1992. Thus, women in Balipatna are over-proportionally drawn from low-income households whereas in Gania they tend to come from better-off households in comparison to the general population.

The male incumbents come from higher income groups, and fewer households have less than Rs. 10,000 per annum (46.6 per cent of women compared to 32.6 per cent of men). One reason for this seems to be that families from higher economic strata are very reluctant to encourage their womenfolk to join politics, and we have seen that among women in politics there is a much higher proportion of SCs (compare Table 3.2). There are only three men with family income below Rs. 5,000 per annum and all are from Gania. All in all, 53.9 per cent of the men are below poverty line, as compared to nearly 60 per cent of the women. This gap is not too pronounced, but much fewer men come from households with income below Rs. 5000 per annum.

As in the female sample, there is a marked difference between the levels of men's income in Gania and Balipatna: 65 per cent of the men in Gania are below poverty line, whereas in Balipatna this figure is 42.5 per cent. One can conclude that mainly persons from modest background have been elected to the institutions. However, as Orissa is a very poor state, there are not too many wealthy families in any case. Additionally, the position of a ward-member, which forms the majority of this sample, is not too interesting for the rural elite. Not surprisingly, one can establish a positive correlation between the position in the PRI and income: the higher the position, the higher the income.[11] Cash income is one important variable in assessing the economic status of a family. In the countryside, however, the most important asset is land (see Tables 3.7 and 3.8). Here, a problem encountered is that some people will understate their assets, especially big landowners, as there is also a land-ceiling in Orissa.

One-third of the women come from landless families. The number is significantly higher in Balipatna (41.0 per cent v. 23.3 per cent). Most of these landless families are very poor, but some have income from shops or

TABLE 3.7: LANDHOLDING OF HOUSEHOLDS OF FEMALE RESPONDENTS IN ACRES

	Landless	1 or less	1.5–2.5	3–5	6–10	10 <	Total
Balipatna	25 (41.0)	22 (36.1)	7 (11.5)	6 (9.8)	-	1 (1.6)	61 (58.7)
Gania	10 (23.3)	11 (25.6)	10 (23.3)	5 (11.6)	5 (11.6)	2 (4.7)	43 (41.3)
Total	35 (33.6)	33 (31.7)	17 (16.3)	11 (10.6)	5 (4.8)	3 (2.9)	104 (100)

Notes: 1. Percentage in rows for Balipatna and Gania are calculated for each sample separately.
2. (n=104), since one woman in Balipatna could not answer the question and was deleted from this sample.

[11] The average income of the sarpanches ranged from Rs. 20,000 to Rs. 50,000, of the samiti chairpersons from Rs. 50,000 to Rs. 1,00,000, while wardmembers had Rs. 10,000 to Rs. 20,000.

TABLE 3.8: LANDHOLDING OF HOUSEHOLDS OF MALE RESPONDENTS IN ACRES

	Landless	1 or less	1.5–2.5	3–5	6–10	10 <	Total
Balipatna	11 (27.5)	13 (32.5)	7 (17.5)	6 (15.0)	3 (7.5)	-	40 (50)
Gania	4 (10.0)	9 (22.5)	10 (25.0)	9 (22.5)	7 (17.5)	1 (2.5)	40 (50)
Total	15 (18.8)	22 (27.5)	17 (21.3)	15 (18.8)	10 (12.5)	1 (1.3)	80 (100)

Note: Percentage in rows for Balipatna and Gania are calculated for each sample separately.

are salaried.[12] Thus the landless families are, economically speaking, a mixed group. One can still assume that even if they nowadays have income through self-employment, they do not come from the traditional elite, which is the landholding stratum of rural society. In Gania, the size of landholdings tends to be bigger. In Balipatna the average landholding is 1.7 acres, whereas in Gania it is 3.6 acres, the mean total being 2.6 acres. However, that does not imply that the people are better endowed in Gania, as there are no irrigation facilities in this block. One acre in Balipatna can produce more harvest than the same piece of land in Gania.

As with income, men tend to come from families with larger landholdings and higher income. The number of landless is nearly one-fifth (Balipatna 27.5 per cent and Gania 10.0 per cent), and most of the families do not own more than 2.5 acres (48.75 per cent). Generally, the pattern resembles that of the women, except that men's landholdings tend to be bigger. The mean landholding in Balipatna is 2.5 acres and in Gania 3.6 acres—together 3.1 acres. Actually, the average size of the landholding for men and women is the same in Gania (3.6 acres), but the amount of landless women is much higher; also the size of the landholdings of male respondents in Balipatna is much higher than that of the women (2.5 acres as compared to 1.7 acres). The incidence of landlessness is also much lower among the men.

Education

Education is considered to be one of the important independent variables for participation and effectiveness in politics.[13] Ordinary villagers as well as scientists and activists frequently bewail lack of education among politicians. They argue that the reservation for women, especially in the rural areas where the educational level is extremely low, is a farce and turns women into puppets on the string pulled by influential men. Lack of education is seen as an impediment for conscious decision-making, for acquiring, processing, and using relevant information, and for acting in a more or less autonomous

[12] From the landless households eleven are below Rs. 5,000, ten between Rs. 5,000 and Rs. 10,000, five between Rs. 10,000 and Rs. 20,000, six between Rs. 20,000 and Rs. 50,000, and one between Rs. 50,000 and Rs. 1,00,000 per annum.

[13] This has been established by most studies on political behaviour; information is a crucial input and often the capacity to get information and to utilize it is a function of education. Its importance should thus not be underrated. For classical participation studies and deliberations on personal factors influencing political participation see among others Milbrath (1965) and Lipset (1959).

way. Illiteracy definitely restricts a person's access and ability to instrumentalize information and makes her thus dependent on others. In higher positions especially, literacy is important for reading and understanding the orders, rules, and regulations. Education usually enhances the personal feeling of efficacy, and lack of it might contribute to low self-esteem.

The results of the survey show the expected—women elected to the PRI have not much of a formal education. As seen in Table 3.9, the majority of them visited school up to primary level only, and among them many dropped out after class 2 or 3 itself. Therefore, they can hardly be considered literate in a functional sense. It is significant that 19 per cent never went to school, but still most of them have learned to sign their name, which is the minimum prerequisite for a position in the PRI.[14] Nevertheless, to perform well as a wardmember, not many literary skills are necessary. Those women who have been elected as sarpanches or samiti chairpersons generally have a higher education: One sarpanch has primary education only; three sarpanches and one samiti member went to class VI–IX; two sarpanches, one samiti member, and one samiti chairperson studied up to class 10; one sarpanch is a graduate, and one samiti chairperson is a post-graduate. Yet, also in this group there are problems related to the lack of formal education. One obstacle is that most of the rules and regulations issued by the Panchayati Raj Administration are still in English. This problem has received attention in the bureaucratic quarters, and now those manuals that are important for the representatives are printed in Oriya as well. However, the Panchayati Raj Secretary of Orissa admitted that even if the documents were translated into Oriya, they were often too technical and incomprehensible to ordinary people, and so they would try to simplify them as well.[15]

In many cases the representatives are very much dependent on the administrative staff, who function as translators but also as interpreters of the content. This gives the bureaucracy a considerable influence over the elected representatives. Kanchana, the samiti chairperson of Gania told me that she asks the peon to translate the relevant documents for her. She feels more comfortable with him than with any other official. The circulars are handed over to her by the Block Development Officer (BDO), but there were some tensions between her and the previous BDO, and so she did not have confidence in him. One has to note that also very few of the men in higher positions are able to understand or speak English. Thus, the lack of formal education relevant for the work of the PRI is not a problem for women alone, but a general predicament for rural representatives.

[14] This is the pragmatic adjustment to the rule as laid down in the Orissa *Grama Panchayat Manual 1994*. This rule declares that a person should be disqualified for holding office if s/he is unable to read or write [Section (11 (b) and (c) (ii), p. 6)]. If one would follow this principle strictly, many constituencies would remain vacant. The practised compromise is that the incumbents should at least be able to write their name.

[15] This information was obtained in a personal communication with Mr Chinmay Basu, Commissioner-cum-Secretary, Department of Panchayati Raj, Government of Orissa, 16 December 1998.

TABLE 3.9: EDUCATIONAL LEVEL OF FEMALE RESPONDENTS

	Illiterate	Can sign name	Primary (I–V)	VI–IX	X	XI < Graduation	Graduation	Post-graduation	Total
Balipatna	-	11 (17.7)	29 (46.8)	16 (25.8)	4 (6.5)	-	1 (1.6)	1 (1.6)	62 (59.0)
Gania	1 (2.3)	8 (18.6)	21 (48.8)	9 (20.9)	4 (9.3)	-	-	-	43 (41.0)
Total	1 (0.9)	19 (18.1)	50 (47.6)	25 (23.8)	8 (7.6)		1 (0.9)	1 (0.9)	105 (100)

Note: Percentage in rows for Balipatna and Gania are calculated for each sample separately.

TABLE 3.10: EDUCATIONAL LEVEL OF THE HUSBANDS OF FEMALE RESPONDENTS

	Illiterate	Can sign name	Primary (I–V)	VI–IX	X	XI < Graduation	Gradua- tion	Total
Balipatna	6 (10.2)	6 (10.2)	19 (32.2)	18 (30.5)	7 (11.8)	2 (3.4)	1 (1.7)	59 (60.2)
Gania	1 (2.6)	4 (10.2)	17 (43.6)	10 (25.6)	1 (2.5)	5 (12.8)	1 (2.5)	39 (39.8)
Total	7 (7.1)	10 (10.2)	36 (36.7)	28 (28.6)	8 (8.2)	7 (7.1)	2 (2.0)	98 (100)

Notes: 1. Percentage in rows for Balipatna and Gania are calculated for each sample separately.

2. (n=98); some of the widows also gave the educational level of their expired husbands.

Returning to the quantitative sample, it is interesting that there is no marked difference between the educational level of women in Gania and Balipatna. This was expected in respect to the gap in educational levels of the general female population in both blocks. One could have inferred that, accordingly, female members in Gania have lesser educational qualifications. We shall see in the next sub-chapter that during the selection process villagers were very conscious of the matter of education and tried to elect the most educated woman who was willing and available. It is often assumed that the women are guided or at least supported by their husbands, and so it is also informative to look at their educational level (see Table 3.10).

More husbands are illiterate, yet there was no need for them to learn to sign their name in order to qualify for participating in the PRI. The majority of them studied only up to primary level; slightly more husbands than wives have been to secondary school; and there are some who have studied up to class 11 and 12, a category that is not found among the women. However, generally speaking, the husbands are not much better educated than their wives, and some are even less educated.[16] Between Balipatna and Gania, again there is not a marked difference; more men went to secondary school in Balipatna, but more husbands are educated up to +2 in Gania. Hence, the female members of the PRI are not very educated in a formal sense, but neither are their husbands.

The male members of the PRI are better educated than the female ones (see Table 3.11), and this complies with the pattern of educational levels of the two sexes in the general population. All male incumbents went to school, even though one-third went to school only up to primary level as well. Mention should be made here of the marked difference between Balipatna and Gania. The educational level in Gania is considerably lower than in Balipatna. A little more than half of the men went to school only up to

[16] In 32.4 per cent of the cases they have the same education, in 47.6 per cent husbands are slightly better educated, and in 20 per cent of the cases the wives are better educated than their husbands. Ten women, for example, went to primary school while their husbands had no education at all; seven went to class VI to IX while their spouses went only to primary school (one even being illiterate), and three women educated up to class X have husbands who were only educated in primary school or up to class IX.

TABLE 3.11: EDUCATIONAL LEVEL OF MALE RESPONDENTS

	Primary (I–V)	VI–IX	X	XI < Graduation	Graduation	Post-graduation	Total
Balipatna	5 (12.5)	16 (40.0)	12 (30.0)	4 (10.0)	2 (5.0)	1 (2.5)	40 (50)
Gania	21 (52.5)	7 (17.5)	5 (12.5)	5 (12.5)	1 (2.5)	1 (2.5)	40 (50)
Total	26 (32.5)	23 (28.8)	17 (21.3)	9 (11.3)	3 (3.8)	2 (2.5)	80 (100)

Note: Percentage in rows for Balipatna and Gania are calculated for each sample separately.

primary school, whereas in Balipatna the majority went to secondary school, a substantial number even being matriculates and above.

Three points emerging from this pattern should be noted: First, female members are not very educated, but there is not much variation between the educational level of the women in Balipatna and Gania. Second, the difference in educational levels of the men between the two blocks is marked, and they are generally higher educated than the female representatives. Third, the husbands are not much better educated than their wives, and again there is not much variation between the two blocks. It appears that female incumbents are drawn from households which have an overall lower educational background than their male colleagues. The pattern of the male incumbents, which shows a difference in the educational level between the two blocks, complies with the macro-data of the two regions—the female sample does not.

The respondents were also asked about the highest educational level reached by any parent. Knowing the level of education of the previous generation enables to draw conclusions on the progress of education in the countryside and intergenerational mobility in general. Furthermore, this information illuminates the intellectual environment in which the female and male politicians have been brought up. Obviously it was the educational level of the father that was highest, whereas most of the mothers never visited school. Only the father of one male member has been a graduate, and there are no postgraduates among the parents. A new category was found in the sample of parents' education, namely no schooling but the functional ability to read and write. Generally speaking, the previous generation was not very educated. In 44.8 per cent of the cases of female wardmembers, neither parent has visited school. 39 per cent of the parents went up to primary level only and very few went beyond that (16.1 per cent). In the case of the male members, 40 per cent of their parents have never visited school and another 40 per cent have been to primary school. Compared with the previous generation, the educational level has improved considerably over one generation. This could also be an indicator of the fact that the present representatives are drawn from lower strata of society than earlier,[17] a fact which is also supported by the level of income of the representatives. There is no big difference in the educational family background of male and female

[17] For a similar line of argument when discussing rural elites in Gujarat and Orissa, see Mitra (1992: 97f.).

members, though the percentage of illiterate parents is higher in the female sample (36.2 per cent *v.* 27.5 per cent), but nearly the same concerning primary education. There is a more perceptible gap between the educational levels of the two regions—a trend that still holds today. In Balipatna, the former generation was better educated than in Gania.

Generally, male education has advanced quite a lot, but so has the female, if one considers that most of the mothers had no formal education at all. Education has made progress for both genders, but women are still lagging very much behind men, and in both cases a lot remains to be desired. In the above discussion, it became obvious that women do not have many formal educational resources with which to cope in the new situation. In this respect, but also for other reasons, it is interesting to look at the political background of the elected members of the PRI.

Previous Political Experience and Political Background of the Family

It is important to investigate whether the present incumbents have any previous political experience. Political experience could help them to perform well despite low formal educational qualifications. Mohanty and Misra (1976: 253) concluded this when they mentioned the low educational level of MLAs in Orissa, which was partly offset by their political experience.[18] Presumably, this argument could hold for lower level politicians as well.

The survey data showed that more women than men are novices (89.5 per cent *v.* 55.0 per cent; no major regional variation), a finding which is not too surprising. As noted, there was already one election held in 1992 with 33 per cent of the seats reserved for women, but most of the constituencies rotated and women were in office only for a short time. But also more than half the men have no prior political experience, and even more are novices in the PRI. It will take several elections until a majority of women that have served for more than one term will be found, and until the lack of formal education can be compensated with political experience. Another fact that comes to play here is the rotation of constituencies. Unless women also contest seats not reserved for them, they will be thrown out of office after one term and will only have the chance to be present in the institutions again after ten years. However, men also have been unseated by the reservation of constituencies, which provides an explanation for the large number of novices. Thus, the way the reservation for various social groups in politics is implemented in

[18] 'While keeping in mind the fact that our educational degrees are at best irrelevant to political activity, we find that even in a backward state like Orissa a large majority of the M.L.A.s have had a minimum formal education. Very low formal education may be a handicap for M.L.A.s who may take months to understand the rules and procedures of the assembly. Generally, they also find it difficult to rise on the political ladder. But political experience in some cases far outweighs low formal education. There are people like the CPI leader, Gangadhar Paikaray, who have not found their low education as any handicap' (Mohanty and Misra 1976: 253).

India poses severe problems for gaining political experience and serving as a representative for consecutive terms.

Not all representatives received their political experience through serving in the PRI—only eight women and 18 men have been in the PRI before. These eight women were wardmembers under the 1992 election. Presumably most other wards have rotated in the 1997 election, and women successfully contested only seats reserved for them.[19] One woman and four men had been defeated in the PRI, and seven men and two women were political activists.

Hence, just 7.6 per cent of the women have previous experience in the PRI in contrast to 22.5 per cent of the men. However, even the rather low quantity of 22.5 per cent men who previously held positions in the PRI indicates that there is a rather rapid turnover of representatives in the institutions; I encountered only few men who have served for several terms. Some men have definitely been up-seated because of the reservation of their constituency for women, but there must also be other factors for this. Either villagers did not vote again for members who did not do a good job or were corrupt etc., or representatives themselves decided for various reasons like age or workload not to run again.[20] The reservation for women even further accelerates the pattern of a high turnover of representatives, as the percentage of members who have already served in the PRI comes down to 14.1 per cent for the whole sample.

It is mandatory to investigate whether the composition of the local political elite is changing. Affirmative action in politics always aims at introducing new elites into the decision-making bodies, hoping for changes in the content and the way politics is done. If the new entrants still belong to the traditional ruling elite and the same families still hold power, changes might be marginal. Additionally, before elections took place under the 73rd Amendment, many critics proposed that only women with political family background would get nominated and elected. The assumption is that women would accordingly be mere proxies, keeping the seat warm for the male family members who would run again in the next election.

A little over 30 per cent of the women come from politically active families whereas the rest claim that none of their relatives are involved in political activities (see Table 3.12). One can debate whether one-third is a lot or not. Generally, it is intuitive that political families are more willing to introduce their womenfolk into politics than families who are not interested in politics

[19] That these eight wards did not rotate has to do with the fact that some wards have been re-delineated for the election in 1997. As a result, some of the wards happened to be reserved for women in a consecutive term. This fact was very much resented by the villagers concerned, as we shall see later.

[20] Also Lieten (1996: 109f.) found a rapid turnover rate of PRI-representatives in West Bengal. However, he mainly interprets this as being due to corruption charges and the voting out of power by villagers. He does not take into account that some representatives might not be willing to serve for another term for various personal or political reasons. That this is actually so came up in many discussions with incumbents and previous wardmembers.

TABLE 3.12: POLITICAL FAMILY BACKGROUND OF RESPONDENTS

	Yes	No	Total
Female B	16 (25.8)	46 (74.2)	62
Female G	18 (41.9)	25 (58.1)	43
Total	34 (32.4)	71 (67.6)	105
Male B	10 (25.0)	30 (75.0)	40
Male G	11 (27.5)	29 (72.5)	40
Total	21 (26.3)	59 (73.8)	80

Note: Percentage in rows for Balipatna (B) and Gania (G) are calculated for each sample separately.

anyway. Yet, also women who have seen politics at work might be more interested to come forward of their own accord. One should acknowledge that for women a political family background can be an important political resource. That does not deny the fact that some women might indeed be acting as mere proxies, but this cannot be argued from the fact of a political family connection alone. Only slightly fewer men than women (26.3 per cent *v.* 32.4 per cent) claim that they have politically active relatives, and thus it is not just a female phenomenon. It appears that the prevalence of political families is a general sociological feature in India that is not necessarily connected to gender. However, it is still interesting to note that in Gania more women come from families that are active in politics. This could be a hint that in the less developed block the traditional elite still has a stronger hold over the PRI and that political family background is an even more important resource for women there.

It is instructive to analyse which relatives are active in politics. Where husbands or fathers-in-law are very active, one can presume that they are more likely to work closely with their wife/daughter-in-law, or even dominate her in decision-making. This will be much less in cases of family relations, who are living at a greater distance. In Gania, more husbands are involved in politics (eight in Gania *v.* two in Balipatna) and fewer other members of the woman's in-laws (two in Gania *v.* eight in Balipatna). Eight female respondents, four each in Balipatna and Gania, have politically active members in their native family, and one woman in Balipatna has a female relative active in politics. In Gania, four representatives have more than one relative active in politics, in Balipatna this holds for one representative only. Males have in response only those persons politically active in their own family, mainly fathers (8), brothers (6), and paternal uncles (4). One male in Balipatna has a sister who is active in politics. The findings also show that most of the relatives are or were active in the PRI itself (20 among the females, 17 among the males). Also interesting was the answer 'defeated in PRI', given by six female wardmembers, three in each block. This could be an indicator that relatives have tried to get into the PRI previously, but failed, whereas now they could manage to get a family member elected. Thus, there was political ambition previously in this family and maybe, thanks to the women's quota only, this household got the chance to become active in local politics.

Membership in Social Organizations

A further resource for representatives for performing well in political
institutions could be involvement in social activities (see Table 3.13). For
women, involvement in social organizations might have already led to some
exposure to the external world. Additionally, they might have gained some
competence, such as accounting, leading discussions, formulating their point
of view, etc. Participation in social groups also indicates a general public
spirit, depending on the kind of activity. If female representatives are active
in women's groups, they probably have some links to their female consti-
tuency, which could help them in obtaining information on the women's
views. For men, their involvement shows the degree of public spirit, and one
can assume that they have gained some important capabilities for performing
better in politics as well. Another consideration is the hypothesis proposed
by the 'social capital approach' that the democratic process is enhanced by
the existence of civil society groups.[21]

It was found that men are more active in various social groups than
women (70 per cent men *v.* 32.4 per cent women). This can be attributed, on
the one hand, to the high burden of household duties for women, but also to
the generally low degree of their public exposure. Women are less likely than
men to participate in groups apart from their family relations. Whereas
the percentage of men involved in social groups is the same in both blocks
(70 per cent), there is a gap between similarly involved women in Gania and
Balipatna. In Gania slightly more than 40 per cent, as compared to a little
more than one-quarter in Balipatna, are involved in one social group or
other.

The majority of female representatives are members of women's groups.
However, most of the groups in Gania are not really functioning. In
Balipatna, on the other hand, the women's groups are working much better
and have benefited the women there in a greater degree. We will see later that
the difference in the quality of the women's groups has a greater impact than
the quantitative aspect of membership. Interesting is also women's mem-
bership in co-operative societies. Either husband or wife can get registered
and they are eligible for certain benefits. Most of the respondents were
involved in milk co-operatives. There are several men and women involved
in committees; in the case of women, these were mainly school committees.
Men were frequently active in youth groups, and in Gania they even tended
to be involved in more than one group. Thus it seems that involvement in
social groups is higher for men as well as women in Gania than in Balipatna.

HOW DID THEY COME TO BE PRESENT?: THE ELECTION

The previous section presented in detail who the representatives are in terms
of their socio-economic status. We turn now to the elections to the PRI that

[21] For the social capital approach, see Putnam (1993, 1995). For critical voices, see
Tarrow (1996) and Levi (1996).

TABLE 3.13: TYPE OF SOCIAL GROUPS IN WHICH RESPONDENTS ARE INVOLVED

	Women's group	Co-op. society	Committee (e.g. school)	Cultural/ Religious	Develop. oriented	Any other	More than one	DK	Total
Female B	8 (50.0)	5 (31.3)	-	-	-	1 (6.3)	-	2 (12.5)	16 (47.0)
Female G	12 (66.7)	2 (11.1)	4 (22.2)	-	-	-	-	-	18 (53.0)
Total	20 (58.8)	7 (20.6)	4 (11.8)	-	-	1 (2.9)	-	2 (5.9)	34 (100.0)
Male B	-	6 (21.4)	1 (3.6)	2 (7.1)	2 (7.1)	14 (50.0)	-	3 (10.7)	28 (50.0)
Male G	-	10 (35.7)	3 (10.7)	-	2 (7.1)	6 (21.4)	7 (25.0)	-	28 (50.0)
Total	-	16 (28.6)	4 (7.1)	2 (3.6)	4 (7.1)	20 (35.7)	7 (12.5)	-	56 (100.0)

Notes: 1. Percentage in rows for Balipatna (B) and Gania (G) are calculated for each sample separately.
2. (n=90).

took place in January 1997. In order to understand why and how those women and men came to be present in the institutions, one has to analyse the election process. It is significant to analyse how the women came to be elected. Why did they enter the arena of local politics? Was it their own interest in politics or were they pushed? In a Western democracy such as Germany, it would be very difficult to suddenly fill a quota of this magnitude. However, in India the more entrenched patriarchal values do act as 'facilitator': Husbands or fathers-in-law filed most of the nominations, often without informing the women in question. Later, when they were told, the women nodded in assent—as dutiful *pativratas*.

Contest of Reserved Seats

It was found that none of the elected women had contested a seat that was not reserved for them. This finding indicates that without the reservation for women it is likely that no women would be present in the institutions of local governance, unless they were to be co-opted. This is ample proof for the importance of the quota for women's political presence in the PRI! However, could women at least imagine standing for election on a non-reserved seat as a kind of hypothetical deliberation? Around 26 per cent claimed that they would also contest a non-reserved seat, 57 per cent said they would not, and 17 per cent were undecided. One needs to understand that these are the perceptions of the women concerned. The answers cannot be interpreted in a way that all women who said that they would contest an unreserved seat would have done this in reality. Some women were not aware of the fact that the women's quota was the only reason for them being asked to stand for election. Accordingly many women said that they would also contest an unreserved seat if they were to be asked by the villagers or their husband to do so. Another important criteria mentioned by some was that they would only participate in the election if they would be the one and only candidate. The importance of unanimous decisions will later be reiterated again in relation to other questions.

Women who said that they would not contest a general seat gave as reason that they could not imagine standing in competition with a man. The women who could imagine running for a non-reserved seat had either gained some confidence or did not really seem to be aware of the implications of that question. However, even if we assume that not all of the women who claimed that they would also stand for election from a general seat would really do this, it is still revealing that more women in Balipatna (30.6 per cent *v.* 18.6 per cent in Gania) gave a positive answer to this question. Less women were also absolutely against contesting a general seat in Balipatna, since the number of women not able to give a definite answer is higher there (25.8 per cent *v.* 4.7 per cent in Gania).

Men also contested from seats reserved for certain groups (like for SCs, STs, or OBCs) and were asked the same question. Regarding the reservation for OBCs many respondents were actually not aware that they had contested a reserved seat. Thus, the number of respondents to this question (n=20) is

smaller than the actual extent of reservation. Interestingly, also in the male sample those from Gania are less likely to contest a seat not reserved for their community (57.1 per cent *v.* 76.9 per cent in Balipatna). It appears that in a more 'backward' socio-economic scenario, reservations for marginalized groups have greater importance. These findings are illuminating for the discussion on reservation of seats for marginalized groups. One could have expected that reservations for SCs and STs are no longer necessary more than 50 years after independence. Reservation for these groups was originally designed as a transitional measure. However, if we look at the results, a clear case cannot be made. In more 'developed' regions, men from SC- and OBC-communities might have become more self-confident than in the more 'backward' ones. Clearly, reservation is still necessary if the stated goal is to elect institutions representing different groups of society in a proportional or adequate manner. It also shows that the hope that quotas will be only a transitional measure might be in vain, at least for the near future, and that it will be a feature of Indian democracy for much longer than originally envisaged. The same would hold for the quotas for women, and it might take decades until a majority of women feel confident enough to contest general seats. The other lesson is that socio-economic development appears to be a decisive factor—the more development there is, the less the need of reservation is perceived.

None of the women contested a general seat, but was there a contest at all or were the women so-called 'compromise candidates', unanimously nominated by the village communities? Many critics supposed that there would be no contest between women, but the reality looks somewhat different. Undeniably, the majority of women were (s)elected without a contest: 41 (66.1 per cent) in Balipatna and 26 (60.5 per cent) in Gania. This may be due to the fact that more families were not willing to let their womenfolk participate. Yet, in contrast to the belief of many critics that no woman would be contested, 35 to 40 per cent of the women actually competed with one or more other women. And one should note that a lot of men also faced no rival, namely, 35 per cent in Balipatna and 37.5 per cent in Gania. That more than one-third of men were not contested, hints at the traditional value village communities attach to unanimous decisions— regardless of the gender of the representative. Electoral competition is despised as dividing the village community, thus villagers are proud to show that there is harmony in their village.[22] The highest number of candidates contesting a woman's seat was six, but the majority faced competition with one to three other candidates. One-third of the men faced only one other candidate and the highest number of contestants for an office was 15.

Regardless of gender, the most contested office is that of the sarpanch, while the position of wardmember is the least contested. Apparently, the sarpanch is the most coveted position, having great power in the two lower

[22] In Haryana, the Chief Minister even set out a reward for villages in which candidates were returned uncontested.

TABLE 3.14: MEAN NUMBER OF CONTESTANTS FOR THE VARIOUS OFFICES IN THE PRI

	Wardmember + Naib-sarpanch	Sarpanch	Samiti-member; Chairperson; Vice-chairperson	Total
Female	2.63 (n=30)	4.0 (n=6)	3.3 (n=3)	2.9 (n=39)
Male	2.56 (n=41)	8.11 (n=9)	5.0 (n=1)	3.59 (n=51)
Total	2.59 (n=71)	6.47 (n=15)	3.75 (n=4)	3.29 (n=90)
Orissa*	3.10 (n=41,811)	7.58 (n=5096)	4.11 (n=4859)	3.63 (n=51,766)

Note: *Computed from State Election Commission (1997: 17). Cases where only one nomination was filed have been subtracted.

tiers of the PRI because they are at the apex of the gram panchayat and additionally have a strong say at the samiti level. Concerning the samiti chairpersons, each had one opponent when elected indirectly for the office, and the small number can be explained with the fact that there are not many samiti members who are women and SC. In the election to become samiti member from her gram panchayat, Nita in Balipatna was uncontested, whereas Kanchana in Gania faced competition from five other women.

When one takes into account that the sample of the case study is predominantly female, whereas the data for all of Orissa is predominantly male, the variations in the mean number of contestants are reasonable (see Table 3.14). Furthermore, since the offices reserved for women are generally less contested, it is plausible that the number of mean contestants in this sample is below the national-level mean. It is an indication of the quality of the sample that the trend is the same as in the national data. The lower number of contestants across the various offices in our sample is more or less proportionate.[23]

Election Campaign

A further issue of interest was whether women had been running the election campaign. Those who answered that no election campaign was conducted (64.8 per cent) were mainly the ones who did not face another contestant. When there is no contest, obviously there is no need for an election campaign. Only one woman who was uncontested in Balipatna claimed that she still ran an election campaign on her own. Two women in Balipatna who said that they did not campaign mentioned that male family members did it for them. All the others (32.4 per cent) asserted that they ran the election campaign on their own, often aided by family members and youth- or women's groups. This is encouraging, especially when one considers that most women did not decide to participate on their own, as we shall see shortly. Still, they ventured out and campaigned for their election. What did the representatives do during their election campaign?

[23] A cautious remark should be made about the samiti level data, as a sample-size of four is much too small to give a conclusive statement. Still, it happens to fit quite well with the overall picture.

Very few of those who faced a contest did not run an election campaign. Thus, one can safely argue that campaigning was seen as necessary for winning. Among the women who did an election campaign, most went from door to door (56 per cent). One can assume—and some women also confirmed—that women mainly talked to the female members of the households they visited, whereas male family members talked to male members of the household. Some of the women (38 per cent) held meetings in addition. Men in Balipatna preferred a combination of door-to-door visits and holding meetings (58 per cent), while men in Gania preferred door-to-door visits without holding meetings also. One can suppose that the election campaign was for many women the first time they ventured out of their house to lobby for themselves and for some it was a difficult exercise. I met a woman who had to be admitted to hospital after the election because she had a nervous breakdown due to the strain of exposing herself outside her house.

Factors Perceived as Important for Successful Election

It is important to learn what people believed to have contributed to their success in the election. Thus the representatives who had faced a rival were asked why they had won the seat and not the other person(s) (see Table 3.15).

It is interesting to see that no woman in Gania attributed her success to her own personality. In Balipatna, five women (22.7 per cent) believed that villagers elected them because of their personal qualities. Nita, the samiti chairperson in Balipatna, who has an MA in Oriya from Utkal University in Bhubaneswar, for example, said:

I think that people voted for me because I am educated and more active than other women. I used to work for a local NGO, and I am also active in the Ambedkar Youth Club. So I was used to going out and travelling alone even before my election.

Most mentioned the support of villagers as the main reason for their successful election, which is a somewhat tautological remark. Obviously the villagers have elected them, and so they must have supported them. Support of family members was mentioned much less than expected, and only a few

TABLE 3.15: PERCEIVED FACTORS FOR SUCCESSFUL ELECTION

	Own personality	Support of villagers	Support of family	Support of caste/tribe	Support of party	Cannot say	Total
Female B	5 (22.7)	17 (81.0)	1 (4.8)	-	-	2 (9.5)	22 (55.3)
Female G	-	16 (94.1)	2 (11.8)	2 (11.8)	3 (17.6)	-	17 (44.7)
Total	5 (12.8)	33 (86.8)	3 (7.9)	2 (5.3)	3 (7.9)	2 (5.3)	39 (100)
Male B	12 (46.2)	19 (73.1)	-	1 (3.8)	-	-	26 (51.0)
Male G	7 (28.0)	22 (88.0)	1 (4.0)	-	-	-	25 (49.0)
Total	19 (37.3)	41 (80.4)	1 (2.0)	1 (2.0)	-	-	51 (100)

Notes: 1. Multiple answers were possible; percentages calculated according to number of persons interviewed in each category; does not add up to 100 per cent.
2. Only those who faced a competitor were asked (n=90).
3. B: Balipatna; G: Gania.

mentioned political parties as playing a role. One can safely assume that the
support of families and of political parties or political people was decisive in
more of the cases than stated. However, people are very reluctant to admit
this and it were the politically less sophisticated women who openly said
so. Clearly, men are more assertive by attributing their success to their own
personality. There is a regional variation—men are more modest in Gania
than in Balipatna, and also here the support of villagers features prominently,
other factors being negligible.

Decision to Participate in the Election

The importance of the verdict of the villagers can be found again among the
answers to another crucial question. Why did the women venture into the
political realm at all? Was it of their own interest? Were they persuaded?
Were they pushed?

By far fewer women than men claim that it was their own decision to
participate in the election (see Table 3.16). Participation in politics was out
of purview for most women before the quota. Noteworthy is the difference
between Balipatna and Gania: more women in the coastal area have decided
at least partly on their own. It is important to note the high percentage of
answers stating that the villagers have encouraged the women. But also in
the case of men, particularly in Gania, many were motivated or even
persuaded by villagers.

I also came across cases where the villagers had to win over the previously
reluctant husband to nominate his wife. Sometimes the husband had already
been nominated as wardmember, and when the ward position became
reserved for a woman his wife was then nominated wardmember auto-
matically. Babita, the naib-sarpanch from Balipatna, said for example:

My husband was the previous wardmember. So when our ward became reserved for
a woman the villagers came to our house and asked me to stand for election. They
feel that my husband was doing good work and that he will also support me. And
they also thought that I would do good work.

TABLE 3.16: DETERMINANTS OF DECISION-MAKING FOR PARTICIPATION IN THE ELECTION

	Own decision	Husband	Other family members	Village leaders	Villagers	Caste/ tribe	Any other	Total
Female B	12 (19.3)	3 (4.8)	11 (17.7)	8 (12.9)	42 (67.7)	1 (1.6)	-	62
Female G	5 (11.6)	9 (20.9)	4 (9.3)	-	36 (83.7)	-	1 (2.3)	43
Total	17 (16.2)	12 (11.4)	15 (14.3)	8 (7.6)	78 (74.3)	1 (0.9)	1 (0.9)	105
Male B	22 (55.0)	-	-	1 (2.5)	18 (45.0)	-	3 (7.5)	40
Male G	7 (17.5)	-	2 (5.0)	1 (2.5)	29 (72.5)	-	5 (12.5)	40
Total	29 (36.2)	-	2 (2.5)	2 (2.5)	47 (58.7)	-	8 (10.0)	80

Notes: 1. Multiple answers were possible; percentages calculated according to number of
persons interviewed in each category; percentages do not add up to 100 per cent.
2. B: Balipatna; G: Gania.

Another important point to note is that the influence of the village community is more salient in the more 'traditional' Gania, particularly for the male representatives. But who are the villagers? Generally, these are the male high-caste elders of the village community.

Women in Gania did not name village leaders as decisive in contrast to Balipatna—a fact that is not easy to interpret. How about family influence? The predominance of the husband's encouragement is more pronounced in Gania than in Balipatna, whereas influence of other family members is found to be greater in Balipatna than in Gania. One can conclude that family authority plays a bigger role for women in Gania than in Balipatna. However, here I tend to think that actual family influence is greater than as stated. Some women did not want to admit openly that their husbands had not asked them before filing the nominations for them. Furthermore, without the assent of the family no woman dared to come forward, which was established through the question whether the family approves of the woman's work in the panchayat. That was answered positively by almost all women (only four women stated that some family members approve while others do not).

Most male respondents in Balipatna claimed that it was their own decision to stand for election, a proportion that is significantly lower in Gania (55 per cent as compared to 17.5 per cent). Conversely, the proportion of men in Gania who said villagers had encouraged them is significantly higher (72.5 per cent as compared to 45 per cent). Other motivations are insignificant as the percentages are very low. It is indeed very interesting that the polarization between belief in one's own determination and dependence on the wishes of the villagers is much sharper in the case of the male than of the female representatives in both regions. It is also extraordinary that more women in Balipatna claimed to have decided at least partly on their own than men in Gania! Autonomy of decision-making or lack of it has so far mainly been perceived as a gendered phenomenon. At this point it seems that it is perhaps also, or even more importantly, due to socio-economic or cultural characteristics of the location. Men seem to be much less independent in their decisions in Gania than in Balipatna and even stand below the female sample from Balipatna. This raises some doubt about the proposition that men necessarily are more autonomous than women in this respect. The question of autonomy will be dealt with in greater detail in Chapter 4.

Deliberations by Village Communities to (S)elect a Woman

The results of the quantitative survey remained rather inconclusive about the process through which women were actually (s)elected to take part in politics. To learn about the procedure was one of the main interests during the second round of field research. Meetings were conducted in the constituencies of women to find out how the villagers decided as to whom to (s)elect. These meetings were normally only attended by men. This is a further indication that spaces are very gender-segregated in rural Orissa. Talks among women could only find place in the home or in the backyards of homes, and it was rather difficult to get informed statements from women concerning their

representatives. In Balipatna it was extremely difficult to organize village meetings because people were still very busy with reconstruction after the cyclone and the planting season was in full swing.

1. Meeting in Shakuntala's ward in a village of a remote gram panchayat (GP) in Gania on 3 February 2000. Shakuntala is a 46-years-old Khandayat; she is married, has two children, is a *bahu*, and was educated till class 5.

 The meeting is taking place in the evening in the community hall of the village. The room is very small and lit by a petroleum-lamp. Around 15 men of various ages and caste backgrounds are present. The ward-member is the only woman attending, but she is leaving soon as well. We (members of the NGO and me) first talk about the Panchayati Raj as such, and then we turn to the election of the wardmember. We ask the villagers about their reaction when they got to know that the seat is reserved for a woman. Several villagers are answering.

When we learned that our ward is reserved for a woman we wanted to rebel and propose a man. See, we do not have educated women here, so we did not accept the decision of the government. But then we had a village meeting and thought that in case our village does not nominate a woman, the other two villages belonging to this ward might propose a woman, and then we are losing out. As our village is the biggest one in this ward, we traditionally nominate the wardmember. Finally we decided for Shakuntala since she is the most capable of the village women here.

2. Meeting in Kali's ward in a village of a remote GP in Gania, on 23 February 2000. Kali is a 56-years-old SC; she is married, has four children, is a *gaanjhia*, and went to class 2.

 The meeting is taking place in the evening. It is pitch dark, because there is no electricity in this village. We are sitting in front of a small shop, and several men have gathered around us. We also ask them about their attitude towards the reservation for women. Unfortunately, only one man is speaking, who seems to be quite influential in the village community.

It is good that there is now reservation for women. It is the pride of our village that a woman has been elected here. Those who are the little *netas* were not happy, but we general voters were happy. I cannot say that I am fully satisfied or fully dissatisfied with Kali. . . . We elected Kali because first she is a Harijan, and the seat was reserved for a Harijan woman, and second because her husband is most active and we hoped that he would support her so that she can perform better.

3. Meeting in Bidyut's ward in a village of headquarters GP in Gania, on 5 February 2000. Bidyut is a c. 35-years-old Gauda; she is married, has four children, is a *bahu*, and went to primary school.

 The village meeting takes place in the evening. The village is populated by milkmen (Gaudas) who have just returned with the cattle from the fields. There is also an SC-sahi, which belongs to this village. We sit on a mat spread over the dusty floor of the new porch in front of the temple that is

under construction. Men come and settle down on the porch as well, others remain outside the boundary of the porch—they are the members of the SC-community. The wardmember does not come from this village but from a neighbouring one, which belongs to this ward.

When we got to know that our ward has been reserved for the second time for a woman, we were very agitated. We protested and went to the GPO [Gram Panchayat Officer] and even to the BDO [Block Development Officer] and asked them to change it. We felt very unfortunate because our village had a women-wardmember already in the 1993 [sic!] election. During this election we belonged to a different ward, but the wards have been re-arranged. However, the BDO told us that he cannot do anything and that we have to elect a woman. We think that this is very bad. But as we were bound to choose a woman, we finally did. We decided for Bidyut because she is able to read and write, and she can also talk in front of others. And she also agreed to contest—normally women do not come forward. Her husband finally also agreed, but the proposal came from us villagers.

4. Interview with the president of an NGO in headquarters GP in Gania, male Teli, on 8 February 2000. In Gania GP, Lita is the sarpanch; she is a 25-years-old SC (Keuta), is married, has two children, is a *bahu*, and went to school up to 9th standard.

 We visit the president of the local NGO in his office. During a talk on general aspects of his work we also ask him whether he has voted for the present sarpanch. When he gives a positive answer, we are asking him for the reasons, why she was elected.

We had to choose an SC-woman, and there were three candidates. Among them Lita was the best qualified. She is able to speak in front of others, and she has some education. Another important reason is that she is a touchable. If the sarpanch has to be an SC she should at least be touchable. It is not that Lita has a special background, but she came forward and we also wanted to elect somebody from Gania village to be the sarpanch. Lita was the most outspoken as well, and she did the election campaign. We from the NGO supported her also because her husband used to work with us. A political leader also supported her.

5. Meeting in Rita's ward in a village of headquarters GP in Balipatna, on 14 March 2000. Rita is a 35-years-old Teli; she is married, has three children, is a *bahu*, and was educated up to 7th standard.

 The meeting takes place in the late afternoon in the primary school of this village, which has been severely destroyed by the cyclone. In the only remaining classroom, seven men have gathered.

We were not very happy when we got to know that we have to elect a woman. Women cannot do anything. They do not go out of their house, they are not used to talking to people, and they have no knowledge about politics. Our wardmember cannot even go to the block office, so how can she do something for the development of our village? Rita is not doing anything and the little she is doing is only according to her wish, not according to our wishes. We have elected her only because of the women's quota. Before the election we could not know whether she will be good or bad. She came forward to contest so we let her contest.

Considering the statements related above and other remarks from discussions not recounted here in detail, various criteria for the (s)election of women candidates came up. First, there is a marked hiatus between a general acceptance of the reservation for women ('It is good to give them a chance—they will advance', 'Now they get the opportunity to go out and learn something'), and the reservation of one's own ward or gram panchayat for a woman ('She is not educated', 'She is shy, look at her, she can not speak', 'There are no educated women in our village, so it is bad to have a reservation here'). However, for the (s)election, one stated criterion was the willingness of the woman, or rather her husband's/father-in-law's willingness to nominate her. Another point was the level of education—they wanted to choose the most educated woman available. This could be a reason why many young women came to be elected since they tend to be more educated than older ones. Generally, male villagers lamented the fact that their womenfolk are not educated, often pointing at my assistant or me as being the right women to elect to a public office as we are educated and can express our views. Asked about their willingness to give education to their daughters, the answers were, however, quite defensive: 'They will go away. Why should we water a foreign tree?' This is further indication for the adverse impact of patrilocal and village-exogamous marriage patterns for women's well-being. Another frequent argument was the distance to the next higher-level school and the labour that is done by girls. Men from a village 8 km away from Gania made the following remarks:

Yes, education is important and can change things, but we will not educate our girls. There are so many things to do here, like grazing the goats and household chores. Who will do this when the girls go to school? In our village not even a single boy has passed the 10th standard, so why should we educate the girls? And the middle school and high school are far away. Ten to fifteen years back our village was surrounded by jungle, so even men did not go to higher school. It was too difficult to get there.

A repeated complaint was the shyness of women. In order to evade this problem one can detect a definite preference for the married *gaanjhia*—the daughter of the village. That a woman should be married is an important consideration. The husbands do many tasks outside the panchayat meetings. It is not by chance that the sole three unmarried women interviewed are in Balipatna, the more 'progressive' block. Men often remarked that they had selected the specific woman because her husband is active and they know that he will do good work. That women were born in the respective village is an advantage—due to cultural norms *gaanjhias* are less inhibited in their social intercourse. They do not have to cover their face when they go out of the house in their native village; they can move relatively freely and have a good relationship with most villagers. It is important to note that there are several *gaanjhias* in the PRI, even though it is not a dominant social custom. I realized this only during the qualitative interviews, when the fact was mentioned to me by various informants. That is why I have no quantitative data on the number of *gaanjhias* in the whole sample. However, it became obvious that there is a preference for them, as villagers stated that they took

it into consideration. The elected women were also aware of the fact. It is interesting that such a rather rare 'species' is more frequently found in the PRI.[24] It appears that rural society can draw on various social resources to deal with a legislation that was imposed from above, but challenges traditional values and beliefs. In this respect, it seems that to elect a *gaanjhia* is a very rational decision, since some of the structural obstacles faced by women in rural society are lesser for them. Thus, I want to reaffirm that apart from caste, class, religion, etc., the politics of marriage play an important role for women's empowerment.

Another consideration is where the woman lives. A ward often comprises up to four villages or, in bigger villages, several *sahis*. People want to vote for a woman from their own village because they feel that they will be better represented. The same holds for bigger villages, where several *sahis* make up one ward. Here, people want to elect a woman from their *sahi*. Thus, mainly women got (s)elected from that village or *sahi*, which is the biggest. Doubtless, the same consideration holds for men as well.

Last but not least, caste does play a role, albeit mainly because caste-groups are concentrated in different localities. As the wards consist often of different communities, the wardmember will usually come from the majority community of the biggest *sahi* or village, thus being of a specific caste. In cases where the office is reserved for SC, ST, or OBC, the choice is limited to begin with. It is not so remarkable that villagers voiced that in case they have to vote for an SC, they would want at least to vote for a touchable SC. In Gania, these SC candidates come from the community of Keuta. This community has been included in the SC category, but is touchable. General villagers voiced the fact that there is preference for SCs from this community and one can meet a high percentage of Keutas in the Gania PRI. Again, the same considerations hold for men as well.

It became apparent that some of the women are or have been members of Mahila Mandals. However, villagers often said that this did not enter into their consideration for selection. But some of the women believed that it positively contributed to their election because they were used to leaving their house previously and to speaking in front of others. Women who made this remark were all from Balipatna since in Gania the Mahila Mandals were not really functioning. In cases where the Mahila Mandals were really working, it seems that the participation of women was enhanced. Mina, an OBC member (Barik) from the remote gram panchayat in Balipatna, for example, said:

Before I became the wardmember I was already secretary of our *Mahila Sangatan*, and I used to go to the office of the Darabar Sahitya Sansad[25] or meet with the other

[24] Out of the women interviewed during the second field-visit, seven were *gaanjhias* (two unmarried, one divorced, four married), and seven were *bahus* (three young ones without much help in the household and small children, and four older ones, either with daughters-in-law or adult children). Thus, half of the women interviewed were *gaanjhias*—which was not a conscious selection but was only found out while conducting the interviews.

groups. So I was already used to leaving my house for such a purpose, and I was also used to speaking in front of others. I think that this is also one reason why the villagers elected me.

WHERE ARE THEY PRESENT? THE EXTENT OF PARTICIPATION

In this section, I shall analyse the extent to which the representatives are present in the local political bodies. It is also important to examine whether they are present in important decision-making bodies. At this point of analysis, the content of their participation is not yet at the centre of our attention. What will be established is if the representatives are present in a physical sense. In studies from the north Indian states it was frequently found that the elected women do not attend the panchayat meetings, but sign the papers at home. The extent of their presence can also be measured through the amount of time spent on their work related to the PRI. Another issue is whether they are present in the grama sabhas—the village parliament. Presence there is connected with their mandate as representative, although the grama sabha is a rather different body from the elected PRI and is supposed to be attended by all villagers.

Presence in the Gram Panchayat or Panchayat Samiti Meetings

The basic indicator for a minimum degree of presence in the political institutions is attendance at the monthly gram panchayat or bi-monthly panchayat samiti meeting (see Table 3.17).

Most respondents claim that they participate in every meeting. There is no marked difference between the two blocks; the difference between the genders is not very significant either. When one compares the situation in Orissa with evidence from other parts of India, especially from the Hindi-belt, that actually the husbands attend the meetings while the women remain at home in *purdah*, there are many indications that the situation in Orissa is different.[26] It seems that it is not tolerated in this region that persons who

TABLE 3.17: FREQUENCY OF ATTENDANCE OF PANCHAYATI RAJ MEETINGS

	None	Few	Most	Every	Total
Female	-	2 (1.9)	13 (12.4)	90 (85.7)	105
Male	1 (1.3)	-	7 (8.8)	72 (90.0)	80
Total	1 (0.5)	2 (1.1)	20 (10.8)	162 (87.6)	185

Note: Percentage in rows calculate the percentage of gender separately.

[25] This is the name of the NGO organizing these women's groups. For details on the work of this NGO, see Harper (1998: 124–31).

[26] The high percentage of regular attendance is not found in other parts of India. Several scholars and activists allege that in cases in which the registers show that all members attended regularly the books are forged or sent home to the members to be signed. In Orissa that kind of thing might happen as well but a more or less regular attendance of most members has been stressed by various informants and was also confirmed in the meetings I observed.

have not been elected to the institutions attend the meetings. The husband of Sabita, a tribal wardmember from Gania headquarters GP, formulated it as follows: 'I am not going to the meeting. Sabita is the wardmember, I am not. Imagine if I would go to the meeting and they would not recognize me and would say there is no wardmember from N* and will not offer me a chair. I will feel insulted!'

Mina, a wardmember from the remote GP in Balipatna Block, gave similar information. In her gram panchayat there is a very poor SC-woman who has been elected as wardmember. Her husband is very active in politics and a member of the Congress party. This wardmember does not attend the meetings very regularly, especially not in the planting season, when she works as a casual labourer. One reason is that she can earn Rs. 50 a day, whereas the sitting fee for attending the meeting is only Rs. 30 and nobody knows when the sum really gets disbursed. I asked whether her husband is attending the meetings in her place as he is not really working, but is busy with political dealings. The answer was prompt: 'That is forbidden! People would never tolerate him coming to the meetings—he is not the ward-member.'

Thus, women are regularly attending the panchayat meetings, and this is accepted as being their legitimate role as elected members. It seems to be commonly acknowledged in Orissa that only elected members can attend the panchayat meetings. Still, in some cases the husbands were considered as the wardmember or as the sarpanch during the survey—I was directed to them when I asked for the representative—and these men said that they can answer the questions much better than their wives who allegedly do not know anything. Nevertheless, these women normally do attend the meetings—sometimes accompanied by their husband or son who might sit outside and listen. But total control by male family members seems to be not widespread in the areas investigated. Thus, one can conclude that women's attendance is substantial, though most likely to a lesser extent than stated. Often illness or family matters prevent members from attending every meeting, but they still claim that they have attended every meeting. Therefore, it is safe to assume that the majority of representatives are present at most meetings, but not necessarily at all of them. We have also seen during the discussion on nuclear and joint families that particularly women from nuclear families with small children sometimes have problems attending the meetings regularly since there is no one to help them with their household duties. I shall come to this point more in detail when we look at the time spent for work in the PRI.

A factor working in favour of the regular presence of poorer PRI-members in the meetings in Orissa is the granting of a sitting fee of Rs. 30—a provision that is not found in every Indian state. There is a lot of discussion on the question of sitting fees at the lower tiers of government. Some argue that the PRI are concerned with public service and that people should work in the institutions because they are public minded and want to work for the welfare of the village, not because they are paid for it. However, for poorer people it poses a serious problem to forfeit a daily wage of around Rs. 40 in order to

attend a PRI-meeting. The sitting fee allows members from poorer sections of society to attend the meetings, which would otherwise be an economic hardship for them and effectively exclude them from participation in the PRI. However, some people believed that the sitting fee is the only reason for many wardmembers to turn up, and their participation in the meeting is limited to devouring the snacks and tea offered. Usually the sitting fee is collected over some months before it is distributed to the members. I asked the members what they are doing with the sitting fee and a rather classical pattern emerged: Whereas most of the men said that they spend the money in the bazaar for buying some snacks or cigarettes—regarding the fee as pocket-money—most women stated that the money flows into their ordinary household expenses.[27]

In the gram panchayat meetings I attended, the female members were normally on time whereas most of the men turned up considerably later. Punctuality is not a prime Oriya virtue but many officials and ordinary villagers as well as the sarpanches stated that the women are normally very punctual whereas the men generally arrive late. The seating order varied. In Gania headquarters GP, for example, there was a table at the head of the room, which was occupied by the female sarpanch and the panchayat secretary, and the wardmembers were arranged in a rectangle along the remaining three walls of the room. In all other panchayats observed, the chairs were arranged in several rows facing a desk occupied by the sarpanch and sometimes by the panchayat secretary. Women tend to sit together in one row or next to each other. But I observed that during the meetings they did not seem to be exceptionally shy and looked as if they felt more or less comfortable; this they also confirmed in the interviews. Male wardmembers generally talked more and sometimes shouted whereas female wardmembers mainly remained silent. However, the more active female members and the female sarpanches did not hesitate to speak if they felt it necessary. Some female wardmembers, however, allegedly never talk or ask women sitting next to them to raise issues for them, as they feel too shy to speak in front of other people. To conclude, the physical presence of women in the Panchayati Raj bodies is substantial and does not differ very much from their male counterparts.

Presence in Important Decision-making Positions

A reservation for marginalized groups in the general political bodies might not be sufficient to secure a relevant presence of them in important political positions as well. In the literature on affirmative action one comes across the argument that a kind of flat-rate reservation might not be sufficient if one does not also ensure that women get into the higher ranks of decision-making, such as Cabinet Ministers or Chief Ministers. We shall look here at

[27] Compare this also with Agarwal (1994: 26) who cites evidence from all over India that women from poor households typically spend most of their income to buy goods for the family's consumption, whereas men tend to spend a good part on their personal needs, like alcohol or tobacco.

women in influential positions in the 1992 election, when positions were not reserved for them, and then at their presence in the standing committees today.

In the PRI-election in Orissa of 1997 the quota for women was implemented not only as a 'flat-rate', but following the provisions of the 73rd Amendment also for the important offices of sarpanch, samiti, and zilla parishad chairpersons. This device secured that women and low-castes are not only elected as wardmembers, but are present also in important decision-making ranks. To show that women might have difficulties in getting into these kinds of positions without a reservation for them, data on women's position in the 1992 election is quite illuminating. As referred to, in the election to the gram panchayats and panchayat samitis under the government of Biju Patnaik, a 33 per cent quota for women had been implemented, but without reserving also relevant positions for them. Thus, Orissa offers a very good case for this question.

In the 1992 election, 28,068 women were elected to the gram panchayats and panchayat samitis (OSCARD 1993: 42). At the level of gram panchayats, only 14 women were elected as sarpanch. As the number of gram panchayats was 5263 at this time, women managed to secure only 0.26 per cent of this position (OSCARD 1993: 49). Since the provision that in case the sarpanch is a man the naib-sarpanch has to be a woman was implemented already during the 1992 election, women filled 5237 positions of naib-sarpanch (ibid.).[28] Out of the 314 posts for samiti chairperson, women could secure 15 of them, i.e. 4.8 per cent, while 301 have been elected as vice-chairpersons.[29] The situation at block level is slightly better than at the level of gram panchayats. But to secure less than 5 per cent of the most important office of samiti chairperson is still abysmally low. One can conclude that without a further reservation for various important positions in the PRI, women would face a difficulty—at least initially—in securing more influential political offices. This could be seen as justification for reserving powerful decision-making posts also for marginalized groups as introduced through the 73rd Amendment. As regards the present case study, where this provision was already implemented, it is interesting to look a little further and assess whether women are present in the standing committees.

There are supposed to be standing committees for the efficient discharge of its functions at the gram panchayat as well as samiti levels. They mainly serve as deliberative bodies, and the functions are not really specified in the manuals.[30] Sarpanches and samiti chairpersons are the ex officio chair-

[28] However, there is no explanation for the 12 'missing' female naib-sarpanches.

[29] Two women must have been elected as vice-chairpersons although a woman secured the office of the chairperson.

[30] At the gram panchayat level five committees are supposed to be constituted, namely (i) Finance and budget matters; (ii) Agriculture, irrigation, co-operatives, industrialization; (iii) Education, health, water supply, sanitation; (iv) Welfare for weaker sections of society; (v) Communication and construction. Representatives returned various designations for these committees.

persons of all committees constituted at the respective level. During the survey, many individuals said that these committees were either not established or were not working properly. Still, it is instructive to establish who actually knows about these committees and who is aware that s/he is a member. By far, fewer women than men declare that they are members of a standing committee. That does not necessarily mean that women are really not members, but that they at the least do not know about it. This can be seen as an indicator of them not being active participants in these bodies. Only a little more than 15 per cent answered that they were members of such a standing committee, and 61 per cent of the women were not aware whether they are members or whether such committees exist at all. More than 50 per cent of the men, in contrast, claimed that they were members of one or more standing committees, and only 30 per cent did not know whether they were members or not. The regional variation is not too pronounced to deserve special attention. Representatives who claimed that they were members of standing committees were asked about which committee they were serving. Out of the 16 women who knew that they were members, 4 (25 per cent) could not give an answer, and out of the 42 men also 4 could not give an answer (9.5 per cent). Men who gave an answer tended to be active in more than one committee, but some stated that these committees actually do not function.

The result shows that women are much less aware of a crucial institution of the PRI, and that they are less selected for these positions, or at least, if they have been selected, they have no knowledge thereof. There is, however, a problem of drawing too many conclusions from this. Some representatives claimed that the committees are not really functioning, thus, being a member thereof might not be too important. Still, it shows whether women are given relevant information and positions, even without a reservation for them in such bodies. The question remains if the information is purposely not given to women or if they are not interested and forget about it. Because sarpanches and samiti chairpersons are ex officio chairperson of all standing committees, it is interesting to have a look at their answers.

It is disheartening to find that none of the female sarpanches could name the five standing committees of which she is supposed to be the chairperson. Two could name at least two committees, and one—a sarpanch in Gania Block who could be labelled as being a proxy of her husband—knew that she is the chairperson of all committees, but could not name them. Three women did not know at all about the standing committees, and Bimala, actually the otherwise most active sarpanch from the remote gram panchayat in Balipatna, claimed that no committees existed in her gram panchayat. This was proved wrong by various male wardmembers from this gram panchayat who claimed that they were members of standing committees. Out of the two samiti chairpersons, Nita from Balipatna did not know about standing committees at all, whereas Kanchana from Gania was well aware that she is the chairperson of all these bodies. The situation looks better for the male sarpanches. Seven out of ten stated that they are the ex officio chairpersons

of the five standing committees, even though one claimed that they do not really function in his gram panchayat. The other three could at least name some of the committees, even though they were not aware that actually five committees should have been constituted. This gives a rather dismal picture of women's presence in important deliberative bodies in the present PRI. One can attribute this to a lack of involvement of women in important institutions for which there is no reservation. However, this is also due to the lack of knowledge on procedures and to general malfunctioning of some of the basic institutions in the Panchayati Raj system.

Time Spent for Work Related to the PRI

Apart from attending the meetings or serving in standing committees, representatives have various works to do—for example, supervising development works or receiving petitioners. Hence, the degree of their presence in the PRI can also be measured by the time spent for the institutions.

Most women (59 per cent) do not devote more than five hours a month, which is basically the time they need for attending the meetings. One-fifth spends between six to ten hours per month. The median of hours spent is 17.03 in Balipatna, and 10.14 in Gania, adding up to 14.21 hours on average spent by women in the PRI per month. The gap between Balipatna and Gania is quite pronounced. However, if one subtracts the two high-profile women dedicating more than 100 hours per month,[31] the average reduces to 11.93 hours in Balipatna. Even though this might not look very impressive, one should keep in mind that the women do indeed attend most of the meetings, which is not self-evident when compared to other states of the Indian Union. Clearly men are spending much more time for panchayat work than women. The biggest group (27.5 per cent) devotes 26–50 hours on work for the PRI, and fewer than 20 per cent just attend the meetings. The average hours spent is 51.95 in Balipatna and 49.19 in Gania, or a general average of 50.53. The difference in time spent between the two blocks is more pronounced among the women than among the men, and men spend around five times more hours per month than women.

The gap between men and women is less when one looks only at the sarpanches or samiti chairpersons. Women in the higher positions obviously devote more time than ordinary wardmembers, but men in the same position seem to be spending even more time; yet, the difference is much less. But due to the two high performing women in Balipatna the gap of time spent between the female representatives is again quite pronounced and women in Gania devote less time.

One of the main problems is that most women have not been relieved from their household duties. One could argue that the entry of women into rural politics is to weigh them down with a triple burden—household, outside work, and politics. Just one tribal woman made this point and argued that

[31] These are Bimala, the very active sarpanch, and Nita, the samiti chairperson who are both unmarried.

women have already so many things to do that men should at least care about politics! Most women said that they get some help when they have to attend the meetings—mainly from other female household members—but basically the amount of work to be done remains the same.[32] This indicates again why a joint family can actually be an important resource for women in politics. In rural India it is especially difficult for women in a nuclear family with young children since they have only the husband for help. When asked whether her husband helps her in the household now that she is busy with panchayat work, the answer of Lita, the young sarpanch in Gania Block was quite revealing:

Being a woman I am used to working hard. I cannot ask my husband to do household work—I would feel ashamed! I rather get up early and do all the work alone before I leave for the office. Normally I do take my children to the office. But when I have to go to the block office I cannot take them with me. My husband does care for our youngest daughter when I am away and cannot take her. When we are entertaining guests I have to stay at home since I am the only woman in this household.

Also, other women stated that they would never ask their menfolk to contribute to the household work, and many looked quite astonished when I asked them why the men do not help them now that they have additional duties. The usual answer was: 'Men just do not do this kind of work.' There were also some women who stated that their husbands care for the younger children when they have to attend the meeting. The husband of Sabita, the tribal wardmember from Gania, prepares the evening meal on the day on which his wife has to attend the meeting. Sometimes an aged father-in-law is also watching over the children in the absence of women. Still, generally speaking, the time-budget of women is constrained through their role as housekeeper to a much greater extent than men are through their occupation.

Presence in Grass-roots Democracy: The Grama Sabha

Another interesting locus of participation in the PRI is attendance of the grama sabha. The grama sabha is hailed as the body for direct grass-roots democracy *par excellence*. It is an old institution, and according to Reddy it existed in some form or another in all states except Kerala and Tamil Nadu in the 1970s (1977: 8). In 1963, the Government of India had appointed a Study Team to look into the position of the grama sabha in the Panchayati Raj Movement and they found: 'Generally, these grama sabha meetings are thinly attended, and a quorum is seldom attended [*sic*!]' (Reddy 1977: 8). As we shall see, the picture does not look much better today.

Recently there have been several efforts by the Central government to strengthen this institution and a new rural development programme was

[32] These remarks are very familiar to women also in the West, where most working women have either not been relieved from their domestic duties or the burden has been transferred to other females (like grandmothers or housekeepers); compare Rerrich (1996).

launched, the Swarnjayanti Gram Swarozgar Yojana (SGSY).[33] In the set-up of the SGSY, '[t]he Grama Sabha authenticates the list of families below the poverty line identified in the Below Poverty Line (BPL) census. Identification of individual families suitable for each key activity is made through a participatory process' (GoI 2000: 41). For this purpose, four additional dates—all of them national holidays—have been declared for the meetings of the grama sabha.[34] Earlier, only two grama sabhas per year were supposed to be held—one in February/March to decide on the budget, and the second in June/July to give a status report on the works done in the gram panchayat. Now, there is the budget session in February/March and the grama sabhas on the above mentioned four additional dates. Before I actually observed the grama sabhas in 2000 the representatives had been asked in the quantitative survey as to whether they participate in these village meetings. The answers reveal an interesting trend (see Table 3.18).

Compared to the panchayat meetings, which are attended by elected members only and have an exclusive atmosphere, the grama sabhas are public meetings, often taking place in school-buildings or open spaces. It is interesting to note here the big difference between the reported attendances of women in both areas. In Gania, a frequent answer to the question whether she participates in the grama sabha was 'I am a *bahu*', which translates more or less into 'Why are you asking me such a stupid question; as a daughter-in-law I can not attend a public village meeting.'

TABLE 3.18: PARTICIPATION IN GRAMA SABHA

	Yes	No	Sometimes	Total
Female B	49 (83.1)	10 (16.9)	-	59
Female G	22 (52.4)	17 (40.5)	3 (7.1)	42
Total	71 (70.3)	27 (26.7)	3 (3.0)	101
Male B	38 (97.4)	1 (2.6)	-	39
Male G	39 (100.0)	-	-	39
Total	77 (98.7)	1 (1.3)	-	78

Notes: 1. Percentage in rows for Balipatna (B) and Gania (G) are calculated for each sample separately.
2. Three women in Balipatna and one in Gania did not know whether such meetings take place, and two men claimed that the meetings do not take place. All have been deleted from this sample and n=179.

[33] The Finance Minister declared the year 1999–2000 as 'Year of the Grama Sabha' in February 1999 (ISS, *PRU*, February 1999: 1). The SGSY, launched on 1 April 1999, is a new self-employment programme and erstwhile programmes like the Integrated Rural Development Programme (IRDP), Development of Women and Children in Rural Areas (DWCRA), Training of Rural Youth for Self-Employment (TRYSEM), Supply for Improved Toolkits to Rural Artisans (SITRA), Ganga Kalyan Yojana (GKY), and the Million Wells Scheme (MWS) ceased to be in operation. For this and details of the programme, refer to GoI (2000: 40–7).
[34] These are 26 January (Republic Day), 1 May (Labour Day), 15 August (Independence Day), and 2 October (Gandhi's Birthday).

It appears that the panchayat meetings are considered as a kind of 'private' space, where women do not face men from their own village, with whom they have fictive or real family relations, traditionally prohibiting social inter-course. The grama sabha, on the other hand, is a public meeting, attended by various men from the village. Nalini, the wardmember from the remote GP of Gania Block, said:

I have no problems to speak with men in the [panchayat] meetings. They do not belong to my village. I do speak to the men like I do speak to the women. Outside the panchayat office I do not speak to the men. After the meeting I go home immediately and stay in the house. . . . I do not go to the grama sabha. My husband attends the grama sabha. I am a *bahu* of the village.

Whereas attending the meeting of the gram panchayat is seen as unpro-blematic because it takes place in a rather secluded setting, the participation in the grama sabha, which should also be part of the wardmember's duty, is much less so. Generally, work to be conducted outside of the panchayat office, for example, solving disputes among villagers or supervising the implementation of development works, are taken over by male relatives.

However, it was found that some women do go to the grama sabha, and among them are also *bahus*. Generally, the attendance of women in public village meetings has gained more legitimacy, but it is mainly bound to their office in the PRI. This can be seen in the revealing statement made by a young *bahu* from Gania village, who is not in the PRI, but wishes to part-icipate in the next election:

I am interested to become sarpanch in the next election. I want to serve the people. No, I have not been to the grama sabha. I am a young *bahu*. If I will be the sarpanch I will go, but not as an ordinary woman.

It is quite important to note that female attendance is less frequent in the more 'backward' or 'traditional' Gania than in Balipatna. The same holds true for the attendance of women who are not representatives of the PRI. Because the grama sabha is in important institution of grass-roots democracy, the last section is devoted to observations made during three grama sabhas in 2000. We shall see that no ordinary village woman was present in the Gania grama sabha, whereas some women participated in grama sabha taking place in the remote gram panchayat of Balipatna Block. This hints at the greater freedom of movement and more accustomed exposure of women in the more 'developed' block.

So far it was established that women normally attend the panchayat meetings, but most of them do not do much more than this. Especially showing up at public village meetings such as the grama sabhas, where the main decisions are determined, supervising the implementation of develop-ment works, or going out to settle village disputes is out of question for most of the women. Also, travelling alone is normally not approved by rural society. However, here again there is a difference between the two blocks. In Balipatna, one can see more young girls and women on bicycles, one bold sarpanch even driving a motorbike. Here, more women come to the

panchayat office without male company (41.9 per cent as compared to 69.8 per cent in Gania). One reason is that women in Balipatna are not so dependent for means of transport since distances there are shorter. In Gania, on the other hand, villages are so small and dispersed that members have to cover distances up to 15 km, often through forest areas, which are not considered safe for women. That is why for attending the meetings most women here are accompanied by male relatives.

THE WORKINGS OF GRASS-ROOTS DEMOCRACY

As argued, the grama sabha is perceived as crucial for the working of the PRI as such. The notion is that the grama sabhas are the real institutions of direct grass-roots democracy, offering participation to all villagers regardless of class, caste, and gender, offering space for social auditing, and serving to make the PRI more accountable and transparent. In respect to the importance, observations that are not merely concerned with the presence of the representatives, but also with the general working of the PRI will be recounted. Three grama sabhas were observed, two in Gania GP, and one in the remote GP of Balipatna Block.

Grama Sabha, Republic Day, 26 January 2000,
Panchayat Office, Gania

In the morning, Lita, the sarpanch of Gania GP, and Kanchana, the samiti chairperson of Gania Block, hoisted the flags in the panchayat office and samiti office respectively. During the major public ceremony in front of Gania high school, the BDO (male Brahmin) hoists the flag. A few days prior, Lita had informed my research assistant and me that the grama sabha is scheduled for 12 p.m. However, at the Republic Day ceremony a wardmember tells us that the grama sabha will take place at 2 p.m. in the panchayat office.

We go there at 1 p.m. to find the panchayat office locked. Nobody is to be seen. The notification at the board gives 1 p.m. as time for the grama sabha. We decide to look for Lita whom we find at home, around 500 m away from the panchayat office. She is here together with the male wardmember who had informed us during the ceremony. Asked why she is at home and not in the panchayat office to preside over the grama sabha she argues that nobody will be coming anyway, the quorum will not be met, and they will have a second meeting next week. Then maybe 40 to 50 will turn up, but not today. She adds 'And women never come—I will be the only woman present.' As we keep on sitting in her house she starts getting nervous and asks her husband to have a look whether some people have turned up at the panchayat office. He declines to do so and argues that she is the sarpanch and it is her job to go. Finally she dresses in her best sari and we go together with her elder daughter and the wardmember back to the office, which has been opened in the mean time by the panchayat secretary.

It is 2 p.m. now. Apart from seven male wardmembers and one male

villager, Kanchana the samiti chairperson has come. Lita and she are the only two women present—but they are very aware of the importance granted through their office. They are both sitting at the desk at the head of the room together with the panchayat secretary and preside over the meeting very confidently. Apart from the panchayat secretary there is no other official present. Lita has removed the pallu from her head since she entered the office. It becomes obvious soon that there is a rivalry between Lita and Kanchana. Both live in Gania GP and everyone tries to satisfy her clientele. They support different political parties, which intensifies the competition.

The villager, who is said to be the aide and confidante of the samiti chairperson, starts complaining that there was no proper grama sabha held for the last year and that he wonders how the lists of beneficiaries are drawn up. Lita is defending herself: 'If nobody shows up at the grama sabha the panchayat will decide who will be the beneficiaries.' The villager keeps on complaining that the palli sabha draws up the list of beneficiaries but then the names vanish from the lists. Now a big argument starts between the sarpanch and the samiti chairperson, both raising their voices. Kanchana accuses Lita that the public has not been informed properly. She asks: 'What is the use of a grama sabha if only the wardmembers show up? Why was there no drum-beating to inform the people?' She also looks at the notification book and claims that only 25 people have signed that they were informed about the grama sabha. She says to the sarpanch: 'You have not fulfilled your duty as a sarpanch so you should step down from your office.'

The controversy between the two women is reaching its peak now. Lita retorts that the samiti chairperson is actually not allowed to participate in the grama sabha and that she should bring a letter from the collector, which grants her the right to sit in the grama sabha. Kanchana replies that if she is not allowed to sit in the grama sabha, then the sarpanch has no right to come to the samiti office. The verbal exchange goes on and the wardmembers are divided into two camps, each faction supporting one of the women. In the meanwhile, two female wardmembers have showed up who sign the register and sit quietly without participating in the debate. The male wardmembers start accusing the panchayat secretary that he has misinformed them about the time. The secretary retorts sarcastically that next time they should look properly when they sign something in the register as the time is given there as 1 p.m.

Finally it is decided to hold the next meeting in seven days. But another discussion ensues on where this meeting should be held. Kanchana wants the meeting to take place in her village that is four to five km from Gania, arguing that more people will come there. Lita is refusing to have a meeting outside Gania and argues that the grama sabha is supposed to be held near the headquarters. But she agrees to have it at another place than the panchayat office, as there is not enough space in case more people turn up.

Before I analyse this grama sabha, the account of the second meeting, which took place nine days after the first one, will be given.

Grama Sabha, 4 February 2000,
Girls Upgraded Primary School, Gania

While taking some interviews in a hamlet belonging to Gania GP we are informed that the grama sabha will take place at 12:00 on Friday, February 4, at the Girls upgraded primary school in Gania. The villagers confirmed that the peon had informed them about the date and place.

When we arrive at the venue we find around 20 people only. Kanchana is again present, as well as the sarpanch, her husband, some male ward-members, the husband of a female wardmember, and some general public— apart from Lita and Kanchana no woman is to be seen and the only official is, like last time, the panchayat secretary. There is a heated discussion on why so few people turned up and, again, why there was no drum beating. Kanchana leaves the place shortly afterwards, followed by the villager who was also present at the last grama sabha. People say that now the Congress faction has left. However, the debate goes on.

A wardmember accuses the peon that he is lazy and has not informed the people properly. The member blames him that the signatures he collected [to prove that he has informed the people] are fake and that they are not sufficient anyway. He adds that the peon should encourage more people to come. But the peon defends himself:

The people do not want to sign! And if I will bring daily labourers here and the meeting will be like this one, they will beat me up and rightly so! Why should they forfeit their daily wage to participate in such a mess? You wardmembers have the duty to bring 10 people from your ward. Why can you not motivate the people?'

Everyone starts accusing everyone else as being responsible for the meagre turn up of villagers. One wardmember says:

People do not even go to the palli sabha which is taking place in their hamlet or village. How can one motivate them to come here? People are so selfish and see only their own benefits; if they do not think they will get something out of it they will not participate.

During this meeting Lita is not talking much, but there is not much to say. After some more debating taking place on the veranda of the school, the remaining persons enter a classroom and settle on a carpet that has been spread out there. The panchayat secretary reads out the prepared 'resolution', stating that Rs. 2,66,000 were spent on 20 different projects, from which 5 are already finished and 15 are in the process of completion. Then, the wardmembers hand over lists of names of people who have been affected by the cyclone, whose houses have been damaged or whose land has been spoiled due to sand-casting. Finally, everybody who is present signs the resolution and the meeting is closed. This part of the meeting took barely 10 minutes. Before people leave, Lita announces that the first sarpanch of the village, a Brahmin priest, has died in the morning and two minutes silence is observed.[35]

[35] This is a marvellous indication of the tremendous social change that has taken place in India since independence: an SC-woman sarpanch is presiding over the mourning for a deceased male Brahmin sarpanch. Lita is not only the first woman heading Gania GP, but also the first SC.

The grama sabha as the main institution for practising direct grass-roots democracy has obviously failed in Gania GP. What are the reasons for the dismal performance? Representatives of the PRI said that a reason for the low participation at this meeting was that the more important grama sabha is the budget session in February/March and people do not want to waste their time with the less important one. Most claimed that the budget-session grama sabha would be better attended. Much debate also centred on the question whether people have been informed in the right way or not. People accused Lita that she did not order the beating of drums, and the peon was scolded that he did not collect enough signatures as proof that he has informed the public. However, this does not appear to be the crucial question because many persons told me later that they had been informed, but still did not care to come. A major problem seems to be that many villagers do not see the point why they should participate in the grama sabha. During a meeting in the ward of Bidyut, some days after the grama sabha had taken place, men from the caste of Gaudas (cow keepers) said:

Yes, we were informed of the grama sabha, but we did not go. We have better things to do. There are these three young wardmembers from Gania village who always make trouble and are drunkards. They never listen if the general people bring forward their suggestions. Everybody just shouts, uses foul language and does not pay attention. So why should we go and waste our time? Even the wardmembers are not going. And they do not follow our suggestions. We draw up the list of beneficiaries in the palli sabha, but at the gram panchayat they do not implement them. So, what we decide here is not done there! The sarpanch says that if you want to have your name included in the beneficiary list you have to pay some money, and when we went to the [samiti] chairman she said exactly the same. We know that the fault also lies with us because we villagers are not united. There are always people who will pay the money. They go directly to the sarpanch and the chairman, give some money and get their names on the list of the beneficiaries. But these people do not realize that later the money which will come for the IAY [Indira Awas Yojana] house will not be sufficient to build a house after paying so many bribes.

It becomes obvious that the village people believe that attending the grama sabha is a waste of time. They complain that nobody is following their suggestions in any case and that only persons of bad character go there. They think that they already decide on the important things in the palli sabha, but the resolutions taken there are not implemented by the gram panchayat. Corruption is seen as a major factor for this state of affairs. Why participate in a meeting to discuss things if later a bribe will decide the matter anyway? However, they also see that the problem lies with the village members paying the bribes, and the inability of the village community to prevent them from doing so.

A senior Brahmin man who is much respected in Gania village gave the following reasons for not attending the grama sabha:

Nobody is going to the grama sabha. I am also not attending the palli sabha. There are only uneducated people, they shout a lot, and say dirty words. That is also the reason why women do not go to these meetings and I would allow no woman of my

household to participate. I went once, but there were only three other people and we waited for two hours. I suggested two things: to build proper roads and to build a Shiva temple. The temple is now under construction. But you see party politics is everywhere today. In our constituency there are basically two influential people: Sri X, the sitting Congress MLA, and Sri Y, who was once MLA here and is now zilla parishad president. These two fight, and they have alliances with politicians at the grassroots. So, if the Congress party is in power, the wards and gram panchayats with the Congress people will prosper and the others will suffer or vice versa. All are involved in party politics—from top to bottom. That is the reason why it does not make sense to go to the grama sabha. If you give suggestions it does not help. In the end, the political people will decide.

The old Brahmin, apart from his patriarchal remarks of not letting the women of his household participate, voices similar concerns as the Gaudas. He does not mention corruption directly but points to the strong involvement of political parties and also mentions the MLA and other state-level politicians as crucial in influencing politics at the village level. This view of things is substantiated when we remember the rivalry between Lita and Kanchana. Different high-level politicians support both. Additionally, they have already learned their politics in so far to know that they have to satisfy the people who have voted for them. So, each wants to have the grama sabha near her place and attempts to secure that most of the benefits accrue to people from their own constituency.

The Brahmin, like the Gaudas, considers participation in the grama sabha as a waste of time and complains that only villains go to these meetings. Many people, especially women, complain about the character of people attending such meetings. Following rules of decent female behaviour, women can obviously not go to such meetings. However, it also seems to be an indication of the fact that it is not necessarily the traditional elite who is participating in the grama sabhas. At least the 'cultured' Brahmins do not go—whether this is actually a progress remains debatable. Others allege that high-caste and rich people do not attend the meetings because there are no benefits for them anyway. Most of the government-sponsored schemes are for poor and SC-people, and so there is no scope for them. As one wardmember said during the grama sabha, people are only interested in coming there if they expect to derive some benefits. This could be a reason for the non-involvement of richer sections in the grama sabha. It goes against conventional wisdom according to which the rural political institutions are captured by the influential elite. Yet, the scenario described above rather seems to be a dreadful indicator of the powerlessness of the lower tiers of the PRI, at least in Orissa. Apparently, the elites do not waste their time with capturing these institutions, but instead go directly to the officials or become active in higher political bodies, like the zilla parishad or state politics.

A neighbour of the sarpanch in Gania, also from the SC-community, complains that the poorest people do not get any benefits. Their names are not given in the palli sabha, and so they will also not be included in the grama sabha. The really poor people also do not benefit from attending. For

them it is a problem to forfeit a daily wage to go to a meeting where not much is decided anyway. They know that they will have to pay money in order to get their name included in a beneficiary list and have to spend even more to remain on the list. To ensure this they would discuss it with the people concerned (sarpanch or officials) directly, and so why should they come to the grama sabha? Another problem is that people also see no reason why they should attend two meetings—the palli sabha and the grama sabha. The beneficiary lists and the micro-plan for the ward are all supposed to be decided by the palli sabha and then communicated to the grama sabha; people wonder why they should go to the grama sabha if only the same things get discussed? However, also at the level of palli sabha, the participation is not very good, but everybody confirmed that more people turn up there than at the grama sabha.

One additional feature which became clear is that villagers do not regard the grama sabha as a public forum for a general discussion of village matters, as an arena in which they can mobilize co-villagers for certain undertakings like cleaning of the village ponds, or as an important meeting point where villagers could exchange their views on topics affecting the well-being of all. One reason for this could be seen in the structural feature that villages in this area are still dominated by casteism and that people conduct most public functions with their caste-fellows. In some cases, there may not be much identification with the village or the gram panchayat as a whole. When a society is segmented in such a way, one actually has to judge whether the concept of the public good, for which the villagers should work together, really exists. High caste people, as mentioned above, seem not to be very interested in participating when they do not gain from the state-sponsored programmes. If this assumption holds true, it might not be too astonishing that most villagers see the grama sabha as a place where decisions are made only on pre-fixed programmes and where the agenda is mostly set by administrative compulsions.

Even if one does not believe in a notion of the common interest of all villagers, an opinion that is far from firmly established, it is still a problem that villagers do not use the grama sabha as an instrument to enhance accountability and transparency of the PRI. On the one hand, basically everybody complains about corruption and malpractices, as we shall see in Chapter 4. Asked why they do not do something against it, they answer: 'What can we do? This practice is done from top to bottom. To whom shall we complain?' Many people do not consider the fact that if they were to attend in numbers they would be better informed and could ask their representatives about different issues, making the processes and dealings more transparent. Here, it concerns money intended for the benefit of the whole village, which might not be spent in the best way if villagers do not pay attention.

The latter fact seems to be one of the reasons why the representatives themselves are not really taking much initiative in motivating the general public: If the required quorum is not met in the second meeting as well they

can pass any resolution without the affirmation of the villagers. That is what the sarpanch pointed out in the first grama sabha. Hence, the elected representatives have no incentive whatsoever to trouble themselves with grass-roots participation. It is evident that the first venue chosen, namely the panchayat office, would not have been spacious enough to accommodate the required number of attendants (at least 10 per cent of the electorate) in any case. So right from the beginning there was no interest in conducting a grama sabha in a proper way. I also became suspicious that the selection of the second venue was on account of a foreigner looking into the matter. The PRI representatives were positive about the fact that not many more people would turn up.

Concerning the participation of women, it was interesting to see that Lita was removing the *pallu* when she entered the panchayat office during the first meeting—it appears that, for her, the office has become a private space.[36] I also mentioned that Lita and Kanchana were very confident and conscious about their elevated position. In contrast to this, the female wardmembers remained quiet and shy. No other women showed up.

Having described the performance of the grama sabha in the more 'backward' block, we shall look at a grama sabha in the coastal area. Two important differences have to be mentioned: The grama sabha observed there was the so-called budget session, which is supposed to be better attended in Gania Block as well. And the grama sabha took place in the aftermath of the cyclone and many people were interested in information on relief measures.

Grama Sabha, 27 March 2000,
*Upgraded Primary School of Village K**

We get to know some days before that the grama sabha will be held on this day. However, when we talk to the panchayat secretary on the same morning he confirms that the meeting takes place today but claims to be unable to tell the exact time. We decide to arrive at the venue at 11:30 a.m.

The school building has been completely destroyed by the cyclone and the meeting is being held under a rectangular canopy of palm leaves that were thrown over a bamboo-pole construction to create some shade in the courtyard of the school. It is very hot and around 300 to 350 people are huddled under the limited shade provided by the provisional shelter. Some sheets have been spread over the dusty ground and most people have settled down there. Bimala (the sarpanch), Mina (a very active wardmember), some male wardmembers, the samiti member, the panchayat secretary and the ex-sarpanch are sitting at the head of the makeshift 'room'. Besides Bimala and Mina, my research assistant and I are the only women there. However, at the other end of the rectangular structure there are around 15 women who are not wardmembers. The rest are men sitting or standing around us.

[36] The fact of removing the *pallu* was also observed from other women during the panchayat meetings.

Bimala announces that the agenda for the meeting is the discussion of the Action Plan 2000–01. Money under the SGSY has been sanctioned and Rs. 3,50,000 have been allotted to the gram panchayat. That amounts to around Rs. 15,000 per ward. Now, the villagers are asked what they want to do with the money. Most of the wards want roads as they complain that there is not much else to do with Rs. 15,000. It is not enough for a new building, and so they will rather spend it on road-repair. The panchayat secretary is noting down the answers. Mainly the wardmembers reply or in case s/he is not present, some senior villager does the talking. Suddenly a big shouting session starts. The money is only sufficient for the repair of one road, but if a ward consists of several hamlets, which road should be repaired? Men jump up, quarrel, shout and the atmosphere under the crowded canopy gets suffocating. Bimala manages to get her voice heard and tries to calm down the masses. Also the samiti member does a lot of talking. He is a Congress party man, whereas Bimala supports the Biju Janta Dal (BJD). After every ward has voiced itself regarding the plans for 2000–01, the sarpanch starts explaining the allotment of the IAY houses.

The government of Orissa had promised to provide everybody whose house collapsed during the cyclone and who is below poverty line money for the construction of an IAY house. However, the government does not have enough money to fulfil this promise. Thus it was decided to distribute the houses through a lottery, which will take place soon at the block office. People start murmuring and rushing to Bimala, the samiti member, and the panchayat secretary to enquire about the procedure. There is a lot of discontent and anger. We find out that the women who have turned up all came for IAY houses. They are either widows or their husbands are ill or could not come to the grama sabha for other reasons. Apart from the Action Plan and the information about the lottery of the IAY houses nothing else gets discussed. There are some clusters of people talking about this or that but soon after the grama sabha is officially over the people leave.

Compared to the grama sabhas observed in Gania, the one in Balipatna was much better prepared and more numerously attended. The panchayat secretary claimed that normally the wardmembers bring some villagers in order to meet the quorum requirement. Are there other causes for the better performance here? One fact was already stated—the grama sabha observed here was the budget session, which is always better frequented than the others. Another reason seems to be that the meeting took place in the aftermath of the cyclone.

Also, in the headquarters GP under investigation in Balipatna Block, we were told that more people attended this grama sabha than normally since everybody was interested in information about the relief. The sarpanch of the headquarters panchayat stated that in this grama sabha more women than usual turned up. As mentioned above, they were interested in the allotment of the IAY houses and other relief measures. It is revealing to compare the actual turnout of women with the statements made by people before the grama sabha took place. Most people claimed that the only women

that would be present at the grama sabha would be the female wardmembers. This was obviously not the case since at least 15 women of the general public turned up; the sarpanch of the headquarters panchayat also maintained that out of 400 people, 100 were females. Mina had said that normally only the wardmembers and women whose husbands are either ill or not available for other reasons attend. That is precisely what I observed during the meeting.

Women do come if they feel they have something to gain and the male household members cannot come for one reason or the other, or they are divorced or widowed. If a male is available to go, why should a woman go? Thus, in Balipatna men still usually care for the external affairs of the household. Compared to Gania, however, there seems to be a certain pragmatism, which allows women to fulfil the function when no male is available. Surprisingly, very few female wardmembers turned up even though they had claimed that they do attend the grama sabha. Still, in Balipatna female wardmembers had claimed in the previous year to be more active in the village meetings than in Gania. It seems that the reason for being active in the meetings like the grama sabha is that in Balipatna the legitimate room for action allowed to women does include public village meetings as well. Lakshmi, a wardmember from the headquarters panchayat, for example, said:

I did not do anything for the MLA election campaign because nobody asked me to do so. I only go to the meetings or do things if I am told. Thus I do participate in the school meetings and also in the palli sabha and grama sabha. But I only go there because I am the wardmember, otherwise I would not go.

Apart from the better attendance and preparation in Balipatna as compared to Gania, the agendas of the meetings were quite similar. Here, no general matters were discussed as well. The agenda was set by administrative compulsions, namely, to draw up the action plan through allotting the money given by the state government. It is also interesting to see the way in which the money is allotted. There was no development plan made which would allocate the money according to need or priority. Instead, it was evenly spread out to every ward. The result was that the wards ended up with an amount that is not enough for projects that might be more deserving. The problem is that no long-term plans have been formulated, but only a short-term, one-year plan. Instead of deciding to concentrate the money on some villages which are most needy, or on projects that are more useful, it was secured that everybody gets the same share, no matter if repairing a small stretch of road is important or not. But there might be another rationale behind this. A member of an NGO informed me that wardmembers and officials normally opt for roads because most money can be diverted for private purposes. A half-finished building makes this obvious, but whether a stretch of road is a little shorter is not so revealing.

Summing up, one can say that the grama sabha does not fulfil the function of a grass-roots deliberative body and it also does not serve to make the dealings of the panchayats more transparent, or the representatives more

accountable. It is not used for discussing development plans, and only predefined programmes are what the decisions are about. The participation of the general population is meagre, and the representatives do not seem to be interested in enhancing the participation. Many villagers in Gania voiced that attending the grama sabha is a waste of time and that corruption or the 'political people' will decide matters anyway. Most villagers do not accept the duplication of palli sabha and grama sabha. Nevertheless, the grama sabha was generally better attended in Balipatna, and also more women showed up there.

CHAPTER 4

Power

IN THE PRECEDING chapter it was established that women are physically present in the Panchayati Raj Institutions, even though to a considerably lesser degree than men. Particularly in regard to activities that are located outside the rather secluded panchayat meetings, the presence of women becomes lower, which also holds true for their participation in other decision-making bodies such as standing committees. In this chapter, I shall analyse to what extent the presence of women in the institutions translates into them exercising power. Being present in formal positions of power alone does not necessarily mean that the representatives are really powerful.

Exercising power has some prerequisites—important among them are, for example, information and knowledge.[1] Without knowing the rules and regulations, it is very difficult to act powerfully in a meaningful way. So far, the level of formal education was established, but that does not tell us much about what the representatives actually know. Thus, first the extent of knowledge of the incumbents will be assessed, and then we shall look at the exercise of power as exemplified through several case studies.

The power, or ability, to decide will be analysed by looking at participation in decision-making in the political bodies. This was assessed in the quantitative survey. Another question concerns the personal autonomy in deciding on political issues. When one looks at power vested in an individual representative, autonomy is an important concept. If the representatives are not autonomous, it is difficult to claim that they are really exercising power. The autonomy in political decision-making will be illustrated by the voting-behaviour during the Assembly elections. The independence or dependence in the voting-decision will be used as an indirect indicator of autonomy also in dealings in the Panchayati Raj Institutions (PRI). Additionally, it gives important clues about the general political behaviour and the political situation in rural Orissa. The same holds for the relationship between local representatives and political parties—though the two lower tiers of the PRI in Orissa are supposed to be partyless, political parties and regional level politicians play a role. The question whether women do introduce a new way of doing politics will be illustrated by women's attitude towards, and practice of, corruption. As noted before, activists as well as ordinary citizens claim that women are less corrupt than men. Therefore, it is very important to

[1] See Foucault (1980); compare also the definition of empowerment by Chandra (1997: 395).

investigate this issue to see if one can really claim a moral superiority of women over men. I shall also examine the statements on projects to be undertaken for the development of a representative's constituency in order to see whether women and men do voice gendered preferences.

As seen in the preceding chapter, only few women participated in the election out of their own interest in politics or public service. Traditionally, politics was no proper domain for rural women, and women were normally not informed about political matters. In fact, knowledge is an important pre-requisite for exercising power and also for participating in a meaningful way and one should establish what the elected representatives actually know about their political environment.

Knowledge of the Larger Political System

Concerning knowledge, the elected members were asked several questions during the survey. Two questions were asked concerning the name of important persons [the Block Development Officer (BDO) and the MLA], and the third inquired after the ruling party of Orissa. These three questions are placed at a kind of higher level, which does not directly deal with information on the PRI alone. They serve to indicate the general awareness of the political situation of their region, and one can conclude that the better the knowledge, the better the awareness of political matters. Later, we shall turn to questions more directly concerned with the PRI, namely, information about the 73rd Amendment, the reservation for women, and government programmes that the representatives are supposed to implement. The results to the first three questions showed that women are lagging behind in knowledge in all areas. Only 13.3 per cent of the women (10 in Balipatna and 4 in Gania) as compared to 40 per cent (also not a very high amount) of the men could give the name of the BDO. The BDO is the most important official at the block level and is responsible for the overall co-ordination of development works. With this question I tried to establish the interaction of the local politicians with the medium level bureaucracy. Both BDOs were new—in Balipatna, the BDO had been appointed roughly one month before, and in Gania two months before the survey. Thus, some of the interviewees, including women, knew that there was a new BDO but could not give the name. The low rate of right answers therefore is partly due to the short incumbency of the officer. Additionally, the BDO is rather remote from the dealings in the gram panchayats, and interaction with him is generally rare for wardmembers.

The respondents are, however, more knowledgeable about the ruling party than about the BDO. Most of the men gave the correct answer (88.8 per cent), whereas about one-third of the women were able to do this. It shows that women are not too well informed about the larger political system. Most of them do not or cannot read newspapers. TVs are not so rare

anymore, but, still, women tend to watch religious plays or soap operas, as I frequently observed while visiting the women representatives. Additionally, most of the public places where politics is discussed are still not accessible for women. The best results were concerning the name of the MLA: 47.6 per cent of the female representatives could give the correct answer, and 95 per cent of the male ones. This result suggests that the MLA plays an important role in the rural power set-up.

In all three cases one can easily see that women have lesser knowledge about formal politics than men. There is also a knowledge gap between the inhabitants in Gania and those in Balipatna. This is even more pronounced when one looks at how many could answer all three questions correctly. Among the women, in Balipatna 5 (8.1 per cent) could do this, in Gania only 2 (4.7 per cent); and among the men, 17 (42.5 per cent) in Balipatna and 14 (35.0 per cent) in Gania.

Knowledge on Specific Features of the Panchayati Raj System

The questions above were mainly concerned with knowledge about important persons or the larger political structure of the state. It is, however, more important to establish whether the incumbents have relevant information on the constitutional Amendment, which is shaping the institution they are participating in. The 73rd Amendment has contributed to several radical changes in the traditional organization of the PRI, especially through the reservation for women, SCs, and STs, also for positions like sarpanch; the reintroduction of the third tier, namely, the zilla parishad; and so on. Thus, it was asked whether the representatives have heard about the 73rd Amendment, and whether they can name the salient features of this Act.

The results to the query showed clearly that knowledge about the existence of the 73rd Amendment is very low. Among the women, only 6.7 per cent have heard about the Act. There is also a gap between Balipatna and Gania, with more women in Balipatna (5 v. 2) claiming to have heard about the Act. In the male sample, I found that information is abysmally low as well. Obviously, a few more men than women have heard about the 73rd Amendment, but 16.3 per cent is not a figure to celebrate. Interestingly, men in Gania are more knowledgeable about the Act's existence than in Balipatna (4 v. 9). If women and men are taken together hardly more than 10 per cent of the representatives have ever heard about the crucial document on which the present structure of the PRI in Orissa is based.

The representatives were also asked about the salient features of the Act. Among the 20 representatives who have at least heard about the 73rd Amendment, there are only 35 per cent who had some information on its specific features. Women who claimed to have heard about the Act were more knowledgeable about it than the men (57.1 per cent of the women compared to 23.1 per cent of the men). The higher proportion of men in Gania who have heard about the Act should be qualified with the lack of knowledge of its concrete content, because only one out of the nine could name some specific features. To be informed about the existence of a

document only, without knowing the details is not very helpful. This finding is everything but encouraging. Only four out of 105 women, that is a mere 3.8 per cent, and only three out of 80 men (also 3.8 per cent) have some knowledge about the features of the 73rd Amendment on which the institutions they are participating in are based! Whereas many critics have speculated that knowledge among the women would be that low, the equally discouraging finding for men should make us wonder whether lack of knowledge on vital features of the PRI is indeed a predicament for women only or whether it is not rather a problem of lack of training and information for all PRI members. Further, it indicates that the political system and the agencies concerned with the training of the newly elected members have not cared enough to inform the representatives about the basis of the PRI they are serving in. I shall corroborate this assessment later, when I discuss the issue of training of the PRI representatives.

It is also important to look at the results in respect to the position the representatives hold in the PRI. Even though one might think it important that ordinary wardmembers should also know about the legal basis of the institutions, it is more relevant to see if most of the representatives in the higher positions are at least informed. The sample is of the representatives who have heard about the existence of the Act (see Table 4.1).

As expected, the wardmembers are the least informed incumbents, especially the female ones. It is not very encouraging to see that also only half of the sarpanches have heard about the Act, although they should definitely know about it. The samiti-chairpersons and the vice-chairperson are informed, but the only two female samiti members interviewed in Gania have never heard about the legislation. What is disturbing is the fact that neither the samiti chairperson nor the samiti vice-chairperson of Gania have any detailed knowledge on the 73rd Amendment. The seven persons with more detailed knowledge are, among the female sample, two sarpanches in

TABLE 4.1: POSITION IN THE PRI AND KNOWLEDGE OF THE 73rd AMENDMENT

	Ward-member	Naib-sarpanch	Sarpanch	Samiti chairperson	Samiti vice-chairperson	Total
Female B	1 (2.0)	- (0.0)	3 (75.0)	1 (100.0)	-	5
Female G	- (0.0)	- (0.0)	1 (33.3)	1 (100.0)	-	2
Total	1 (1.2)	- (0.0)	4 (57.1)	2 (100.0)	-	7
Male B	2 (6.1)	- (0.0)	2 (33.3)	-	-	4
Male G	5 (14.7)	1 (50.0)	2 (66.7)	-	1 (100.0)	9
Total	7 (9.1)	1 (33.3)	4 (44.4)	-	1 (100.0)	13
Total (Male + Female)	8 (4.7)	1 (6.7)	8 (50.0)	2 (100.0)	1 (100.0)	20

Notes: 1. Percentages are calculated concerning percentage of the sample in the specific positions. For example, three out of four female sarpanches in Balipatna have heard about the Act, which is 75 per cent.
2. (n=20), these are all 'knowledgeable' persons.
3. B = Balipatna; G = Gania.

Balipatna (50 per cent of all female sarpanches there), one in Gania (33 per cent), as well as the samiti chairperson in Balipatna (100 per cent), and among the men two sarpanches in Balipatna (33 per cent) and one sarpanch in Gania (33 per cent). It is revealing that the male sarpanches were in fact less informed about specific features of the amendment than the female ones!

It seems that the Constitution and the legal provisions are very abstract in general and do not form the basis of knowledge of the representatives. More directly relevant, especially for our research, but also for the members of the PRI, is the provision for a 33 per cent reservation for women. One would expect that most representatives know about this condition as they have either been elected on this basis (in case they are women), or were directly confronted with the fact that now 33 per cent are women sitting in the gram panchayats and the higher levels. This feature of the new PRI is one of the most visible and revolutionary ones. In Orissa, as we have seen, it is also not directly connected with the 73rd Amendment because it had been introduced already before the ratification of the Act.

As regards the question of the reservation for women, it is conspicuous that men are much better informed than the women. About 23 per cent of the women only did know about this provision as compared to more than 75 per cent of the men. It was puzzling to find that the women who have all won seats reserved exclusively for them did not know about the constitutional basis for this![2] They generally knew that they had contested a 'Mahila' seat, but they were obviously not informed about the larger scheme. It seems that they also did not really reflect upon why they had suddenly been asked by their husbands or villagers to participate in rural politics, which was hitherto a male prerogative, but accepted it as a matter of fact. Thus, they are seemingly unaware about the reasons behind bringing women into the grassroots political institutions. Most representatives were also not conscious about the procedure of the reservation, especially the fact that the seats will rotate in the next election. The high percentage of men (although the fact that one-quarter did not know about this feature is also disheartening) is not so puzzling. This feature was much debated among men and was resented by many male villagers in general.

The quantitative survey was conducted roughly two years after the election of the present incumbents. One has to acknowledge that this is a short timespan to become acquainted with a rather complex institution, especially if one considers the fact that prior to this election most women had nothing to

[2] The results to this question still leave me perplexed. Actually, the initial question was 'How do you see the 33 per cent of reservation for women in the PRI?' It took a while to realize that many respondents did not know about this fact. I had not anticipated such a state of affairs at all. Seven representatives in Balipatna have not been asked this question. These were people interviewed during the pilot study, whose other responses were, however, used for this study. Consequently, in the modified questionnaires, respondents were first asked whether they know about the 33 per cent of reservation. In case they answered in the negative they were informed about this feature of the Act and then asked whether they appreciate it or not.

do with politics. During the second field visit many women who had appeared to be rather uninformed during the first survey had definitely gained in knowledge and confidence.

Knowledge of Government Schemes

Apart from information about the political system and the rules and regulations pertaining to the grass-roots institutions, it is important that the representatives know about the different government schemes because one of the main duties of the representatives is the implementation of these programmes. The role of the PRI, especially in regard to the identification of beneficiaries for various schemes, has been strengthened through several changes introduced on 1 April 1999 (see fn. 33, Chapter 3). The government schemes form the main bulk of the financial resources sanctioned to the panchayats and they are devolved via these state-sponsored schemes; the resource base for works to be taken up independently by the panchayats is very meagre, as will be discussed in greater detail in Chapter 6. At the time of the survey there were several schemes in existence, out of which most have been subsumed under the new SGSY in 1999.

First we shall look at the number of schemes mentioned by the respondents (see Table 4.27). During the survey there was unfortunately no scope to ask further questions in order to explore whether the respondents were actually acquainted with the different procedures of the scheme. At least, being able to mention a scheme shows that they have heard something about it.

A little more than a quarter of the female respondents were not able to mention any government scheme, most of them being wardmembers (24 persons), two naib-sarpanches, and one samiti member. That could be a hint that so far they have not been very active in the PRI or that they do not pay much attention to what is going on in the panchayat. Even the wardmembers are normally in charge of some function connected to government programmes. Also in the gram panchayat meetings as well as during the grama sabha there is talk about various schemes and the identification of beneficiaries. Most women know about one to two schemes, and more than 50 per cent of the sarpanches were able to name more than two. Sarpanches are actually in charge of the programmes and should accordingly know.

TABLE 4.2: KNOWLEDGE OF GOVERNMENT SCHEMES—NUMBER OF SCHEMES MENTIONED

	0	1–2	3–4	5–6	7–10	Total
Female B	16 (25.8)	30 (48.4)	11 (17.7)	2 (3.2)	3 (4.8)	62 (59.0)
Female G	11 (25.6)	16 (37.2)	9 (20.9)	7 (16.3)	-	43 (41.0)
Total	27 (25.7)	46 (43.8)	20 (19.0)	9 (8.6)	3 (2.9)	105 (100.0)
Male B	-	11 (27.5)	17 (42.5)	10 (25.0)	2 (5.0)	40 (50.0)
Male G	2 (5.0)	10 (25.0)	17 (42.5)	8 (20.0)	3 (7.5)	40 (50.0)
Total	2 (2.5)	21 (26.3)	34 (42.5)	18 (12.5)	5 (6.3)	80 (100.0)

Note: Percentage in rows for Balipatna (B) and Gania (G) are calculated for each sample separately.

TABLE 4.3: FREQUENCY OF MENTIONING OF SPECIFIC GOVERNMENT SCHEMES.

	Female		Male		Total
	Balipatna (n = 46)	Gania (n = 32)	Balipatna (n = 40)	Gania (n = 38)	(n = 156)
IAY	35 (76.1)	22 (68.8)	29 (72.5)	27 (71.1)	113 (72.4)
JRY	12 (26.1)	12 (37.5)	20 (50.0)	29 (76.3)	73 (46.8)
IRDP	11 (23.9)	8 (25.0)	30 (75.0)	15 (39.5)	64 (41.0)
OAP	15 (32.6)	15 (46.9)	10 (25.0)	13 (34.2)	53 (34.0)
BSY	8 (17.4)	22 (68.8)	9 (22.5)	14 (36.8)	53 (34.0)
DWCRA	4 (8.7)	1 (3.1)	6 (15.0)	5 (13.2)	16 (10.3)
Widow Pension	5 (10.9)	5 (15.6)	1 (2.5)	4 (10.5)	15 (9.6)
TRYSEM	2 (4.3)	1 (3.1)	6 (15.0)	3 (7.9)	12 (7.7)
MWS	-	2 (6.3)	1 (2.5)	4 (10.5)	7 (4.5)
MSY	1 (2.2)	-	2 (5.0)	-	3 (1.9)

Notes: 1. Percentages are calculated according to the persons giving answers in the several categories. For example, 35 out of 46 women in Balipatna named the IAY, which is 76.1 per cent.
2. (n=156), these are all persons who gave an answer.

Among the men, most know around three to four schemes, and, here, the sarpanches are generally more knowledgeable. The mean number of schemes mentioned by women is 1.95 in Balipatna and 2.12 in Gania, together 2.02, and, among the men, 3.75 in Balipatna, 3.37 in Gania, and together 3.56— thus, men are more informed in this respect than women.

What kind of schemes do the respondents know? Table 4.3 gives the break-up of the most frequently named programmes or schemes. There were also answers concerning schemes which could not be identified or which were given by only two or three people. Additionally, some sources of money were named that are not really 'government schemes', like the MP Untied Fund, and the MLA LAD.[3]

The most popular scheme among women and men is the Indira Awas Yojana (IAY). Under this scheme Rs. 20,000 is given to people below poverty line to construct a dwelling, and the property is supposed to be registered in the name of the woman or of the husband and wife. The beneficiaries of this scheme are supposed to be identified by the wardmembers and verified in the palli and grama sabhas. Women are very interested in this scheme, and I have mentioned that most of the women who had participated in the grama sabha in Balipatna block attended to get information on IAY houses. The schemes that offer loans for various purposes such as the Jawahar Rozgar Yojana (JRY) and the Integrated Rural Development Programme (IRDP) are also known, men naming them more frequently. Women repeatedly mentioned the Old Age Pension (OAP) and to a lesser degree Widow Pension, which are both disbursed from state funds. Men named these programmes region-wise less than women did. That is, there is a gap between men and women from the same region; however, men in Gania named OAP more frequently than

[3] These are funds given to the MPs and MLAs to spend in their constituencies according to their priorities.

women in Balipatna. Ballika Samrddhi Yojana (BSY) is extremely popular among the female respondents in Gania and much less so in Balipatna. This scheme gives incentives for the girl-child. Even though Development of Women and Children in Rural Areas (DWCRA) is a scheme specifically designed for women it is mentioned more often by men than by women.

One can detect a slightly gendered pattern in the mentioning of various schemes. Women are rather knowledgeable about schemes favouring old people, girl-children, and housing, whereas men more frequently mention schemes by which one can obtain loans for productive purposes or for the development of the village's infrastructure. One reason for this could be the different life experiences of men and women. It might be dependent on how the representatives got to know about the schemes. Only very few have been trained. Thus, representatives who are wardmembers get information either from the sarpanches or from people who come to them and ask to get registered for certain schemes. It seems that village women who want loans for an IAY house, their Old Age Pension, or money under the BSY mainly address female representatives. That is why they know about these schemes. Male representatives are presumably more often addressed for loans. They may also know about the other schemes. But when asked, they rather name the JRY, as it is more on their mind than maybe the OAP.[4]

It has been established that women have less knowledge than men in general. I have argued that a necessary condition for exercising power is knowledge. That is quite straightforward: If one does not know about the rules and procedures, if one has no information about government schemes, one cannot exercise power in the PRI effectively. However, that does not automatically suppose that to have the relevant knowledge is sufficient for exercising power. The association between power and knowledge is not that clear and there are various approaches to this relationship.[5] An individual also needs resources to transform knowledge into power. For example, to know about a given government scheme is not enough. One must be able to process this information, one must know the relevant procedures to apply for the money, and maybe one also has to know the relevant people. Good education should help the representatives to acquire further relevant knowledge.[6] The ability to procure knowledge on their own would also make the representatives less dependent on other persons—such as higher officials—who might not be willing to share all relevant knowledge with them or try to manipulate them. To acquire information on one's own would thus strengthen individual autonomy. Autonomy is another crucial factor for exercising power and will be discussed in the next section. A further

[4] Whether this result is to be seen as positive or negative is not easy to answer. It shows that there are slightly gendered patterns, which can be seen as a justification for the inclusion of women in politics. On the other hand, it also shows that women are less involved in the more decisive programmes that are concerned with productive inputs.

[5] See, for example, the various articles in Fardon (1985).

[6] We shall see later that Babita, the naib-sarpanch in the headquarters GP of Balipatna Block, started reading the Panchayat Manual in Oriya to gain further knowledge.

supportive personal quality is inquisitiveness and self-confidence. A curious and self-confident person may ask officials for additional information. The question of confidence and consciousness shall be discussed in Chapter 5.

I have also pointed out that many female representatives were not informed about the fact that 33 per cent of the seats in the PRI were reserved for them. I interpreted this to mean that women are most likely not informed about the greater scheme behind that reservation. If women were conscious about it they might become more aware about the role they could play in the PRI for promoting women's issues. The issue of gender-awareness will be addressed in Chapter 5 as well. Apart from the above, information has an overall relevance for the democratic process. This emerged, for example, in a seminar, which brought women representatives from Kerala and Rajasthan together. It was found that 'the right to information is an absolutely central need to give any real meaning to this decentralized form of government' (N.N. 2000).[7] It is further important to stress that knowledge also carries a non-instrumental value for the process of empowerment. That holds even if knowledge itself were not directly leading to exercise of power. As I shall show in Chapter 5, all female representatives interviewed in greater detail gained in knowledge while serving in the PRI. And all highly value this fact. It appears that acquiring knowledge as such is already empowering, whether one has the ability to actually apply this knowledge or not.

DECISION-MAKING, AUTONOMY, AND THE ROLE OF POLITICAL PARTIES

In this section we shall look at power understood as the participation in the decision-making process. Of importance also is the question of how far the representatives are autonomous in their decisions. This will be exemplified through their participation in the Legislative Assembly elections. Furthermore, the role of political parties at the lowest political level and their relationship to the representatives will be exemplified.

Participation in Decision-making

During the survey the respondents were asked if they participate in the decision-making in the PRI.

The answers (see Table 4.4) show that there is a variance between the female and male members in the PRI. Less than two-third of the women claim to have participated in every decision, and one can safely assume that the real figures are even lower since some women believed that nodding in assent is already a significant contribution. One can equally suppose that the participation of some of the men, who state that they participate in all decisions, also does not go beyond the mere confirmation of a resolution,

[7] This was the main result that emerged in a meeting in Jaipur, where PRI members from Kerala and Rajasthan came together to look at ways to empower the grama sabhas; see 'Shared Experience' (N.N. 2000). This issue also came up in various national seminars I attended in Delhi between 1998 and 2000.

which has been discussed by more active members of the panchayat or made by the sarpanch alone. Thus, in a comparative perspective these figures are useful and quite revealing.

In most gram panchayats it was found that the sarpanch is the most important figure in decision-making. Many members in the PRI complained behind closed doors about the high-handedness of the sarpanch; that s/he does not consult the members properly; that s/he does not give all the information necessary; or that s/he only consults the members belonging to his/her party or faction, whereas members belonging to the rival party lose out. It also became clear that the training of PRI members conducted by the State Institute of Rural Development (SIRD) is directed towards the sarpanch only. As the financial means of the states are very limited, the sarpanch is supposed to function as multiplier. But in India, like everywhere, the truism holds that knowledge is power, and in some cases the sarpanches were accused of being reluctant in handing down information to the ward-members. The high-handedness of the sarpanches might also stem from the peculiarity of the Panchayati Raj System in Orissa. As mentioned, the grama directly elects the sarpanch; hence many sarpanches claim that they feel more accountable to the villagers than to the wardmembers.[8]

As regards decision-making in relation to position, most sarpanches or samiti chairpersons claimed that they participated in every decision, apart from one female and one male sarpanch, both from Balipatna, who said that they have participated in most, but not every, decision. One can conclude that regarding decision-making gender plays a role and that men are more likely to participate than women; yet, apart from gender, position or rank is decisive as well. Most of the female sarpanches are active in decision-making, and in the sample there was only one female sarpanch (in Gania Block) who was actually not functioning on her own but was a mere proxy of her husband. However, she still asserted that she participates in every decision.

The male sarpanch from the remote gram panchayat (GP) in Gania Block told me that women do actually participate in the decision-making in his

TABLE 4.4: PARTICIPATION IN DECISIONS TAKEN IN PR MEETINGS

	None	Few	Most	Every	Total
Female B	6 (9.7)	9 (14.5)	10 (16.1)	37 (59.7)	62
Female G	6 (14.0)	6 (14.0)	3 (6.9)	28 (65.1)	43
Total	12 (11.4)	15 (14.3)	13 (12.4)	65 (61.9)	105
Male B	-	1 (2.5)	6 (15)	33 (82.5)	40
Male G	1 (2.5)	-	-	39 (97.5)	40
Total	1 (1.3)	1 (1.3)	6 (7.5)	72 (90.0)	80

Note: Percentages in rows for Balipatna (B) and Gania (G) are calculated for each sample separately.

[8] I asked some individuals what should be changed in the organization of the PRI to make them more efficient. The sarpanch of a remote GP in Gania argued that it should not be possible to remove sarpanches through a no-confidence motion of the ward-members, but only through the villagers who have elected him/her directly.

gram panchayat like the men do. If they have to say something, they would raise their voices and make the others listen to them. The observer's view on women's performance could be rated as indicator for the real extent of women's participation. Because of this, male representatives were asked whether they think that women participate in the PRI in the same way as men. Participation encompasses more than just taking part in the decision-making processes. However, if men were of the opinion that women come to sit in the meetings only and do not participate in the discussions, they could answer that they participate less. It appears that men are quite undecided on this issue, and the number of those who believe that there is no difference is surprisingly not much smaller than the number of those who believe that women do participate less (45 per cent $v.$ 48.8 per cent). In Gania men were more likely to give a statement in favour of equal participation than in Balipatna (52.5 per cent $v.$ 37.5 per cent). In addition, four men (5 per cent) gave the answer that some women do participate in the same way and some do not.

Participation in State Assembly Elections

Having established the degree of participation in decision-making, it is interesting to see to what extent women and men take autonomous decisions. Autonomy is linked to the notion of individualism, which is often supposed to be a Western concept. Still, in order to evaluate the extent of decision-making by individuals, the notion of autonomy is important. Otherwise, it would not matter much who is actually present in the political institutions, at least not for decision-making. Autonomy is not easy to measure, and so I shall leave the confines of the PRI and turn to the voting decision in the Assembly elections. Since voting is a basic political activity, some assumptions can be made on this basis for participation in the PRI as well. Participation in the State Assembly election is used on the one hand as an indicator for the autonomy in decision-making, especially when one looks at the processes, which took place during the observed Assembly election in February 2000. However, it also serves another purpose. Participation in elections is a basic indicator for a more general participation in the political process, which is a marker for the representatives' interest in politics and their political involvement as such. Thus, I am not only dealing with the issue of the representative's autonomy, but also with their interest in politics and the rural political system in general.

During the survey, the respondents were asked whether they had voted in the last State Assembly (Vidhan Sabha) election, which took place in 1995. Later the election in February 2000 was observed in Gania Block while conducting the second round of field research. As regards the participation in the 1995 Assembly election it emerged that most women had given their vote (86.7 per cent). It is interesting to note that less women in Balipatna voted than in Gania (80.6 per cent $v.$ 95.3 per cent). All male representatives answered that they had voted in this election. The question remains open how informed the vote was and if the women participated because of their

own interest. That some representatives could not name the sitting MLA, as shown above, raises some doubt concerning the consciousness of the vote. To find out whether those who said that they had participated in the election could remember whom they had elected and also to see their political inclinations, they were asked for which party they had voted (see Table 4.5).

Only one man refused to give an answer. Eleven per cent of the women could not recollect for whom they had voted, thus it seems fair to assume that they did not vote very consciously at that time. The higher preference for the Janta Dal in Balipatna is congruent with the fact that the MLA elected at that time was from the Janta Dal. In Gania the question proved to be tricky. Here the MLA elected in the Assembly election in 1995 was from the Congress party. However, he participated in the PRI for the zilla parishad president elections in 1997 with a ticket from the Biju Janta Dal and won the election. Thus there was a by-election through which an Independent candidate who later rejoined the Congress party was elected. Hence, some of the answers referred to the election in 1995, and some to the by-election 1997. This political hotchpotch of defecting and joining parties in pursuance of personal benefit was also quite obvious during the State Assembly elections in February 2000. The observation of this election helps to illuminate political processes in rural Orissa as well as the process of the decision-making on whom to vote for.

The situation when the election took place was rather special since it took place in the aftermath of the super-cyclone. During this difficult time the Congress government had proved to be unable to manage the affairs in a professional way. Giridhar Gamang, a senior tribal politician who allegedly was not very experienced especially in administrative matters, headed the government at the time of the cyclone.[9] His predecessor, J.B. Pattnaik, the most shrewd and influential politician in the Orissa Congress party, had been pressed to step down following several scandals, and Gamang, without substantial backing by any faction of his party, was seen as a compromise candidate. His lack of experience and command over the state-bureaucracy

TABLE 4.5: VOTES GIVEN TO POLITICAL PARTIES IN THE 1995 VIDHAN SABHA ELECTION

	INC	BJP	Janta Dal	Independent	Don't know	Refuse to say	Total
Female B	21 (42.0)	-	25 (50.0)	-	4 (8.0)	-	50 (54.9)
Female G	21 (51.2)	2 (4.9)	6 (14.6)	6 (14.6)	6 (14.6)	-	41 (45.1)
Total	42 (46.1)	2 (2.2)	31 (34.1)	6 (6.6)	10 (11.0)	-	91 (100)
Male B	16 (40.0)	3 (7.5)	20 (50.0)	-	-	1 (2.5)	40 (50.0)
Male G	22 (55.0)	5 (12.5)	10 (25.0)	3 (7.5)	-	-	40 (50.0)
Total	36 (45.0)	8 (10.0)	30 (37.5)	3 (3.8)	-	1 (1.3)	80 (100)

Notes: 1. Percentages in rows for Balipatna (B) and Gania (G) are calculated for each sample separately.

2. (n=171), these are all persons who have participated in the election.

[9] The Oriyas made jokes about his name. They said that Gamang dropped the final 'o' normally pronounced in his name because otherwise it would read 'Go man go'.

proved to be fatal when he was faced with the severe crisis. The veteran Congress politician Hemanand Biswal replaced him shortly before the elections, but could not stem the tide in favour of his party. The population of Orissa was very disenchanted by the way in which the crisis had been dealt with, predominantly the slowness of relief, and the high prevalence of corruption. Chandrababu Naidu, the Chief Minister of the neighbouring state of Andhra Pradesh, on the other hand, was the hero of the day: He had sent troops for relief measures directly after the cyclone had hit coastal Orissa. He joined the BJD/BJP combine in the election campaign.

Generally, one can say that the Congress government was not in high favour after the dismal performance in the months before and because of scandals, like the Anjana Mishra gang-rape case.[10] The new star on the regional political horizon was Naveen Patnaik, son of the over-towering politician Biju Patnaik, who had moulded Orissa's political scene for several decades until his death in 1997. The party that Naveen founded and named in memory of his father, the Biju Janta Dal (BJD) was in high favour. Naveen was seen as a new face, having credibility for being the son of the much-revered Biju Patnaik, and people believed that he would not be corrupt as he has a considerable amount of wealth of his own.[11] The BJD, being part of the National Democratic Alliance government, had an electoral alliance with the BJP. It was decided before the election as to which party would contest in which constituencies in order not to split the vote. The final decision led to controversies because many believed that the BJD had given too many constituencies to the BJP. This was, in brief, the political scene at the state level when the election campaigning started. How did the local scene look like?

In Daspalla constituency, to which Gania belongs, there were three important candidates: The sitting MLA of the Congress party Harihar Karan, who was minister twice and who allegedly accumulated a lot of money

[10] Anjana Mishra is a well-known woman from Bhubaneswar who is living separately from her husband. She had filed a case against a high official, supposedly a friend of the then Chief Minister J.B. Pattnaik, for assaulting her in his house and asking sexual favours. Later she got police protection, but on 9 January 1999 she left her house without informing the security personnel and was gang-raped by four people just outside Bhubaneswar on a backside road to Cuttack. The rape was proved to have taken place by medical examination and a journalist travelling with her was an eye-witness. Anjana Mishra claimed that J.B. Pattnaik was behind this. The whole story is quite nebulous and nobody actually knows what has really happened. Some people claim that it is her own fault and a result of her immoral behaviour and politicking. These persons believe that she has many illicit relationships with men, the journalist witness being one of them. Others assert that she is the victim of high politics, and the political opposition of the Congress party instrumentalized the case for political mileage. Four days after the gang-rape on 13 January 1999 there was an Orissa *bandh*, and many people demonstrated against the Chief Minister.

[11] One major drawback criticized by Oriyas is his inability to speak their mother tongue. Naveen Patnaik was raised outside Orissa and has tremendous difficulties to converse with the ordinary people.

during his terms; the zilla parishad president from the Biju Janta Dal, Rudra Madhab Ray, who had been MLA once from this constituency under the Janta Dal-led-government of Biju Patnaik in the early 1990s; and a young Brahmin campaigning for the BJP, Sukant Panigrahi, who had no previous political office in the State Legislature. When Daspalla constituency went to the BJP in the seat-sharing arrangements, the politician from the BJD decided to run as an Independent and was accordingly expelled from his party. Thus, the anti-Congress vote got split between the BJP and the rebel candidate.

Election campaigning started seriously after the filing of nominations by 3 February 2000. There was extensive canvassing for the respective candidates, posters pasted on every available wall often with images of national-level politicians like Atal Behari Vajpayee or Sonia Gandhi; touring of the candidates in the villages and hamlets; organized public meetings where other politicians or prominent figures of Indian public life appeared in support of the candidate. In Gania the masses were blessed with a visit from the actor of 'Shaktiman', an extremely popular children's TV serial on a righteous and pious man—a kind of Indian Superman—who was campaigning for the BJP. At this meeting some women were also participating, accompanying their children who were very eager to see their hero. The other public meetings were only visited by men. I observed two gatherings. The first one was by the BJP candidate who marched through the villages on foot—khadi clad and heaped with garlands—followed by a jeep blaring election slogans. The other one was a meeting with the rebel candidate, which was not as big. In both cases only men gathered, and in the latter case there were many youngsters intoxicated by the freely distributed liquor. The closer the date of election approached, the more liquor flowed in Gania.[12] The bazaar was often full of drunken youngsters and many rumours were heard about buying of votes in exchange of money, bicycles, or even scooters. A lot of money was spent and a single vote could be worth Rs. 50 to Rs. 100, sometimes even more. In this atmosphere, I asked many wardmembers and villagers during the meetings how they decided whom to vote for. Lita, the sarpanch from Gania, was very interested in the Assembly election. She was supporting a specific candidate who helped her during her election.

He came to our house and asked me to contest as sarpanch. At this time I was pregnant and my mother-in-law was ill in bed. So I refused. But then he promised that he would do something to help my husband and only for this reason I agreed to contest. But he has done nothing for my husband so far and he also gave no money for expenses during my election campaign. Actually I do not like him very much; I do not think that he is a good man. I do not even like his campaigning symbol. However, when he was MLA here under the [...]-Government a lot of things were done. But he has changed parties too often. Still, I will support him, because he was in my house. And the sitting MLA has not done anything for his constituency; he did not even visit it once, so why should I support him?

[12] Normally the candidates distribute money to the so-called 'little *netas*' (lit. leaders) and *chamchas* (sycophants), who in turn spend it on liquor to woo the male electorate.

Lita openly asked the wardmembers to vote for her preferred candidate during a panchayat meeting that I observed. Two wardmembers, among them Sabita, were asking why they should vote for this person. Lita snapped that he would be good for the village and GP and that he would give money for development works. However, it did not seem that the sarpanch's effort would bear any fruits.

I talked later to Sabita about this episode. She comes from a tribal village around 8 km away from Gania village, which is very badly connected. She says that the people in her village are very united. The male members will have a meeting and will decide on whom to vote for. And everybody will be bound to that decision. When I ask her whether it will make any difference for their village who will win she says: 'Forget it!' She recounts that the last two MLAs who are also contesting in this election have not done much for the area. Once the villagers had asked the then MLA to help them dig a well, but nothing happened. Hence, people are quite disillusioned about politics.

In the remote GP of Gania Block under investigation, the situation is described in a similar way. Nalini, the young *Muduli* wardmember was interviewed while she was protecting her field of brinjals and tomatoes against monkeys. By chance my research assistant and I were accompanied by Shakuntala, another wardmember from the same GP but different village. Nalini says that she is not deciding for whom to vote—her husband will decide. But in her ward it is not the same as in the village of Shakuntala. In Shakuntala's ward the whole village votes for one candidate. Nalini complains: 'There is no unity in the villages anymore. Every family is deciding for themselves. You see, nobody listens to anybody anymore.' Shakuntala recounts that in her village the men will decide in a village meeting whom to vote for, and everybody will vote for this candidate. She proudly says: 'In our village there is still unity. Also I was elected unanimously.' Both are not really interested in the election, but still think it to be important that the candidate should be a good person. They have heard of the young BJP candidate, who is new. Nalini even knows his name because she comes from near his village. Both believe it could be good to vote for some new person, but add: 'What the husbands will decide we will do.' They also say that there was no discussion so far about the election in the panchayat meetings, but they know for whom the sarpanch is campaigning.

It appears that ordinary female wardmembers normally do not make their own informed decision on whom to vote for. The decision is often made by the 'villagers'—a category which was already mentioned as being mainly responsible for the decision to run for election. When I asked the two wardmembers about who these villagers were, they gave the same information as then: the 'villagers' are male elders who will have a village meeting to discuss this matter. 'Village' does often not refer to the whole village but the ward or *sahi*, where people of one caste live. The male caste elders then take the decision. The political candidates or the 'little *netas*' seem to be instrumental in some cases in bribing the influential persons. Sometimes a village asks, for example, for a generator for the community hall in exchange

for their united vote. Questioned about this practice some people replied: 'You see, that will be the only thing we will ever get from the politicians. When they are elected they will forget us, so let's get at least some benefit now.'

In cases where the matter is not decided by the village elders, the husband or father-in-law as head of the household decides. In all scenarios, however, the decision of the women is not an independent one, and most women, especially outside the PRI, are not interested in the election very much. Also, many men do not decide independently. The difference here is that men are likely to be more instrumental in reaching the final conclusion. Many persons, whom I talked to, whether male or female, saw the unity of the village as a value per se, and the Assembly election provides an opportunity for the unity to be manifested, as well as in the decision for the wardmember. In this respect, as well as in regard to the decision to take part in the PRI election, neither men nor women are really independent in their decisions. The village community is still very influential, especially in Gania. In Balipatna I could not observe the election campaign, but here persons made similar statements, even though it appears that there is less incidence of a whole village voting *en bloc* as compared to Gania. But also in Balipatna it seems that very few women made an independent decision.

Unfortunately, it was not in the purview of this study to analyse in detail who in the village community really dominates political decision-making. There was some indication that a kind of 'feudal' political machine still exists in Gania. I heard about landlords who were influencing their labourers to vote for a specific candidate. Also respected village elders—mostly high caste (Brahmin or Karan) and descendants of the traditional *Sarbarakars* or *Sardars* (see Appendix)—were instrumental in influencing the voters. They have direct access to the political candidates and can bargain on the value of the vote. Politicians often employ men from different castes to distribute the liquor in order to induce a positive vote from members of this caste-group. Caste still plays an important role in the voting decision. Most persons from the SC-category said that they would vote for the Congress party whereas the higher castes favoured more the BJD/BJP combination.

Although many believe that the electors will really cast their vote in favour of the candidate who gives them some benefits, lately doubts have been raised. Many candidates spent a lot of money in the 2000 election. Accordingly, they should have won the election if the electorate would feel bound to the benefits taken. However, despite the money given, many of these candidates have actually lost this election. Voters have become aware that their vote is secret, and, nowadays, some dare to vote according to their own feelings, either without accepting bribes at all, or even in contradiction to the bribe given. However, one can still assume from information gathered during many talks that women rarely would vote against the family or village decision and that most men feel bound to the community decision and to the candidate who did them some favour in cash or kind. It was also found that the representatives of the PRI are busy in election campaigns for specific

candidates who have either supported them during their own election or promised to support them in the future.

This result of women's restricted autonomy is very consequential for the process of women's empowerment at large. We have already seen while discussing how villagers decided which women to (s)elect that village women were not present in these forums and presumably had not much say in the decision-making process. Female wardmembers are hardly involved in deciding whom to elect as MLA, so it is fair to assume that common village women face an equal dilemma in respect to the PRI elections. Considering this it is hard to maintain that female incumbents should feel accountable to the village women, since they were not even involved in the PRI election. It will be shown later that some female wardmembers feel indeed induced to cater more towards male demands, since there is not much support from the female constituency.

Representatives and Political Parties

The question of what role political parties should play in the PRI was very controversial right from the beginning of the Indian Republic. Some favoured a partyless village democracy, whereas others argued for the involvement of political parties. Bhargava distinguishes two positions: the *Sarvodaya* (welfare for all) school following the ideas of M.K. Gandhi, V. Bhave, and J.P. Narayan, who argue for a 'partyless, communitarian or participating democracy', and the other school of thought that argues for the participation of political parties in local government (Bhargava 1979: 7–21).

As already noted, the legislative in Orissa followed the ideas of a partyless democracy for the two lower tiers of local government that are supposed to be held without party symbol, whereas parties are allowed to compete in the zilla parishad elections. In the preceding section, some background information on the political scenery in Orissa was provided, and it was found that some PRI representatives, especially in the higher positions, are linked to the larger political system. In order to see the connection of PRI representatives and political parties we shall first have a look at the rate of membership, although this is only a very crude indicator for the alliance of members of the PRI with political parties or higher level politicians. We shall later proceed to some qualitative observations and interviews.

As expected, male incumbents are much more likely to be party-members than their female counterparts (51.3 per cent *v.* 12.7 per cent). There is a difference between the two blocks, but it is not too pronounced and it also does not point in the same direction for both genders. Whereas men in Gania are less likely to be party-members than in Balipatna (45 per cent *v.* 57.5 per cent), the pattern for women is the other way around (8.5 per cent in Balipatna *v.* 18.6 per cent in Gania). However, one should not overestimate this trend, as at least one woman in Gania gave the answer that she is a party-member during the survey. When asked a second time and when the concept was explained in more detail (like whether she pays membership fees), she answered that she is not a real party-member, but feels close to the party. Even though

there may be several more respondents who follow a different concept of 'membership', the answer 'yes' indicates that there is at least a strong identification with the specific party or a close connection to politicians of this party. It was already argued that the sarpanch is one of the most powerful positions in the present structure of the Orissa PRI. Thus, it seems interesting to look at their involvement in political parties (see Table 4.6).

For both genders the majority of sarpanches are party-members and male sarpanches are more likely to belong to a party than female ones (77.8 *v.* 57.1 per cent). Women in Gania are more likely to be party-members. Among the men, more sarpanches in Balipatna are party-members. However, the sample is too small to draw substantive conclusions. The sarpanches who responded that they are not party-members have mostly some indirect contacts to powerful politicians, without having joined a party officially. The alliance is anyway often not with a political party, but rather with individual powerful politicians. If these higher-level politicians choose to leave the party, the affiliation to them normally continues. One case in point is Lita, the sarpanch of Gania mentioned before. A similar situation was found with the male sarpanch of a remote panchayat in Gania. He was openly campaigning for a specific candidate. When asked directly he was first a bit reluctant but then said:

Yes, I am campaigning for Sri [X], because he supported me during my election. Actually I am more in favour of Sri [Y], but he only supported me a little bit. That is why I am campaigning now for Sri [X].

It is interesting to see that both sarpanches feel obliged to campaign for a specific candidate who once has supported them, even though they are not so convinced about his politics nowadays. Some women joined the respective parties shortly prior to or after their election. I shall give two examples here:

1. *Samiti Chairperson of Balipatna—Nita*: Nita is from the SC-caste of the Chamars. At the time of election, she was 23-years-old. She is highly educated, having passed her MA in Oriya as extern from Utkal University, and she used to work for a local NGO. She was elected uncontested as samiti

TABLE 4.6: PARTY-MEMBERSHIP OF SARPANCHES

	Yes	No	Total
Female B	2 (50.0)	2 (50.0)	4 (57.1)
Female G	2 (66.6)	1 (33.3)	3 (42.9)
Total	4 (57.1)	3 (42.9)	7 (100.0)
Male B	5 (83.3)	1 (16.6)	6 (66.6)
Male G	2 (66.6)	1 (33.3)	3 (33.3)
Total	7 (77.8)	2 (22.2)	9 (100.0)
Men & Women Total	11 (68.8)	5 (31.3)	16 (100.1)

Notes: 1. Percentages in rows are calculated for each block and gender separately.
2. (n=16), these are all sarpanches.
3. B = Balipatna; G = Gania.

member from her gram panchayat. For the seat of the samiti chairperson, which was reserved for an SC-woman, she had one rival from another gram panchayat. The Congress party backed Nita, while the Janta Dal supported her competitor. Finally Nita won with seven to five votes. Interestingly at this time the MLA was from the Janta Party, but Nita believes that he did not support any candidate. Other persons from the block maintained that Nita had been supported by the male sarpanch of her gram panchayat and by other sarpanches of Balipatna Block who belong to the Congress party. Some also said that the BDO at that time was also in favour of the Congress party and had supported her candidacy during the election. Nita said that she joined the Congress party after her election because they had supported her.

2. *Sarpanch of Gania—Lita:* Lita was 22-years-old at the time of election. She is from the SC-caste of Keuta. She has contested against two other women for the position of the sarpanch. We have seen already that she, or better, her father-in-law, was asked for her nomination by the then MLA who belonged to the Janta Party. This party also supported her during her election, however not in terms of money. At this time she also joined the Janta Party mainly because of the support they extended or promised to extend to her. Nowadays she is quite frustrated by the party because she thinks that they have not done enough to support her.

Also wardmembers are sometimes linked to specific politicians or political parties, but to a much lesser degree. However, several female wardmembers in Balipatna related that they campaigned for a specific candidate. All of them are members of the headquarters panchayat, and it seems that the powerful sarpanch here might be responsible for their participation. In Gania, most female wardmembers were not very active in the election campaign for the Legislative Assembly, whereas some of their male counterparts participated in electioneering for specific candidates.

It is not easy to estimate or give a definite account of the hold that the PRI representatives have over the electorate. In the case of Lita, her authority was questioned by two wardmembers. One finds in general that the gram panchayats are divided along party lines. During the quantitative survey, many representatives as well as ordinary villagers voiced that in their gram panchayat things do not get done because the representatives belong to different parties and no unity can be reached in decision-making. There was, for example, one GP in Balipatna Block, where money was not spent at all even though there was a lot of work to be done. This was due to different factions in the gram panchayat, which could not agree on a project. In the remote GP in Balipatna that was investigated in greater detail, a similar situation prevailed. Here, the gram panchayat is nearly evenly split between the parties. Out of 23 wards, 12 favour the BJD/BJP and 11 support the Congress party.[13] The main reason for the retarded development, especially

[13] This information was first given by the panchayat secretary and was also confirmed by general villagers.

when compared to the headquarters panchayat in Balipatna, is that the political factions fight among each other. Thus, development works do not get conducted and the members of the rival faction block proposals made by the sarpanch. The situation is further aggravated because the sarpanch Bimala supports the BJD/BJP while the naib-sarpanch supports the Congress party. Also the samiti member from this GP is politically very ambitious, and he belongs to the Congress party. I was informed that he and Bimala used to fight over most issues. But a positive outcome of the cyclone was that the samiti member and Bimala started to work together, and since then the situation has become slightly better. Before, there was often a stalemate in decision-making.

What also became obvious is the considerable interest and involvement higher-level politicians have in the PRI. I have already referred to the samiti meeting in Balipatna that was held on 16 March 2000. There, the newly elected MLA Ragunath Chandra Sethy was obviously calling the shots, reducing the samiti chairperson to the ceremonial head of the session. He gave orders for reconstruction and distribution of relief in a rather dictatorial manner, shoving officials around like chicken in a den. Nita was quietly sitting in the middle of the dais without a greater role to play.

The interest of the MLAs in the PRI representatives might be the latter's influence on the voting in their constituencies. Sarpanches often act as broker between the MLA candidates and the electorate. It seems to depend on the personal strength of the representative, his or her connection to influential politicians, and the structure and strength of the village communities if they can really deliver votes or not. In some cases it seemed that the real political power lies outside of the PRI with the traditional elite. Yet, it is undisputable that the PRI are important in the political set-up of local politics—one indicator already cited for this was also the violence involved in the PRI-elections. Furthermore, although parties are officially not present in the lower tiers of the PRI they are in reality very active there.

POWER TO CHANGE THE WAY OF DOING POLITICS AND ITS CONTENT

In Chapter 1 it was argued that many theorists as well as activists cherish the hope that the inclusion of women into the political process would change the way in which politics is done. In the West this is captured by, for example, the concept of a 'politics of care'. Studies tried to establish this for the Nordic countries, where the representation of women is quite substantive. This belief is grounded in assumptions that the traditional role of women and the socialization of girls as caretaker of the family, as nurturer and guardian of dependants, be it children or the elderly, leads to a different way of dealing with politics. Women are supposed to be more concerned about the common good; their style of doing politics would be less aggressive. Some believe that women are more co-operative, tolerant, and thoughtful of others. It was not possible in this study to investigate all issues, and, generally speaking, the time frame of the working of the 73rd Amendment is too short to establish

major changes. Furthermore, the room to manoeuvre in the PRI is very circumscribed because of lack of finances and lack of leverage for policy formulation. However, it is important to scrutinize this question and some important insights can be drawn already at this early stage and also at this level of the political system.

The first query is to investigate whether women are really able (or willing) to introduce a new way of doing politics. This will be examined with the issue of corruption. In India, one frequently comes across statements from common villagers, bureaucrats, activists, and also scientists that they believe and expect women to be less corrupt because corruption is apparently believed to be a male 'quality'. Thus, it was imperative to analyse how women representatives deal with corruption. In the second part we shall have a look at whether women are able to change the content of politics. This refers to the assumption that the inclusion of women would lead to changes in political agendas. Again, the time frame is rather short, and also the space for policy formulation in the institutions as such is not great. However, it is important to take a close look at these issues. We have already seen that female representatives are likely to name government schemes that are related to women or children. We shall further investigate this subject through the preferences voiced by the representatives about what they wish to do for their constituency. Are there gendered patterns? And can this lead us to conclude that women will indeed introduce new issues?

Women Representatives and Corruption

In the following part we shall deal with a very sensitive subject in connection with the PRI as such, and with female representatives in particular. Corruption is what everybody talks and complains about. However, it is not always easy to find out what the real situation is. Obviously, not everybody openly admits to taking or offering bribes. Corruption charges can be levelled against everybody and anyone, and incriminating someone with corruption is a much-favoured tool for character assassination. General villagers claim that everybody in the political system and bureaucracy is corrupt; ward-members claim that the sarpanch is corrupt; the sarpanch claims that the officials are corrupt; and so on and so forth. Establishing the truth is not an easy task. Yet, I was astonished that quite a lot of data could be collected on this subject; this data could be cross-checked, and individuals were sometimes extremely frank to talk about their different dealings. Because this is very confidential material, which was revealed to me in good faith, the instances will be related without disclosing the identity and the location of the informant.[14]

Two broad categories of corruption emerged. The first one is paying money in order to get elected. This can be bribes in cash to voters, but also offers of tea, liquor, or food. I shall give some telling examples below. The other form

[14] This does not lower the analytical value because region does not play a major role in this issue—corruption is everywhere and there is no indication that a regional pattern does exist.

is what is more commonly understood as corruption, namely, accepting favours in order to include someone on a beneficiary's list, diverting money that was sanctioned for a certain work, seeing that some benefits, e.g. an Indira Awas Yojana (IAY) house, go to one's own household, etc. In Balipatna many villagers accused wardmembers and sarpanches of not distributing all the relief material and taking a lot of it for themselves. We shall look at some of the allegations in greater detail.

Generally speaking, in most of the discussions with male villagers, but also with women's groups, the subject of corruption came up. It was often argued that women are not very efficient politicians, that they are shy and not educated, but at least they are more honest, straightforward, and less corrupt than men. However, on the other hand, when individuals talked about the PRI and the bureaucracy they alleged that everybody was corrupt, from top to bottom, and men and women were not differentiated from each other. One male member of the Congress party, who is a samiti member in Balipatna Block, described the situation as follows:

The population of Orissa is 3.5 crore. Out of this 5 lakh are government employees, from the top IAS officer down to the peon. Then there are 3 lakh political representatives plus followers, and 2 lakh of followers of the officials. And these 10 lakh are the only people who profit from the system. The main mischief is done by the top-bureaucrats—if they are not corrupt, how could the others be corrupt? The politicians are corrupt as well. It works like this: When money is sanctioned for a public purpose, every officer takes his share. The BDO might take 7 per cent, the Junior Engineer 5 per cent, the Collector 3 per cent and so on. Then the politicians also take shares, and the contractor in particular will not utilize the whole amount he gets. So at the end, not much development work gets done. A further problem is that many officials and politicians work hand in glove. . . .

The reservation for women is good—now they get the chance to go out and participate. But the problem is that they are new, and they have no idea about politics. Actually women are good and not corrupt. But they are not independent. They are asked to be corrupt by their husbands, sons, or fathers-in-law. What can they do? They cannot decide on their own, so they are dependent for every work on some male members. But it is bad that the women are taking money or asking for bribes. For a man such behaviour is acceptable, but not for a woman.[15]

I heard similar statements being made in various contexts. At the beginning of a discussion, most people (men and women alike) argued that a positive point about women now being in the PRI is that they are not corrupt. Confronted with the fact that their female sarpanch, samiti chairperson, or wardmember actually is corrupt and that they had just lamented this fact, many stated that they did not expect such behaviour from a woman and that they felt it a disgrace. Most believe that women are not corrupt as such, but are only following the orders of their husband, father-in-law, or similar influential males of their household. Before I come to a conclusion on this point, I wish to present some more cases.

[15] I shall deal with the implication of this stunning remark later.

I came across various occasions where representatives mentioned that they paid money in order to get elected, or where persons claimed that they received money in exchange for their vote. Generally speaking, representatives as well as villagers maintain that one needs money to win an election, at least when there is a contest. This holds true for wardmembers and more so for the higher positions. One has to entertain the electorate, offer them tea, snacks, or even money to charm them for their vote. I shall give some revealing examples of women or their families that aspired for higher positions and only then draw my deductions.

1. *Spending money to become elected as naib-sarpanch:* I came across two cases, one in each block, in which bribes were given by representatives to get elected as naib-sarpanch. Both incidents were not related by the acting naib-sarpanches but by fellow wardmembers. The more telling and better-established case is the following, as reported by a wardmember.

After the PRI election, a male relative of mine wanted to become the naib-sarpanch and I agreed to vote for him. But then we got to know that the naib-sarpanch actually has to be a woman because our sarpanch is a man. Two women were interested in becoming the naib-sarpanch mainly because of the prestige and the remuneration of Rs. 300 per month. Srimati X asked the wardmembers to vote for her and gave each of us Rs. 400. But we decided to vote for Srimati Y because she is from a good family. So we returned the money to X. The present naib-sarpanch we elected had promised to give Rs. 200 of her Rs. 300 monthly salary to us wardmembers. With this money we wanted to organize a trip for all wardmembers. Initially she gave Rs. 1600, which is in our bank account now. But then she stopped giving the Rs. 200 per month. We complained to the sarpanch and asked him not to disburse the remuneration to her any longer, and the sarpanch and panchayat secretary stopped giving her the money. The naib-sarpanch and her husband went to the collector to complain that they are not receiving the money that is due to her. Since that time we have not been talking to her. We are planning to give her back the Rs. 1600. She should not have gone to the collector; we would have solved this problem internally. But now we are planning to move a no-confidence motion against her and elect a new naib-sarpanch.

2. *Spending money to become elected as sarpanch:* This incident was related by the sarpanch herself, but was also corroborated by general villagers from this GP. The position of the sarpanch was reserved for a woman. Three nominations were filed. The sarpanch relates that Rs. 30,000 were spent in order for her to get elected. She does not know where the money actually came from. She only knows that her father-in-law has somehow organized this substantial sum. The money was given to one of the rival candidates to withdraw from the contest and to prevent her from undertaking an election campaign. One informant from outside the PRI reported that one of the rivals of the present sarpanch became quiet after the sarpanch's family had offered her a substantial amount of money. He believes that the main incentive behind the wish to become a representative is to make money afterwards. However, he also believes that once the nominations are filed,

candidates want to win the election because the family feels they will lose
face if the family member does not get elected.

3. *Spending money to become elected as samiti chairperson:* The samiti
member herself, who aspired to become the samiti chairperson, related this
incident.

As our chairmanship is reserved for an SC-lady I wanted to become the chairman. I
planned to spend Rs. 80,000 to give to the other samiti members, so that they will
elect me, instead of the present chairman. I raised the money through selling my
house in K* [district headquarters town], which belongs to my family. I had already
given some money to the samiti members, but then Sri X [one of the very influential
state-level politicians from this area] got hold of four samiti members and entertained
them in Bhubaneswar until the day of election. The son of Sri Y [another very
influential politician from that area] drove them to the meeting. I presume that the
samiti members also got money from these politicians, and they finally voted for the
present chairman. I think that the politicians did this, because they can influence the
present chairman more easily than they could have influenced me.

In all three cases, money was given to an electoral body to secure a success-
ful election. There are two major motivations that are admitted openly. One
is that a higher position, in the case of naib-sarpanch and sarpanch, is
remunerated with Rs. 300 per month and, in the case of samiti chairperson,
with Rs. 750 per month. One sarpanch also said that there was a convention
of sarpanches in Bhubaneswar at which they had demanded a higher salary,
one comparable to that of the panchayat secretary, who is paid Rs. 1,200 per
month. The argument was that the sarpanches do all the work and so they
should be paid accordingly. They also hoped to get a pension when they
complete a five-year term. The other reason mentioned was that when one
agrees to contest, the family would lose face if the candidate from their
household is defeated in the election. Thus, most women preferred not to
face a contest at all, and if there is a contest, money is paid to voters or rival
candidates, as in the case of the sarpanch. Generally speaking, to hold an
important post, even a rather ceremonial one like the naib-sarpanch, is a
matter of prestige and carries with it an elevated status in the village
community. The last motivation, which however was not openly admitted by
the representatives, is the money they can make while being elected. That is
what most persons outside the PRI believe, and they have had many
experiences of this. It also becomes evident when one observes the huge sums
spent on an election campaign.

It is interesting that the wardmember who related the incident about the
naib-sarpanch election thought that all such dealings were normal procedure.
It was expected that the future naib-sarpanch would give two-thirds of
her remuneration to the wardmembers. When she stopped doing so, the
wardmembers called for action, as if it were their right to receive this money.
It was seen as extremely offensive that the naib-sarpanch turned to the
District Collector to establish her right to the remuneration. This is a breach

of village etiquette—such problems are supposed to be solved locally and interference from outside is very much resented.

The question still remains as to what extent the women representatives acted as according to their own wishes, or if they were mainly instructed by male family members. In the naib-sarpanch's case, I did not get a definite answer from the wardmember, but I could observe that the naib-sarpanch is actually a rather shy woman who seems to be dominated by her husband. Thus it seems safe to assume that her spouse was behind the whole affair. The sarpanch also had no idea about where the money actually came from. However, when she was informed that the money was paid, she did not seem to resent this fact. In this case, it appears that the woman was not really conscious of the import of the dealings, but simply accepted what she was told and, moreover, believed it was a legitimate practice since she did not feel ashamed to relate the whole incident. The samiti member's case seems to indicate that she herself was very interested because she spent the money belonging to her and this sum was also organized by her or at least out of her property and not by her husband. Thus, she showed agency and was also aware that she had to do the bribing in order to see the result she wished for—thus, she accepted the way politics works. This case indicates also the substantial interest and influence of state-level politicians in the rural local bodies. That they were instrumental in getting the present chairperson elected was not only established by the interview with her rival, but also by many other indications during the field study. Some critics have claimed that not the most suitable women in terms of education and will-power become elected because the political elite can influence such women less easily. This is definitely valid for some cases.

One has to emphasize that paying money or offering cash and kind in order to get elected is not really seen as corruption or as a condemnable act. Offering money to the electorate is understood as the way politics works, and it was argued before that the buying of votes in State Assembly elections is a routine procedure. However, people are also aware of the fact that if representatives spend a lot of money to get elected—and sums of 30,000 or even Rs. 80,000 are more than a yearly household income for most—they expect to recover at least the sum of money which they invested during the election campaign. And this cannot happen through the meagre remuneration alone. Thus, the paying of bribes to get elected, which is expected by the electorate as we could see in the interview with the wardmember, is one reason for corrupt practices while in office. In this respect, complaining about corruption would also mean to resent the practice of buying votes, a link that seems to be not explicitly understood by the villagers. They expect or even encourage the first type of corruption (giving money to the electorate), but resent the latter one (taking money from the villagers and enriching themselves while being elected).

What come next are incidents of corruption in the more conventional sense. Again, I shall give several cases and draw the conclusions afterwards.

There are different ways of making money while serving for a public office, and they vary according to position: the higher the rank, the greater the possibility of diverting resources to one's own pocket. One indication for this is the amount of money spent to get elected—the higher the office one aspires, the more money needs to be spent on the election campaign.

1. *Wardmembers and corruption:* Wardmembers do not have many opportunities to divert money, and they do not have much power of patronage. Here, the usual way to get money is to divert money from works done in one's ward. I have frequently heard that husbands of female representatives work as contractors for public works, and they do not spend all the money that is allotted. Villagers related another interesting incident from a constituency of a female wardmember. There were major disturbances in this ward, which were related by the wardmember. She was complaining that the villagers did not consult her anymore, but went directly to the sarpanch to get things done. With this information I turned to the male villagers present at a meeting and asked them whether and why this is so. They claimed that the wardmember's family is taking money from the husband of the wardmember of the neighbouring ward in order that works actually sanctioned for their ward gets done in the other ward. To prevent this, they went directly to the sarpanch to demand that works be done in their ward. They are positive about the fact that both women wardmembers are actually not responsible for these dealings, but their husbands, who are both political figures in the village.

In another instance, I talked to a women's group. The wardmember was present at this meeting as well. The women recounted that their wardmember is taking money. When I asked the present wardmember, who is also a member of this women's group, directly she actually admitted the fact. It appears that the other women are complaining, but nobody is really exerting pressure on her to stop. In this case, it remains open whether the woman took the money because she was pressured by her husband or out of her own wish. However, she did not seem to resent the fact in any way.

But there are also different voices. In a village meeting conducted in the cyclone affected coastal district, the distribution of relief material was discussed. Present were people who belonged to different wards of that village, of which one was represented by a woman and the other by a man. Villagers bitterly complained that relief material (like polyethylene sheets, foodstuff, etc.) was held back and diverted into the pockets of the PRI representatives and the bureaucracy. When I asked if they perceived a difference between the two wardmembers, the villagers said:

One advantage of having women now in the PRI is that they are less corrupt. Our male wardmember kept a lot of the relief to himself. Srimati X on the other hand came to us after the cyclone, asked us about our needs and distributed the relief material. As far as we know she did not keep more than was her due.

Still, there were also voices that claimed that this woman was corrupt as well. Some villagers complained that she was not giving them what they

demanded, but kept it to herself. When the wardmember was confronted with this charge, she replied that indeed she did not give these people very much because they are quite rich and not eligible for the things they asked her for. Having had long conversations with this lady in her house, which revealed an extremely poor household, and considering her open and simple manners, I am inclined to believe her, and other villagers also confirmed my view. In this respect it becomes obvious that the charge of corruption is in fact a handy tool for character assassination, as it is not too easy to prove the contrary.

2. *Women in higher positions and corruption:* The opportunities to divert money are much greater for representatives in higher positions of the PRI. Sarpanches do enjoy a greater autonomy in financial matters nowadays than previously. They can decide on works to be implemented up to an amount of Rs. 15,000 which can be ordered from the District Rural Development Agency (DRDA) at the district headquarters by the signatures of the sarpanch and the panchayat secretary. Thus, there are many allegations by villagers and wardmembers that the sarpanch and the panchayat secretary work in a team to enrich themselves. Another way of making money when holding a public office is to take money from people who want to be included in a beneficiary's list for loans for an IAY house or for other purposes. Several people told me that those persons who apply for an IAY house, for which they are supposed to receive Rs. 20,000, pay around Rs. 4,000 for various bribes. They have to bribe the sarpanch, the samiti chairperson, and officials in order to get included and remain on the list. Often, relatives of the sarpanches work as contractors for public works and divert money from these. In a longer interview, a sarpanch complained that people blame her for taking money.

Villagers have accused me of taking money from the IAY scheme, which has been sanctioned in my GP. But the panchayat only gives the names of the beneficiaries, the officials in the block office decide the rest, and there the mischief happens. People also complain about irregularities in the construction work. But the grama sabha decides everything, and when people do not receive the amount of money due to them, it has to do with the malpractice of the officers. I only identify the beneficiaries and the works that are to be done are discussed at the grama sabha, and the block office does the rest. Here especially the BDO and the Junior Engineer are taking their share. And actually the people should come to the grama sabha, but only the *chamchas* of the politicians turn up, but then later the people complain.

However, during the same interview, perhaps half an hour later, when asked about her future ambitions and chances to be elected again as the sarpanch, she said the following:

Villagers have requested me to run again. I am very popular and people like my sweet behaviour. You see, when people come to me and offer me Rs. 200 to get included in a beneficiary's list, I give them back Rs. 100 and tell them that they should spend this money on their children. That is why I am so popular.

Another interesting incident comes from Balipatna block. As already mentioned, the sarpanch was accused of corruption. Bimala herself was very reluctant to give details on this matter, and it was not very easy to find out what actually happened. The sarpanch was accused because of some irregularities during the construction of a road. Money was sanctioned and withdrawn with her signature, but the work was not done. What actually happened remained unclear, but the fact is that she was summoned by the District Collector to give a written statement about this event in a certain period of time. She claimed that she had sent this statement, but the Collector declared that he did not receive it in time and suspended her, even though only for few days. Bimala filed a case in the High Court and proved that she had sent the document in time. In a later conversation, she states that the plot to remove her from office was politically motivated. The removal from office through no-confidence motions or other measures can be a political instrument to get rid of rivals or representatives who become unmanageable. Most other female sarpanches would have succumbed to this onslaught, and it was due to Bimala's personality and education, as she has studied law, which made it possible for her to fight and win her case in court.

3. *Combined corruption of several panchayat members:* As already mentioned, frequent corruption charges are levelled against the sarpanch–panchayat secretary combine. This is due to the structural feature, i.e. both have to give their signatures to withdraw money from the DRDA. The secretary is in charge of the accounting, and often he and the sarpanch are the only ones who have more intimate knowledge about financial matters. Thus, it is easier for them to divert money. However, they have to lay open the financial dealings in their monthly statement to the gram panchayat and also during the grama sabha. Thus there is some transparency of the finances. However, we have seen that the grama sabha seldom works as a body for accountability. Most of the villagers are not really interested and also may not be able to grasp the complexity of all financial transactions. The situation is a bit different for the gram panchayat. One should assume that also the ordinary members have some knowledge about the financial situation, although especially women were not really aware about the procedures and all the details of financial transactions. Yet, during the gram panchayat meetings that I observed, the secretary always gave the monthly report on money spent for different works and on the money that was sanctioned. Thus, there is the obvious suspicion that the wardmembers also participate and profit from some of the shady dealings. This supposition was proved right at least in one case.

During a village meeting I came across the following incident. One very active young male villager, who is working for a local NGO, reported of a case, which was also confirmed by the other villagers present. Public works to be undertaken by the gram panchayat are normally publicized on the public notice board in front of the panchayat office. There was a notice that Rs. 16,500 had been spent on the cleaning of wells. However, the villager

knew that the work had actually not been conducted. He went to the female sarpanch and asked her about this case. She finally admitted that the money had been distributed to the panchayat members: The sarpanch and panchayat secretary took Rs. 2,000 each, while the wardmembers got Rs. 1,000 and Rs. 500, depending on their bargaining power. When I asked whether some action was taken, he said no.

To whom should we complain? The samiti chairman is also corrupt, and the officials are normally even worse. None of them will take action; otherwise they have to fear the same charges. The only thing I could achieve was that the sarpanch promised that such a thing will never happen again, but all of them kept the money.

It is evident that corruption is basically institutionalized in the PRI. A major problem is also the fact, as already mentioned in the introductory statement to this section, that officials and representatives often work together or at least have no incentive to charge each other with corruption officially, even though behind closed doors everybody is accusing everyone. Normally, they are dependent on each other for such dealings, as the signatures of a representative and the concerned official are required to withdraw money from the account. Thus, internal transparency is not effective if those who should oversee each other collaborate, and even external transparency, for example, publication at the notice-board or the forum of the grama sabha, has not solved the problem since the villagers are not interested or, in the cases where they are interested, they do not see many avenues to rectify the situation.

When one considers the cases mentioned, one can draw some conclusions. Most importantly, no clear statement can be made whether women are less corrupt than men. In the case of the wardmembers in the first example it is safe to assume that the husbands were behind the malpractices and that the wives followed their orders. The case of the first sarpanch is, however, different. She is aware that corruption is illegal because she complained that people have blamed her for it and then defended herself. It seems that she does not view her taking Rs. 100 to include somebody on the beneficiary's list as corruption because she uses this argument to show that she is not as greedy as others and thus more popular. In this respect, one can claim that what an outside observer might call corruption can be seen partly as normal practice, at least in regard to small sums. The local population as well as officials do expect that such money is given and received. This feature of institutionalized corruption makes it also rather unrealistic to expect women to be more clean politicians than men. Corruption in the PRI is apparently a well-oiled machinery. In such circumstances, a representative would need a lot of resources, material as well as immaterial, to fight corruption, and women are even more unlikely to have command over such resources.

There must first be awareness that corruption as such is to be condemned and abolished. It is not the case that this awareness is completely absent since villagers complain about it, and also members of the PRI are defending themselves against corruption charges as well as level them against fellow members. Yet, it seems that a certain degree of corruption is understood as a

normal way of doing politics. And villagers were also quite self-critical in this respect. In a village meeting, one male villager said:

The fault also lies with us. We are not united and the people who want to get something do offer the money to the representatives. And why should they not take it? As long as the villagers do not stop this practice our representatives will be corrupt.

In fact, it is overly idealistic to hope that women could stem the tide against this kind of systematic corruption. And anyone who wants to change this practice would face many obstacles. Particularly women, who are still new in the institutions and command less resources, are unlikely to fight it through. Furthermore, if women were to start fighting corruption, they would have many enemies: the bureaucrats, who earn a nice sum out of it, but also fellow-representatives would presumably protest as everyone inside the system actually profits from corruption. And again, if a family has spent substantial sums to get the woman of the household elected, it would be extremely difficult for her not to care about recovering at least this invest-ment. Also, villagers will be disgruntled to a certain degree since they are used to bribing their way to get what they aspire for.

Still, there is the persistent belief that women are less corrupt, and people are especially disenchanted that many women proved the contrary, since this goes against the ideal of proper female behaviour. Ordinary villagers often defend women. The problem is seen in women's dependence on men, and there is the assumption that they are not acting according to their own wish, but are pressured. It is very difficult to really substantiate this assumption. It was observable that women are indeed corrupt, and some are most likely to be induced by others to be so. But it was rarely evident that these women have major problems with the fact or really resent it. However, there are also indications that some women are less corrupt than men, as illustrated by the example of the distribution of relief, but there may equally be some men who are less corrupt than some women.

Something else that is illustrated by the example of the second sarpanch is that corruption charges are also used to get rid of political rivals. Women are potentially more vulnerable to no-confidence motions or other measures as they normally have less experience and resources. It was due to the exceptional personality of Bimala that she successfully defended herself against these charges, which, however, does not mean that she is not corrupt. To sum up the above discussion, it can be said that women have not been successful so far in introducing a clean politics as was expected by many. There are many reasons for this. However, one cannot deduce clearly that if women were to be given more resources to work against corruption in future, they necessarily would do so. To presume that corruption is an exclusively male activity is a normative statement that can hardly be validated empirically.

However, I want to draw attention to a very important issue in this discussion. It came up already in the introductory statement by the male samiti member. That statement was: 'For a man such behaviour is acceptable,

but not for a woman.' On the one hand, everybody is complaining about corruption, on the other hand, women should carry out the solution to the problem alone. The question is: Why should that be so? Does it not overburden the as yet weakest segment in the PRI to carry this rather heavy burden on their shoulders? And if women prove to be corrupt, would it then be used to argue against a quota for women? Why do the villagers not demand that all—both men and women, representatives, officials, and villagers—have to work against corruption? If one ties the arguments for a quota for women to the expectation that they will be the better politicians one may run into trouble theoretically as well as empirically. This is not to deny that the way of doing politics might change through the inclusion of a different kind of people: For instance, men nowadays no longer smoke in the gram panchayat meetings as was the practice before women became elected. This is just a minor instance, but other, more substantive changes may happen as well. However, we cannot know beforehand what these changes will be, and they will definitely take a longer time to become perceptible. Thus, the changes expected from the introduction of new social groups into politics should not be the sole argument for a quota, especially if these expectations are rather unrealistic to begin with, as in the case of corruption. We shall now turn towards the question whether the content of politics has changed since women became elected to the institutions.

Preferences for Development Works to be Undertaken

During the survey, the representatives were asked what they want to achieve in their ward, gram panchayat, or block. As the answers were numerous and also highly varied, they were grouped together in several categories (see Table 4.7).[16]

The answers to this question do not differ very much between the genders. Top priority is given to infrastructure. This is not surprising as the level of infrastructure is very low; particularly, roads, housing, and electricity are seen as not being adequate. In Gania, irrigation facilities are especially lacking and were frequently mentioned. There is not a great difference between the genders, with men being a little bit more likely to mention this issue (77.5 per cent v. 74.3 per cent). The gap between Balipatna (69.6 per cent) and Gania (83.1 per cent) in regard to the wish for better infrastructure is understandable, as the situation is worse in the less developed block.

The second priority concerns the improvement of health conditions and

[16] The first category *infrastructure* comprises the building/repairing of roads, irrigation-facilities, electricity, housing, embankments; improvement in the *health situation* consists of sanitation, drinking water, erection of hospitals, and family planning; *education* is mainly the building of schools; *community development* means the erection or renovation of religious buildings (temples), community halls, organization of Mahila Mandals, institution of a library; *economic development* includes the promotion of plantations, of fishery, agriculture, and general employment creating activities, and *government schemes* means that the respondents answered that they want to implement various government schemes, identify beneficiaries, etc.

TABLE 4.7: PREFERENCES FOR WORKS TO BE UNDERTAKEN IN THE PANCHAYAT

	Infrastructure	Health	Education	Community Development	Economic Development	Government Schemes	Nothing	DK	Total
Female B	42 (67.7)	35 (56.5)	8 (12.9)	24 (38.7)	7 (11.3)	8 (12.9)	2 (3.2)	3 (4.8)	62
Female G	36 (83.7)	24 (55.8)	6 (14.0)	14 (32.5)	5 (11.6)	5 (11.6)	-	3 (7.0)	43
Total	78 (74.3)	59 (56.2)	14 (13.3)	38 (36.2)	12 (11.4)	13 (12.4)	2 (1.9)	6 (5.7)	105
Male B	29 (72.5)	24 (60.0)	13 (32.5)	13 (32.5)	4 (10.0)	5 (12.5)	-	-	40
Male G	33 (82.5)	21 (52.5)	8 (20.0)	12 (30.0)	7 (17.5)	8 (20.0)	-	1 (2.5)	40
Total	62 (77.5)	45 (56.3)	21 (26.3)	25 (31.3)	11 (13.8)	13 (16.3)	-	1 (1.3)	80

Notes: 1. Multiple answers were possible; percentages are calculated according to number of persons interviewed in each category; the percentages do not add up to 100 per cent.

2. B = Balipatna; G = Gania.

there is again no difference between the genders. There is only a variation in the category of male respondents. Since the general health situation in Gania is much worse than in Balipatna, one could have expected a regional discrepancy here as well; however, the perception of problems does not always parallel the objective situation.

Compared to the first two issues, education enjoys a rather low priority, although representatives mentioned in particular the low education of women as a major obstacle for their full participation in public life. As already seen, women's lack of education is bemoaned, but when one asked the villagers to improve the situation, they—especially male villagers, but also women—were quite reluctant to really commit themselves to sending their girls to school. In this respect, there is a gap in identifying a problem and really addressing it, as it would mean a considerable change in traditional beliefs and social customs. People who were concerned with education mainly mentioned the building of schools. Interesting here is the gendered distinction between men who are stronger promoters of the improvement of educational facilities and women who are less so (26.3 per cent *v.* 13.3 per cent). This is a rather counter-intuitive result because it is mostly believed that women are more concerned with education or health issues.

A higher priority is given again to the category of community development, and women are a bit more likely to promote this issue when compared to men (36.2 per cent *v.* 31.3 per cent). Women frequently mentioned the building or restoration of the village temple, the construction of women ghats at the village tank, the organization of Mahila Mandals, or the erection of community halls. Men were also interested in building temples and community halls. It is important to emphasize that these issues enjoy considerable interest because international and also Indian development agencies often do not consider community development an important area.

When one considers the economic position of the two blocks, it seems surprising that economic development enjoys a rather low priority (women 11.4 per cent, men 13.8 per cent). This is due to the fact that it is in some way a kind of a residual category in this table. Improving the standard of infrastructure, especially through irrigation facilities, is also a promotion of economic development. The same holds true for the following category of the implementation of government schemes, which are also partly concerned with employment-creating activities. Thus, under this rubric, activities were grouped which were neither improvement of infrastructure, nor mere implementation of government programmes, but suggestions such as, for example, the promotion of fishing or agriculture *per se*, without going into further details. Men in Gania mentioned such endeavours more frequently than men in Balipatna, which could be seen as a consequence of the lesser employment opportunities in Gania. The last category deals with the implementation of government schemes. Schemes were often not differentiated from each other, and respondents voiced their wish to get several government schemes for their villages. Men were a bit more likely to mention this issue (16.3 per cent *v.* 12.4 per cent).

Only two women answered that they have no wish to do anything for their ward, and only three in Balipatna and three in Gania did not know what answer to give. These were all wardmembers, apart from one naib-sarpanch in Gania. One can conclude that these women are not very involved in the institutions and do not have much of an idea about their role as representatives. All others (barring a man from Gania Block) had some ideas of what they wanted to achieve in their constituency. Generally speaking, there is no major difference between the sexes in preferences for works to be done. This could be attributed to the fact that there are really no gendered priorities. However, it appears that the preferences voiced are also guided by the state-sponsored programmes available, since finances are normally tied to them. Another reason might be that women do not have the ability and autonomy yet to formulate and defend their preferences. There was already an indication for women's lack of autonomy, and it can also be detected in a remark by Nalini:

Since I became the wardmember many things have been done in my ward. There is a community hall now, the roads have been repaired and work is in progress for a bridge. Most of these works were started two years ago. The village committee decides on all these works [this committee consists only of men]. Finally the panchayat decides what should be done, and the village committee is implementing the decisions. If I would really be the one to decide I would have demanded a *picchu* road.

Sabita, the tribal wardmember from Gania GP also voiced that she is following the wishes of the 'village community':

Women coming to me normally ask for a loan for leaflet making. But the villagers do not want them to take a loan because then outsiders will come to the village, like bankers, in case that they do not repay the loan. And these women are also not very skilled and with making leaflets only they will not be able to repay the loan. This is why I do not want to help them to get the loan.

These instances point to the direction that some women may not have enough autonomy to decide. Furthermore, power does not really lie with them as the representative, but is vested in the village committees that are still dominated by men. In this respect, it appears that the wardmember is a mere mandate holder, who has to voice what the village communities decide. This might be positive in regard to accountability to the constituency. The problem, however, lies in the composition of this external decision-making body, which represents only a particular group of people. As mentioned above, men alone generally constitute the village committee, at least in Gania Block. There are also clues that the traditional elite dominate these bodies. In Nalini's village lives the son of the former *Sabararkar*. Nalini said:

This man is very rich, the biggest landowner in this area. People obey him because he is the oldest person and has a lot of knowledge. He is a member of the Village Committee, and what he says will be done by the people. The whole area obeys him.

The above scenario does not augur well for the supposition that women

indeed introduce new issues in the PRI, at least not at this early stage of inclusion.

Yet, the picture is not that clear. The answers to the above question were also coded in a further way: I had made notes on the questionnaire if the respondent voiced some special concern for women and children, on the one hand, and for poorer sections of society, on the other. These could be various remarks as, for example: 'I want to do something especially for the poor families', or 'I want to organise a Mahila Mandal', or 'I want to do something specifically for women', or just 'I want to implement the widow pension'. The results of the coding are as given in Table 4.8.

Preference for doing something specifically for the poor is not very different between the genders (18.8 per cent for women, 16.3 per cent for men). However, we find a major concern for the poor among the women in Balipatna, while it is much less among the women in Gania (21 per cent *v.* 7 per cent only). Concerning a special preference for bettering the situation of women and children, there is a more distinct gender gap (women 12.4 per cent *v.* men 5 per cent), which is purely due to the preferences of the female representatives in Balipatna (21 per cent *v.* 0 per cent in Gania).

It seems that women in Balipatna have a higher degree of gender-awareness than women in Gania. The regional gap in the female sample seems to indicate that the cause for this pattern may lie in the overall higher development and greater freedom of movement of women in Balipatna (that will be discussed in greater detail in the next chapter). There is also a remarkable distinction between men and women, especially if we take the case of Balipatna. The variation between the genders indicates that women, at least when they have gained some awareness, have indeed specific preferences in contrast to men. And it might not be too unrealistic to speculate that this will also translate in a more gender-sensitive pattern of policy making in the future. Still, this will depend a lot on developments, that give the women a higher capability to develop and defend their decisions and priorities. In the next chapter we shall have a look exactly at these issues, namely whether such developments are already taking place. That is what empowerment is after all about, that women get empowered to decide, to voice their ideas and wishes, and to be able to carry them through.

TABLE 4.8: SPECIAL CONCERN FOR THE POOR, WOMEN, AND CHILDREN

	For the poor	For women and children	For both	For none	Total
Female B	13 (21.0)	13 (21.0)	2 (3.2)	34 (54.8)	62
Female G	3 (7.0)	-	1 (2.3)	39 (90.7)	43
Total	16 (18.8)	13 (12.4)	3 (2.9)	73 (69.5)	105
Male B	6 (15.0)	1 (2.5)	1 (2.5)	32 (80.0)	40
Male G	7 (17.5)	3 (7.5)	-	30 (75.0)	40
Total	13 (16.3)	4 (5.0)	1 (1.3)	62 (77.5)	80

Note: Percentages in rows for Balipatna (B) and Gania (G) are calculated for each sample separately.

Empowerment

*T*HIS CHAPTER IS devoted to the crucial question of the analysis. Does the reservation for women really lead to their empowerment? As already argued in the theoretical chapter, it is important to distinguish between the women who are present in the political institutions and the larger society outside the institutions, with a special focus on women as a group. The analysis will start by scrutinizing to what extent the female incumbents have become empowered. In contrast to the discussion above, which dealt with the question of whether women actually have power, procedural aspects are now at the centre of attention. The main focus lies on the changes that have taken place since the women were elected as representatives. We shall then turn to the larger society. The perceptions of the village women about their representatives and what they perceive to have gained through the reservation for women will be examined. This is followed by the men's points of view.

EMPOWERMENT OF THE REPRESENTATIVES

In this section the female representatives will be the exclusive focus. We shall hear their voices since their perceptions about themselves and their role in the Panchayati Raj Institutions (PRI) and society is a crucial indicator for their empowerment. The perception of the female representatives gives an important clue about their psychological empowerment: Do they feel better informed now? Do they perceive their capabilities? Do they enjoy being in the political institutions? The chapter gives case studies of individual women. Out of the 14 women interviewed more intimately, I have selected eight who gave revealing statements on all issues. One ought not to forget, however, that the women I talked to were usually the more active ones, as I was obviously dependent on the willingness of the women to interact with me more frequently, and expectedly the more interested and dynamic ones made themselves available. Thus, the eight women are not really representative of all women present in the PRI, but nevertheless they give a good indication of what happens to some women as a result of the reservation. I have taken care that the selection covers all four gram panchayats investigated more intimately. As already mentioned, these were the two headquarters panchayats and two more remote panchayats. The women were visited up to four times each, and the conversations all took place in their homes. We were mainly alone, although at times the husband was present, but most of them left after a while.

Gaining of Knowledge and Interest in Politics

When we reconsider women's lack of political experience prior to their election and the extent of their knowledge around two years after the election, one had to note that their knowledge of the larger political system, the PRI as such, and specific features of the 73rd Amendment in particular was not very impressive. However, presently, we are interested in looking at the procedural aspects. To what extent have women gained knowledge as well as interest in politics since they were elected? There was a perceptible change between the two rounds of field research, and many women have made progress during the lapse of one year. The voices of the eight women will be heard first, and then I will summarize the main features.

NITA, samiti chairperson of Balipatna, residence 8 km from block office, 25-years-old Scheduled Caste (SC) (Chamar), unmarried, *gaanjhia*, MA in Oriya:

Before my election I did not know much about politics and the Panchayati Raj as such. But I read some guidelines and got to know some things. However, only after my election did I attend training workshops organized by the Centre for Youth and Development [non-governmental organization (NGO) based in Bhubaneswar], the SIRD [State Institute of Rural Development], and the Gopabandhu Academy. I am very happy about the training and I have learned a lot. Before the election I was never interested in politics, and that is the case with most of the women. But now I am very interested in politics. I also like being the samiti chairman since I can do many things for the people.

The chairperson became especially active after the cyclone and went to NGOs to organize relief, instead of just waiting for the state agencies to step in.

BABITA, naib-sarpanch of headquarters panchayat in Balipatna, residence 1 km from panchayat and block office, 47-years-old SC (Chamar), married, three children, *bahu*, 6th standard:

Even before my election I was interested in politics. I have seen other people standing for election and I also wanted to become a wardmember. My husband was a wardmember, you know. So I had seen things, but I did not know very much. But I was very interested and determined to learn. I thought that first I would become a wardmember and when I have learned enough I would maybe become a sarpanch later. Now I am reading the Panchayat Manual in Oriya. I am also interested in state-politics and watch the news. At the moment I also follow the parliamentary session on TV.

RITA, wardmember in headquarters panchayat in Balipatna, 2 km from panchayat and block office, 35-years-old Other Backward Class (OBC) (Teli), married, three children, *bahu*, 7th standard.

Before I became wardmember I was not interested in politics at all. This started only after my election. I learned a lot of things because everybody is talking about politics in the meetings and there are discussions in the panchayat office. Now I am interested in politics and I also campaigned in this MLA election [in February 2000]. I have also

learned a lot of other things. Now I get to know everything about different government programmes, and I even get information from the Collector. So I am learning a lot.

MINA, wardmember in remote panchayat in Balipatna, 3 km to panchayat office, 15 km from block-office, 42-years-old OBC (Barik), married, three children, *bahu*, 7th standard:

Before my election I was not interested in politics. I had no political experience and none of my family members had anything to do with politics. My husband has a general interest in politics, and since I became a wardmember I am also interested in politics. I was asked by the villagers to stand for election, it was not my own decision. I did not know anything about the rules and regulations or about the Panchayati Raj as such. But I learned quickly and after some meetings I got to know everything.

LITA, sarpanch of the headquarters panchayat in Gania, 500 m to panchayat and block office, 25-years-old SC (Keuta), married, two children, *bahu*, 9th standard:

Before my election I was not interested in politics. Actually my father-in-law asked me to contest, and also the MLA came to our house. . . . However, I attended my first training after 6 or 7 months in office and then I started to become interested and also understood certain things. I also got a lot of important information there. I attended also another training session and learned even more.

In a later interview, however, she said:

Actually I am not very interested in politics. I am going out now and I also get to know a lot about politics, but I am not doing politics.

SABITA, wardmember in headquarters panchayat in Gania, 4 km from panchayat and block office, 45-years-old ST (Kandha), married, three children, *gaanjhia*, primary education:

The villagers have asked my husband and me to stand for election and I agreed. But we told the villagers that we are inexperienced and that we do not know what to do. We did not know anything, like when an officer will come, we do not know what to say. But they thought that I will be able to handle the things, and I think the most important fact is that I am a *gaanjhia*. . . . I like to be the wardmember because I am getting more information now, and I am also going out of my house now. . . . Now I am a political person and I know that the sarpanches or wardmembers will support their party people or the people who voted for them. Before my election I did not have the slightest idea about politics.

KALI, wardmember of remote gram panchayat in Gania, 10 km from panchayat office, 25 km from block office, 56-years-old SC, married, four children, *gaanjhia*, class 2:

The panchayat is no political institution; it is there for the development of the people. I have learned something already when I was the *Mahila Mandal* secretary 10 to 15 years ago. And I became more aware about the things during this time. . . . I started speaking shortly after I became elected as the wardmember. After my election I went to the four villages, which belong to my ward. And the villagers told me that it is my responsibility to go to the villages and look after their problems. The two previous

wardmembers [a woman and a man] never went to the villages and the people did complain. So it is my duty as the wardmember to do these things. If I will not do this, the people will think that I came only once for getting their vote.

SHAKUNTALA, wardmember of remote gram panchayat in Gania, 2 km to panchayat office, 13 km to block office, 46-years-old Khandayat, married, two children, *bahu*, class 5:

The biggest change that happened since I became the wardmember is that I have more knowledge now. We are getting the information from the sarpanch. He is going to the training and when he comes back he explains everything to us. I could never imagine before becoming a wardmember one day. Women did not participate in such matters and only males have run for elections. There was no reservation before. So we women were inside the house doing our work. Now it is better because we are going out and get to know things and can do some good work. I think the reservation is good and I will also encourage other women . . . I was not speaking in the meetings for a year, because I did not know anything and was also not informed about my duties and responsibilities. But when I got to know more about it I began to speak. The panchayat is for us, so I have to speak. Why some of the women do not speak I do not know, whether they are too shy or why? . . . I do not think that to be a wardmember is a political post. We are here for the development works and for the service to the people, not for politics. The sarpanch has gone for the election rally to support Sri X, but he is a man. As women we are not doing any politics. I have enough work to do at home and I do not do any politics.

In these eight statements it becomes obvious that all women perceived a gain in knowledge since serving in the PRI, and this new knowledge is valued highly by them. The information gained is, for example, about general politics, because politics are discussed in the PR meetings. General political issues were especially prominent during the Assembly election in February 2000. But the newly acquired knowledge also covers information about government schemes, general issues concerning village problems, and the rules and procedures of the PRI. The information comes to them either through training, general discussions, or relatives. The naib-sarpanch of the headquarters panchayat in Balipatna appears to be a special case because she works very closely with the sarpanch who is training her in many aspects. She even reads and watches the news. I shall turn to this special relationship more in detail a little later. Generally, these women gained knowledge about the public realm of which they were previously excluded from and thus had not shown much interest in before.

However, many women still brought up the fact that they want more knowledge. The training of the PRI representatives is normally only meant for people occupying higher positions. During the survey, the representatives were asked if they had attended training and if they wish to receive (more) training. Less than 15 per cent of the women received some training on the PRI as compared to 21.3 per cent of the men. Among the women, only one wardmember from Gania received training, the others were seven sarpanches, five naib-sarpanches, the two samiti chairpersons, and one samiti member. Among the men five wardmembers received training, the rest were also in

higher positions. The institutions conducting the training are the State Institute of Rural Development (SIRD), which is the official state agency entrusted with it, and some courses are also held by NGOs, like the Centre for Youth and Social Development (CYSD) from Bhubaneswar.[1] The training takes place in the district headquarters, and sometimes it is also organized in the block office. Women mentioned that it is a problem to attend a training, which is conducted far away from their homes, especially if it covers several days. Some male family member has to accompany them and it would be easier if the training would take place in their vicinity. However, it was also mentioned that it was interesting to travel far, and particularly the exposure to other representatives was regarded as very positive.

That sarpanches actually do hand over information was mentioned by Shakuntala who said that the sarpanch is giving them the information he got in the training. However, many representatives complained that the sarpanches are actually not spreading all the relevant information and that they would like to receive training as well. Many mentioned it as problematic that they do not have enough knowledge on the Institutions and government schemes. The representatives were also asked if they would like to receive (more) training. Most representatives are actually very eager to learn more (69.5 per cent of the women and 88.8 per cent of the men). Some of the women could not give an answer (11.5 per cent), and 20 per cent did not want any (further) training. This is due partly to lack of interest, partly to lack of time to participate in training. The representatives did not only want to get to know more about the PRI, but many were especially interested in learning more about government schemes, health issues, employment opportunities, or literacy programmes.

Concerning women's interest in politics the pattern is varied. It was argued also by other women that before their election they were not interested in politics. They said: 'There was no scope for women in politics. So why should we have been interested?' Now, many have started to become interested in politics and it seems that in this case—in contrast to the grama sabha—the supply of participation creates demand for it, as Pateman argued already in 1970. In cross-cultural comparison it is interesting to note that women in the municipal body of Germany's national capital, Berlin, voiced similar experiences. Female incumbents from parties who follow self-imposed quotas said that initially they were not really interested in politics, but were motivated by friends or party members to participate. In the course of being

[1] The SIRD normally gives only training to the sarpanches, naib-sarpanches, and chairpersons. They are supposed to act as multipliers and hand over the information to their fellow members. The training is mainly concerned with the organization and the rules and regulations of the PRI and the government schemes that are to be implemented by the representatives. There is no special training for women, and gender is no issue. This information was given by Mr S.K. Das, Vice-Director, SIRD, personal communication on 15 December 1998. He was very sceptical about the impact of the training. 'The training they forget already at the exit gates.' The state gives also mandate to NGOs to conduct training courses, which are, however, often of similar content.

in politics and even moving up the ladder they developed interest and started to recognize their capabilities (Geissel 2003).

Traditionally politics or the problems of the village were not discussed with or among women, but were a male prerogative. Babita, the naib-sarpanch from Balipatna, was the only woman I met who said that she was interested in politics even before her election, which was because of her husband being the wardmember. Some women above stated that they have become now more interested in politics and that they perceive themselves to be political persons. Others, like Shakuntala and Kali, do not perceive the PRI as political institutions, and they also disclaim being political persons. Also Bimala, the very active sarpanch from the remote gram panchayat (GP) in Balipatna, who has not been included above said that she is not doing politics and is also not interested in politics: 'I am not interested in politics. Politics is completely corrupted.'

Politics is perceived as a 'dirty business' by most people in Orissa and is especially not suited for women. In this respect, politics gets often equated with party politics and many representatives do not want to be seen as being involved in this. Resignation about the political system, the well-known corruption of many state-level politicians, and the unfulfilled promises made by them has created disillusionment about the positive effects of the political process. This was also voiced during the Assembly elections, when people said that they do not believe that it matters much whom to elect.[2] In this respect the statements of women who said that they are not 'doing politics' or are not interested in it has to be seen as an attempt to distance themselves from this type of politics. Actually, all the women who made such remarks were actually quite conscious about the politics involved in their work, and many were speaking in a rather strategic manner. Another important feature in the statements above is that women mentioned that they are now going out of their house, whereas they had no opportunity to do this before. This leads us to the next area of empowerment, namely, the gaining of visibility and status.

Gaining of Status and Visibility

Before the reservation for women, there was hardly any scope for them in rural politics. Generally, women do not occupy much space in the rural public sphere as was seen in Chapter 2; their freedom of movement as well as their social interaction is very much curtailed. There is, however, a perceptible difference among women that is mainly due to caste. Scheduled Caste-women are more used to travel and normally have a wider radius of movement, which results from the fact that some of them are casual labourers or are selling products on the weekly *haats*. Yet, Agarwal reminds us that 'the freedom of movement which low caste or poor women appear to enjoy needs

[2] Bob Currie, while analysing the politics of hunger in Kalahandi District of Orissa, has termed this view on electoral politics as the 'Power to "get rid", not the power to "get right"' (Currie 2000: 212). It means that in Orissa the choice is often between two equally corrupt or inefficient political parties.

to be weighed against [the] loss of social status which affects both them and their families' (1994: 304). Women from higher castes largely remain inside their houses for most of their married lives, and one can say that the higher the caste and status, the more profound the seclusion. Thus, apart from performing their duties women are confined to their homes. Interaction with men who do not belong to their clan is basically nil. In this respect, women are not visible in public village life.

Another feature of the countryside in Orissa is that women are rarely known by their proper names. They are either the *bahu* of household X, wife of Sri Y, mother of son Z; thus, they are normally seen in relational context only. It would be interesting to know if this has changed due to their position in the PRI, and also if their status has changed. In some cases the women were asked directly about these issues, and in other cases remarks about these subjects developed during the interview.

NITA, samiti chairperson of Balipatna, residence 8 km from block office, 25-years-old SC (Chamar), unmarried, *gaanjhia*, MA in Oriya:

I used to go out even before my election. I used to work for the GYS [local NGO] and also for the Ambedkar Youth Club. Since my election there was no major change for me in my family. I am the youngest daughter, so what should change? But in the village the people respect me more now, and everybody knows me. I was very active during the cyclone and I also organized relief from NGOs, and people are happy with me.

BABITA, naib-sarpanch in headquarters panchayat in Balipatna, residence 1 km from panchayat and block office, 47-years-old SC (Chamar), married, three children, *bahu*, 6th standard:

In one of the interviews I also had a talk with her husband, and he said:

Without the reservation for women I would not have introduced my wife into politics. She was a housewife and busy in the home, she did not go out. But now I am helping her with everything, in- and outside of the house.

The naib-sarpanch herself believes that her status in the family has become better. She also claims that her husband is supporting her in everything.

My husband is guiding me in everything, and also our sarpanch [a 63-years-old Brahmin] is supporting me and teaching me a lot. From 12 to 4 p.m. I am going to the office and learn things like the keeping of records and the essentials of politics. The other women and also most of the men do not know anything on management and politics, but I know now. I am also doing many works and I am very experienced. Six months ago one of our wardmembers passed away, and since then I am also taking care of his ward. People do respect me because I know more and I am active. The other women do not get that much respect because they do not know much. The important thing is that I get good support from my husband, and the other women get none or less.

RITA, wardmember, headquarters panchayat in Balipatna, 2 km from panchayat and block office, 35-years-old OBC (Teli), married, three children, *bahu*, 7th standard:

My husband and the villagers asked me to become the wardmember. First I did not want to do it because I have two small children and did not know anything, not even where the block office is, which is just 2 km away. Before my election I also never went out or mixed with people. But now I am more confident and mix with others. When I met our sarpanch the first time [as mentioned a much respected senior Brahmin] I was very nervous, but after the meeting I was very happy. Also the other wardmembers helped me to overcome my nervousness and it helped that there were also other women, not just me. I also adjusted slowly to sit together with men, and now I can also speak to men in the village. Before I could not talk to them, but now I think that they do respect me.

MINA, wardmember, remote panchayat in Balipatna, 3 km to panchayat office, 15 km from block office, 42-years-old OBC (Barik), married, three children, *bahu*, 7th standard:

I used to go out even before my election. I am the secretary of our *Mahila Sangatan* organized by the DSS [Darbara Sahitya Sansad], so I was used to going to their office or meeting with other women's groups. I was also already used to speaking in front of others, and I believe that this is also the reason why the villagers asked me to become the wardmember. My family approves of my work in the panchayat and my sister-in-law helps me with the household work. My husband supports me in my work for the panchayat. I think that my status in the family has become better because I feel that I get more respect now. I have learned a lot and know many things now. So family members and the village people come to me and ask for my advice.

LITA, sarpanch, headquarters panchayat in Gania, 500 m to panchayat and block office, 25-years-old SC (Keuta), married, two children, *bahu*, 9th standard:

I feel good in Gania now. People know me now, they know that I am the sarpanch and they respect me. Before they elected me they did not know me, but my father-in-law is well known and a respected man. . . . Since my mother-in-law died I am the only woman in the household, so I have a lot of work to do to care for my father-in-law, my husband, and my two little daughters. When I go to the panchayat office I take my children with me, but when I have to go to the block office I cannot take them, and my husband takes care of the youngest. Otherwise I am doing all the household work. Being a woman I am used to working hard. I cannot ask my husband to do household work—I would feel ashamed! I'd rather get up early and do all the work alone before I leave for the office. . . . But he accompanies me whenever I have to go out of Gania to attend training or the meetings at the District headquarters.

SABITA, wardmember, headquarters panchayat in Gania, 4 km from panchayat and block office, 45-years-old ST (Kandha), married, three children, *gaanjhia*, primary education:

Because everybody knows me, I am going alone to the panchayat office. To the first three meetings villagers accompanied me. . . . The villagers come directly to me and not to my husband. Mainly men come. The women think that their male family members are going, so they see no reason to come to me. The males come directly to me because I am a *gaanjhia*. They come with demands for pension, the construction of the road, and also the Anganwadi workers come to me and I go with them to

Gania to receive the food grains. . . . I did not go to the grama sabha, because I was on a visit. But I have organized the palli sabha, and I go there alone. Only if the meeting continues till late evening, my husband will come to fetch me, and we go home together. To solve village problems my husband is going. On the days of the panchayat meeting I do prepare the lunch, but my husband prepares dinner. I have no daughters, and my eldest son is working in Sambalpur, and my two other sons are very young. . . . I do not know whether the people respect me here, you have to ask them. For the social functions they invite my husband as the wardmember and as general villager. The villagers see us both as the wardmember, but I am doing more work.

KALI, wardmember of remote gram panchayat in Gania, 10 km from panchayat office, 25 km from block office, 56-years-old SC, married, four children, *gaanjhia*, class 2:

Actually our ward was reserved for an SC-lady already in the previous election and the villagers asked me to contest. But my husband and son did not allow me to contest. So I have asked another woman to contest, but she did not do a good job. This election, the villagers asked me again. My husband finally agreed, but my son was still against the election. He was afraid that I could lose the election and he would feel ashamed. He would also feel embarrassed if I will not work properly. But I managed to persuade him, and now he also accompanies me when I go to places. . . . People do respect me here because in every village work has been done. In my family I get some help in the household work when I have to attend the meetings or go to the villages. And my husband or my son is accompanying me. I have to travel a lot because the villages are so dispersed here, and I am also going to Gania. I am involved in all decisions of the household, but that was already so before my election. But my status in the village has improved a lot. I am going out more often now and I can now speak in front of others. For some occasions, like *pujas*, the villagers call me, because I am the wardmember. There are no village disputes here, but men and women come to me with their problems.

SHAKUNTALA, wardmember of remote gram panchayat in Gania, 2 km to panchayat office, 13 km to block office, 46-years-old Khandayat, married, two children, *bahu*, class 5:

I do not face any problems of acceptance in the village. Why should I? The villagers have selected me and also have elected me. And see, I am working for the people and they are happy. Since I am the wardmember a new well has been dug and now they are doing the drainage for my village. I like to undertake development work and the meetings are my duty. In the last three years I never missed a meeting. It is important and I can leave my household work for a while. And there is also my daughter-in-law who is doing work in the household.

The above statements make it clear that many women are going out now, whereas most had been confined to their homes before. That is not to be taken literally, as obviously women have left their houses before, but not to mix with other people, especially men, or to discuss public topics. Exceptions are women who had been previously exposed through their work for a woman's group or an NGO. In these cases they had already gained some visibility in the village communities before their election. Some believe that

this was also a reason for their election, whereas some thought that it had not influenced the voters' choice. Hence, the position in the PRI has relaxed the regulations of *purdah*. Remember the remark by Rita—she had not known before where the block office is, though she lives in fact just 2 km away from it. The rules of female seclusion lead to a situation where women are not aware of the outside world, not even the one just beyond their village.

Through their election women have now become visible in public village meetings—if they do attend them—like Sabita who is conducting the palli sabhas. They also became visible in the offices—for example Lita as sarpanch and Nita as samiti chairperson, who are visited by people asking them for help. Villagers also go to the wardmembers, although men normally talk to women only if these are *gaanjhias* or belong to the same caste—otherwise, they will talk to the husbands. This shows again the importance the cultural concept of *gaanjhia* has for women's work in the panchayat. Only in Balipatna did women say that men come also to their homes and talk to them and not to their husbands, even in cases where they are not *gaanjhias* or caste-fellows. This was also mentioned during other interviews not related above.

Kali stated that she is now invited to village functions in her capacity as wardmember, whereas in the case of Sabita her husband gets invited only. In many cases, the position of the representative is constituted as husband and wife teams, and both are regarded as representing their constituency. Nevertheless, in cases where the women are very active, they gain their share in visibility and recognition. Where women are mere proxies, their status has hardly changed. Furthermore, the women's status in the village community is still very much dependent on her family relations, as one can see in the remark by Kali—if her husband or son does not allow her to serve for another term, she would not be able to do it.

In the above statements it is apparent that most of the active women perceive that they now get more respect from the village community. It also fills them with pride that people know them and acknowledge that they are the sarpanch or the wardmember. That becomes obvious in the statement of Lita. As argued above, the fact of being perceived as a person in one's own right, instead of just being seen as the wife of somebody, is no trifle development. In some cases there was also a good dose of vanity in the statements, obvious in the introductory quotation given in a gathering of all female wardmembers in the headquarters panchayat of Balipatna: 'We are happy to be wardmembers because we get prominence now and have more prestige. Actually we would like to have 100 per cent Mahila Seats!' This statement reveals a lot about their gain in confidence, which will be discussed in greater detail later.

Some women also perceive an elevation of status within their families. During the survey all women were asked if their status has changed at home due to their new position in the PRI. Around 42 per cent of the women perceived that they enjoy a better status now. Interestingly, there is a big gap in the perception of the gain of status between both blocks. Nearly 80 per

cent of the women in Gania felt that they enjoy a better status now in the family; in Balipatna only 16 per cent had this impression. There is no immediate explanation for this. It seems very likely that women in Balipatna felt that their status was good already before their election, and that the gain was perceived to be larger in the more backward area. Gain in status was often understood as getting more respect and support from family members for the work in the PRI and also at home. The gain of respect and visibility in the village community has positive repercussions on their status at home as well. Additionally, that most women were encouraged by their husbands or fathers-in-law to participate, and that family members discuss political matters with them now might be understood as acknowledgement of their capabilities. However, when we analysed the time spent for their work in the PRI, it appeared that usually the women were not relieved from their household chores and that it is beyond imagination to ask male family members to help. In this respect, their status might have become better, but gender-relations and the division of labour in the family have not changed much so far.

In this respect, empowerment, when understood solely as becoming able to change the power-relations between the genders, has not taken place. It seems rather that their husbands guide most women and conflict of interests is either not perceived or not voiced. Many women stated that they do attend the meetings, but that their husbands solve village problems. Asked whether they always agree with their husbands on the solution, a woman in Gania said: 'The main point is that the problem got solved!' For analysing the relation between husband and wife not much empirical data could be gathered. When I discussed the answers given concerning the voting decision in the Assembly elections I pointed out that most villagers, regardless of their caste or status, value harmony in social relations even if it is created through domination. Thus, empowerment in terms of understanding the power-relations and the structural reasons of one's oppression is dependent on the perception of actually being oppressed. And this is not mentioned very frequently in rural Orissa. Most women still appear to accept their traditional role. However, one should keep in mind that women do not have many fall-back options besides their family; it is fair to assume that even if they perceive clashes of interest, they do not see the scope to really address them. If they have a fall-out with their husband, where should they go? In this respect it remains open whether women really do not perceive major differences of opinion or oppression, or whether they just do not have the means to address them.

The female representatives mentioned leaving their homes to mix with village people as positive, and this indicates that they indeed prefer the new freedom of movement to their previously secluded life. Additionally, the very fact that many women are now working closely together with their husbands might change the husband's perception of his wife's capabilities and, thus, also the relationship between the partners in the long run. This does not happen automatically and depends very much on the personality of the

husband as well as that of the wife. In the case of Babita, her husband was proud that she is performing so well and is supported by the sarpanch. On the other hand, some husbands did not even let me interview their spouses. One husband of an SC-wardmember in the remote gram panchayat in Balipatna, for example, said:

My wife does not know anything. I am doing all the work for the panchayat, except attending the meetings. You see, my wife is uneducated and does not know anything about politics. So let me answer your questions.

In such cases, one can presume that the presence of his wife in the PRI did not actually change her personal life, except in having the additional burden on her time-budget of attending the meetings.

Gaining of Consciousness and Confidence

One of the major problems for women, not only in the Indian countryside, is becoming conscious and confident about their personal capacities and capabilities. Women are frequently confronted with remarks on their inability to handle things, their shyness, their lack of education or knowledge which allegedly makes them fit only to stay in the house and care for domestic matters. Many women have internalized this and believe themselves to be incapable of handling public affairs. When asked, some said that they do not know anything, that they are not educated enough, that politics should be looked after by men because women have no natural aptitude. This was either claimed by women about themselves or about other women in and outside the PRI. Obviously, this was also the constant refrain heard from male villagers, but what concerns us here is the self-perception of the women. The belief in one's own incapability and the acceptance of the role attributed by society is part of what has been labelled 'internalised oppression' (see Rowlands 1998: 14) and is very difficult to overcome from a psychological point of view.

Thus, I was interested to find out if some women have mastered this inhibition after they had experienced that they are indeed capable of many things. As one could gather from some of the statements above, many women have definitely become more confident as a result of their exposure and their involvement in public life. They mentioned mixing with people who do not belong to their clan, speaking in front of others, and leaving their houses in order to deal with village problems or attending village meetings. Here, I shall give some further telling examples of how women overcome their initial shyness, how they deal with authorities, how they perceive their capabilities, how they become confident about the importance of their political office, and what hopes and wishes they have concerning their future.

NITA, samiti chairperson of Balipatna, residence 8 km from block office, 25-years-old SC (Chamar), unmarried, *gaanjhia*, MA in Oriya:

I think I can do everything. I go to my office regularly by bus, and people come to me, men as well as women. I think that the women come because I am a woman myself. They even come to my residence when I am not in office. I have a good rapport with

most of the people. I also have no problems with the present BDO [Block Development Officer] and the other officers. But if they do not do well, I will have them transferred. I believe that the present BDO respects me as his boss. When my term as the samiti chairman will be over, I will either join an NGO for doing social work, or stand again for election for any post in the zilla parishad or even as MLA, if I get a ticket from my party.

BABITA, naib-sarpanch, headquarters panchayat in Balipatna, residence 1 km from panchayat and block office, 47-years-old SC (Chamar), married, three children, *bahu*, 6th standard:

It became evident also in her previous remarks that the naib-sarpanch has become very self-confident. She had said there that she is more active and doing good work. The degree of confidence is also seen in the following statement:

I am very interested to learn. I thought that first I will become a wardmember and can learn important things, like keeping records and the essentials of politics, and later I can become sarpanch. Our sarpanch is very old, and he will not contest again. In the next election my husband will contest as wardmember, and I will contest to become the sarpanch, even if the seat will not be reserved for a woman.

In the case of Babita, part of her good performance is due to the assistance of her husband, but very important is also the major support of the Brahmin sarpanch. Considering that she is a Chamar it might seem counter-intuitive that an alliance has developed between these two personalities. Also the villagers confirmed that the comparatively good performance of this gram panchayat is mainly due to the exemplary understanding between the sarpanch and the naib-sarpanch. It seems that the old Brahmin is coaching Babita as his heir. He was also very proud to show how he is teaching her everything, how he promotes her, and how well she is learning. There is apparently a patriarchal relationship between them; Babita touches his feet in reverence when they meet and obeys him in most matters, as I was informed by other wardmembers. However, to show respect to male elders either of one's own family or to a village dignity is a widely followed custom in Orissa. It also seems that the sarpanch has had no major problems from dealing so closely with an SC. This alliance is probably due to the fact that both support the same party and that the sarpanch can mould her according to his interests. However, following conventional wisdom about caste equations in the countryside this alliance is far from what one could have expected.

RITA, wardmember, headquarters panchayat in Balipatna, 2 km from panchayat and block office, 35-years-old OBC (Teli), married, three children, *bahu*, 7th standard:

I would like to remain the wardmember. But I am not very educated, so I cannot imagine running for a higher position. I have not studied enough but I try to do as much as is in my capacity. And I also have three small children, and my husband is not helping me. So I do not have much time. And it is also difficult to be a wardmember. People are complaining about you because they come to you and if

you do not give them what they want, they are complaining. I have done everything I could, especially after the cyclone. And often the rich people come and demand things, which are not due to them. However, the rich women do not come, they send their husbands, only the poor women come to me, and I try to help them.

MINA, wardmember, remote panchayat in Balipatna, 3 km to panchayat office, 15 km from block office, 42-years-old OBC (Barik), married, three children, *bahu*, 7th standard:

I am very satisfied with the Panchayati Raj and I am also very happy to be a wardmember because I could do something for the people, especially after the cyclone. I would like to remain in the Panchayati Raj, but I think I can only contest again for wardmember because I am not educated enough to become the sarpanch. But I would like to become the naib-sarpanch, and I think the panchayat secretary can arrange this, if he wants to. . . . I am also very much in favour of the reservation for women. I think that men can do everything, but women can also do everything if they get the chance and put their minds to it. But the problem is that women normally cannot solve the village problems because mainly their husbands or fathers-in-law do not give them a chance to talk and go out. So, also in the panchayat most women are not active. Especially women who live only with their husbands and children cannot spend enough time. I can spend more time because I live together with my husband's brothers' families.

LITA, sarpanch, headquarters panchayat in Gania, 500 m to panchayat and block office, 25-years-old SC (Keuta), married, two children, *bahu*, 9th standard:

I go alone to the panchayat office and the block office. The GPO [Gram Panchayat Officer] supports me and also the BDO is very helpful. My husband only accompanies me when I have to leave Gania. . . . Once I went with the federation of the sarpanches to Bhubaneswar to demand that the PRI will not be dissolved. We want to serve our five-year term and we are also demanding to get pensions, and that our remuneration is raised. . . . Nowadays I also settle village disputes like those concerning boundaries or theft. I do this because I have plans for my future. Normally my husband accompanies me and some wardmembers, but if I have no time, my husband goes alone, and his decision is respected. . . . I am happy to be the sarpanch even though I have to work a lot. But I have more prestige than even the zilla parishad chairman and the samiti chairman, who is not very respected here. Nowadays the gram panchayats have a lot of power and I can do a lot as the sarpanch. We are the people who are really doing the work. Who is going to the block office or to the zilla parishad? The people come to me! And the people like me, some have already asked me to stand for election again.

SABITA, wardmember, headquarters panchayat in Gania, 4 km from panchayat and block office, 45-years-old ST (Kandha), married, three children, *gaanjhia*, primary education:

I was very silent in the first meetings. But then I thought I have to speak, that is the reason for being here. And the male wardmembers also encouraged me to speak. It is true that some women do not open their mouth, like the lady from T* but I do not know why. For me it is easier to speak in front of the sarpanch because she is a woman herself. But I think I would also speak in front of a male sarpanch because as

a wardmember I have to speak. . . . I am doing the things according to my ability, and I like doing it. I like to sit with the people and listen to some new things. We are getting information. Within the boundaries of this house you cannot get to know anything. But as I am the wardmember and have the power now, I can go out. But when my term is finished I will not go out anymore and will be inside my house again. I will be sad when my term is over. If the people will decide and ask me again to become the wardmember I will do it again. I think that women should take part in the panchayat. For us it is a chance to go out and get to know some things. But I feel that the situation for the other women has not changed much. The main problem for women is water. We do have a tube-well for which the drainage will be done, but it does not give water all the time. Then the women have to go to the open well, which is out there in the field. The application we gave to the zilla parishad chairman had no effect so far. I am also talking with the sarpanch and the panchayat secretary about this, but they say they have written the application. We also gave applications for the Ballika Samrddhi Yojana (BSY). But they say that the government has no money. I wonder why the government has started the scheme.

KALI, wardmember of remote gram panchayat in Gania, 10 km from panchayat office, 25 km from block office, 56-years-old SC, married, four children, *gaanjhia*, class 2:

I would like to participate in the next election, but I think that my husband will be against it because he always has to accompany me. . . . I did not expect that it would be such a lot of work. But I am happy now to be the wardmember and there are more works done for development, like the construction of a community hall. . . . I also have been to the BDO to ask him about the digging of a well, and he was listening to me and I had no problems. I have been to the BDO also before my election, when I was secretary of the *Mahila Mandal*. Now as a wardmember I am bound to go. If I do not go, the people who have voted for me will complain that I am not putting their demands before the panchayat. But also if I will not be the wardmember anymore I would go to the villages and meet the people, but I would not be able to help them anymore.

SHAKUNTALA, wardmember of remote gram panchayat in Gania, 2 km to panchayat office, 13 km to block office, 46-years-old Khandayat, married, two children, *bahu*, class 5:

Last year when you asked me I was not very happy with the panchayat, but in the meantime some work has been done and I am more satisfied. I also have gotten to know more things and can point at problems. . . . I would like to become the naib-sarpanch, and I would also like to become the wardmember again, if the villagers will nominate me.

A pattern that emerges from the above case studies and interviews with other women is that most felt initially very shy and unable to talk in front of others. One samiti member in Gania who is not included in the cases above even said that she had to be admitted to a hospital after her election campaign because she had a nervous breakdown. She attributed this to the exposure she got for the first time, which made her very nervous and agitated. However, all women claimed that they have overcome this shyness now. They were either encouraged by other wardmembers or the sarpanch; their

constituency also pushed some. Many claimed that they perceived it to be their duty to speak now that they are elected. Sabita mentioned that it was easier for her to speak in the meetings because the sarpanch is also a woman. During the interviews other women also argued that they were encouraged to overcome their shyness because there were more women present. This strengthens the argument that a critical mass or threshold presence helps women to overcome some of the obstacles faced by them. One should not forget, however, that some representatives still have not mastered their reserve and sit quietly in the back of the office, sometimes asking a female colleague to raise issues for them. It shows how deeply ingrained values of womanly behaviour and past conditioning in a specific role work against full participation. However, considering the social framework described in Chapter 2, it should be seen as no little gain that some women could overcome their shyness and reluctance to speak to non-family members.

It is also interesting to note how confident some women became about the power of their position. A telling example is Nita who proudly mentions that she is actually the boss of the senior BDO, and that she has the power to transfer him if he does not fulfil his duty. Generally, the interaction with officials of the local-level administrative structure is also an indicator for a gain in confidence, but also for more general involvement of women in the public sphere. During the survey the representatives were asked whether they had contacted officials like the BDO prior to their election.

Before their election, 21 per cent women had already met with officials. Most of them had done this in their capacity as members of Mahila Mandals, co-operative societies, or Anganwadi workers. Some had served previously in the PRI. There is a regional difference: More women in Balipatna had already contacted officials (24.2 per cent *v.* 16.3 per cent). However, among the seven women in Gania, five had interacted with officials very frequently, whereas in Balipatna most of the women had contacted officials between two to five times. I was particularly interested to find out whether women contacted officials more frequently after they had been elected.

As expected, after the election more women came into contact with officials, and for many it was the first time. Nearly half of them had some interaction (49.5 per cent). But there is still a variance between the two blocks: Women in Balipatna have more exposure than women in Gania (54.8 per cent *v.* 41.9 per cent). Sarpanches and the chairpersons frequently interact with officials because of their position, but even some wardmembers contacted officials. In most cases, the women stated that they were treated with respect and did not face difficulties. We have also seen that Nita was very confident about her position as the boss of the BDO. Lita mentioned the support she receives from the block office staff. Kanchana, the samiti chairperson in Gania, not included in the cases above, related the problems she was facing with the previous BDO. In all cases, interaction with the local-level bureaucracy can be judged as important exposure to the public world and is an integral part of political participation. It also indicates that some women gained enough confidence to interact and deal with bureaucrats.

TABLE 5.1: FUTURE ASPIRATIONS OF WOMEN IN POLITICS

	Getting out	Running for the same post	Going up	Can't say, don't know	Total
Female B	9 (14.5)	18 (29.0)	27 (43.5)	8 (12.9)	62
Female G	10 (23.3)	15 (34.9)	12 (27.9)	6 (13.9)	43
Total	19 (18.1)	33 (31.4)	39 (37.1)	14 (13.3)	105

Note: Percentages in rows for Balipatna (B) and Gania (G) are calculated for each sample separately.

In Balipatna, the intercourse between ordinary wardmembers and the block office personnel became even more enhanced because of the relief operations after the cyclone.

The women's gain in confidence and interest in politics is also revealed in respect to their future aspirations in politics. We have seen this already in some of the statements above. The question had also been asked during the quantitative survey in the previous year (see Table 5.1).

Outstandingly, almost 70 per cent of the women would not only like to remain in the PRI, but more than half of them even aspire to a higher position. It is interesting to note the considerable gap between Balipatna and Gania in respect to 'going up'. It seems to indicate that women are more assertive in the more developed block and also more self-confident. Generally, the reservation must have given a boost to their self-image in terms of their capabilities. Asked why they aspire to a higher post, more women and men in Balipatna named, among other things, more power to do more work and the wish to do more for the people. Thus, they perceived their present post as not powerful enough to do what they would like to do. It also became quite obvious that for many women it is a matter of prestige to be a 'member saab'. now. Some of those who want to quit are often more aware of the difficulties which are involved with this post. Some of them were frustrated because they could not do anything so far, and so they perceived it as a waste of time to remain in the institutions; some women said they have too much household work to do and cannot afford to spend so much time for the PRI; and some were simply not interested or felt they lack education or other competence to perform well.

An open question is how far these changes and personal gains that accrued to the women through holding office will remain when they leave the institutions. Two women in Balipatna, namely Bimala and Nita, said that if they would not be re-elected they would start working in an NGO. In these cases, one can argue that there might be some long-term gains from their political presence. In other cases, such as in the case of Sabita, women will step back into their old household duties and will not go out again. It is difficult to speculate in these cases how far their lives have changed in the long run. But I would like to argue that at least the gain of confidence in their abilities will remain as well as the psychological empowerment of having been able to participate in the public realm. More long-term gains could be expected in cases where the women have gained some gender-consciousness.

That could have positive repercussion not only for themselves as individuals but also for the female constituency.

Gaining of Gender-Awareness

In this section I shall forego the previous format of relating statements given by the eight women, as not all women above made conclusive remarks. We shall hear the voices of individual women here as well, but some general observations will also be given.

It is not very easy to assess the degree of gender-consciousness or awareness. When one looks at the 'preferences for works to be done' it already became apparent that women in Balipatna seem to be more gender-sensitive. They voiced more frequently that they would like to do something specifically for women. In these cases, one can argue that if the representatives were able to implement these ideas, the situation of women in the countryside would change in the long run. But let us first have a look at the situation in Gania Block.

In a meeting with the female wardmembers serving in the remote panchayat of Gania Block on 29 January 2000 all were pleased about the fact that there are now women in the PRI, but they could not give any reasons why that is so. They said that women are only there because of the reservation, but still they perceived it as positive. I drew blank faces quite often when I asked female representatives or village women whether they perceive specific women's issues. Most could not give an answer at all. Some stated that widows need special attention and that procurement of potable water is primarily the problem of women. However, the area is not drought prone, so most women did not see a pressing problem in the availability of drinking water. In cases where ground water is not fit for consumption (in some areas, iron-content is very high), they draw water from the rivers. Fuel, another issue that has been identified in the literature as a women's issue, was not mentioned at all. This has partly to do with the fact that many of my interviews were taken in a forested area, where the collection of wood for fuel does not pose a severe problem yet.

In individual interviews, some women were able to give more detailed statements. Kanchana, after some minutes of silent deliberation on the question why she thinks it positive that there are now women in the PRI, finally said that the situation would become better in general because women do know more than men. 'They are running a household and make ends meet, and so they know better how to deal with poor resources.' She was also aware of the fact that it does make a difference that she, as a woman, is holding the post. 'I think that now more women come to the samiti office to speak with me because I am a woman myself. Young girls come to me, they would not dare to address a man.'

Shakuntala said that the reservation is good and that she would also encourage other women to become involved in the PRI. However, she also was not able to formulate an opinion on whether the inclusion of women will change something. She only maintained, as already stated above, that it

is good that women now get out of their houses and participate in development work. Shakuntala has studied up to class five and believes that her own education helps her to perform better as a wardmember. When asked whether she sent her own daughter to school, she said that her daughter did not go to school at all because the school was too far away from their village. She also declared: 'Nowadays it is more important to educate our girls. They are now also working in the service sector. Girls should study up to class seven, but getting higher education is too expensive.' Thus, lack of education is perceived as posing a problem for women, but in this case employment opportunities were seen as more important than other considerations. What also becomes clear is that it is not only a matter of traditional values that one does not educate the girls, but also a matter of institutional infrastructure. It was voiced frequently that if schools are too far away parents feel reluctant to educate their daughters. However, boys are sent to farther away places, but girls are supposed to need more protection. It is also a fact that not all who perceive the problem of the lack of educational institutions in the vicinity argue accordingly for the setting up of more schools. The notion that sons are more welcome than daughters, and that it is more important to educate one's sons, still remains.

A good case in point is Lita, the sarpanch from Gania headquarters GP, who has two young daughters. During our first meeting Lita declared that she is very unhappy that she has no son who will care for her when she is old and who will perform her funeral rites. For this purpose she has adopted her neighbour's son. Later she said, however, that nowadays the sons do not care anymore for their mothers but instead the daughters support their aged parents, and so it is actually good to have daughters. Here we see that the traditional preference for sons is still very important due to the pattern of marriage where daughters leave the house whereas the sons stay and are supposed to support their parents in old age. The religious importance of having sons is still very salient as well.

However, due to an incremental change of social norms, nowadays parents cannot be sure that they will be supported by their sons later, and many witness that parents receive support from their daughters instead, especially in cases where the daughters have not moved very far away. I encountered several instances of this in the village I lived, like the fate of the two widows I mentioned before. The religious compulsion to have a son found some solution in the adoption of a male child from somebody else to perform the necessary rites. In this kind of adoption the child does not leave his family. He stays with his parents, but has some special relationship to the other family for whom he will conduct the rites. There is the exchange of some gifts and the forging of a special bond between the two families in the case that they are not relatives. The practice seems to be quite established in Orissa.

This change in social practices has overtly nothing to do with the entry of women into the political institutions, but appears to be due to an incremental transformation of rural society. It is also indicative of some changes taking place that the sarpanch is not trying to conceive a son, but argues that two children are enough. One could speculate, however, that it is partly due to

the very controversial two-child norm that was introduced in Orissa.[3]

Several women were also asked whether they had started any agitation against alcohol consumption. This topic is mostly perceived in the literature as a 'women's issue' because women are the main victims of husbands, who squander scarce household resources on alcohol and often end up beating their wives (see e.g. Rao and Parthasarathy 1997). This also happens in Orissa and incidents occurred in the areas I investigated, although it was initially not openly acknowledged. When asked more specifically about this problem, giving instances I had come across during my stay, a standard answer was that it was regarded as a private problem. It was not really seen as a public issue on which women could press for action, either inside or outside the PRI, but rather an issue with which neighbours could try to help the concerned woman. I also discussed this issue with Lita. When asked whether she made alcohol consumption a public topic, Lita gave a very revealing statement:

Yes, there is a problem with liquor consumption here. Especially the young boys drink too much, and I am really lucky that my husband does not drink. You can get

[3] This following clause was inserted by the Orissa Act 6 of 1994, S. 12 (ii); (GoO 1994a: 13) in the *1994 Gram Panchayat Act*, Section 25. It says that a person should be disqualified from serving as a wardmember or sarpanch if a third child is born after the commencement of the Act:

25 (1) A person shall be disqualified for being elected or nominated as a sarpanch or any other member of the Grama Panchayat constituted under this Act if he [*sic*!] — . . . (v) has more than two children: Provided that the disqualification under clause (v) shall not apply to any person who has more than two children on the date of commencement of the Orissa Grama Panchayats (Amendment) Act, 1994, or, as the case may be, within the period of one year of such commencement, unless he [*sic*!] begets an additional child after the said period of one year.

If a representative does get a third child after the election an aggrieved party has to file a case. See Sections 31–41 for the procedure of filing petitions to declare an election invalid (GoO 1994a: 18–20). An advocate from Daspalla (Sri Misra, interviewed on 17 February 2000) said that he had three cases dealing with this provision, but all of them were settled outside the court in a compromise. There were apparently some shady deals involved that he did not want to relate in detail. He also mentioned a case where the rule had been violated but nobody filed a petition either for lack of knowledge or lack of interest. The regulation itself is rather questionable, especially from a democratic point of view since it bars people from running in elections who might be actually very interested and suitable. Additionally, it allegedly gets used more frequently against women than against men. This was argued by activists in the 'South Asian Regional Seminar on Women and Local Government in South Asia: Promises and Prospects' organized by the Centre for Development Studies and Action and the Friedrich Ebert Foundation in Delhi, 25–27 November 1999, in which I participated. Still, the enactment might promote a development that those people who wish to become politically active refrain from having more children and settle with two children even if these might be daughters. A more threatening scenario could be, however, that in case the preference is still for sons, girl-children might be neglected or, where possible, aborted so that at least one son will be born. In all possible scenarios, the impact of this questionable provision is only in regard to a tiny minority. However, this minority might nevertheless serve as a role model.

country-liquor here in every *pan*-shop. I would really like to do something about this, but I am helpless. Were I to do anything against the selling and drinking of alcohol, who would support me in future? There is one thing I could do. The government wanted to open a foreign liquor-shop here. I conducted a signature campaign among the wardmembers and village people and could stop it for the time being because I did not want this to happen under my tenure. I do not want to be remembered as the sarpanch under whom the foreign liquor store was opened.

Obviously, she is very conscious about the politics involved in this issue. Her constituency and especially the politically decisive people are male and potential alcohol consumers. To block their access to country liquor would be political suicide, especially if she wants to run in elections again, which she does. There is no women's movement in this area, which could support her in an anti-liquor campaign. Lita claims that she has done something to prevent the opening of a foreign liquor store. However, the practice in Gania is such that 'foreign' liquor (especially whiskey, but beer as well) are sold by the local shop-owners—presumably not officially, although it seems to be tolerated.[4] Thus, Lita's success in preventing the opening of the foreign liquor shop could also be due to the fact that shop-owners would lose a nice and secure income. Additionally, potential consumers of foreign liquor are only few because it is comparatively expensive (a bottle of beer nearly costs a daily agricultural wage) and can only be afforded by a minuscule portion of Gania society. In this respect, Lita's move to obstruct the establishment of a foreign liquor store must not necessarily be interpreted as a special concern to fight for women's interests, and it is rather unlikely that she has lost crucial political support through this agitation. What becomes obvious here is the lack of a vigorous women's movement, which can be seen as being responsible for the fact that the issue of alcoholism does not get addressed in Gania. It is obvious that women representatives lack gender-awareness, which is not automatically created through serving in a political institution. Nevertheless, they prove to have learned their politics fast, which goes against the discourse of women being politically incapable. Yet, many people would have wished that women's capacities would lead to different outcomes.

In Balipatna, women were more gender-sensitive in some respect but it is difficult to assess whether this can be related to their new position. Babita, the naib-sarpanch and the sarpanch Bimala both wanted to do something for the empowerment of women. Babita conducted training workshops with women on education and tried to provide the Mahila Mandal in which she is working with a Development of Women and Children in Rural Areas (DWCRA) scheme so that they can produce some things at home.[5]

You see, I would like to help the women more but the problem is that they are sitting at home and cannot do much. Thus, one has to provide employment opportunities

[4] I observed policemen drinking beer more or less openly in the early hours of the day in front of a shop—thus it might be illegal but not punished by the local authorities. One could speculate if they get their share of the profits for this 'toleration'.

[5] The Development of Women and Children in Rural Areas (DWCRA) was introduced in 1982–3 as a sub-scheme of the Integrated Rural Development Programme (IRDP) and

that they can do at home and the two schemes are the only thing I can provide them as naib-sarpanch.

Bimala said that she would like to start an NGO to work specifically for the empowerment of women after her term as sarpanch is over and she does not get re-elected. She is a graduate in law and is very active and intelligent. But she claims that the other women are very shy, except one wardmember.

I tried to motivate them but the problem is that women do not want to go outside. They only stand for election because their husbands asked them and they obey. And the other problem is that they lack education. Still, I believe that through the reservation society will change, but it will take a long time.

The wardmember whom she refers to is Mina who is very active in a women's group. I interviewed Mina and she was of the opinion that women gain much more from the *Mahila Sangatan* than from the Panchayati Raj because they get money for productive investment. Still, she is also very positive about the fact that women are in the local political institutions now, for she believes that women are capable of many things.

In the first two cases, the limitations of the other women were voiced very strongly, and it appears that the respondents believe other women to be rather incapable. Mina, on the other hand, thinks that other women are very able as well, but sees more scope through women's groups for the betterment of their lot especially from an economic point of view.

To sum up, it is obvious that the female representatives have gained substantially—whether it is their new found freedom to move around, their knowledge, their status, or their confidence. A crucial issue, namely gender-awareness, is unfortunately less developed. Yet, it is not only a lack of consciousness but also a limitation posed by the political system. This became clear through Lita's case. Since women are elected in an environment where the voting-decision is dominated by men, they act rationally if they also cater more to the interest of the influential voters. Because there is no women's movement in Gania that would press Lita or support her, it would be political suicide for her to work against the wishes of the dominant villagers.

EMPOWERMENT OF WOMEN AS A GROUP

In this section we come to the most controversial issue concerning the inclusion of women into the political system. Many supporters of the political presence of women in the institutions of local government assume that female politicians will represent women's interests and needs. The same assumption

aims particularly at improving the status and quality of life of poor women and children in rural areas. Under the programme, income generating skills and activities for poor women are provided. It also gives access to appropriate technology, to pre-school education, to applied nutrition, to functional literacy, to education in family welfare, and to resources and credit for purchasing income generating assets. In contrast to other IRDP schemes which are basically credit-based, under DWCRA a sum of Rs. 15,000 is provided to a women's group as a one time grant. The group members can use it collectively or share it to be used in selected activities.

and hope emerges also from the related debate concerning the introduction of a quota for women in the Parliament. This was already made clear in the early documents concerning the PRI discussed before. Here, the nomination or co-opting of women was seen as important to secure that the 'women's point of view' was heard, especially concerning programmes which affected women and children. Also in the early women's movement the demand for a quota for women was justified with the expectation that these representatives would work for the betterment of women.

But women are divided by caste, religion, social status, age, location, and so on. To what extent will a Brahmin woman represent the needs of an SC-woman? Does gender-identity play a role in politics at all? If one defends the inclusion of women into the PRI with the strong expectation that they will mainly work for women, one might be seriously disappointed, even if one were to subscribe to the rather unsatisfactory view of an essential woman-hood. On the other hand, I have already argued that although women do not necessarily converge on all issues, it is still valid that some interests are gendered. It was discussed that most women are limited in their mobility only because they are women, though the degree depends on caste, age, or region. Most notably, virtually all women were traditionally excluded from rural politics, and most have in common issues concerning reproductive health and face similar discrimination in education and occupation. In the following chapter we shall thus turn to the general population to find out how various individuals and groups perceive the situation after the reservation for women. We shall first have a look at the 'women's' point of view and then at the 'men's' perspective.

Perception of Village Women on Female Representatives

To come into contact with village women, especially in Gania, was not always an easy task since women were mostly busy in the house or in the fields. Only in a few cases was I able to speak to women's groups. The situation in Balipatna was different because there some viable women's groups have been organized by the NGO I was staying with during my field research. We shall first have a look at the women in Gania and then at the women in Balipatna.

In Sabita's ward, a tribal village of the headquarters panchayat, I could talk to some women who had gathered in the backyard of a house. It was in the early afternoon and only very old women and some young girls were present, the able-bodied women being busy in the fields. The women who were present were asked about their female wardmember, and if they are happy with her. One old lady did most of the talking.

We do not know anything. We know the wardmember, but we cannot say if she is doing a good job or not. You have to ask the men. I have never talked to her since she became the wardmember. When she was a member of the *Mahila Mandal* we talked to her in the meetings. But the *Mahila Mandal* is not functioning anymore. When the wardmember wants something, she calls a village meeting and the male villagers go. So we do not know what she wants and what she is doing.

Later I asked Sabita if the village women were inquiring about her work and if they have asked her about what she was doing. Somehow I expected some curiosity from the village women because one of them has entered a domain which was hitherto exclusively male. However, Sabita replied that none of the women has asked her any questions. In this case, it seems that the woman representative has crossed a line, which separates her from the 'female sphere' and the other woman regard her as part of the 'male world of politics'.[6]

A similar situation was found in the ward of Kali who is actually very active. Her ward consists of four villages that are very scattered since the area is sparsely populated. One village is inhabited by tribal Kandhas and is around 8 km away from the representative's residence. Here members of the Gania Unnayan Committee (GUC) and I met some male and female villagers in the early afternoon. The village, typical of the villages of the Kandhas in this area, is arranged as a small lane lined with houses that are attached to each other, sharing an open veranda towards the street. When we entered the village, a bunch of men were sitting on the veranda on the left side, and a little bit down the road, women were sitting in front of the houses on the right side. We first talked with the men about several issues, which will be described later. After we had finished talking to the men, we turned to the women. Walking down the street, we met the women who had been sitting there all the while watching us curiously. I asked them what they thought about Kali and if they were happy that their wardmember is a woman. They answered:

We are not speaking to the wardmember. She comes and speaks with the men. She has not organized a meeting with us or asked us any questions. She has never asked us to sit with her like you have now.

When asked what they would like to tell their wardmember, they said that the main problem in their village is the grinding poverty, under which the whole village suffers.[7] If one legitimizes the political presence of women only with the assumption that the female representatives will represent and work for the village women, these two observations do not augur well.

However, one point that emerged in all other talks with village women in Gania is that they value the new presence of women in local politics. One reason can be found in the gender-segregated nature of rural society: Women outside the PRI do not meet with men. Thus, whereas women had no access to their representatives earlier because all of them were male, they can now envision placing their demands in front of the female wardmember, sarpanch, or samiti chairperson. In the ward of Nalini in the remote gram panchayat of

[6] Compare *Crossing the Scared Line* (Kumari and Kidwai 1996); the authors, however, do not perceive the negative side of 'crossing the sacred line', namely, the possible alienation of women in politics from women who remain outside.

[7] The Kandhas do some agriculture, but crops are sufficient for five to six months only; the rest of the year they have to depend on wild forest produces. Since they are no fishermen, they do not catch fish. Hunting is prohibited because they live in a wildlife sanctuary.

Gania, I had a talk with some girls and women who were busy in preparing *chuda*. I started talking to the women and girls. They said that they are happy with their wardmember: 'She is a woman, and so we can go to her and place our demands.' When I asked Nalini later whether the women really come to her, she said: 'Yes, the women come to me. The men come only to my husband, they cannot talk to me.' The prevention of women to talk to men not related to them is a fact that makes a quota for women even more important in the Indian countryside as compared to the situation in the West. Thus, we find in Gania on the one hand that in some villages women do not really feel represented by their female wardmembers, but at the same time they often express pride that women as such are now present in the public bodies and that they have gained new access to their representatives (though they not always use this access). We shall see that this was frequently mentioned in Balipatna as well.

Let us turn now to the situation in Balipatna, which is quite different. The DSS is very active in organizing women's groups around micro-credit, also linking them to DWCRA-projects whenever possible.[8] Thus, in contrast to the situation in Gania, I could meet several organized women's groups in this area. I participated among others in a meeting of a *Mahila Sansad* in the remote GP. The women planned to take a loan for the construction of a building as a meeting place for their *Mahila Sangatan* since the school building they were using was too small for this purpose. The women in these

[8] See Harper (1998: 124–31), chapter 'Puri Gramin Bank and DSS Balipatna, Orissa, India', for the organization of credit-groups and their linking up with a local bank through the NGO. Here I shall give a short description of the organization of the women's groups as explained to me by members of the DSS and the women concerned. (I lived in the office of this NGO during my field research and I am very grateful for the hospitality and the amount of time the DSS devoted to me.) The DSS organizes the credit and saving groups *sahi-* and thus mainly caste-wise. The argument for this procedure is that these women share the same location and have a greater congruence of interests as well as economic capabilities. That does not hold if the NGO would organize the groups cross-caste and cross-locality. The women's groups in the block are organised like a pyramid. The base is constituted by the groups organized at the *sahi*-level which comprise of 10 to 25 members. Fifteen of these groups do constitute a cluster (*Mahila Sangatan*), usually located at the gram panchayat level. In case the gram panchayat is very big and many groups have been organized, a given gram panchayat can contain more than one such cluster. The small groups meet once a week, while the cluster meets once in a month. Every member of the group is saving around Rs. 10 per month, sometimes more, for example during the planting season, sometimes less, when it is lean season. Every group and cluster has a president and a secretary who are responsible for keeping the records. These two manage the joint bank accounts which have been opened for the groups by the NGO at a local bank. Every group is giving Rs. 5 per month. Out of these, Rs. 2.50 are for the *Mahila Sangatan* (cluster) and the other half is for the *Mahila Sansad*, the union of the 12 clusters presently constituted in the block. A loan from the bank can only be taken by the *Mahila Sangatan*, which distributes it to the women concerned. The *Mahila Sansad* or the *Mahila Sangatan* can then give loans for developmental work. Loans to individual women for private investment or consumption are taken out of the accounts of the small groups.

groups have become quite vocal. They usually come without male company to these meetings, mostly two women go together and many of them walk to the office of the NGO either in pairs or groups, the presidents and secretaries sometimes go alone. The secretaries and presidents even go to the block office if the need arises. They are normally better educated, as they need writing skills to manage the accounts.

I was interested in what kind of issues the women discuss during their meetings. They mostly answered that apart from some village gossip, they only talk about matters concerning savings and credit. Asked whether they also deliberate about matters like domestic violence or related issues, they stated that they do not interfere in such things. They cannot spend much time for this. The weekly meeting is normally for one hour, during which they need to discuss the money-related matters. The women also said that they do not debate village matters. 'Women do not discuss these matters, only men discuss such things.' Several women stated that in the beginning their husbands were against the formation of their groups. Some said that they had not told their husbands initially about their meetings because they were against them moving outside the house. But all agreed that now their spouses are happy mainly because they realized that their wives bring home money when they become eligible for taking a loan. But how do they get the Rs. 10 per month? Most of the women from this cluster are from middle-caste households, and these women normally draw no cash income of their own. Accordingly most women said that they get this money from their husbands. And who decides for which purpose the loan is taken? 'The husbands decide, but we do not differ with our husbands. Most loans are taken for agricultural purposes, and men know best what to do with the money.' Concerning their perception of the inclusion of women in the PRI, all were very positive:

It is good that there are now women in the Panchayati Raj Institutions. It is good because now women are coming out of their houses. Earlier, women were not participating, but now we get the chance to participate at different levels. Our daughters might participate in the next election, when there is again a reservation for women. We want to stand on our own feet, but sometimes we are dependent on our husbands. In our panchayat, the female representatives are doing the work and they are all participating in the meetings. They also go out and supervise the work. In the Village Committees there are mainly men, but nowadays at least one woman gets nominated as well. Before they did not allow women in the Village Committees, but now that there are women in the panchayats they also allow them in the Village Committees.

However, many women also complained that not much work is done by the panchayat. Most think that this is due to political pressure. One group of women I met in a ward represented by a female representative also complained about her. They alleged that she was taking money for herself and that the panchayat as such is not doing much for them. Many feel that the DSS, especially after the cyclone, has done much more for them than the Panchayati Raj Institutions. They claim that they got only a little bit of relief from the panchayat, whereas the NGO had organized a large amount of

relief and channelled resources from international relief organizations to the women's groups. 'Our wardmember is not doing much for us; she does not help, but works for her own pocket. The same holds true for our sarpanch— she is also thinking only about herself.' The meetings described above were all conducted with women's groups from the remote GP.

There was also a meeting with a *Mahila Sangatan* from a big village in the headquarters GP where Rita represents one ward. The gathering was organized by facilitators from the DSS and took place in the school-building of the village where the female wardmember lives. The school had been severely destroyed by the cyclone, and only one rather small room was spared. When I arrived it was crammed full with around 100 women in colourful saris, some with children on their laps, and all with expecting eyes. Asked what they think about the fact that there are now women in the panchayat, some say:

We are happy that there are now women in the panchayats. Because we can put our demands and requirements in front of the women, we cannot do this in front of men. We women are not independent here, and before we could not talk to the Panchayati Raj people because they were all men.

However, that they can now address their female wardmember seems to be a rather hypothetical notion, though it is very important that it is perceived in this way. As we saw, this issue also emerged in Gania. Women in Balipatna admit that they have not talked to their wardmember yet because their husbands go to her. But in principle they could, and this potential opportunity appears to be very important to them. Still, many women are complaining that Rita is not doing much for them. Other women from wards represented by men, however, say that the men are also doing nothing. The atmosphere in the meeting got very charged. Women started shouting: 'Look, we have no electricity, no roads, no nothing. Nobody cares for us.' Many women accused the wardmembers and the sarpanch and claimed that the representatives only work for themselves, but not for others. Rita, who was present at this meeting because she is also member of this *Mahila Sangatan*, defended herself. 'I did repair the road, got new tube-wells, and also distributed the relief. But I cannot fulfil all your demands. You demand too much. What can I do?' A general problem, which becomes obvious here, is that the state has aroused expectations among its citizens that cannot be fulfilled. Most representatives feel overburdened with the demands of their constituencies and frustration is apparent on both sides. A difference between the situation in Balipatna as compared to Gania is the fact that generally women were more inquisitive and various female representatives said that other women have asked them about their work, which was basically absent in Gania.

Concerning the question of empowerment, it emerged that in Gania women are hardly organized. This could be seen as a prerequisite for developing a gender-sensitive point of view, and to be able to pressurize the representative to introduce issues important to them. There used to be some Mahila Mandals in Gania, which originated mainly from efforts of the government in the late 1980s. But in the villages where I conducted more

intensive research, these Mahila Mandals were all more or less defunct. The stories related by the women on why there was no Mahila Mandal in their village anymore resembled each other. It mainly happened that one member did not pay back a loan and the means of social boycott were not strong enough to force them to do otherwise. As a result, the Mahila Mandals collapsed and women ceased to meet. Apart from the women's groups, there are not many locations or situations where women can or do meet. Better infrastructure, especially through the provision of tube-wells in the vicinity of the houses, accounts for the fact that women do not meet anymore for the fetching of water. In Gania, only one event could be observed in which all the village women, with the exception of the SC-women, met. There was a big gathering that took place for the *Mangalvara-puja* as I have already mentioned earlier. During this *puja* women were busy with the ceremony only. Also while going there and coming back the topic of talk was mainly about the religious function.

Women did not attend other public functions, such as the *Rama-katha*, *Hanuman-katha*, and singing in the evenings, which were taking place during my stay. Thus, women normally only meet when they visit each other at home. Then the well-being of family members and things related to the household are the main topics of conversation. Several women (predominantly from a middle or high-caste background) told me that village matters—especially those concerned with politics—are not discussed. They gave as reasons for this their lack of interest towards such topics, but also the remark that these are 'male' topics frequently came up. Thus, women have no space to deliberate about certain matters, and most women outside the PRI voiced that they do not have much interest in such issues in any case. Another problem is the fact that the village communities are very much segregated on caste-lines. In the *Mangalvara-puja*, SC women were not included. In the more private gatherings taking place at home, caste plays an even more dominant role. Normally only women from the same caste or even clan meet at home, and cross-caste visits are reportedly very rare.

In Balipatna, the situation is different to the extent that the NGO has organized several vibrant women's groups. However, as we have seen, even if such groups exist, it does not necessarily mean that the meetings are used as a forum in which to discuss political matters. Women are busy dealing with the financial transactions, and these are considered to be more important in any case. It became obvious that women participating in these groups become more vocal; they gain confidence because they can leave their home for the meetings. Furthermore, they feel that they get more respect because they contribute to the meagre resources of the household. However, in several discussions it came up that the major advantage was seen in the material profit. Women frequently stated, for example, that they benefited much more from the women's groups than from the PRI—but this gain was only seen as access to precious cash resources—which is, however, fair enough—and not as having a space in which to develop one's own ideas or talk about problems faced collectively.

In an interview with Pramilla, the secretary of the *Mahila Sangatan* in the remote GP who was the naib-sarpanch in the 1992 PRI-election, she said:

I liked to be the naib-sarpanch. Before my election I had not left my house. Around the same time I became the naib-sarpanch I also joined the women's group organized by the DSS. I did not run for this election because I am too busy with the *Mahila Sangatan*, and I do prefer this kind of work. I also do not go to the sarpanch or the wardmembers anymore because now I can do things on my own. And I gain much more through the women's group. The DSS has done much more for the villagers than the gram panchayat!

Other women also voiced that the DSS has done much more for them after the cyclone than their wardmembers or sarpanch. They do not appreciate that the NGO had access to international help, whereas the PRI-representatives were dependent on contributions by the state government and the co-operation of the bureaucracy.[9] However, they were right in so far as corruption definitely hampered the official distribution network. Yet, one problem for the representatives in the PRI was the fact that the Election Commissioner issued a decree that relief was not to be distributed by elected representatives during the Assembly elections in order not to influence the voters. The PRI representatives had previously been instrumental in getting relief material to the needy population. That now the administration should only distribute the relief material overburdened them. The whole relief operation was marked by incompetence of the administration as well as the political representatives. There was allegedly heavy corruption. However, the situation for the Orissa state machinery was also very difficult. Additionally the national BJP-led government in Delhi did not declare the cyclone a national calamity which would have brought more financial resources. People allege that this was due to political considerations since at this time Orissa had a Congress government.

To sum up, in both regions it appears that the most perceptible positive impact of the reservation for women is in terms of symbolic recognition. It fills the village women with pride that now other women are going out to participate in public affairs and some want their own daughters to join in the future. What should be emphasized here is that the female representatives are seen as 'women' who are now going out and contributing something in the public sphere. The social background of these representatives does not matter according to this perspective. In Gania, it appeared, however, that some women representatives are distanced now from the female constituency. Still, definitely the symbolic recognition works for women as a group, which is empirical proof of the thesis that women are indeed a social group with at least some interests in common.

[9] In this point co-operation is not always there. When I visited the block office in Balipatna in the beginning of January 2000, several sarpanches were present and argued with the BDO to release the relief-material that was stacked in the office. The problem seemed to be that the amount was not sufficient and there was no regulation relating to which panchayat would get how many blankets and so on.

The second point that emerged is the fact that village women now feel that they have access to their representatives. This is very important, even if women might not make use of it yet because they might still believe that they have nothing to say on politics. The reason seems to be that village women do not see themselves as being responsible for contributing to the functioning of the Panchayati Raj, and politics is still understood as a male prerogative, unless one is involved in the Institutions directly. A further problem is the perception that the women representatives are part of the male world now and have distanced themselves from the female population. Most village women remain very critical about the PRI as such, no matter if a woman or a man represents them. They perceive the participation in credit and savings groups to be more rewarding because supplementing financial resources is valued very highly. As the women's groups are not fostering gender-awareness, they are not serving as pressure-groups yet. In this respect, empowerment of women as a group has taken place only to a rather limited degree so far.

Even so, one should not underestimate this change because it also proves that women in both regions, despite differences among them, do value the symbolic recognition as well as the new access to their representatives. This process still has to be supported by other processes if the stated goal is the improvement of women's overall status and empowerment in the long run. Thus, from the women's point of view, there are perceptible advantages emanating from the women's quota, even though their material situation has not become much better through this legislation so far. More positive developments could ensue if vibrant women's groups are fostered which also work as pressure groups on female representatives.

Perception of Men on Female Representatives

In what follows I shall not only look at the perception of men in regard to women's empowerment, but also examine how they evaluate the performance of the female representatives and what they think in general about women in politics. Men's perception is crucial for the empowerment of women, as men have to contribute to this process. In the preceding chapters it was established that women are still very dependent on men in various ways—most still need male support to function effectively. If men were hostile toward the reservation, it would be more difficult for women to make an impact. Additionally, the support of bureaucrats who are still mostly male (compare Pattnaik 2002) is crucial because they are usually the ones who have greater knowledge about the rules and procedures and can support women in becoming effective politicians—or obstruct their progress. In this section, I shall draw on statements made during several village meetings and in interviews conducted with male representatives, influential male villagers, and officials. First, the evidence from Gania will be presented, then from Balipatna.

1. Meeting in Shakuntala's ward in a village of remote GP in Gania on 3 February 2000:

We decided for Shakuntala because she is the most capable of the village women

here. And she is doing the work now, and we are getting the benefits. In the beginning she was not very active, but we made her active. We pushed her, accompanied her, and saw to it that she is opening her mouth. It took nearly three years to get her to the stage she is at now. Now she is as good as a man! It was worth our while to support her and make her active. You see, there was no woman interested in running and she came forward only because we pressed her. Actually nobody wants to become the wardmember. People pester you with all their demands and you just cannot fulfil them all. Then the people become angry with you. So, most men also do not want to become the wardmember.

I asked if they would elect Shakuntala again, as she is willing to serve for a second term, and they have just stated that there are not many people who are willing to become a wardmember. Most of the villagers stared at me in bewilderment.

We will never elect a woman if we are not forced to do so! Look at our women. They cannot go anywhere. If there is some problem or meeting in the evening, they cannot go. For everything we have to support her. But a wardmember should support the village, not the other way around. And look at her how she is sitting here, covering her head and looking with big shy eyes. No, we are very happy that there will not be a Mahila seat here for the next ten years. We think that this reservation for women is a wrong decision done by the government. Women should not get involved in politics. There is no opportunity for women to decide on village matters and they are also not able to decide. Lack of education is the main problem. And then women are shy. Women are not used to going out—and this is our tradition. We won't change. And if the women change—who will do the work?

2. Meeting in Kali's ward in a village of remote GP in Gania, on 23 February 2000:

You see, the people we elect are only interested in their own benefits after election. We have proposed many things to her, but nothing has been done. However, she is much better than the previous wardmembers. Better than the lady, who was elected for two years, but also better than the male wardmember we had before. He was very lazy.

3. Meeting in Bidyut's ward in a village of headquarters GP in Gania, on 5 February 2000. Bidyut is a *c.* 35-years-old Gauda; she is married, has four children, is a *bahu*, and visited primary school:

We feel that the reservation for women is really bad. Women just cannot handle the situation. If a man is saying anything to them they get quiet. That even holds true for the sarpanch. Women are just not used to going out and speaking in front of males. . . . Our wardmember is good for nothing. She sits in the back and gives her signature only. The same holds true for the sarpanch and even the samiti chairman—they are all not very capable. If somebody shouts at them or is using foul language they are unable to do anything. . . . However, Bidyut has improved. She is participating more now and she has also become more vocal. In case ill-fate strikes us and we have to choose a lady again as a wardmember, we will choose her.

Regarding whether women should be in politics at all, the opinions are split. One SC-man is absolutely against women in public bodies. A member of the Gauda-community on the other hand says:

Women are now more like men. They are in jobs and services; they go to the university, so why should they not be in politics as well? However, here in our villages we are against reservation. We oppose the reservation because there are no educated women here. There is no woman in our village who is a matriculate.

4. Interview with the president of an NGO in headquarters GP in Gania, male OBC (Teli), where Lita is the sarpanch, on 8 February 2000:

Nobody is actually in favour of the reservation and many people think that especially the reservation for SCs and STs as well as the one for women are used for political manipulation. Like you give the Mahila seat in a constituency where there is a strong opponent of your party. People here were especially angry that their sarpanch has to be an SC-lady because we are the headquarters panchayat. The sarpanch here has to deal a lot with the officials and a woman just cannot do the work. Lita is not always aware that she is the sarpanch, her small children keep her busy and she has to do a lot of household work. So, she is not doing enough. In my opinion the biggest problem is the combination of a reservation for women who are SC. There are no educated women in this caste group. The quota in the quota is a very bad thing. If we have to elect a woman, she should be educated. There is this sarpanch in Daspalla. She is from a general caste, she is educated, and is performing very well.

I reminded him of a sarpanch with high-caste background in his block who is a mere proxy to her husband.

You are right, the sarpanch from A* is from a general caste, but her husband is doing everything. Thus, women have to be educated and also to be able to speak in front of others. And training them does not help much; they do not understand it anyway. Here in Gania nobody depends on the sarpanch. If you want to get something done, you go directly to the BDO. The GPs who have women-sarpanches do face problems in the samiti as the men can shout louder. However, as Gania is the headquarters panchayat they do get their share. . . . Gania as a block has also problems because the samiti chairman is an SC-woman and she is good for nothing and does not know anything and is lazy. I believe that the person should have a good and respected family background as people give more respect to established families. Kanchana was a labourer before, working on her field. It is very difficult for such a person to deal with a first-class OAS [Orissa Administrative Service] officer. You need a good background and education to deal with them. Earlier, we used to invite the samiti chairman to inaugurate functions or training programmes of the NGOs. But nobody invites her now.

Asked whether the previous male chairman was highly educated, he says:

Actually the samiti chairman before was also not very educated. He had a Personal Assistant who helped him, so he could do the work. And as a man he could speak in front of others. I think that next time there will be more contestants for the Mahila seats. Earlier there was less money coming and no travel allowance for the sarpanches. They also can take some money from different sources. As there is no Village Committee in Gania, the wardmembers can also get something out of it. So the main incentive is the money one can make while being elected.

5. Interview with the BDO in Gania, OAS officer, Brahmin, MA in History from Utkal University, on 25 January 2000:

The problem with the reservation is that there is no minimum educational

qualification. So the elected people are illiterate and not informed. Look at the samiti chairman here. She is supposed to be at the apex of the block and is the one to decide and she does not even understand English. Especially if seats are reserved for SCs or STs, there is a big problem. How can India develop if unqualified people are ruling it? My predecessor was a gold-medallist from Utkal University in English literature and got himself transferred when this samiti chairman got elected.

6. Interview with medical officer of Gania, general caste, on 6 February 2000:

With women in the PRI here in Orissa, it is like in Bihar with Laloo and Rabri Devi.[10] Women here do not know what to do. Somebody like Sushma Swaraj[11] can be effective but not the rural women here. They have to be educated first. They should know how to face the people, how to talk, and how to solve the village problems. The women here do not even know how to run their homes efficiently. The men actually also do not know. And if people do not understand the problems, how will they be able to solve them? It will take at least half a century or more until they can be effective, and this will only happen if the population is educated and aware. You see, people here are like animals—they are eating and producing and there is not even much to enjoy for them.

7. Interview with the panchayat secretary of Gania headquarters GP, SC (Keuta); he is the PS since 1988, on 26 February 2000:

Our sarpanch Lita is actually not able to do many things and she is also not putting the demands before the samiti. Her predecessors were calling village meetings to discuss the problems of the panchayat but she is a woman and cannot do this. She is also not going to the office regularly and I often have to go to her home to bring her the files. Sometimes I also have to accompany her to the block office so I have much more work than I used to. The other sarpanches worked more independently, but she needs help from others. In the beginning she also did not want to talk to me because we live in the same *sahi* and I am senior to her. She was troubled by this and only started talking to me after some time. I actually do not have a problem with the fact that she is my boss, but she should be more efficient. I am not against the reservation but capable women should come forward, like the sarpanch in Daspalla. She is well educated and can act independently.

8. Meeting in Rita's ward in a village of headquarters GP in Balipatna, on 14 March 2000:

Before the cyclone she did nothing for our village and we men did all the work. After the cyclone she got the chance to do something for her ward, but she did not do much. Well, men also could not do much in the face of the cyclone and the problems afterwards, but still women do not have leadership qualities. And they are also not educated.

[10] Chief Minister of Bihar since July 1997; wife of ex-CM Laloo Prasad Yadav. Following Laloo's arrest in a Rs. 1,000 crore (approx.) corruption scandal (the fodder scam), Laloo Yadav resigned his post and named his wife Rabri Devi as his successor.

[11] Member of the BJP from Delhi; among other offices she has held, Sushma Swaraj was a member of the Union Cabinet from 19 March to 12 October 1998, Chief Minister of Delhi from 13 October to 3 December 1998, and member of the 12th Lok Sabha.

Asked about the male wardmembers of the neighbouring ward they did admit that he is even worse.

One advantage of women is that they are less corrupt. The male wardmember kept a lot of the relief for himself, whereas our female wardmember came and asked the people about their needs and distributed the relief material. One positive point about women is that they are less corrupt and if these women are active we have nothing against women in politics. Rita as an individual has certainly gained from being a wardmember. She became more vocal and learned a lot. But still, first educational requirements should be met and men have more education than women. However, without the reservation no woman would come forward. This is because of the conservative attitude here which puts a lot of pressure on women. Women here are not free to move and decide. So maybe this reservation policy now can lead to social change.

One lecturer from a private college in Banmalipur said:

Whether the reservation for women in the PRI is good or bad depends on the perspective. From a political point of view the reservation for women is good. It gives them a chance to participate, to go out of their houses, to learn new things. It will give them a new consciousness. And it was solely for political gains that this law was passed. But if we see it from a service or development point of view it is bad. Women cannot function efficiently because ours is a very conservative society. You know that we only educate our sons. So most women are not educated and that makes it very difficult for them. Thus, the development of our villages will suffer because of this decision. However, there was not much protest here against this law. Only some Hindu and Muslim fundamentalists were against it because they do not want their women to come out.

9. Interview with a samiti member of remote GP in Balipatna, OBC, and a Congress Activist (Brahmin) on 27 March 2000:

Some of their statements were already referred to in the section on corruption. They said that women are not independent and are thus asked by male relatives to be corrupt. Most revealing was the remark below:

The reservation for women is good—now they get the chance to go out and participate. But the problem is that they are new and they have no idea about politics. Actually women are good, and not corrupt. But they are not independent. They are asked to be corrupt by their husbands, or sons, or fathers-in-law. What can they do? They cannot decide on their own, so they are dependent for every work on some male members. But it is bad that the women are taking money or asking for bribes. For a man such behaviour is acceptable, but not for a woman. . . . Only if the ladies become independent the system will improve. Years ago, before Biju Patnaik introduced the women's quota, women were only sitting at home, caring for the kitchen and children. But because of the reservation they are forced to go out now. In the beginning not many women were willing to do this, but in the course of time more women will come forward. . . . There is too much reservation in the PRI for SCs, STs, OBCs, and women. The problem is that the SCs are uncivilized and illiterate, and like women they are dependent for their ideas on others. So they are doing politics, but not with their own ideas but with the ideas of other people like the *chota netas* and *chamchas* who influence them. These people are utilizing them. If

they will become independent and work according to their own ideas, the working of the PRI will be much better.

10. Interview with the sarpanch (64-years-old Brahmin) of the headquarters panchayat in Balipatna, where Nita is the naib-sarpanch, on 22 March 2000:

Women are able to do everything if they get the chance, but they need education and training. The main problem for the PRI is that the representatives, men and women alike, do not know about the rules and regulations. The problem is the lack of training . . . and the other problem is that people are not committed to what they are doing. They do not have the right attitude. . . . Out of 19 members in this panchayat only four are really interested in the panchayat work. Three are men and the only woman is Nita. . . . The problem of women is that they do not have much time. They are housewives and have to look after their children, the husband and the parents-in-law. Most of the women do not have a voice and the husbands are against them moving around outside. They are afraid that they will become like Anjana Mishra[12] who is a loose woman. Husbands do not want to let their women go around because they have a conservative attitude. So if women being sarpanches or wardmembers cannot go out, why should they stand for election? But if they go out, they get the chance to learn something and to do a lot of good things. And they should go out, everywhere it is demanded now and women are coming forward in different areas, and I think that this is good. Look at Nita, she is eager to learn and performs well.

From the above statements one can gather several things. Generally speaking, there is no uniform 'men's' point of view. There were widely varying answers to the question of their view of their representatives and women in politics in general. Still, one can detect several patterns.

Most men were of the opinion that women representatives have gained through participating in the PRI. They admit that these women have become more vocal, that some became active, and that they even might be performing better than the previous male wardmember or other males in the PRI. Still, many are reluctant to give an overall positive statement. Most men still believe that women are less capable, that they are too shy, that social customs inhibit them, and that they are not educated. Even in a case where the women proved to be quite capable and willing to serve another term, villagers could not imagine electing her again except if they are forced to do so. Many claim that women should be present in the PRI, but they should first be educated. The problem is that there is a marked hiatus between a general acceptance of women now having a public role to play, like in high politics or in the service sector, and the promotion of women in one's vicinity. There is also a reluctance to change the traditional division of labour, as was perceptible from the villagers' remark that was taken also as the introductory quotation: 'We will not change. And if the women do change—who will do the work then?'

Also interesting is the distinction made by the lecturer from Banmalipur. He supports the reservation for women from a socio-political point of view,

[12] See fn 10, Chapter 4.

but believes that it is bad from the developmental perspective. He understands development mainly as rendering services to the villages. Some men seemed to be quite sympathetic to the inclusion of women but still complained about the limitations women have. In this respect, one can say that though the structural forces that relegate women into the private sphere are acknowledged, there is not much willingness to remove them. Such arguments are used rather as an excuse for why women should not be in politics and come without the commitment to really enable women to participate fully in public life. Educational deficits are only bemoaned in respect to women. That men also are not always educated seems to be acceptable because at least they are men. This is obviously taken as sufficient proof for their superior intellect and capabilities.

The standpoint of the officials is very significant as well. They are normally highly educated and delegated to rural areas, which do not offer many amenities to them and their families. They have problems in coming to terms with the fact that an 'uncouth' villager is actually their boss. Most do not have much patience with villagers and their way of life, and one gets the feeling that the officials remain rather aloof. Recall the harsh comment made by the medical officer who equated the villagers with animals, or the 'gold-medallist' BDO who got himself transferred. It seems that many high caste and educated persons resent reservation in general, be it for SCs, STs, or women; the quotas are blamed for being the ruin of the country. As one could also see from the interview with the president of the NGO, the sub-quota for SC-women is regarded as very problematic. However, we witnessed in the case of Nita, the naib-sarpanch from the headquarters panchayat in Balipatna, that if men are supportive, as in the case of the sarpanch and her husband, women can become very effective. Thus, men need to become partners in the endeavour to empower women; otherwise it will be very difficult to do so. Yet, one can gather from the statements given above that there is a long way to go and that traditional perceptions do not change overnight. It seems, however, that some capabilities of women are acknowledged and that, though grudgingly, the male population does attempt to deal with the new role for women. As with the call for support of women's groups, also men need to be included in the efforts of gender-sensitizing activities. Officials especially should be made aware of the new role of women, and of the role of the elected representatives in general. As long as villagers are seen more as obstacles rather than partners in rural development, the PRI will face problems in becoming effective agents of rural development and social change.

Restrictions Resulting from the Framework

IN THE PRECEDING chapters I examined how women became present in the Panchayati Raj Institutions (PRI), to what extent they can and do exercise power, and what repercussion this had on the empowerment of female representatives and of rural women as a group. We have listened to the voices of the women and men concerned and drawn several conclusions. Before I presented the empirical evidence from the case study, the framework of the PRI and women's status in Orissa was described. I shall now consider how this particular framework impinges on the process of women's political presence and empowerment in the PRI of Orissa. The focus lies on those structural properties which were found to work against effective political presence as well as against the empowerment of women. I shall also deal mainly with the particular problems of the present case. The relevance of the findings for the theory of political presence and empowerment will be discussed in the final chapter. Below, I will consider first the dilemmas emerging from the structure of the Panchayati Raj System as such and then the constraints that result from women's status in rural society. Wherever possible, I will make suggestions on how problems could be overcome.

RESTRICTIONS RESULTING FROM THE STRUCTURE OF THE PRI

As I have argued, the representatives' room to manoeuvre is restricted by the institutional framework of the Panchayati Raj and the general political system as such. It sets certain limits that might work against an efficient political process and also against the empowerment of women. Here, we shall consider three main issues, which emerged from the interviews and from observations during the field research. They consist in the method of the delineation of constituencies, the role of political parties, and the lack of command over financial resources.

Delineation and Rotation of Constituencies

It is argued that countries that have multi-member rather than single-member constituencies offer more favourable conditions for women politicians. Anne Phillips believes that this is mainly because it looks more obviously indefensible when parties draw up a list of candidates on which only males appear (1995: 59). However, there are other reasons why multi-member constituencies are more favourable to women's participation and empowerment.

In the Indian case, the electoral system is based on single-member constituencies. A portion of these constituencies get reserved for specific sections of the population and rotate in subsequent elections. The quota does not operate through the party system, as assumed by Phillips, and political parties are banned in any case from the two lower tiers of the PRI in Orissa. Also in states where parties participate in local-level elections, as for example in West Bengal, the quota is secured through the reservation of constituencies and not at the party level. Such a system has several major drawbacks from a theoretical but also empirical point of view, and this became obvious during the field research. It should be noted that the problems analysed here are not restricted to Orissa only but are general in nature.

The first problem concerns the question as to what extent female representatives can promote 'women's issues' in a set-up where they are elected to represent all voters in their constituency. As wardmembers, they are elected from a geographical unit that might be homogeneous in respect to caste and social standing, but at least with differentiation between men and women. The higher the position, the more complex the electorate is in respect to caste, class, and religion. How can a woman representative therefore work solely for women in a geographical unit populated by a great variety of people? Does she not have to represent her ward, her gram panchayat, her panchayat samiti, or zilla parishad?

During talks with female representatives of the PRI not only in Orissa, but also at a workshop in Delhi,[1] this dilemma became clear through the remarks by various female representatives. Most answered in the negative when asked whether they see their mandate as that of representing women. They argued instead that they are not representing women in particular, but are working for their constituency. In cases where parties are officially operating in the PRI, like in West Bengal, female representatives additionally voiced a strong allegiance to the party programme. And what answer can a politician give whose constituency is populated by all kinds of people and where maybe none of the politically salient sub-groups of a given society commands a sizeable majority? Even in the case of women, who constitute around half the population, it was argued that women might not converge on all subjects or that they are not able to communicate issues that could then be taken up by female representatives. However, this problem holds for all political systems and quota regimes. It also holds for other social sub-groups based on caste or religion. There is no way to establish that all Scheduled Castes (SCs) or Scheduled Tribes (STs) always have common priorities. But we shall turn to this problem specifically in regard to women in the final chapter. Let us remain with the issue of the delineation of the constituencies.

For a representative to proclaim to represent the point of view of any social sub-group (especially if this sub-group is not very influential) is close

[1] I participated in a National Workshop on 'Women in Panchayati Raj' on 27–28 April 2000, organized by the Konrad Adenauer Foundation and the Indian Social Institute in Delhi.

to committing political suicide in single-member constituencies. And most of the women in the PRI have already realized this important rule of the political game, whether or not they started their political career with the wish to work for women. To exemplify such reasoning, I refer to an instance already related. Recall the answer of Lita, the sarpanch of Gania, to the question of whether she has initiated anything against liquor consumption in her gram panchayat. She replied:

I would really like to do something about this, but I am helpless. In case I am doing anything against the selling and drinking of alcohol, who will support me in the future?

I have argued that since Lita wants to become re-elected again, she cannot work against the wishes of the influential persons in her constituency, and there is no sizeable majority that would support her on this issue. Thus, her hands are tied, and she has to succumb to a pragmatic point of view. Pressure from an organized women's movement that would influence the male members of the community to forge a consensus on this topic could help her out of this dilemma, but in the given situation she behaved as most politicians would. To antagonize the majority of the voting population is a bad recipe for re-election, which is after all one of the major goals of politicians.

A second problem of the quota regime operating in a political system with reserved single-member constituencies is the fact that the voter's choice is limited to a much greater degree than in multi-member constituencies. Additionally, politicians who wish to serve the community might be prevented from competing for political office. This poses a serious dilemma from the point of view of democratic theory, but also for the people concerned. The resentment voiced mainly by male villagers at being forced to elect a woman has already been referred to extensively and needs no further elaboration. But here I want to stress that this grudge makes the life of the women politicians even more difficult. That a population is forced to vote for somebody they would under other circumstances not elect makes the representative very vulnerable and prone to all kinds of criticism. She constantly has to prove that she is actually better than another (male) candidate would be, and even if she were to succeed, her constituency would still be unhappy that they had been compelled to this non-choice.

A third problem is that motivated citizens who want to participate in the election are prevented from doing so. That this actually has happened becomes obvious in the following statement given by a male Other Backward Class (OBC) samiti member in the remote panchayat of Balipatna Block.

The position of a samiti member is politically very frustrating because we have no power. Our only function is to elect the samiti chairman. The samiti chairman and the sarpanches hold the main power in the system. But I could not compete for any other position. In my area the position of the sarpanch, the samiti chairman, and the zilla parishad member were all reserved for women, and the seat of the MLA is reserved for an SC. So, the position of the samiti member was the only one that was open for me to contest.

In this case the concerned individual could not participate in the election to an office he was interested. It was an extremely unlucky coincidence that all except one position was reserved for social groups to which the OBC-man does not belong. Thus, the problem of this mode of reservation is that it might frustrate potential candidates and it actually debars them from competing for political office.

A fourth problem concerns the rotation of reserved constituencies. Because elections are organized in single-member constituencies, the legislature did not want to block constituencies for successive elections for general competition and, therefore, decided on a rotation of reserved seats. It has been noted frequently that this is especially problematic for women since so far very few can imagine running for a general seat and would accordingly be thrown out of office after one term. Hence, the rotation of seats hampers women in acquiring political experience and knowledge in successive terms and introduces novices in every subsequent election. Suggestions were made that women's constituencies should not rotate at least for two consecutive terms to prevent this. However, such a system would compromise even more the choice of the electorate, which is not enthusiastic about electing women for one term only, and debar other interested citizens for an even longer period. Considering this, there are certainly some valid reasons for the provision of rotating constituencies.

Concerning women, one could hope that after some time they would start contesting unreserved seats which would at least solve the problem of them being forced out of office in every consecutive election. Still, another problem would persist: This is not only in connection to women, but has a general relevance. Rotating constituencies give less incentive to politicians to care for their constituency because they might be up-seated in the election to come. If a politician can be sure that s/he has no chance of becoming re-elected in any case, the incentive to be corrupt and accumulate wealth in one term is even greater. Furthermore, committed politicians who did a lot for their constituency are forced out of office, which is frustrating for them as well as for the population concerned.

Most of the problems mentioned above could be solved through the provision of multi-member constituencies, as for example practised in Germany. There, voters in communal elections are presented with a list of candidates drawn up by competing political parties. In such a system one can secure, for example, that every third candidate listed would be a woman, and then the voter may pick and choose. The result may not be exactly 33 per cent of elected women, but a higher number than obtained without reservation is definitely secured without restricting the voter's choice to such an extent as in the Indian system. The same procedure could be followed concerning the reservation for SCs and STs.

In such a system, women—if they wish—could voice their interest in specifically women's issues more easily because they do not need the majority of votes to get elected. For example, if 10 members were elected from one area, 10 per cent of the vote would be sufficient to get elected. Thus, if a

woman succeeds in getting support from 20 per cent of the women only, she can still be successful in getting elected, and, moreover, the interests of minority communities are better secured. This, however, presupposes that women become autonomous in their voting decisions.

The provision of a list in multi-member constituencies would also solve the problem of denying access to interested citizens to participate in the election. Restricting access and the choice of the electorate is a feature of every quota-system to a certain degree and is in general a price to be paid for affirmative action. However, one should not forget that restriction of access because of structural reasons and exclusive networks is also working under non-quota regimes, which actually was the basis of the unbalanced representation of women in the first place. Nevertheless, the price of a reservation policy is much lower in multi-member electoral systems, where people are not restricted to participate only because their geographical location coincides with a reserved constituency. In regard to the reservation of important offices, which is necessary if one subscribes to the view that it not only matters how many members of a certain sub-group are elected, but also which positions they hold, there is no easy solution. Still, in multi-member constituencies one would at least not be denying men from a certain village to compete at all since several seats would still be open to them. Also, if one could ensure that parties draw up lists in which several groups like SCs, STs, and women must appear, the MLA constituency would not have been out of reach for the samiti member of our example. Last, but not least, not rotating multi-member constituencies would solve the fourth problem. In such a system, politicians who care for their constituencies could be rewarded with re-election, while those who indulge in corrupt practices would be punished. Furthermore, well-performing women would have better chances to get re-elected more easily.

The introduction of an electoral system based on multi-member constituencies would change the political landscape of India in numerous ways and not just at the local level. It is a vision that requires serious commitment, and India might not be willing to uproot its political system, which is in many respects working satisfactorily since independence. One also has to mention that such a political system is rather complicated and would call for training of the voters. Furthermore, multi-member constituencies increase the problem of covering large distances that is especially faced by women, since the area served is potentially bigger. Thus, if the call for rearranging the electoral system into multi-member constituencies happens to be considered too demanding or 'non-Indian',[2] one should at least follow the suggestions made by Narayan and others.[3] The authors are actually concerned with the reservation for women at the national and state level, but the same arguments

[2] However, the present electoral system is basically British and not indigenously developed.

[3] For this and more details, see Narayan et al. (2000). It is a very interesting document with many useful suggestions. For an earlier interesting article on the reservation for women that goes beyond the mere quotas, see Kishwar (1996).

could be used for the PRI as well. In the '*Alternative to the Government Bill for Women's Reservation*', they propose that reservation should be introduced at the level of political parties and not at the level of constituencies and, thus, that no rotation would need to take place. To ensure an even spread of women candidates and to prevent parties from nominating women only where they have fewer chances to win, they propose to constitute units of three contiguous constituencies, in which one of the candidates filed has to be a woman.

Whatever solution may seem more attractive or feasible—there should be a serious discussion in India on how to redesign her quota-regime. Otherwise the undeniable positive effects of affirmative action might be compromised by preventable side-effects resulting from the mode of reservation and not from the reservation as such. As we have seen, both suggested solutions would allow political parties to operate in the Panchayati Raj elections.

Role of Political Parties

In India, the role parties should play in the Panchayati Raj Institutions has been extensively debated. There are those who argue against the involvement of parties in local-level politics, following the tradition of M. K. Gandhi. The problem is—whether one appreciates it or not—parties are present in the PRI also at the lowest level.[4] Wherever there are elections, parties will be involved in one way or the other. We have seen that the MLAs are quite interested in local-level politics, and they try to place their associates into important positions. Even where local-level politicians are not official members of political parties, they are influenced by, or are allied with, higher-level politicians. Since participation in local politics is also seen as training camp for politicians who aspire to higher offices, eager rural politicians need to forge links with state and national-level politicians. Thus, one should accept the 'power of the fact' and accordingly allow political parties to operate officially in the PRI also in the lowest tiers.

It seems true for some gram panchayats that political parties obstruct the smooth working of the institution because opposing factions disable each other. I have related one instance from a gram panchayat in Balipatna Block where this was the case. In other cases, followers are nurtured, while foes are neglected. However, this situation exists even without acknowledging parties at this level. The recognition of parties to file their candidates also at the gram panchayat and panchayat samiti level would legalize an already common practice. It would also be the best practice for a multi-member constitutional system as well as for the proposal made by Narayan et al., in which the quota is supposed to be implemented by the parties while drawing up their lists. Parties who fail to file the sufficient number of reserved seats could be expelled from competing for votes or punished in other ways.

[4] That was already established by Bhargava (1979) in the surveyed district of Rajasthan. See his Chapter 8, where Bhargava argues that political parties are already a reality in the PRI (p. 232). A classical article on parties in the PRI is Weiner (1962).

Letting the party system operate freely in the PRI does not foreclose the possibility that independent candidates will be successful. One would only need to secure that if the quota gets implemented through political parties, that the elite does not evade this rule by running as independents and joining their parties again later.

Another factor mentioned is that Panchayati Raj elections were frequently postponed by the state governments. This happens mostly when the party in power at the state level assumes that opposition candidates will fill the PRI. This could be used as a counter-argument against parties in the PRI since the incentive to bar opposition parties would be even stronger. However, as postponement of elections also occurred when parties did not operate in the PRI officially, nothing would be lost by this move. Furthermore, the very implementation of the 73rd Amendment prevents state governments from postponing elections eternally.

A further beneficial effect of introducing parties at this level would be that they will take over the responsibility of training the new entrants into local politics, a fact which had already been proposed by Bhargava (1979: 410). It would enhance the transfer of knowledge since the parties would be eager to see their candidates informed. During the field research it became evident that the state of affairs in respect to training is far from satisfactory. Political parties could fill the crucial gap between the need for training and the availability of resources and state personnel.[5] The very lack of financial resources, which is not only in regard to training, will be our next theme.

Lack of Control over Financial Resources

There is extensive literature on the problem of bottlenecks in rural development created through the lack of financial resources, and requires no further deliberation.[6] However, it is not only a question of how much money the local bodies actually command, but also of how free they are in spending it according to their preferences. The 73rd Amendment provided for the institution of a State Finance Commission (SFC) to decide on the allocation of funds to the PRI (GoI 1992: 243-I). The State Finance Commission of Orissa, constituted on 1 November 1996, submitted its report only in December 1998, nearly two years after the elections to the PRI had taken place. It states that, generally speaking, the local bodies in India have never been and perhaps will never be financially self-sufficient (State Finance Commission of Orissa 1998: 17).

Local resources come from fees on weekly *haats*, ghats, selling of fruits from orchards, leasing tanks for fishing, vehicle and entertainment tax, etc. In Orissa, the income of the gram panchayats from its own resources is only ten per cent (ibid.: 74). The mismatch between expenditure responsibilities

[5] For the enormous amount of persons to be trained in the PRI and the lack of training infrastructure in various states of the Indian Union, see Pal (1994).

[6] See for example KAS (1998a, 1998b). For the financial status of the PRI in a comparative perspective, see PRI and NCRSOs (1999); for an analysis of several Panchayati Raj Acts concerning financial aspects, see Vithal (1997).

and revenue raising capacity was aggravated following the allocation of extensive developmental functions to the PRI in the 73rd Amendment Act. A system of transfer from the Consolidated Funds of the state to the local bodies is applied to close the financial gap. In Orissa, the PRI receive grants for various purposes from schemes sponsored fully by the Central government or jointly by the Central government and the state government. This money is tied to specific undertakings, and the PRI may only decide where this money should be spent and who would be the beneficiary. Thus, for the representatives and village communities concerned, the room to manoeuvre and to decide on development priorities is extremely limited. That is also why we cannot expect major policy changes as a result of the election of women. If the scope for change is limited due to the structure of the PRI one has to lower one's expectations concerning the difference women can make at that level.

The total amount proposed by the SFC to be devolved from the state government of Orissa to the local bodies is around Rs. 126.31 crore per year. The Joint Secretary for Panchayati Raj of the Central government, in a letter to the Panchayati Raj Secretary of Orissa, has noted various problems with this recommendation.[7] She was critical of the fact that this amount includes the salary for the staff of the gram panchayats and panchayat samiti, which is shown together as amounting to Rs. 88.88 crore (more than 70 per cent of the proposed sum). She asks if the PRI have any kind of control over these personnel. She cites a paragraph in a letter, which she received on 30 April 1999 from the Panchayati Raj Secretary of Orissa on the recommendations of the SFC. This letter states that

. . . the salary expenses on account of this post are fully born by the state government and as such these are not treated as grants to Panchayat Samitis. There is, however, no doubt that these expenses are borne for the proper functioning of Panchayat Samitis and should, therefore, be treated as expenditure for them.

The Joint Secretary also rebukes the fact that the Government of Orissa is violating the law because no mention of the *Panchayats (Extension to Scheduled Areas) Act, 1996* is made. This document lays down certain rules for panchayats located in Scheduled Areas which are areas mostly inhabited by *adivasis*. Several districts in Orissa belong to this category. In Scheduled Areas, the gram panchayats and panchayat samitis are supposed to be vested with the ownership of Minor Forest Produce, which was disregarded by the SFC of Orissa.

Through this document it becomes evident that salaries mainly eat up the amount that is supposed to be devolved to the PRI in Orissa, leaving not much untied money for the development priorities of the local communities.

[7] See a letter (D.O.NO.N-110111/20/98-PR, 1999) written by Ms Sudha Pillai, Joint Secretary, Ministry of Rural Areas and Employment, Dept. of Rural Development, to Mr Chinmay Basu, Commissioner-cum-Secretary, Department of Panchayat Raj, Government of Orissa on 13 May 1999. She gave a copy of this letter to me in a personal meeting on 26 April 2000.

Furthermore, money that is due to some gram panchayats and panchayat samitis, as according to law, is not distributed in the proper manner. Hence, the situation of the local bodies is marked by meagre self-acquired resources, which may be spent according to local priorities; grants-in-aid by the central government, which are tied to specific projects; and devolved funds from the state government, which are not substantial enough to carry out development projects according to local needs. Regulations that panchayats may levy taxes on specific items exist, but there are two problems involved in this regulation. The first is that the resource base is rather small, and the population might not be able to pay those taxes. However, even if the tax could be paid, it is problematic that the panchayat representatives can decide whether to levy the tax or not.[8] Paradoxically, the freedom of local decision-making is problematic in this case. In an interview in Angul District, a female sarpanch said that she wanted to impose a bicycle tax, but the constituency opposed this, and so she gave up her plan.[9]

If the meagre resource-base is considered as well as the fact that finances are tied to specific programmes, one can understand why representatives did not offer many suggestions—apart from the ones already formulated by the higher-level agencies—when asked what they would wish to do in their constituencies. We have also seen during the discussion on the performance of the grama sabhas that only issues pertaining to government programmes were talked about and that not much initiative for a formulation of local priorities was taken. Financial dependence on the state and Central government compromises imaginative and locally originating development priorities that are not already formulated by the higher agencies. The very value of decentralization, namely, the employment of local creativity, active conceptualization, and planning, are stifled in such a system.

If empowerment is supposed to take place, the representatives in the institutions, as mandate holders for the local population, have to be financially empowered to implement their priorities. For this, there has to be local control over financial resources, which was shown to be very limited. In this respect, apart from augmenting local financial resources as such, one should think about devolving more untied funds to the local bodies. These untied funds would give the political bodies more power to invest in locally formulated policies—provided that routine duties are fulfilled and that a system of accountability is in place. Furthermore, village communities should receive training on how to develop long-term plans that take into account local conditions. The training should also enable the village communities to monitor the political and administrative agencies, and to press for

[8] I mentioned that the District Collector can order a gram panchayat to levy taxes. However, as it is not institutionally fixed it does not really solve the problem. Furthermore, this regulation gives too much power to one official, who is not even democratically elected.

[9] I conducted this interview while I was visiting Angul on 14 December 1998 with members of the NGO Institute for Socio-Economic Development (ISED). This trip took place before I had finally selected the study area.

accountability and transparency. Decentralization of power will remain a paper tiger if it is not matched by a devolution of finances for the discrete use by the local communities and if it is not monitored by an active citizenry contributing to the planning process and demanding accountability.

RESTRICTIONS RESULTING FROM THE STATUS OF WOMEN

Clearly, the empowerment of the representatives is circumscribed by the structure of the political institutions. In this section, we shall look at obstacles in empowerment that result from the status of women in rural society. Whereas in the above section the focus was on men and women alike, here I shall stress the features that work against the empowerment of women. I concentrate on three themes: the dependence of women on men to perform well in politics—like the need for support or an escort to meetings; the general village and administrative discourse; and the lack of a real mobilization of women on gender issues in both areas.

Women's Dependence on Men to Perform in Politics

In the course of the case study it became manifest that women are in many ways dependent on male support to conduct their work in the PRI. In the village meetings in which the mode of (s)election was investigated, it was apparent that men often decided on the ground of whether the husband would support his wife in her duties as the village representative. Additionally, often male relatives were instrumental in nominating the woman of their household. Thus, most women did not get into the positions of power independently, and they are also mostly not independent from male support or command while serving in them. Here, I want to recall some of the most common features of this discourse, which have been already partly discussed in the chapter on the status of women and which emerged during the field research. Most of them can be captured with the concept of *purdah*, the epitomized segregation of spaces.

Women usually do not leave their house unaccompanied, especially after dark. Thus, male relatives—mostly the husband—care for the majority of duties that have to be taken care of after nightfall. This holds true for acting as arbiter in village disputes or for participating in informal village meetings taking place after the day's work is over, when the elder and/or high-status men discuss politics. But female representatives rarely address even meetings taking place during the day. They are also not seen in other places of debate and political discussions, like the *chai* shops and the bazaar. One reason for women's absence there is the presence of male villagers with whom the women have a fictional family-relationship. And this fictional relationship prohibits social intercourse with those men.

Additionally, many women are very reluctant to venture out of their homes alone, and if they dare to do so they become easy targets of character assassination. Thus, whether women have internalized the cultural shackles on their freedom of movement and behaviour, or whether it is imposed on

them through the threat of character assassination or even violence, it makes them dependent for most of their undertakings on men. Consequently, many women are accompanied to the meetings by male relatives. The situation is more acute in Gania because villages are quite dispersed. Here, women sometimes have to cover distances of 10 km to reach the panchayat office. They are not allowed and, most probably, would also not want to go alone. Hence, the problem of mobility is not only cultural, but is also aggravated by a structural feature of the PRI—that is, the size of the gram panchayats, which are organized according to population and not area. This leads to large constituencies in respect to area in less populated regions, which poses a problem particularly for women. As mentioned, already Rao (1977: 199) had complained about the big size of Orissa gram panchayats. Travel to more far-off places like the district or state capital are moreover out of question and are only undertaken with a male chaperon. If the husband or any other male relative are not supportive or available, the woman would rather stay at home.

The fact of restricted mobility and limited social intercourse greatly compromises the ability of women to act on their own and is, without doubt, a major constraint on their autonomy. It is furthermore very difficult even to formulate preferences autonomously, if one does not see much scope to realize these priorities. Also, women still do not have access to the informal male circles of power, i.e. the village meetings, where most things are actually discussed and decided. In this respect, women are often mere mandate holders as they can only echo the already decided policy of the village males.

All this puts an additional burden on the male partners and on the village community, who have to assist the female representative in many of her undertakings. And if they were not willing to do so, the woman would face severe difficulties. Thus, I frequently came across statements of village men who were unhappy with the performance of the female representative. They felt that they had to spend additional time in helping her, whereas there would have been no need if the representative were a male. Here, I want to recall the statement made by the villagers in Shakuntala's ward.

Look at our women. They cannot go anywhere. If there is some problem or meeting in the evening, they cannot go. For everything we have to support her. But a wardmember should support the village, not the other way around.

Nearly all men said that they would elect a man given the choice. Considering this, it does not augur well for the proposal to co-opt men, as argued by Chitnis (1988: 94), in the process of empowering women—because the men do not see that they could gain from this process, but rather appear to view women's empowerment as a zero-sum game.

On the other hand, it was also found that men extended their support to female representatives, and this was often crucial for their good performance. This could be seen, for example, in the case of Babita, the naib-sarpanch of the headquarters GP in Balipatna. Her very active husband, as well as the Brahmin sarpanch, both back and promote her. She could, therefore, acquire

a lot of knowledge and confidence, which contributed to her good performance. In some cases, the block office staff or the panchayat secretary was instrumental in extending help to female representatives. In these cases, the performance of women might be aided, but this does not change the basic tenet that they are dependent on men and are, therefore, more likely also to follow their wishes or ideas. Still, as mentioned in the chapter on the status of women, women perceive men often as partners, and, historically, men have contributed much to raising the status of women in India. The articulation of a potential clash of interest between husband and wife that is frequently found in the West is remarkably absent. Recall the instance in connection to the solving of village disputes: Women did not mention possible conflicting interests. I frequently encountered husband and wife teams that worked more or less in harmony. Both felt responsible and accountable towards the village community. All this can enhance the process of empowering women in the household and in public. Hence, the support of men does not need to be seen as problematic *per se*. What is, however, problematic is the compulsion and dependence—that women can rarely act against the wishes of their male relatives if they were inclined to do so. Thus, one should be aware that the remarkable silence concerning conflict of interests between spouses could be rooted in the lack of alternatives. What fall-back option do women have if they have a fight with their husbands? Most cannot go home to their native family, and there are hardly any state structures that care for single women who either have abandoned or have been abandoned by their husbands. In this respect, lack of open dispute and the appearance of an acceptance of their traditional role might not be fully internalized by women, but be also a result of lack of options to behave otherwise. Apparently only very singular personalities like Bimala, the sarpanch of the remote GP in Balipatna, have enough personal resources to swim against the tide. And it is especially for these women that the quota offers a unique opportunity space.

Apart from the support given by male family relations or officials, women can also get support from caste-networks. Interesting in this context is an instance I came across in Gania. I was spending some time in Lita's house, when she was suddenly visited by the male sarpanch from the neighbouring panchayat. I was quite astonished that he just entered the house and came into the kitchen, even though Lita's husband was not present. This went against all known conventions. The puzzle was finally solved when I was made aware that the male sarpanch belongs to the same caste and is actually junior to Lita's husband. So, he could address Lita as her younger caste-brother and did not have to approach her via the husband. In this case, belonging to the same caste gave Lita special access to some circles of power and made it possible for the other male sarpanch to approach her in an easy manner. Thus, a traditional institution regulating social intercourse can also serve for supporting women. The other customary resource I mentioned that mitigates women's dependence is the social concept of *gaanjhia*. *Gaanjhias* need less support than *bahus*, since they can move more freely in the village and also men can come directly to them and do not need to go via the

husband. That is why there was a stated preference to elect *gaanjhias*, especially in Gania block.

However, the general problem of women's restricted autonomy and dependence on others persists. So far, women do not command many independent resources to cope with the new situation and to start acting independently—they lack economic, educational, and informational resources. The case of Bimala who managed to defend herself even against a high official is rather an exception. Bimala was aided by her good education and remarkable personal autonomy. She always wanted to be a boy and also behaves like one (according to village mores): She drives a motorbike, addresses men and women alike in a carefree way, and is very energetic. Also, finances are still controlled by men to a large extent. Note the exception of the samiti member who planned to sell her own house to raise resources to become elected as the samiti chairperson—again an exception to the rule.

These structures of gendered behaviour and restricted mobility for women in particular are deeply ingrained in rural society. It will take a lot of time and also additional effort besides the quota in politics to change these structures. It will not happen as an automatic reaction to the inclusion of women into the PRI, even though the process seems to have been accelerated. Thus, the quota for women needs to be augmented by literacy programmes, by measures to improve women's economic status, and by general awareness raising methods. Also men have to be made aware that their support is crucial, although it might be difficult to convince the majority of them. The present situation does not augur very well for this proposition, as we shall see in the next section.

Village and Administrative Discourse on Women in Politics

In the section in Chapter 2 on women's status in the cultural framework of Hinduism, I have argued that there are two major role models for women—the dutiful wife and the mother. As regards Indira Gandhi and other high-level female politicians, the mother could have served to legitimize their powerful role. The ideal to be emulated by an 'ordinary' woman is more so that of the dutiful wife.

In village and administrative discourses, both concepts of femaleness were evident. Many men as well as women asserted that women command moral power, which led them to conclude that women would work against corruption or would at least not be corrupt themselves. It was also acknowledged that women can have a powerful role to play in politics or society, and allusions were made to Indira Gandhi or Sushma Swaraj. However, concerning one's wife or the women from one's own village, the dominant discourse prevailed. I want to recall here the remark made by the medical officer in Gania:

With women in the PRI here in Orissa it is like in Bihar with Laloo and Rabri Devi. Women here do not know what to do. Somebody like Sushma Swaraj can be effective but not the rural women here.

Rabri Devi is the epitome of the *pativrata*, who follows the orders of her husband and keeps the Chief Minister seat warm for Laloo Prasad Yadav, whereas Sushma Swaraj stands for the powerful, independent, and effective woman. Women in the local political institutions are perceived only in their role as dutiful wives. Also, in other discussions it frequently came up that men complained that their women were shy, dependent, uneducated, and generally not fit for holding a public office. Men charged that women are proxies, that their husbands induce them to unlawful behaviour, that they are not able to formulate their own ideas, etc. In these remarks one can detect that it is actually acknowledged that a woman who is following the role model of the dutiful wife faces difficulties if she has to perform a public role. She is then criticized for being too shy and not able to promote the interest of the village. However, men did not show great willingness to accept 'un-wifely' behaviour by their village women. I came across cases where people complained that the elected women are moving around alone. Bimala, the sarpanch in Balipatna, was criticized for 'unwomanly' behaviour, like riding a motorbike or talking to officials in harsh language.

Obviously the acceptance of women's involvement in politics in general and positive remarks concerning the policy of affirmative action is reversed when related to one's own wife or village women. This attitude poses a severe dilemma to the women in the PRI and is quite an obstacle to their effective political presence and empowerment. If they follow the ordained ideal of the dutiful wife (in which most women have been brought up), they are criticized for being powerless and not effective. If some few odd-balls dare to act in a different way and more independently, they are criticized for not being a decent woman, and particularly husbands rarely tolerate this. This leaves women in a fix: however they behave, either as a dutiful wife, or as a more independent agent, they cannot please their electorate or their families. Although it is somehow acknowledged that women cannot become effective in politics if they follow the role model of the wife, this does not induce the village communities to employ the symbol of the powerful mother, but lets them rather argue that village women should just not be in politics. The same holds true for the issue of education. Village women are uneducated—hence villagers believe that they are not fit to serve in public institutions. Unfortunately, this view does not lead to a commitment to educate the girls, but rather to argue against an involvement of women in local-level politics.

It will be important to follow the future developments of these discourses because they are very powerful in constructing social reality. Some change of perception should happen in the course of time, as mentioned by Dahlerup (1988: 295) who states that the stereotyping of gender-roles got diminished in Scandinavia because of women's greater presence in politics. To speed up the process, one could try to project women more so in their capacity as powerful and capable mothers through posters, stories, or dramatic performances in the villages. The heroines should be ordinary village women, not a remote personality like Indira Gandhi, whose elevated role has been

anyway accepted by most villagers. Women and men have to be convinced that village women can also be powerful, that they do not need to be shy and submissive to be a good wife. Undeniably, such changes are usually very slow to happen, and one can hope that gradually more powerful and independent women will emerge from the PRI who can serve as new role models and influence the village and administrative discourse on female behaviour.

Another problem, not only in connection with the reservation for women, is that the administration seems to regard the PRI mainly as implementing agencies. The involvement of 'unqualified' villagers is seen as hampering the state-designed development process—there is obviously not much sympathy for local participation as it is regarded as potential interference. In such a setting, a real decentralization and empowerment of the rural population is very difficult to realize. It seems that especially the civil servants have to be made aware that decentralization means that the local population has to be taken seriously and regarded as partners in the overall development process, not as mere implementers or even obstacles.

Apart from the support of males—be they officials, husbands, or collea-gues—female representatives need even more importantly be supported and strengthened in their autonomy and gender awareness through vibrant women' groups. This leads me to the last but not least area of concern.

Lack of the Mobilization of Women

The situation of women's groups in both areas has been described. In Gania, such groups, if constituted at all, are mainly dysfunctional. In Balipatna, the situation is different, but here the women's groups serve mainly economic purposes—which is undeniably important—but they are as yet no medium for the discussion of more general topics or for evolving a female perspective on village problems and development priorities. To argue for creating forums like this is not completely unheard of. The Indian government itself has started an important process through its Mahila Samakhya Programme launched in 1989 initially in three states (Gujarat, Karnataka, and Uttar Pradesh). It is a scheme for women's education executed though NGOs. Under this programme, village women come together to discuss their economic and social problems in a group. The literacy component is only introduced when the women themselves demand them—usually after a process of recognizing the importance of literacy to deal with everyday problems and handling the local administration (Agarwal 1994: 497). Another way is the organization of women's groups solely through initiatives of NGOs. The work of the NGO AWARE has led to empowerment of women to a considerable degree through the organization of women's groups which provided the space to develop common concerns and ensuing action (Narasimhan 1999a). Whatever is the preferred model, it has to be said clearly that women's empowerment can be best—and most likely only—attained with a multipronged approach. The quota is definitely an important step, but it will remain less effective if it is not coupled with other efforts to strengthen women's independence and capacities.

Nevertheless, members of the credit and savings groups in Balipatna at least questioned the work of the PRI and also aired their dissatisfaction. Still, it appeared that the elected women in the PRI hardly received any support from the female population, even in cases where they have personal ties to women's groups. This leaves them dependent solely on the more outspoken and politically active males, who are very unlikely in this setting to have a gender-sensitive point of view. I have cited already the case of Lita, who cannot work against liquor consumption if she is not assisted by a strong women's movement that could pressurize the male electorate. Since the general female population is not very outspoken so far and does not command the autonomy of the vote, women in the institutions are induced to cater to the interests of the male population, who will finally be decisive for their re-election as well as for the smooth running of affairs while in office. A further problem is that in those cases where women representatives have no ties to viable women's groups, it is very hard for them to get to know what the female constituency would want them to do. Or, like in the case of Sabita, who got addressed by women to organize loans for leaflet making, she got convinced by the rhetoric of the male village elders, who do not hold village women to be capable to utilize and repay the loan and resent outside involvement in their village affairs.

It became clear that the female representatives are acting in an extremely male-dominated environment while hardly receiving any corrective or support from the female population. In this respect it is not so surprising that some of the female representatives are crossing the 'sacred' line and are then viewed by the village women as belonging to the male world of politics. The lesser the input from the larger female society, the lesser the chances that representatives can really evolve gender issues and work for the empower-ment of women in general. Thus, the very lack of empowered women's groups at the village level also constrains the empowering impetus of the women's quota. This holds mainly where the elected women do not have a gender-sensitive state of mind before entering the institutions.

Generally speaking, one problem of the whole process seems to be the fact that rural women have not really been mobilized before the introduction of the quota. There was no large scale struggle in the countryside for the right to be present in the local political bodies. It was a battle fought by the urban-based women's movements in the corridors of power in Delhi. This is not to blame the promoters of the women's quota in the PRI. One only has to pay attention to the fact the quota appeared like a *deus ex machina* in the countryside—nobody had really demanded it, not even the women. As I have mentioned, most women were not even aware of the 33 per cent quota for them even though they had all been elected on this provision. This fact is definitely responsible for the lack of gender awareness of the representatives, as well as the more general lack of awareness of what they are supposed to do in the PRI. Yet, one might have to wait another 50 years until this struggle

would come about—considering all the obstacles women face in rural India. In this respect it appears that the quota needed to be bestowed from above. Yet, in such a scenario several empowering strategies have to go hand in hand, and one can not necessarily rely on the women's quota only to deliver empowerment to all women.

Summary and Conclusion

THE OBJECTIVE of this book was to theoretically and empirically examine the process of women's political presence and empowerment following the reservation for women in the Panchayati Raj Institutions (PRI). In this final chapter I first want to recapitulate the main insights gathered from the empirical case. The summary will obviously not engage with the full complexity of issues addressed, but serves as background to reconsider the theoretical deliberations on women's political presence and empowerment as presented in Chapter 2. What general conclusions can we draw from the case of Orissa for processes emanating from a reservation for women in politics? What empirical insights from the case study could be valid for other Indian states, or for polities that are even more distant to Orissa in cultural and socio-political terms? Furthermore, I shall deal with the question as to what extent the theoretical arguments should be modified as a result of the empirical insights gained. Finally, I shall address the question of how successful the combination of the concept of political presence and empowerment approaches was for the analysis of the present case and in more general terms.

Let me begin with the summary. The process of empowerment was divided into four analytical stages: Women's political presence— that is their moving into positions of power; women's exercise of power—that is the extent of decision making, the introduction of a new style of politics, and the formulation of new priorities concerning development works; the empowerment of the women representatives—that is the gaining of knowledge and interest in politics, of status and visibility, of consciousness and confidence, and of gender-awareness; and the empowerment of women as a group—that is women's perceptions on what they have gained as well as the male and administrative discourse on women in politics.

In regard to women's political presence, discussed in Chapter 3, it was established that the quota has indeed been implemented. The required number of women were elected from the reserved constituencies and they are actually physically present in the meetings of the political bodies. In this respect, one can confidently claim that empowerment in the sense of coming into positions of power has been successfully established through the legislation of the 73rd Amendment in Orissa. Who are these women? As regards their socio-economic characteristics in comparison to those of male representatives it was found that women are a little bit younger (mean age 37.7 years *v.* 41.3 years). This runs counter to expectations prior to the implementation of the quota. It was believed that mainly older women would become elected, since they command a higher status in the village com-

munities, and are also less restricted in moving in the public space. Most women are married and have around three children which puts a heavy burden on their time budget in case the offspring is young. Revealingly, women are more likely to come from nuclear families than men. Nuclear families are believed to grant the *bahu* a greater freedom because she is not under the sharp eyes of her mother-in-law. The frequency of nuclear family background was higher for women in Balipatna than in Gania, which could be a sign of Balipatna's 'forwardness'. Yet, women in Gania also mentioned that they cherished the support they got from the joint family system.

It was also found that the elected women are drawn from lower income groups and lower castes than their male colleagues. The presence of SC women was over-proportional. This fact plus the higher prevalence of women from landless families and from households with lower income disproves the supposition that the quota mainly benefits the elite. It appears that high status families are still reluctant to introduce their womenfolk into the public sphere, and the new opportunity was seized more by lower status and poorer families. However, most of the elected women do not work outside their homes, with the regional variation that in Gania more women follow a paid occupation than in Balipatna—the implication of which will be discussed soon. As expected, women have less formal education than men; yet, they also come from families with less educational background. That again indicates that women from modest milieus have become elected.

Women are a little bit more likely to come from a family with a background in politics, though the difference to their male colleagues is rather slim (32.4 per cent *v.* 26.3 per cent). It shows that 'political families' are a socio-political phenomenon that is not necessarily linked to gender. The political family setting is normally taken as face value that these women are proxies. However, political involvement of relatives could also be interpreted as an important political resource, because women, especially in the initial stages of their political careers, have less experience than men. Furthermore, women have fewer networks in general, because they are still mainly relegated to the household sphere and are less involved in political parties and other social groups than men.

In regard to the election-process it was established that none of the women was elected from a non-reserved seat. That shows the importance of the women's quota if the goal is to elect political bodies that are representative of the population. Slightly more than 25 per cent could nevertheless imagine standing for election from a general seat, and more women in Balipatna than in Gania could envisage this. The women's seats were less competed and women had fewer opponents than men; around 63 per cent were selected without a contest. Yet, among the men also, more than 36 per cent faced no rival. This indicates that for village communities unanimous decisions are an independent value that is not necessarily associated with gender.

Women in general attributed their successful election much less to their own personality, and they were also less likely to have decided on their own to participate in the election than men. Most women had either been induced

or nominated by their family, or by members of the village community. However, only a little more than 36 per cent of the men stated that they had decided on their own, and interestingly more women in Balipatna had decided at least partly on their own than men in Gania. This indicates that restriction on independent decision making also holds for a substantial number of men.

A very interesting pattern emerged in respect to the deliberations of the voters which woman to (s)elect for office. Information about the (s)election process could only be gathered from men. It became obvious that the elected women have been chosen mainly by the male electorate, which still dominates the voting decision in rural India. Interestingly, more *gaanjhias* became present in the institutions than could be expected from the prevalent patrilocal and village-exogamous marriage system, where women leave the native village after marriage to live with their in-laws. This is a fascinating example of how village communities attempt to solve the problem of traditional codes of behaviour for women, which work against an effective role in the public sphere. *Gaanjhias* have greater freedom of mobility and are less constrained in their social intercourse with the village males than are *bahus*. Men come and talk directly to a wardmember if she is a *gaanjhia*, which is unthinkable if she is a *bahu*—at least in Gania. Also the rules of seclusion apply to a lesser degree to *gaanjhias*. This preference as well as the following ones show that village communities were indeed interested to elect a woman of whom they could expect some efficiency in dealing in the public sphere, instead of electing mere proxies—although this happened as well. Further factors for (s)election were the willingness of the candidate (or her husband/father-in-law), her educational level, oral abilities, place of residence, and the expected support by her husband. The latter is an important criterion for the villagers because many works that have to be conducted outside the confines of the panchayat office are still taken care of by men. Caste features much less than what is usual in Indian politics. This was partly due to the reservation for Scheduled Castes (SCs), Schedules Tribes (STs), and Other Backward Classes (OBCs), which limits the electorate's choice in any case and partly to the small size of the consti-tuency—especially in the case of wardmembers—where the locally dominant caste happens to be most decisive. In Gania, one caste-factor was found in the strong preference of voters for members from the caste-group of the Keutas who are SC but touchable.

When looked at the extent of political presence, it was found that women are attending the meetings regularly and male relatives are not allowed to take their place in the panchayat office. It was proved, however, that women are not likely to get elected for higher positions unless these were also reserved for them. In the 1992 election already, 33 per cent of the seats had been reserved for women, but no posts for sarpanch or samiti chairperson. As a result, only few women managed to get elected for higher offices. The same is true for women's presence in today's standing committees, which are, however, mostly not functioning in any case.

Women spend considerably less time for their work in the PRI than men.

This can be attributed to the fact that the majority of women have still not been relieved from their household duties. Additionally, as mentioned before, many tasks of the panchayat work are taken care of by male family members due to cultural reasons. Accordingly, women's presence in the grama sabhas—the village parliaments—is also considerably less than that of men. It appeared that the panchayat meetings have been transformed into a kind of 'private' or semi-public space. Here, women are facing men from other villages only with whom they have no social relationship that demands seclusion. That became visible through the ease with which women participate in the secluded meetings and the incidence of some women removing the *pallu* after they entered the panchayat office. Women also mentioned that it helped that they were not the sole woman but that more women are present in the gram panchayats. That strengthens the hypothesis that a critical mass of a minority facilitates to overcome obstacles faced by them. On the other hand, women's attendance in public meetings still poses problems in respect to village mores and the prevalent ideal of womanhood. Nevertheless, the attendance of women in communal gatherings has gained some legitimacy, and in Balipatna especially, women were present at the grama sabhas. However, the attendance of women, particularly in Gania, is mainly bound to their position in the PRI.

When the issue of having power was examined in Chapter 4, I started first with an assessment of the representatives' knowledge—of the larger political system, the PRI, and government schemes—as a prerequisite. In all respects, men were more knowledgeable than women though even among men the knowledge on specific features of the PRI was abysmally low. An interesting configuration emerged regarding information on government schemes, where the pattern was slightly gendered. Women were more likely to mention schemes that benefit old people, widows, and girl children. This might lead to a more gender-balanced development in future. Regarding decision-making, fewer women claimed to have participated in every decision of the political body. However, male representatives were quite undecided whether women participated in the same way as their male colleagues or not—opinions were more or less evenly split.

Women also participated less in the State Assembly elections of 1995 than men, and they were bound in their decisions to the resolutions of the male head of family or village-community members. However, men were also obliged to follow the judgement of the village or caste-group, but they might have been more instrumental in reaching the resolution. In that respect, it appeared that lack of autonomy is not just a predicament for women, but holds for men as well—though to a lesser degree. Especially in Gania, where a feudal political machine appears to be still in existence, the political autonomy of men is severely compromised as well.

A major question was whether women could or want to change the way politics is done. This issue was investigated using instances of corruption, because this is one area where changes were expected by scientists, activists, and by common villagers. Generally speaking, corruption appeared to be

rampant in the PRI. It could not be established that corruption was less prevalent among female representatives when compared to their male colleagues, or that men had necessarily induced corrupt women, or that the women resented being dishonest. The relevance of this result for the theoretical considerations will be discussed below. In regard to the power to change the content of politics, women voiced more or less the same preferences for public works to be undertaken as men. Apart from the still limited autonomy of women as well as the restricted space for deliberations, this result could be due to the constrained resource base of the PRI, since preferences are likely to be induced by finances available for certain undertakings. Nevertheless, there was a gendered configuration in the general outlook. More women than men claimed that they wanted to do something specifically for women or children, which was, however, solely due to the preferences of the female representatives in Balipatna.

The question of the process of empowerment resulting from women's political presence was dealt with in Chapter 5. I made the distinction between the empowerment of the elected women and of those not present in the PRI. Empowerment of the female representatives was defined as personal gains in several areas. It became evident that the women in the PRI have gained in knowledge and interest about political matters. This new knowledge is valued highly by the mandate holders and many voiced the wish to learn even more. The recent interest in politics is mainly due to their position in the PRI. Earlier there was no scope in rural politics for women and accordingly they did not pay much attention. The representatives also gained in status and visibility. That they can now go out and mix with other people was mentioned as a very positive development. It shows that one feature that holds for nearly all women in the countryside is their restricted mobility. Women can only leave the house if they have a legitimate purpose to do so—they have no right to loiter! Their political work has now added a legitimate opportunity for venturing out, and this is highly appreciated by women, no matter what their social background. They also perceived that their status has been enhanced in the family as well as in the village community. Another area of change was their new consciousness and confidence. Women were proud of their new position and saw it is an acknowledgement of their capabilities. The gaining of gender-awareness, however, was less pronounced, but found in some cases especially in Balipatna. As regards the last issue, it appeared that a political position alone might not secure a gender-sensitive attitude.

While the representative's empowerment could only be established in regard to the perception (in contrast to hard empirical evidence) of gains of the women concerned, it should be seen as important evidence for a process having been started. That 70 per cent of them would like to stay in politics is also indicative of the positive attitude of the female incumbents concerning their new political role. And although male colleagues and villagers were much more critical towards women's progress since the quota, even they admitted that the elected women have advanced in several areas.

Still, one has to keep in mind that the 14 women who were interviewed

more intimately were generally the more active ones; I do not propose that all women in the PRI have gained in all these respects. But the progress made by the women portrayed indicates without doubt that the quota has created a space that is utilized by some women, though they might still be rather exceptional. These extraordinary women can also serve as role models for future generations and might enlarge the space of opportunities so that more and more women might come forward to occupy it. A problem persists in the sustainability of the personal gains. If women will leave the institutions at the end of their term, most may return to their previous household existence: Their present freedom of movement, status, and visibility is bound to their position in the PRI. However, as mentioned, the majority wants to remain in politics, and also the gain of knowledge and confidence in their abilities will most likely remain.

The impact of the presence of women in the PRI on the empowerment of women as a group is less direct. Up to now, village women have not gained much in material terms and there are hardly any effects that could be attributed to changed policy priorities resulting from women's inclusion in politics. That is definitely due to the short time span of female incumbency, but is also a consequence of the limited room for policy formulation in the institutions of local government. Furthermore, one observation proved very disturbing, namely that some wardmembers in Gania appeared to be aloof of the female constituency. Those two wardmembers allegedly dealt not with village women but conducted meetings with the male villagers only. However, there was also no curiosity from the side of the village women and they did not seem to co-operate with the female wardmembers. In such a scenario, elected women are induced to cater more to male demands since the male elite still dominates the voting decision. In this context, it became quite clear that some women have smartly understood how politics works. One example was Lita, the sarpanch of Gania, who knows that she cannot alienate the influential male villagers by working against alcohol consumption if she wants to be re-elected. This suggests that unless village women start becoming interested in the Panchayati Raj and commence pressurizing the female representatives as well as the male voters, it is less likely that the elected women members will pursue women-friendly politics.

It appears that this is a general dilemma of democratic politics in India that is not easily resolved. Although the marginalized sections of Indian society are the majority in numbers, they still lack bargaining power to translate their numerical strength into political gains. Furthermore, deprived groups are rather segmented and thus do not necessarily fight in a combined effort. That does not mean that disadvantaged groups will never be able to influence the political agenda,—the political forces of the SCs and OBCs prove that over time some manage to gain power (which, however, does not benefit all members of a given community in the same way). But it is a slow process of social transformation and it is usually combined with a struggle for those rights. As argued, this struggle is largely absent among the rural women who have not fought for their right to be present in rural politics.

This could also be one reason for the lack of gender awareness encountered in the study region, since awareness about one's marginalized position is mostly created and disseminated through struggles and group mobilization.

Nevertheless, two important areas of women's empowerment could be established. The first was the significance of the symbolic recognition of women's political role. Village women mentioned their pride of the fact that other women were elected and present in the PRI. This satisfaction in regard to women's new public role was relevant to women as a group, no matter what caste or class they hailed from. They valued it as acceptance of their right and capabilities to serve in a public office. The second point emerging as positive was the new access they gained to their elected representatives. Earlier they could not address the person in power, who was invariably male, but now women can imagine placing their demands before a female representative. It also became clear that women in Balipatna are more interested in the PRI and question their representatives. There some female representatives showed gender-awareness and were inclined to promote women's interests. I shall come to the regional implications in greater detail below.

To conclude, men are still more present—in quantitative as well as in qualitative terms—in the PRI than women. They still command more power over the decision-making process and are more autonomous in their actions than their female colleagues. However, when one compares the situation presented above with the one found prior to the introduction of the quota for women, one can definitely argue that women have marched forward considerably.

Apart from the difference between the two sexes, it was argued that a comparison between two geographical areas—differing in respect to women's status, political culture, and overall developmental position—could give important insights into the workings of the process of political presence and empowerment. Thus, I want to draw attention to the regional pattern that emerged from the empirical study. The process of women's empowerment through political presence gives the impression of being more successful in Balipatna than in Gania, although the evidence is not unequivocally clear but rather complex. Still, even if one keeps in mind the variety of experiences, one can detect certain patterns.

In several respects, women in Balipatna are more present, autonomous, confident, and gender-sensitive than women in Gania. Women in the first block devote more time to their work in the panchayats. They are also more present in the grama sabhas. Even women who were not members of the PRI were participating in the grama sabha in Balipatna Block. In respect to autonomy, more women in Balipatna decided on their own to participate in the election and a greater number attributed their success to their own personality; in Gania, women pointed frequently to the village communities as being decisive in these matters. Interestingly, men in Gania were more dependent on the influence of the village community when compared to women in Balipatna. They decided less than women in Balipatna to

participate in the election and they were more hesitant to believe that their own personality had played a major role for their victory. In both questions they mentioned the village community as being most decisive. Thus, the dependence of the representatives on dominant villagers is much more pronounced between the regions than between the genders. Regarding decision-making, fewer women in Balipatna stated that they had participated in none of the decisions of the panchayat. Concerning preferences for works to be conducted in one's own constituency, women in Balipatna appeared also to be more gender-sensitive than their female colleagues from Gania. They were also more confident and happy with their presence in the PRI, since fewer wished to get out of the institutions and more aspired to a higher post. Additionally, more women in Balipatna could imagine running in the election from a non-reserved seat.

Women as a group also appeared to feel more empowered in Balipatna than in Gania. As mentioned, in Gania the dilemma arose that some village women perceived that the women elected to the institutions have crossed a line and now belonged to the 'male' world of politics. Village women in Gania seemed to be more shy and less curious to interrogate their fellow sisters about their new position and the political process in general. Women in Balipatna, on the other hand, were highly critical about their female and male representatives, but were also curious about their work. They even imagined encouraging their daughters to run in the elections to come. Moreover, it became obvious that in regard to women's participation in public gatherings, society in Balipatna was more pragmatic than in Gania. Some women were present in the grama sabha because their husbands could not come for one reason or the other. However, this fact might also be due to the particular situation, which arose after the cyclone devastated the coastal area.

How can this regional variation be explained? For this, one has to turn to the local environment and to the socio-economic characteristics of the representatives. I have argued that Balipatna is more advanced in terms of infrastructure, literacy, and general economic indicators than Gania. It is also located in a region which has been historically more politicized. During the freedom struggle more women were drawn into the public sphere in the coastal areas than in the feudal states, although they retreated again afterwards. When one looks at the results from the Assembly elections since independence, MLAs have frequently been voted out of power in Balipatna and the block is much politicized even today. In Gania, on the other hand, part of the traditional political machine is still in place. The influence of the village communities is more prevalent there as well, constraining both the male and the female representatives. The enhanced influence of the village communities in Gania could be interpreted as positive in respect to the accountability of the representatives towards their constituency. However, the problem concerns the composition of this external decision-making body, which is actually not constituted out of all villagers, but of the influential and

dominant ones. Thus, accountability is to the village elite only, which is not necessarily beneficial to the village as a whole.

In regard to socio-economic characteristics, there was an important result. The general higher female literacy rates in Balipatna have *not* been translated into the presence of better educated women in the PRI as compared to Gania. Despite the differences in women's literacy in both blocks—women having less education in Gania than in Balipatna—the educational level of the elected female members did not differ much. The individual educational level alone does not seem to be most decisive, but rather the *influence of the social environment*. It was established that women are more knowledgeable in Balipatna in most respects, which has to be due to other factors than formal education. This does not deny that higher formal education contributes to better political performance. Bimala, the sarpanch of the remote gram panchayat in Balipatna was definitely aided by her good education. A greater determinant, however, seems to be that women in Balipatna already had greater freedom of movement to begin with. The sole three unmarried women of the sample come from Balipatna. More women also live in nuclear families there which supposedly results in a greater independence. Women in Bali-patna were also found to be less often accompanied by men to the meetings. This is mainly due to the fact that Balipatna is more densely populated and accordingly constituencies are much smaller area-wise. Women do have to cover shorter distances to reach the panchayat or samiti office than women in Gania. This fact has little to do with variation in cultural values, but is a mere geographical feature. I talked to a woman representative in a remote tribal panchayat in Gania. She said that she was not attending the meetings regularly because it takes her nearly two hours to reach the location on foot. We have also seen that women in Gania, as for example Kali, serve as many as four villages that are quite dispersed. This puts a very heavy burden on the shoulders of these women in comparison to the representatives in Balipatna.

What is rather counter-intuitive is the fact that women in Balipatna were less involved in other social groups than in Gania, and fewer were party members as well. Following the social capital approach, civic society as measured in membership in social groups and in the number of social groupings is supposed to play a supportive role for the democratic process. However, it emerged that it was not the involvement of the individual alone that was decisive, but rather the social environment and *qualitative* aspects of the civic groups. Although more women in Gania stated that they were or had been members of women's groups, most of these groups were more or less defunct. In Balipatna, there were vigorous women's groups, and members were comparatively vocal and exposed to public life to a certain degree.

Another socio-economic feature, which is supposed to assist the process of women's empowerment, is wage-work outside the home. In Balipatna, more women were unpaid family workers than in Gania. Among the women in Gania, more cultivators and self-employed were found. It is true that women

working outside the house are already more exposed to the public world than are women who are only staying at home. On the other hand, the time budget of women working outside is even more restrained since normally the household chores remain the same. Furthermore, it seems that in Gania women who did work outside immediately returned home when their work was done. In this respect, it might not have enhanced their public exposure very much, although one could still speculate that their status in the household was better because they provided additional cash resources. In Balipatna, this was ensured for some women through their participation in women's savings and credit-groups.

If one considers all the arguments above, it appears that what has to be gained by the process—namely empowerment—is to some degree already a precondition: the more empowered—in terms of confidence, gender-awareness, exposure, mobility, and autonomy—women already are, the greater is the impact of the reservation of women. I shall return to the implications of this conjecture a little later when I discuss the findings from the viewpoint of the empowerment approach. Nevertheless, even in Gania, positive developments have taken place. One should also not forget that the process has just started, and one can not expect major changes to happen overnight. Even with devices of affirmative action, societies and long-held values are changing rather slowly. Still, it is safe to claim that without the reservation for women one would find hardly any woman in Orissa's local politics,[1] and the women in the institutions undeniably have become empowered to a certain degree. Additionally, women as a group have gained in Balipatna as well as in Gania, in terms of symbolic recognition and enhanced access to their representatives.

What can we draw from this empirical case for women's political presence and empowerment in more general terms? For this we have to go back to the theoretical deliberations of Chapter 1. I recounted three key arguments of Anne Phillips for a politics of presence: the importance of symbolic recognition; the need for a more vigorous advocacy for disadvantaged groups; and the importance of a politics of transformation in opening up a full range of policy options.

It can be claimed without hesitation that the symbolic recognition is a very important and empirically established argument. Symbolic recognition was valued highly by most women in Orissa—inside and outside of the PRI. The statement carries even more weight in a social setting such as the one prevalent in most regions of India. Here, spaces are more gender-segregated than, for example, in the West. Besides the symbolic recognition, women gained access to their elected representatives which was not so before the introduction of the quota. I suggest that the value of symbolic recognition is

[1] Recall the percentages of positions women managed to secure in the PRI in Orissa prior to the quota: They ranged between 0.33 per cent and 0.68 per cent in positions of sarpanch, and between 0.18 per cent and 0.19 per cent for wardmembers in the 1975 and 1984 elections respectively (Devi 1988: 46; percentage calculations mine).

one of the most direct effects of a politics of presence, which should also be the case for polities that are disparate from Orissa. The importance of symbolic recognition, apart from being a value in itself, lies in the fact that it contributes to status enhancement, self-esteem, and pride—we only have to remember the introductory quotation of the female wardmembers. The evidence of the positive significance of symbolic recognition moreover proved beyond doubt that women indeed are a social group that has certain interests in common—a notion which has sometimes been contested or neglected even in recent feminist writings.[2] The direct effect of gaining access to one's representatives, however, is mainly valid for societies where there is no free interaction between females and males. Hence, this should hold for most South Asian countries, but also for other states—like the Islamic countries outside South Asia—in which female and male spaces are very segregated and free social intercourse between the sexes is curbed by cultural values.

Concerning a more vigorous advocacy for marginalized groups, the empirical results were inconclusive. It seems that female representatives have not gained enough autonomy and power yet to vigorously defend their preferences. Furthermore, a major degree of formulation of specific policy priorities could not be established, which is definitely also due to the limited policy making capacity of the PRI. It appeared that most policy options are determined by severe financial compulsions. These financial restrictions lead to induced preferences and stifle local original thinking. Thus, the space created by the quota in the PRI for policy formulation is very confined, which could be a reason why gender appeared to not have a major impact on the general preferences voiced. I have argued already in Chapter 6 that one solution would be the devolution of more financial resources to the PRI for their discrete use, which would also promote the process of democratization and decentralization in general. Additionally, the representatives in the PRI are also bound to policy formulations by higher political institutions. In this respect, one would need to examine the process that would ensue if the quota for women were also introduced at the higher echelons like the State Assemblies and the Parliament, as well as into the bureaucracy. Yet, the delays in passing the Women's Bill in Parliament might be due to the very fact that there are not enough women present for a vigorous advocacy.

Nevertheless, in Balipatna women have already started to voice some priorities for projects that benefit women and children in particular—these were mentioned less by men. There was also a gendered pattern found in the mentioning of government schemes. But there was no evidence of women defending these priorities in public. One can assume that those women drawn

[2] It is still interesting that the objection against a reservation for women because they allegedly do not constitute a relevant social category has hardly been levelled against social groups such as castes, classes, or religious communities. However, as regards such groups it does not seem convincing that all members have necessarily all interests in common, or that they always arrive at one point of view. Thus, many deliberations and criticisms concerning the group status of women hold for other social groupings as well—a fact that is not always paid attention to in the discussions on a quota for women.

into the political process at the national or state level in India would already be more empowered and autonomous than women at the local level in the less developed state of Orissa. Still, there is no absolute guarantee for this, as was pointed out by the Medical Officer who alluded to Rabri Devi as being Laloo Prasad Yadav's proxy. Nevertheless, there are already a few influential and autonomous women present in Indian high politics, but it appears that their numbers might not be sufficient enough to push the Women's Bill through the parliamentary process. It also seems safe to maintain that women in Western democracies are already more empowered and aware and can thus be expected to press their priorities with greater determination, as long as they form a critical mass in the decision-making institutions. As mentioned in Chapter 1, this has been already established by studies on women's presence in national parliaments in Western democracies. However, one cannot give definite guarantees that the elected women in India would really promote women's issues, but can only fall back on intuitive confidence that women's interests are better promoted when there are more women present in the decision-making bodies.

The first part of Phillips' last argument, the transformation of politics, could not be proved with the empirical results. I looked at the issue of corruption. To be fair to Anne Phillips—she never supposed that change would occur in such an area. Phillips rather argues that the experience of both presence and empowerment can generate new visions of how life could be organized that did not even figure before this point, like being able to imagine a society without gender divisions, or being able to think of women as what Martha Nussbaum would describe as ends in themselves.[3] Yet, also such a kind of transformation has obviously not happened yet, which should be due to the short time of incumbency, but most likely also because local political institutions do not lend themselves for major policy formulation. However, lesser corruption was a change expected by many Indian scientists as well as ordinary villagers. Thus, it was imperative in the Indian setting to have a close look at this issue. Yet, contrary to popular expectations it could not be substantiated that a change towards cleaner politics really took place, nor were there many signs that this will happen in future. Apparently this anticipation is the most empirically contested one.

In my opinion, it is hard to argue for the 'moral superiority' of women theoretically as well as empirically. Arguments of a 'natural' inclination of women towards cleaner politics, furthermore, tend to ignore the force of the political and social structure in which women must act once they are elected. Phillips seems right when she concluded that the political process and compulsions emanating from it might be ultimately more determining than a representative's gender. And there is a good reason for this assumption. Differences between men and women are seen mainly as resulting from the structural properties of a given society that accords distinct spaces for women and men as well as specific roles in the division of labour. According to such

[3] Personal e-mail communication with Anne Phillips on 29 January 2002.

a line of thinking, distinctions between the two sexes do not flow from a kind of biological determination—rendering women less corrupt, or more co-operative, or more caring—as a kind of natural property. Instead, these distinctions are seen as resulting from the different life-experiences mainly due to the way in which the given society is organized. If women enter the space occupied and structured by a male majority, the differences between the sexes might be moderated. Furthermore, corruption happens to be institutionalized in the PRI. Large sums have to be spent to secure a successful election, and at least that money needs to be recovered while serving in office. Also bureaucrats as well as politicians expect to make their cut and it would be very difficult for women to work against corruption, even if they were inclined to do so. Women still command very few resources to work against a deeply ingrained practice. Finally, the contrast between those who are active in politics and those who are not may be greater than any gender differences between those who are present in politics. As already mentioned, there are some indications for this in Gania, where some women repre-sentatives became rather removed from the female constituency. All this does not deny that changes in the way of doing politics might occur. But one cannot predict these changes beforehand, one definitely cannot see them after a short span of time, and it is difficult to predict what kind of changes will occur. It will depend also on a critical mass of women's presence, and 33 per cent might not be sufficient in the difficult environment of rural Orissa. Also the level of the PRI might not lend itself for the development of drastic new outlooks on politics, since the local institutions are rather powerless and concerned with day to day business of policy implementation rather than formulation. Nevertheless, we should also think hard on whether such arguments, especially when they are linked to expectations that women will be the 'better' politicians, really serve the cause of the political presence of women in general. Perhaps one should drop such arguments since other arguments are strong enough to defend a reservation for women. Why do women necessarily need to be better than men? Is it not enough to argue that they are as capable as men in serving in a public office? If one argues for equal capability for holding public positions, there is another contention that one must address.

Many villagers and PRI members—men as well as women—were not of the opinion that women are equally capable; they mentioned women's lack of education, their shyness, and their dependence on male relatives for conducting their work. These statements are important in the discussion of the case study in particular and in discussions of similar social settings where women are lagging behind in terms of education, public exposure, or personal autonomy to a major extent. Such arguments do not carry much weight in the argument on the politics of presence in societies where differences between the sexes in these areas are less marked or absent. Nevertheless, as in the present case, all characteristics mentioned emanate from structure-based discrimination against women and not from a 'natural' superiority of men in regard to being active in politics. The reservation for women

is actually designed to overcome these structural obstacles to women's participation in politics. Furthermore, it emerged from the case study that social change counteracting discrimination against women will not, or only slowly, happen if there is no deliberate intervention. The question remains: How much can the process be accelerated? It appeared that certain social transformations have already taken place and that they can be interpreted as direct outflow of the reservation in local politics. Some women in the PRI definitely have enhanced their public-speaking capabilities, have gained new knowledge, and also confidence. However, until such individual gains are translated into social change affecting the larger mass of women, it is likely that the time frame for real results will be extended.

Another major stumbling block in this respect is also the dominant male biased discourse which I referred to in the previous chapter. It became obvious that women's performance is measured with a different yardstick—and expecting clean politics from them while males are excused is only one instance. Lack of knowledge and education, for example, is bemoaned when it concerns a woman, but excused when it involves men. The same tendency became visible in the different judgement of the lack of autonomy and the political family background of representatives. Both relate to men as well but whereas women are portrayed to be turned into proxies because of this, men are free from such suppositions. Also the support rendered by males towards women gets used for proving her proxy status. That might be the case in some instances, but is not necessarily so. In addition, also male politicians receive support without turning them into proxies in the public eye. One example might illustrate this: Bill Clinton was hardly portrayed as incompetent or a proxy only because his wife Hillary was known to be responsible for many of his political programmes! It is much more difficult for women to please their electorate than for men. If women follow the ordained ideal of the dutiful wife, they are criticized for not being effective. If they dare to act more boldly, they are chastened for their unwomanly behaviour. All this proves to be an obstacle for women's public endeavours and it will presumably take a long time until these discourses are altered. One can only hope, following the experience in Scandinavia, that the quota will actually contribute to diluting such stereotyped role models.

It has been debated that a society that decides for a deliberative intervention at the institutional level should have the awareness that there are costs involved—although the costs of exclusion due to structural discrimination are hardly paid attention to in such a line of thinking. I have mentioned the price to be paid in regard to the freedom to choose one's representative. I argued in the previous chapter that the problem could be mitigated through a different way of implementing the quota, through, for example, the party system and/or multi-member constituencies. At this point in the discussion, I want to focus on another aspect of this debate—namely, the loss that is perceived in connection to a lesser functioning of the political process. Because of structural reasons, women in Orissa are indeed less equipped than men (in terms of knowledge, time budget, freedom of

movement, rules regulating social interaction, etc.) for holding a public position. However, it could not be empirically established that the development process was really hampered by the presence of women. Rather, other conditions such as corruption, lack of finances, and political antagonisms seemed to be more decisive.

The problem that women are in some respects less equipped than men for a political office was moderated by the fact that some husbands or male representatives indeed rendered support to female representatives. This co-operation might not be entirely altruistic and those males might also promote their own goals by backing a woman. However, if male assistance is not sheer domination using the woman concerned as a vessel for one's own gratification only, it can be seen as an important resource to facilitate women's political role especially in the initial stages of her career. As mentioned, Sabita was supported by her husband and it did not appear that he was dominating her to a major degree; he appeared rather humble and accommodating. Lita, the sarpanch from Gania, complained about the lack of help by her husband, who is, in her words, rather too simple. Also Babita, the naib-sarpanch from Balipatna, did not look to be a mere proxy to her husband. Nor was she necessarily wax in the hands of the supportive Brahmin sarpanch even though she apparently accepted his guidance in many respects. It is also indicative that women mentioned proudly the good support they received, or in the case of Lita, bemoaned the absence of it. Furthermore, women also gained in knowledge and experience through the close interaction with male mentors, becoming more efficient in the course of time. One can speculate that after an initial phase of mentorship women start becoming more independent. The need for mentorship in the initial stages of female political careers has been established even for women in the West, though it would obviously be preferable if those mentors would be other females—like higher level politicians (see for the case of Germany, Geissel 1999).

Thus, rural society proved capable to adjust to the new situation without major problems arising for the political process or the delivery of goods, besides from the predicaments already existing prior to the political inclusion of women. Additionally, there was no evidence that men were necessarily always more capable than women. In this respect, one should expect, rather, that the development process would be enhanced in the long run if it were to become more gender-balanced through the presence of women. This would presume that the second part of Phillips' final argument—the opening-up of a fuller range of policy options—really takes place after the inclusion of women in the political process.

Again, the time span of women's incumbency is too short to arrive at unequivocal empirical insights. The establishment of a slightly gendered pattern concerning the mentioning of government schemes and in regard to development priorities is a very important result. It is an indication that a more gender-balanced rural development might take place in future. However, the evidence so far is not very pronounced, and I could not

empirically verify if these preferences were transformed into policies. I want to examine the last argument for political presence along with the assumptions of the empowerment approach.

There is an inherent tension between the theoretical approaches of empowerment and the arguments for a politics of presence. Empowerment is a process that is supposed to occur at the grass-roots, while political presence is unmistakably a top-down approach. It was argued that some advocates of the empowerment approach do not see the inclusion of women into politics as a successful strategy. Some believe that women ought to be first psychologically empowered and that they need to have some gender-awareness and an understanding of the oppressive structural forces. Bystydziensky (1992: 5) argued that a critical mass of women's presence in the political process, supported by a strong women's movement outside the institutions, might be an effective means to empowering women—an argument that was disregarded by Phillips.

The case study established without doubt that the reservation for women is a step towards their empowerment—the question is about the size of the step. A problem of the proponents of empowerment via political presence is that they do not differentiate between women in the political institutions and those outside. However, I believe that it is important to make this distinction. We saw that the elected women as individuals have indeed become empowered, although in their case a lot still remains to be desired. Yet, most proponents of empowerment favour a group approach, and it is open for debate how far women as a group or society as whole are gaining from the political inclusion of some women. The value of symbolic recognition and access to one's representative is undeniable. Further gains would result from a fuller range of policy options and the vigorous advocacy of these priorities.

The empirical evidence concerning the opening up of policy options and the capacity to realize them remained rather inconclusive, as has been pointed out before. This has definitely to do with the short time-span of women's incumbency and the limited room for policy formulation at the level of the PRI. However, other factors emerged as well. We have seen in the case of Balipatna that female representatives indeed mentioned specific policy preferences, what was not that apparent in Gania, but, admittedly, the starting positions were more favourable. In this respect, the advocates of the empowerment approach are right that a certain level of gender-awareness, of understanding structural forces, and autonomy are crucial if women's inclusion into politics is to result in substantive gains for women as a group. Thus, the goal becomes founding the process—which presents itself on first sight as a vicious circle. However, even in Gania, changes took place, although to a lesser degree. The presence of women led to changes in village life in both geographical areas: women became more visible in the public sphere, their participation in politics was considered legitimate to a certain degree, and their service as role models in some respects did have an impact on the larger group of women. All this points to the conclusion that the reservation for women alone will not automatically lead to women's

empowerment as such, but it is definitely still a starting point and may accelerate the overall process. It was also argued that women could be enabled to start formulating their own preferences only when they are drawn into the political process. We have seen that in Orissa this has hardly been the case so far, except in the case of some women in Balipatna. Again, this should be partly due to the short time-frame of women's inclusion, but it appears that in a setting as is prevalent in Orissa additional measures may be needed.

It was already stressed that strong women's movements and female representatives might support each other, for example in the issue of alcohol consumption. Phillips believes that the organization of women's movements to provide women with enabling conditions to formulate a group's point of view poses a too high threshold for participation and is, therefore, rather difficult to follow in practice (1995: 55). This might be true for the national level. However, at the local level in Orissa and elsewhere in India women's groups have already been constituted. They could be promoted to develop a women's point of view, which could then be transmitted to the representatives. In the present case, so far, women's groups dealt with financial matters only, but they could be encouraged (by non-governmental organizations (NGOs), for example) to discuss issues important to women as a group. One cannot assume that these women's groups will always arrive at unified policy priorities. But regarding some issues—such as better maternity care, enhanced access for women to all kinds of resources, working against alcohol consumption and resulting wife beating, etc.—one can imagine that a sizeable number of women could converge on some priorities. I do not suggest that these women's groups should necessarily press women representatives only. However, in societies like that of Orissa, where women's access to male representatives is still rather limited, it seems more likely that they would prefer to address women representatives. Whether the female representatives would really follow these suggestions is an open question. It will definitely depend on the influence these women's groups can exert over their representatives to make them accountable, as well as on the pressure they put on the dominant voters, which are so far still the male villagers. As long as women outside the institution do not co-operate with the female representatives, these aspiring politicians act rational if they are catering to the needs of the politically decisive population—the male elite. Thus, the collaboration of men is another crucial variable, as already mentioned above. If women representatives remain mainly dependent on influential male villagers who have not been co-opted to the cause of women's empowerment, only energetic women's groups might offer a viable solution to the problem.

It appears that in the Orissa setting (and in most, if not all states of the Indian Union) for women to gain independence as well as gender-awareness—inside and outside of the political institutions—is the basis as well as a crucial factor of their empowerment. And this does not happen automatically because of the reservation for women in politics. Again, it appears that what one hopes to be resulting from the quota for women is also partly a pre-condition for its actualization. This does not mean that

nothing has changed so far, but that the pace of change is faster when some preconditions are already met. For a greater impact, the political inclusion of women in Orissa and similar social settings has to be coupled with other strategies—consciousness-raising being one of them, but also capacity building, literacy, and economic measures, like income generation and better implemented property rights. Every policy that enhances women's individual independence and capacities and promotes group based gender-awareness supports the process of empowerment to a considerable degree.

To sum up, one can confidently claim that the combination of approaches to women's political presence and empowerment provided important insights. It was imperative to examine the connection in any case, since many authors, especially in India, have claimed that the one would somehow lead to the other. They claimed this without caring much for the implications of this correlation. It was established that the coming of women into positions of 'power over' is a beginning of the process of women's political empowerment. However, the reluctance of some proponents of the empowerment approach towards the overall impact of women's political presence (especially if some preconditions are not met) proved to be justified. Phillips was very cautious about the transformations of the political process from the inclusion of women as well. She warned that changing the gender-composition of elected political bodies has to be seen mainly as an enabling condition and should not present itself as a guarantee. Undeniably, positive changes—at least from the women's point of view—have already occurred. It has been established that the quota has opened up a new space for rural women to become active in the public sphere. This space was used to different degrees, but some women have undeniably gained from the chance provided to them. For women as a group the major gain was in regard to their pride in the symbolic recognition and the new access they gained to their elected representatives. The individual benefit of the representatives, which might not be a very convincing argument for advocates of a group approach, can be expected to get translated into gains for women as a group, especially since the female representatives could serve as role models for other women. Also, one should not forget the sheer number of women that have become included in the PRI since the implementation of the 73rd Amendment.

The empowerment of women in India has definitely received an important impetus through the quota in local politics—but it will be a long-lasting process. Furthermore, it will be very difficult to expect women representatives to work in the interest of women if there is no sizeable support and pressure from the female constituency. Additionally, they need to be aided by male citizens, officials, and representatives, and one must ensure that men are co-opted for this cause. Another problem poses itself when empowerment is mainly understood as gaining the ability to understand the systematic forces of women's oppression and becoming more autonomous. One has to refer to the fact that the quota in the PRI was not the consequence of a struggle by rural women, which would have forged a certain consciousness, but was bestowed by the 73rd Amendment, which most have never even heard of.

In this respect, one has to argue for the adoption of additional measures—like literacy campaigns, awareness raising, and the promotion of economic independence—but without disregarding the fact that a certain kind of empowerment has already taken place as a direct consequence of the reservation only. There must always be a starting point, and the women's quota in politics is apparently not the least influential one.

Still, as long as women are for the most part dependent on male relatives to fulfil their public duties, as long as they are not relieved of domestic work to some extent, and as long as they do not participate in the institutions such as the grama sabha, where the real decisions take place, it will be very difficult for them to formulate and follow their own preferences and thus become fully empowered to contribute to changing society. Furthermore, as long as the dominant social discourse and rules of segregation discourages women to act independently it will be very difficult for women to follow an effective political career. However, let me remind you once more that Orissa provided a rather difficult environment for women's empowerment to begin with. One can expect greater gains for women's empowerment from women's political presence in more favourable settings. And one should also acknowledge that India as a whole has reached a quantitative level of women's participation in politics of which women in many so-called 'developed' countries can only dream of. And even from the rather difficult case of Orissa there is the strong indication that a process has been started. If we have the patience and promote some additional strategies there may come a time when we shall be able to proclaim: India—A million Indiras now!

Glossary

Adivasi	indigenous population; tribal
Bahu	daughter-in-law; bride
Bandh	collective cessation of public activities; strike
Basanda	(Oriya) social boycott (see also *ekgharkiya*)
Behera	(Oriya) title of the head of a caste group
Chamcha	lit. 'large spoon'; sycophant, flatterer
Chota	small, little; e.g. in *chota neta* ('little leader')
Chuda	flattened rice
Crore	1,00,00,000
Devadasi	lit. 'slave to the god'; female temple dancer
Dharma	law; religion; religious order
Ekgharkiya	(Oriya) lit. 'the single house'; social boycott (see also *basanda*)
Gaanjhia	(Oriya) 'daughter of the village'; woman born in the village
Garjat	territories under the local kings in Orissa at the time of the Mughals (see also *Mughalbandi*)
Gaudas	Milkmen
Ghat	steps to go down to the water (tank or river)
Gram Panchayat	local government at village level
Grama	village or group of contiguous villages having a population between 2,000 to 10,000 in Orissa
Grama Sabha	meeting of the *grama sasan*
Grama Sasan	all persons on an electoral role in a *grama*
Haat	weekly local market where agricultural products and other items are sold
Hanuman-katha	story of Hanuman, the monkey general of the Indian epic Ramayana who helped Rama to get back his wife Sita, told in the villages
Ghee	clarified butter
Izzat	honour
Jagirdar	somebody who is remunerated with land for services rendered to the *raja*
Jhia	daughter
Kaccha	not strongly built; made of mud (opposite of *picchu*)
Kandha	Indian tribe
Kandhayat	peasant militia caste in Orissa; conglomeration of several cultivating castes
Karan	writer caste in Orissa; seen as general caste just below the Brahmins
Keuta	(also called Kaibartta); caste group in Orissa; are either fisherman or prepare *chuda*; they are a 'clean' caste, but have been included into the SC-category
Khadi	home spun cotton
Kisan Sangha	peasant federation

Lakh	1,00,000
Lok Sabha	Indian Parliament
Mahila Mandal	women's group
Mahila Sangatan	women's group organized at gram panchayat level by the NGO DSS in Balipatna
Mahila Sansad	women's group organized at panchayat samiti level by the NGO DSS in Balipatna
Mangalvara-puja	*Puja* made by village women in a group for the well being of their sons
Muduli	name of a potter caste
Mughalbandi	territories directly under the influence of the Mughals in Orissa (see also *Garjat*)
Naib-sarpanch	elected vice-mayor of gram panchayat
Neta	leader; see also *chota* for *chota neta* ('little leader')
Palli	ward
Palli Sabha	meeting of the *palli*
Pallu	end of the sari that is pulled over the head to cover it; veil
Pan	betelnut rolled into a green leaf with various ingredients (sometimes tobacco); chewed in Orissa by men and women
Panchayat Samiti	local government at block level
Pativrata	lit. 'one who fasts for her husband'; dutiful wife
Picchu	(Oriya; Hindi = *pakka*) proper; strong; well-built
Praganath	territorial division in Daspalla kingdom
Prajamandal	freedom movement in the feudal states during the struggle for India's independence
Prakriti	nature (grammatical gender is female)
Puja	religious ceremony
Purdah	lit. 'veil'; practice of female seclusion
Purusa	cosmic man
Raja	king
Rama-katha	story of Rama, the hero of the Indian epic *Ramayana*; told in the villages
Sahi	(Oriya) street; ward
Sahu	name of a caste of oilmen (Teli)
Salwar–Kameez	Indian garment; wide trouser worn with a long tunic by young women
Sarbarakar	head of a village in Daspalla kingdom; appointed by the *raja*; was remunerated with land (compare *jagirdar*)
Sardar	head of a *praganath* in Daspalla kingdom; appointed by the *raja*
Sarkar	government; also territorial division under the Mughals
Sarpanch	directly elected mayor of the gram panchayat
Sarvodaya	lit. 'welfare for all'; village development programme initiated by M.K. Gandhi
Sati	self-immolation of the wife on the pyre of the deceased husband
Satyagraha	lit. 'holding on to the truth'; M.K. Gandhi's agitational means of non-violent resistance
Shakti	power (grammatical gender is female)
Shastra	text form; lays down rules
Shraaddha	death ceremony

Sindoor	vermilion; put on the parting of the hair to indicate the married status of a woman
Smritikaara	special text form
Stree	woman
Subah	territorial division
Swami	lit. 'master'; common title for husband in Orissa
Teli	caste of oilmen
Zamindar	revenue intermediary
Zilla Parishad	local government at district level

Appendix: Gania's History

DASPALLA State, of which Gania was a part, was founded in 1495. Before, the area of Daspalla was part of the kingdom of Boudh. The ruler of Boudh at this time was Birabhanj and he had a younger brother named Sarabhanj. They had a dispute and Sarabhanj proceeded to the east. On this journey he took rest in Badamul, at the mound of the Satkosia Gorge of the Mahanadi River. Here he collected 10 villages (Das-Palla) and established his kingdom. The first capital of Daspalla was Badamul, but it was shifted to Gania in the sixteenth century, and again to Purna (old) Daspalla, which is *c.* 5–6 km away from today's Daspalla. There is actually no village named Daspalla, although everybody refers to the village in which the Palace and the Court is situated as Daspalla. The proper name of the village is Kunjabhanaghara. The legend concerning the name is as follows:

In the eighteenth century there was a ruler of Daspalla named Badhana Padma Bhanj. At the place of the present Daspalla a tribal king was ruling with the name Kunjabhana Mallik. He was wearing a talisman around his arm that protected him from death, but he did feel pain. When he was fighting with Badhana he had to succumb. Not being able to suffer the pain and shame he urged the king to take off his talisman and kill him. In return, the king should bury his head at the very spot and name the place Kunjabhanaghara in his memory. That is how the village got its name.

Daspalla was merged with Orissa after the last *raja* Kisore Deobhanj had been persuaded by Patel while he visited Orissa. Kisore Deobhanj was a member of the National Congress party, and twice Minister of Industry in Orissa. He was not a member of the Gyanatantra Parishad, which was led by other ex-rulers. He died around 1959, and his son Purna Chandra Deobhanj was crowned king. But the present king is living in the house of his father-in-law in Vizhakapatnam (Andhra Pradesh). He comes only once a year for the Lankapuri-Puja—the Festival of Daspalla that is associated with the killing of Ravanna. It takes place in the month of Vaishak (April/May).

The rulers of Daspalla were Kshatriyas—denoted by Deo and the Bhanj title. They have family connections to the rulers of Mayurbhanj, Parikud (Chilika) Boudh, Bisama Cuttack, Puri, and Bolangir. The teacher and advocate stated that the rulers of Daspalla were quite oppressive in general. The last king became more benevolent after the 1940s and also more progressive. They said that the *prajamandal* movement started only very late in Daspalla. Sahu, the nephew of a former *sardar*, said on the other hand:

* The information on Daspalla History was gathered from Dhruba Charana Pradhan (retired teacher from Daspalla high school) and Mohendra Sahoo, Advocate in Daspalla on 17 February 2000, and on Gania in particular from Upendra Sahu, oldest inhabitant of Gania Block (*c.* 85 years), nephew of a former *sardar* on 9 February 2000.

The last ruler of Daspalla was a good ruler. Since Daspalla was sparsely inhabited there was not much revenue. Kisore Deobhanj let cut some of the trees and cleared the jungle for fields and left them to his subjects for cultivation. He also abolished bonded labour and gave justice to everybody. There was a *prajamandal* movement and it was very active. It was started by Loknath Das, my uncle Rasbihari Sahu (the *sardar*), and Bangar Patra. There were 100 other members. There was some agitation but very soon after this the state merged (*c.* after 5 to 6 months). There were meetings in Daspalla and they gave demands to the ruler who fulfilled them, so there were no riots. Women were not active here. It was a very remote and inaccessible area, so women did not participate. There were no roads and people had to walk up to Daspalla. All was dense forest.

As regards the administration, Sahu said:

Gania village was the police station under Daspalla State. The state itself was arranged in 7 *praganaths*. One *praganath* consisted of several villages and was administered by a *sardar*. These *sardars* were responsible for the administration in the villages and their development. They normally had some family background and control over the population. They were nominated by the ruler. If the *sardar* was not efficient, somebody else was made the *sardar*. The *sardars* were the ruler's link to the population. Every year there were two *darbars* (open councils) at the palace of the *raja* in Daspalla and the *sardars* had to report the difficulties in their area. They got a yearly remuneration for this service. Normally they were rich and respected people of this area.

There were also *jagirdars*, the so called *sarbarakars*. There was one *sarbarakar* in every village and they were responsible for the collection of land revenue. The *sarbarakar* got land for his services. Daspalla State was in the borders of today's Daspalla Block and Gania Block. One *praganath* was on the other side of the Mahanadi, which is now Cuttack District. Under Gania Police Station there were 5 *Praganaths*:

(i) Baispalli—today Badasilinga GP (Bais = 20; Palli= Village);
(ii) Panchapalli—today Chhamundia and Rasanga GPs (Pancha = 5);
(iii) Kula Praganath—Kishore Prasad and Gania GPs;
(iv) Jagannath Prasad—Adakata GP and parts of Daspalla Block;
(v) Jorum—trans Mahanadi, now Cuttack District.

Earlier the old Daspalla State formed one block, but it was divided later into Gania and Daspalla Block. Gania is very small in respect to population, but the area is very big. Daspalla State was a medium-sized state, comprising 576 square miles.

Daspalla has a very interesting history. Furthermore, the well known Oriya writer Fakir Mohan Senapati was once Diwan of Daspalla. It is very interesting to read his accounts in his autobiography *Atma Jivan Carita* (My Times and I) 1985. Daspalla has also a special relevance for Orissa's culture; the wood used to build the carts for the famous Jagannath procession traditionally comes from the forests of Daspalla. Furthermore, Daspalla is located at the so-called 'Jagannath Trunk Road', where pilgrims came from Madhya Pradesh on foot on their way to Puri. Every 10 km there were rest-stations that have now been converted to Inspection Bungalows.

Bibliography

Afshar, H. (ed.), 1987, *Women, State and Ideology: Studies from Africa and Asia.* Houndmills/London: Macmillan.

——, 1998, *Women and Empowerment: Illustrations for the Third World.* Houndmills/London: Macmillan.

Agarwal, B., 1994, *A Field of One's Own: Gender and Land Rights in South Asia.* Cambridge: Cambridge University Press.

Agarwala, S.N., 1985, *India's Population Problems.* New Delhi: Tata McGraw-Hill Publishing Company.

Agnihotri, I. and V. Mazumdar, 1995, 'Changing Terms of Political Discourse: Women's Movement in India, 1970s–1990s', *Economic and Political Weekly,* 22 July, pp. 1869–78.

Agnihotri, S.B., 2000, *Sex Ratio Patterns in the Indian Population: A Fresh Exploration.* New Delhi/Thousand Oaks/London: Sage.

Akerkar, S., 1995, 'Theory and Practice of Women's Movement in India: A Discourse Analysis', *Economic and Political Weekly,* 29 April, pp. WS2–WS23.

Almond, G.A. and B.G. Powell (eds.), 1996, *Comparative Politics Today.* New York: HarperCollins.

Almond, G.A. and S. Verba, 1989, *The Civic Culture: Political Attitudes and Democracy in Five Nations.* Newbury Park/London/New Delhi: Sage (1963).

Altekar, A.S., 1991, *The Position of Women in Hindu Civilization.* Delhi: Motilal Banarsidass [1938], Reprint of 1959.

Arun, R., 1996, 'Role of Women in Panchayati Raj', *The Administrator,* April and June, pp. 115–26.

Asthana, P., 1988, *Party System in India: Development or Decay.* New Delhi: Criterion Publications.

Athreya, V.B. and K.S. Rajeswari, n.d., 'Women's Participation in Panchayati Raj: A Case Study from Tamil Nadu'. M.S. Swaminathan Research Foundation Chennai, *c.* 1998 [mimeo].

Austin, G., 1966, *The Indian Constitution.* New York: Oxford University Press.

AVARD (Association of Voluntary Agencies for Rural Development), 1962, *Panchayati Raj as the Basis of Indian Polity: An Exploration into the Proceedings of the Constituent Assembly.* New Delhi: AVARD.

Bachrach, P. and M.S. Bachratz, 1963, 'Decisions and Nondecisions: An Analytical Framework', *American Political Science Review,* Vol. 57, pp. 641–51.

Bagwe, A., 1996, *Of Women Caste: The Experience of Gender in Rural India.* (1995). Calcutta: Stree

Bailey, 1958, *Caste and the Economic Frontier.* Bombay: Oxford University Press.

——, 1963, *Politics and Social Change: Orissa in 1959.* Berkeley: University of California Press.

Baird, R.D., 1991, *Religion in Modern India.* (1981). New Delhi: Manohar (2nd rev. edn.)

Bajpai, A. and M.S. Verma, 1995 and 1997, *Panchayati Raj in India: A New Thrust.* Vols. 1&2, Delhi: Sahitya Prakashan.

Banerjee, K., 1988, 'Sub-Regional Politics in Orissa: A Case Study of Ganatantra Parishad', in B.B. Jena and J.K. Baral (eds.), *Government and Politics in Orissa*. Lucknow: Print House, pp. 228–46.

Banerjee, M., 1998, 'Women in Local Governance: Macro Myths, Micro Realities', *Social Change*, Vol. 28, No. 1, pp. 87–100.

Banerjee, N.K., 1995, 'Grassroot Empowerment (1975–1990): A Discussion Paper'. *Occasional Paper No. 22*, New Delhi: CWDS.

Barai, K., 1994, *Role of Women in the History of Orissa*. Calcutta: Punti Pustak.

Baral, J.K. and K. Patnaik, 1990, *Gender Politics: A Study of Socio-Economic Condition and Political Participation of Working Women in Orissa*. New Delhi: Discovery Publishing House.

Barik, R.K., 1990, 'Popular Culture and Political Elite in Orissa'. *Occasional Papers on Perspectives in Indian Development 22*, New Delhi: Centre for Contemporary Studies, Nehru Memorial Museum & Library.

Basham, A. L., 1991, *The Wonder That Was India*. (1954). Calcutta: Rupa.

Batliwala, S., 1993, *Empowerment of Women in South Asia: Concepts and Practices*, New Delhi: Asian-South Pacific Bureau of Adult Education and FAO's Freedom from Hunger Campaign—Action for Development.

Beetham, D., 1993, *Auditing Democracy in Britain: The Democratic Audit of the United Kingdom*. Democratic Audit Paper No. 1, Essex.

Begin, M., 1998, *Towards a Critical Mass: Women in Politics*. New Delhi: CWDS.

Benhabib, S., 1995, *Selbst im Kontext*. Frankfurt a. M.: Suhrkamp.

Benhabib, S. et al., 1993, *Der Streit um Differenz: Femininsmus und Postmoderne in der Gegenwart*. Frankurt a. M.: Fischer Taschenbuch Verlag.

Berreman, G.D., 1993, 'Sanskritization as Female Oppression in India', in B.D. Miller (ed.), *Sex and Gender Hierarchies*. Cambridge: Cambridge University Press, pp. 366–92.

Beuria, S.T., 'Panchayat Polls Marred by Violence', *Deccan Herald*, Bangalore, 11 July 1992.

Bhandare, M.C. (ed.), 1999, *The World of Gender Justice*. New Delhi: Har-Anand.

Bhargava, B.S., 1979, *Panchayati Raj System and Political Parties*. New Delhi: Ashish Publishing House.

Bhargava, B.S. and A. Samal, 1998, 'Panchayati Raj System: The Orissa Experiment', *Prashasnika*, Vol. 25, No. 2, pp. 91–106.

Bhargava, B.S. and K. Samal, 1993, 'Panchayati Raj System in Orissa: Problems and Prospects', *Institute for the Study of Developing Areas Journal*, Vol. 3, Nos. 3&4, pp. 190–209.

Bhargava, B.S. and K. Subha, 1999, 'Political Empowerment of Women: The Case of Karnataka's Experiments with Panchayati Raj', in R. Ghosh and A.K. Pramanik (eds.), *Panchayat System in India: Historical, Constitutional and Financial Analysis*. New Delhi: Kanishka, pp. 169–88.

Bhargava, B.S. and K.C. Vidya, 1992, 'Position of Women in Political Institutions (With Special Reference to Panchayati Raj System in Karnataka)', *Journal of Rural Development*, Vol. 11, No. 5, pp. 601–28.

Bhaskar, M., 1997, 'Women Panchayat Members in Kerala: A Profile', *Economic and Political Weekly*, 26 April, pp. WS13–WS20.

Bhat, S.C. (ed.), 1997, *The Encyclopaedic District Gazetteers of India*. Vol. 9 (Eastern Zone), New Delhi: Gyan Publishing House.

Bhat, Y. and Y.S. Rao (eds.), 1993, *Image of Women in Indian Literature*. New Delhi: B.R. Publishing Company.

Bhattacharya, J.N., 1973, *Hindu Castes and Sects: An Exposition of the Origin of the Hindu Caste System and the Bearing of Sects Towards Each Other and Towards Other Religious Systems*. (1896). Calcutta: Editions India.

Bhattacharya, M., 1997, 'Democracy and Reservation', *Seminar*, Vol. 457, September, pp. 23–4.

Bhavani, V., 1998, 'Society, Culture and Political Empowerment of Women'. Paper submitted to the 8th National Conference on Women Studies, 30 May–2 June 1998, Pune [mimeo].

Bohra, O.P., 1997, 'Women in Decentralised Democracy', *Journal of Rural Development*, Vol. 16, No. 4, pp. 673–83.

Bose, N.K. (ed.), 1960, *Data on Caste: Orissa*. Calcutta: Anthropological Survey of India, Government of India.

Boserup, E., 1970, *Women's Role in Economic Development*. New York: St. Martin's Press.

Bourdieu, P., 1997, *Outline of a Theory of Practice*. (1977). Cambridge/New York/Melbourne: Cambridge University Press.

Bryant, C.G.A. and D. Jary (eds.), 1997, *Anthony Giddens: Critical Assessments*. London/New York: Routledge.

Bunagan, K. et al., 2000, 'The Quota System: Women's Boon or Bane?' *Women around the World: A Quarterly Publication of the Centre for Legislative Development*, April 2000, Vol. 1, No. 3. Found at *www.cld.org/waw5.htm* on 12.09.2001.

Butler, J., 1990, *Gender Trouble*. London/New York: Routledge, Chapman and Hall, Inc.

Bystydziensky, J. (ed.), 1992, *Women Transforming Politics: Worldwide Strategies for Empowerment*. Bloomington: Indiana University Press.

Calman, L., 1992, *Toward Empowerment: Women and Movement Politics in India*. Boulder: Westview Press.

Carr, M., M. Chen and R. Jhabvala (eds.), 1997, *Speaking Out: Women's Economic Empowerment in South Asia*. (1996). New Delhi: Vistaar Publications.

Carroll, B., 1972, 'Peace Research: The Cult of Power', *Journal of Conflict Resolution*, Vol. 6, No. 4, pp. 558–616.

Chakrapani, C. and V. S. Kumar (eds.), 1994, *Changing Status and Role of Women in Indian Society*. New Delhi: M.D. Publications.

Chandra, S.K., 1997, 'Women and Empowerment', *Indian Journal of Public Administration*, Vol. 43, No. 4, pp. 395–9.

Chandrashekhar, B.K., 1989, 'Panchayati Raj Bill: The Real Flaw', *Economic and Political Weekly*, 1 July, pp. 1433–5.

Chatterjee, B.B., S.S. Singh and D.R. Yadav, 1971, *Impact of Social Legislation on Social Change*. Calcutta: The Minerva Associates.

Chatterjee, P., 1993, *The Nation and Its Fragments: Colonial and Post-Colonial Histories*. Princeton: Princeton University Press.

Childs, S., 2001, '"Attitudinally Feminist"? The New Labour Women MPs and the Substantive Representation of Women', *Politics*, Vol. 21, No. 3, pp. 178–85.

Chitnis, S., 1988, 'Feminism: Indian Ethos and Indian Convictions', in R. Ghadially (ed.), *Women in Indian Society: A Reader*. New Delhi/Newbury Park/London: Sage, pp. 81–95.

Choudhury, R.C. and S. Rajakutty, 1997, *Fifty Years of Rural Development in India: Retrospect and Prospect*. Hyderabad: National Institute of Rural Development (NIRD).

Clark, A.W. (ed.), 1994, *Gender and Political Economy: Exploration of South Asian Systems.* New Delhi: Oxford University Press.

Cobden, Ramsey, 1982, *Bengal Gazetteers: Feudatory States of Orissa.* (1910). Kolkata: Firma KLM

Currie, B., 2000, *The Politics of Hunger in India: A Study of Democracy, Governance and Kalahandi's Poverty,* Houndmills/London: Macmillan.

CWDS (Centre for Women Development Studies), 1986, *The Seeds of Change: Role of Grass-root Rural Women's Organisations in Development.* New Delhi: CWDS.

——, 1987, *Perspectives on Rural Women and Development.* New Delhi: CWDS.

——, 1989, *Partners in Grassroots Democracy: Report of the Workshop on Panchayati Raj and Women.* New Delhi: CWDS.

——, 1995, *Confronting Myriad Oppressions: The Western Regional Experience.* New Delhi: CWDS.

——, 1998, *Gender and the Reservation Debate: A Bibliographic Compilation.* New Delhi: CWDS.

D' Lima, H., 1983, *Women in Local Government: A Study of Maharashtra.* New Delhi: Concept Publishing Company.

D.O.NO.N-110111/20/98-PR, 1999, Letter written by Mrs Sudha Pillai, Joint Secretary, Ministry of Rural Areas and Employment, Dept. of Rural Development to Mr Chinmay Basu, Commissioner-cum-Secretary, Department of Panchayat Raj, Govt. of Orissa on 13 May 1999, held by the author.

Dahl, R., 1989, *Democracy and Its Critics.* New Haven: Yale University Press.

Dahlerup, D., 1988, 'From a Small to a Large Minority: Women in Scandinavian Politics', *Scandinavian Political Studies,* Vol. 11, No. 4, pp. 275–98.

Das, B.N. and N.B. Pradhan, 1988, 'Political Factors in the Economic Development of Orissa', in B.B. Jena and J.K. Baral (eds.), *Government and Politics in Orissa.* Lucknow: Print House, pp. 42–56.

Das, S. (ed.), 1984, *Life and Culture in Orissa.* Kolkata: Minerva Associates.

Das, S., 1994, *Indian Women.* New Delhi: Ess Ess Publications.

Das, U., 1994, 'Aetiology of Gender Gap in Political Representation of Orissa', in *Orissa Review,* January, pp. 5–9.

Datta, B. (ed.), 1998, *'And Who will Make the Chapatis?': A Study of All-Women Panchayats in Maharashtra.* Kolkata: Stree.

Datta, P., 1998, *Major Issues in the Development Debate: Lessons in Empowerment from India.* New Delhi: Kanishka.

Deb, P.K., 1985, 'Working of Panchayati Raj in Orissa', in A.P. Padhi (ed.), *Indian State Politics: A Case Study of Orissa.* New Delhi: B.R. Publishing Company, pp. 247–83.

Desai, M., 2000, 'Constitutionality of the Women's Reservation Bill and it's Proposed Amendments'. Found at *http://altindia.net/gender/readings/ constitutionalityof. html,* downloaded 01.12.2000.

Devi, A., 1986, 'Women in Orissa Politics: A Study in Political Socialisation', in A.K. Gupta (ed.), *Women and Society: The Developmental Perspective.* New Delhi: Criterion, pp. 137–62.

Devi, A., 1988, 'Women in the Local-Self Government Administration in Orissa', *Orissa Review,* September, pp. 43–8.

Dhagamwar, V., 1997, 'Reservations About Further Reservation', *Seminar,* Vol. 457, September, pp. 20–2.

Dhal, S., 1992, 'Rural Development and Panchayati Raj: A Case Study of Orissa, 1952–1989'. University of Delhi: unpubl. M. Phil. thesis in Political Science.

Dhar, A., 2000, 'Political Will Changes Women's Status in Rural Kerala', in *The Hindu*, 6 June 2000, found at *www.the-hindu.com/2000/06/06/stories/ 0206000b.htm*, downloaded 26.3.2001.

Director of Census Operations, Orissa, 1991, *Census of India 1991, Series 19, Orissa, Paper 1 of 1991 Supplement, Provisional Population Totals*. Bhubaneswar.

———, 1996, *Census of India 1991, Series 19, Orissa, Part IV-B (ii), Religion (Table C-9)*. Bhubaneswar.

———, 1997, *Census of India 1991, Series 19, Orissa, Part II-A, General Population Tables*. Bhubaneswar.

Drèze, J. and A. Sen, 1999, *India: Economic Development and Social Opportunity*. (1995). New Delhi: Oxford University Press.

Driscoll, J.M. and C.S. Hyneman, 1955, 'Methodology for Political Scientists', in *The American Political Science Review*, 49 (3), pp. 192–217.

Dube, L., 1997, *Women and Kinship: Comparative Perspectives on Gender in South and South-East Asia*. Tokyo: United Nations University Press & New Delhi: Vistaar Publication.

Dube, S.C., 1990, *Indian Society*. New Delhi: National Book Trust.

Dubey, M. (ed.), 1995, *Indian Society Today: Challenges of Equality, Integration and Empowerment*. New Delhi: Har-Anand.

Elshtain, J.B., 1990, *Power Trips and Other Journeys: Essays in Feminism as Civic Discourse*. Madison: University of Wisconsin Press.

———, 1993, *Public Man, Private Woman: Women in Social and Political Thought*. (1981). Princeton: Princeton University Press.

EPW Research Foundation, 1994, 'Social Indicators of Development in India—II: Inter-State Disparities', in *Economic and Political Weekly* (21 May), pp. 1300–8.

Esaiasson, P. and S. Holmberg, 1996, *Representation From Above. Members of Parliament and Representative Democracy in Sweden*. Aldershot: Dartmouth.

Eschmann, A. (ed.), 1978, *The Cult of Jagannath and the Regional Tradition in Orissa*. New Delhi: Manohar.

Evans, J., 1995, *Feminist Theory Today: An Introduction*. London/ Thousand Oaks/ New Delhi: Sage.

Everett, J.M., 1979, *Women and Social Change in India*. New Delhi: Heritage.

Fardon, R. (ed.), 1985, *Power and Knowledge: Anthropological and Sociological Approaches*. Edinburgh: Scottish Academic Press.

Forbes, G., 1998, *Women in Modern India*. (1987). NCHI 4.2, New Delhi: Cambridge University Press.

Foucault, M., 1980, *Power/Knowledge: Selected Interviews and Writings 1972–1977*, edited by Colin Gordon, New York: Pantheon Books.

Frankel, F. and M.S.A. Rao (eds.), 1990, *Dominance and State Power in Modern India: Decline of a Social Order*. Vol. 2, New Delhi: Oxford University Press.

Freire, P., 1970, *Pedagogy of the Opressed*. New York: Herder & Herder

———, 1973, *Education for Critical Consciousness*. New York: Seabury Press.

———, 1985, *The Politics of Education, Culture, Power and Liberation*. Hadley, Mass.: Bergin & Garvey.

Geissel, B., 1999, 'Approaches for Supporting the Innovative Potential of Female Politicians: The German Case', Conference Paper available at *www.unc.edu/ depts/europe/conferences/Germany_celeb9900/abstracts/geissel_brigitte.htm*, downloaded 10.12.2001.

———, 2003, 'Participation and Mobilization of Female Politicians. Differences Between Parties with and without Quota Rules—the German Case', Paper

presented at the Conference 'Women's Quotas in Urban Local Government: A Cross-national Comparison', organized by the Centre de Science Humaines and the Institute of Social Sciences, 6–7 February 2003, New Delhi: India International Centre.

Ghadially, R. (ed.), 1988, *Women in Indian Society: A Reader*. New Delhi/Newbury Park/London: Sage.

Ghosh, A., 1989, 'The Panchayati Raj Bill', in *Economic and Political Weekly*, 1 July, pp. 1429–31.

Ghosh, D.K., 1995, 'Women Panchayat Members as Heads of Offices: A Study in West-Bengal', in *Journal of Rural Development*, 14 (4), pp. 357–66.

——, 1997, 'Grassroot Women Leaders: Who Are They? A Study in a West Bengal District', in *Journal of Rural Development*, 16 (2), pp. 291–311.

Ghosh, R. and A.K. Pramanik (eds.), 1999, *Panchayat System in India: Historical, Constitutional and Financial Analysis*. New Delhi: Kanishka.

Giddens, A., 1984, *The Constitution of Society*. Cambridge: Polity Press.

Glasenapp, von H., 1986, *Indische Geisteswelt Vol. 1. Glaube und Weisheit der Hindus*. Hanau: Verlag Werner Dausien.

Gopalan, S., 1993, '*Women in Panchayati Raj: Empowerment of Women*'. Unpubl. paper presented at the Workshop on: 'Women and Panchayati Raj Institutions', organized by National Commission for Women, 18–19 October 1993.

——, 1994, 'Paradigm Shift from Welfare to Empowerment', in *Social Welfare*, August, pp. 32–3.

Gould, C. (ed.), 1997, *Key Concepts in Critical Theory: Gender*. New Jersey: Humanities Press.

GoI (Government of India), 1957, *Report of the Team for the Study of Community Projects and National Extension Service*. 3 vols., New Delhi.

——, 1974, *Towards Equality: Report of the Committee on the Status of Women in India*. New Delhi.

——, 1978, *Report of the Committee on Panchayati Raj Institutions*. New Delhi.

——, 1988, *National Perspective Plan for Women, 1988–2000 A.D.* New Delhi.

——, 1989, *The Constitution (Sixty-Fourth Amendment) Bill, 1989*.

——, 1993, *The Constitution (Seventy-Third Amendment) Act, 1992*.

——, 1994, *Powers and Functions of the Panchayati Raj Institutions: A Framework*. Occasional Paper 5, New Delhi.

——, 1995, *Towards Empowering Women*. New Delhi.

——, 1998a, *Indira Awaas Yojana: Guidelines 1998*. New Delhi.

——, 1998b, *Annual Report 1997–98*. New Delhi (Ministry of Human Resource Development, Dept. of Women and Child Development).

——, 2000, *Annual Report 1999–2000*. New Delhi (Ministry of Rural Development).

GoO (Government of Orissa), 1949, *Report of the Land Revenue and Land Tenure Committee*. Cuttack.

——, 1977, *Orissa District Gazetteers—Puri*. Bhubaneswar

——, 1994a, *Orissa Grama Panchayat Manual 1994*. Bhubaneswar.

——, 1994b, *Orissa Panchayat Samiti Manual 1994*. Bhubaneswar.

——, 1994c, *Orissa Zilla Parishad Manual 1994*. Bhubaneswar.

——, 1998, *Compendium of Circulars*. Bhubaneswar.

——, 1999, *Report on Important Activities of Panchayati Raj Department During the Year 1997–98*. Bhubaneswar.

——, s.d.a, *District Statistical Handbook 1993: Khurda*, Bhubaneswar.

——, s.d.b, *District Statistical Handbook 1993: Nayagarh*, Bhubaneswar.

Gowda, S.G., M.S. Dhadave and M.V.S. Gowda, 1996, 'Developmental Role of Women Members of Panchayati Raj Institutions: A Study in Karnataka', in *Journal of Rural Development*, 15 (2), pp. 249–59.

Gunew, S. and A. Yeatman (eds.), 1993, *Feminism and the Politics of Difference*, Sydney: Allen & Unwin.

Gupta, A.K. (ed.), 1986, *Women and Society: The Developmental Perspective*. New Delhi: Criterion.

Haq, M. ul, 1997, *Human Development in South Asia 1997*. Karachi: Oxford University Press.

Harper, M., 1998, *Profit for the Poor: Cases in Micro-Finance*. New Delhi/Calcutta: Oxford and IBH Publishing Co.

Hartsock, N., 1985, *Money, Sex and Power: Towards a Feminist Historical Materialism*. Boston: Northeastern University Press.

Hermsen, J.J. and A. van Lenning (eds.), 1991, *Sharing the Difference: Feminist Debates in Holland*. London/New York: Routledge.

Hirway, I. and D. Mahadevia, 1996, 'Critique of Gender Development Index: Towards an Alternative', in *Economic and Political Weekly*, 26 October, pp. WS87–96.

ICSSR (Indian Council of Social Science Research), 1975, 2nd edn 1988, *Status of Women in India: A Synopsis of the Report of the National Committee*. New Delhi.

Indira, R. and P.K. Behera (eds.), 1999, *Gender and Society in India*. Vol. 2, New Delhi: Manak.

IDEA (International Institute for Democracy and Electoral Assistance), 2001, Gender Section in *www.idea.int/gender/index.html*, downloaded on 12.09.2001.

IFES (International Foundation for Election System), 2001, *Representation of Women in National Elected Institutions: Differences in International Performance and Factors Affecting This*. Paper for Seminar 'Women's Political Representation in the Coming 2004 Election', 14 June 2001, Jakarta.

ISED (Institute for Socio-Economic Development), 1994, *Strengthening Role and Participation of Women Members in Panchayats*. Report of the National Workshop at Panthanivas, Bhubaneswar, 19–21 May 1994.

——, 1997, *Panchayati Raj: Retrospect and Prospect*. National Seminar to Commemorate the 50th Anniversary of our Independence, 20–22 March 1997, Panthanivas, Bhubaneswar.

——, 1998, *Panchayati Raj and Women's Participation: A Stock Taking. A Case Study in Angul District*, Orissa, Bhubaneswar (mimeo).

ISS (Institute of Social Sciences), various years, *PRU (Panchayati Raj Update)*, New Delhi: ISS (available from 1994 onwards).

——, 1998a, *Orisare Panchayatiraj Mahila Pradinidh Samajika Citrapata*, Nua Dilli 1998 [in Oriya]—'Social Profile of Elected Women Representatives in Panchayats of Orissa (Jagatsinghpur, Nuapara, Rayagada)'. New Delhi: ISS.

——, 1998b, *Status and Progress of the Decentralisation Process: West Bengal, Orissa, Andhra Pradesh*. New Delhi: ISS (mimeo).

Jacobson, D., 1999, 'The Women of North and Central India: Goddesses and Wives', in D. Jacobson and S. Wadley, *Women in India: Two Perspectives*. New Delhi: Manohar, pp. 15–109.

Jacobson, D. and S. Wadley, 1999, *Women in India: Two Perspectives*. New Delhi: Manohar.

Jain, D. (ed.), 1975, *Indian Women*. New Delhi: Government of India.

Jain, S.P. and T.W. Hochgesang (eds.), 1995, *Emerging Trends in Panchayati Raj (Rural Local Self-Government) in India*. Hyderabad: National Institute of Rural Development (NIRD).

Jayalakshmi, K., 1995, 'Gender and Political Empowerment', in S.P. Jain and T.W. Hochgesang (eds.), *Emerging Trends in Panchayati Raj (Rural Local Self-Government) in India*. Hyderabad: National Institute of Rural Development (NIRD), pp. 121–6.

——, 1997, 'Empowerment of Women in Panchayats: Experiences of Andhra Pradesh', *Journal of Rural Development*, 16 (2), pp. 369–78.

Jeffery, P. and A. Basu (eds.), 1999, *Resisting the Sacred and the Secular: Women's Activism and Politicized Religion in South Asia*. New Dehli: Kali for Women.

Jeffery, P. and R. Jeffery, 1996, *Don't Marry Me to a Plowman: Women's Everyday Lives in Rural North India*. Colorado/Oxford: Westview Press.

Jena, A.C. and B. Mukherjee, 1994, 'Discrimination Against Women in Rural India and the Perceived Role of the Panchayati Raj for Its Removal', in C. Chakrapani, C. and V.S. Kumar (eds.), *Changing Status and Role of Women in Indian Society*. New Delhi: M D Publications, pp. 291–310.

Jena, B.B., 1994, 'Orissa Politics', *The Indian Journal of Political Science*, 55 (3), pp. 285–98.

——, 1995, 'Orissa', in G. Mathew (ed.), *Status of Panchayati Raj in the States of India 1994*. Delhi: Concept Publishing House, pp. 157–65.

Jena, B.B. and J.K. Baral (eds.), 1988, *Government and Politics in Orissa*. Lucknow: Print House.

Jena, B.B. and J.K. Baral, 1989, *Election Politics and Voting Behaviour in India: A Study of Orissa*. New Delhi: Discovery Publishing House.

John, M.E., 1998, *Feminism, Internationalism and the West: Questions from the Indian Context*. New Delhi: CWDS (Occasional Paper 27).

Kabeer, N., 1994, *Reversed Realities: Gender Hierarchies in Development Thought*. New Delhi: Kali for Women.

Kakar, S., 1988, 'Feminine Identity in India', in R. Ghadially (ed.), *Women in Indian Society: A Reader*. New Delhi/Newbury Park/London: Sage, pp. 44–68.

Kamble, J.R., 1985, *Pursuit of Equality in Indian History*. New Delhi: National Publishing House.

Kanango, S.D., 1996, 'Panchayati Raj and Emerging Women Leadership: An Overview', in *Social Action*, January-March, pp. 76–91.

Kanter, R.M., 1977, 'Some effects of the proportion of group life: Skewed Sex Ratios and Responses to Token Women', in *American Journal of Sociology*, 82 (2), pp. 965–90.

Karlekar, M., 1993, *A Fieldworker in Women's Studies*. New Delhi: CWDS (Occasional Paper 19).

KAS (Konrad Adenauer Stiftung) (ed.), 1998 a, *State-Local Fiscal Relations in India*. New Delhi: Manohar.

——, 1998 b, *Local Government and Finances in India*. New Delhi: Manohar.

Kasturi, L., 1995, *Development, Patriarchy and Politics: Indian Women in the Political Process 1947–1992*. New Delhi: CWDS (Occasional Paper 25).

Kaushik, S., 1993, *Women and Panchayati Raj*. New Delhi: Har-Anand (Friedrich-Ebert-Stiftung).

——, 1995, *Panchayati Raj in Action: Challenges to Women's Role*. New Delhi: Friedrich-Ebert-Stiftung.

——, 1997, *Women Panches in Position: A Study of Panchayati Raj in Haryana*. New Delhi: Centre for Development Studies and Action.

——, 1999, 'Political Empowerment and Gender Justice', in M.C. Bhandare (ed.), *The World of Gender Justice*. New Delhi: Har-Anand, pp. 183–91.

Khanna, B.S., 1994, *Panchayati Raj in India*. New Delhi: Deep & Deep.

King, D. and G. Stoker (eds.), 1996, *Rethinking Local Democracy*. Houndmills/London: MacMillan Press.

King, G., R.O. Keohane and S. Verba, 1994, *Designing Social Enquiry: Scientific Interference in Qualitative Research*. Princeton: Princeton University Press.

Kishwar, M., 1996, 'Women and Politics: Beyond Quotas', in *Economic and Political Weekly*, 26 October, pp. 2867–74.

Kohli, A. et al., 1995, 'The Role of Theory in Comparative Politics: A Symposium', in *World Politics*, 48 (1), pp. 1–49.

Krishna, S., 1997, 'Women and Panchayati Raj: The Law, Programmes and the Practices', in *Journal of Rural Development*, 16 (4), pp. 651–62.

Krishnakumar, R., 2000, 'A People's Movement', in *Frontline* 17 (12), 10 June–23 June 2000, at *www.frontlineonline.com/fl1712/17121140.htm*, downloaded 12.10.2001.

Kumar, A.K.S., 1996, 'UNDP's Gender-Related Development Index: A Computation for Indian States', in *Economic and Political Weekly*, 6 April, pp. 887–95.

Kumar, R., 1989, 'The Women's Movement', in *Seminar*, 355 (March), pp. 21–5.

Kumari, A. and S. Kidwai, 1996, *Crossing the Sacred Line: Women's Search for Political Power*. New Delhi: Friedrich-Ebert-Stiftung.

Kumari, R. (ed.), 1992, *Women in Decision Making*. New Delhi: Vikaas.

Lal, G.M.M., 1994, *Rajiv Gandhi and Panchayati Raj: Democracy and Development at the Grassroots*. New Delhi: Konark Publishers.

Lele, M.K., 2000, 'Social Justice, Representation and the Issue of Reservations', *http//altindia.net/gender/rea...ialJusticeandreservations.html*, downloaded 01.12.2000.

Lelithabhai, K.N., 1998, 'Empowering Women through Panchayati Raj', in *Kurukshetra*, August, pp. 9–12.

Levi, M., 1996, 'Social and Unsocial Capital', in *Politics and Society*, 24 (1), March, pp. 45–55.

Lieten, G.K., 1996, *Development, Devolution and Democracy*. New Delhi/Thousand Oaks/London: Sage.

Lijphart, A., 1984, *Democracies: Pattern of Majoritarian and Consensus Government in Twenty-one Countries*. New Haven: Yale University Press.

Lipset, S.M., 1959, *Political Man*. London: Heinemann.

Loomba, A., 1999, *Colonialism/Postcolonialism*. (1998). London/New York: Routledge.

Lovenduski, J. and A. Karam, 2001, 'Women in Parliament: Making a Difference', in *http://www.idea.int/women/parl/ch5a.htm*, downloaded 12.09.2001.

Lukes, S., 1974, *Power: A Radical View*. Houndmills/London: Macmillan.

Maddick, H., 1970, *Panchayati Raj: A Study of Rural Local Government in India*. London: Longman.

Mahapatra, L.K., 1984, 'The Role of Hindu Princes in the Caste System of Orissa', in S. Das (ed.), *Life and Culture in Orissa*. Calcutta: Minerva Associates, pp. 42–60.

Mahtab, H.K., 1960, *History of Orissa*. Cuttack: Prajatantra Prachar Samiti.

Mallick, R.M., 1996, 'Empowerment of Women in Development Perspectives: Some

Basic Issues', in B. Mohanty (ed.), *Development of Women: Present Status and Future Strategy.* Bhubaneswar: Mayur Publications, pp. 22–42.

Manikyamba, K., 1994, 'Women in Panchayati Raj Bodies: Shift from Peripheral to Leadership Roles', in C. Chakrapani and V.S. Kumar (eds.), *Changing Status and Role of Women in Indian Society.* New Delhi: M D Publications, pp. 311–23.

Manikyamba, P., 1989, *Women in Panchayati Raj Structures.* New Delhi: Gyan Publishing House.

Manin, B., 1997, *The Principles of Representative Government.* Cambridge: Cambridge University Press.

MARG (Multiple Action Research Group), 1998, *They Call Me Member Saab: Women in Haryana Panchayati Raj.* New Delhi: Multiple Action Research Group.

Mathew, G. (ed.), 1995a, *Status of Panchayati Raj in the States of India 1994.* New Delhi: Concept Publishing House.

——, 1995b, *Panchayati Raj: From Legislation to Movement.* New Delhi: Concept Publishing Company.

Mathew, P.M., 1997, 'Women in Panchayats: The More Relevant Questions', in *Economic and Political Weekly,* 7 June, pp. 1362–3.

Mazumdar, V., 1985, *Emergence of the Women's Questions in India and the Role of Women Studies.* New Delhi: CWDS (Occasional Paper 7).

——, 1995, 'Gender Dimensions of Social Development', in M. Dubey (ed.), *Indian Society Today: Challenges of Equality, Integration and Empowerment.* New Delhi: Har-Anand, pp. 158–85.

——, 1997, 'Historical Soundings', in *Seminar,* 457, September, pp. 14–19.

McAllister, I. and D. Studlar, 1992, 'Gender and Representation among Legislative Candidates in Australia', *Comparative Political Studies,* 25 (3), pp. 388–411.

Meenakhshisundaram, S.S., 1995, 'Empowerment of Women through Panchayati Raj', in *The Administrator,* July–September, pp. 161–5.

Menon, N., 2001, 'Introduction', in N. Menon (ed.), *Gender and Politics in India.* (1999). New Delhi: Oxford University Press.

Mies, M. and V. Shiva, 1993, *Ecofeminism.* Halifax: Fernwood Publications.

Milbrath, L.B., 1965, *Political Participation: How and Why Do People Get Involved in Politics.* Chicago: Rand MacNally & Co.

Miller, B.D., 1981, *The Endangered Sex.* Ithaca, N.Y.: Cornell University Press.

Minault, G., 1981, 'The Extended Family as Metaphor and the Expansion of Women's Realm', in G. Minault, *The Extended Family: Women and Political Participation in India and Pakistan.* Delhi: Chanakya Publications, pp. 3–18.

Mishra, P.K., 1979, *The Political History of Orissa: 1900–1936.* New Delhi: Oriental Publishers and Distributors.

——, 1985, 'Political Processes in Orissa (1938–51)', in A.P. Padhi (ed.), *Indian State Politics: A Case Study of Orissa.* New Delhi: B.R. Publishing Company, pp. 8–26.

Mishra, R., 1998, 'Devolution of Power to Women in Panchayati Raj in Orissa: Challenges and Opportunities', in *Kurukshetra,* November, pp. 19–24.

Mishra, R.N., 1984, *Regionalism and State Politics in India.* New Delhi: Ashish Publishing House.

Mishra, S., 1997, 'Women and 73rd Constitutional Amendment Act: A Critical Appraisal', in *Social Action,* 47 (1), pp. 16–30.

——, 1999, 'Women and Work: Development Experiences in Rural Orissa', in R.

Indira and P.K. Behera (eds.), *Gender and Society in India*. Vol. 2, New Delhi: Manak, pp. 30–47.

Mishra, S.N., L. Kumar and Ch. Pal, 1996, *New Panchayati Raj in Action*. New Delhi: Mittal Publications.

Misra, B., 1988, *Village Life in India: Past and Present*. Delhi: Ajanta Publications.

Misra, S.N., 1989, *Party Politics and Electoral Choice in an Indian State*. Delhi: Ajanta Publications.

Mitra, S.K. (ed.), 1990, *Politics of Positive Discrimination*. Bombay: Popular Prakashan.

——, 1991, 'Room to Manoeuvre in the Middle: Local Elites, Political Action, and the State in India', in *World Politics*, 43 (3), April, pp. 390–413.

——, 1992, *Power, Protest and Participation*. London and New York: Routledge.

Mohanty, Bedabati (ed.), 1996, *Development of Women: Present Status and Future Strategy*. Bhubaneswar: Mayur Publications.

Mohanty, Bidyut, J. Roy and S. Gupta (eds.), 1996, *Women and Political Empowerment 1997: Women's Political Empowerment Day Celebrations on Panchayats, Women and Primary Education*. New Delhi: ISS.

Mohanty, Bidyut, 1995, 'Panchayati Raj, 73rd Constitutional Amendment and Women', in *Economic and Political Weekly*, 30 December, pp. 3346–50.

—— (ed.), 1996, *Women and Political Empowerment: Proceedings of Women's Political Empowerment Day Celebrations 23–24 April 1995*. New Delhi: ISS.

——, 1999, 'Panchayati Raj Institutions and Women', in R. Ray and A. Basu, *From Independence Towards Freedom*. New Delhi: Oxford University Press, pp. 19–33.

Mohanty, J., 1996, *Glimpses of Indian Women in the Freedom Struggle*. New Delhi: Discovering Publishing House.

Mohanty, M. and L.N. Misra, 1976, 'Orissa: Politics of Political Stagnation', in I. Narain (ed.), *State Politics in India*. New Delhi: Meenakshi Prakashan, pp. 240–61.

Mohanty, M., 1990, 'Class, Caste and Dominance in a Backward State: Orissa', in F. Frankel and M.S.A. Rao (eds.), *Dominance and State Power in Modern India: Decline of a Social Order*. Vol. 2, New Delhi: Oxford University Press, pp. 321–67.

——, 1995, 'On the Concept of "Empowerment"', in *The Indian Journal of Social Science*, 8 (4), pp. 333–8.

Mohanty, N., 1982, *Oriya Nationalism: The Quest for a United Orissa*. New Delhi: Manohar.

Mohapatra, J.K., 1985, *Factional Politics in India*. Allahabad: Chugh Publications.

Mohapatra, K., 1995, *Women in Panchayati Raj in Orissa: A Study from the Field*. Bangalore: UMA Resource Centre (Occasional Paper Series No. 8).

Mohapatra, K.K., L. Mohapatra and S. Mohanty (eds.), 1998, *The HarperCollins Book of Oriya Short Stories*. New Delhi: HarperCollins Publishers India.

Momsen, J.H., 1991, *Women and Development in the Third World*. London: Routledge

Moser, C., 1993, *Gender Planning and Development: Theory, Practice and Training*. London/New York: Routledge.

Mossuz-Lavau, J., 2003, *Political Parity Between Women and Men: History and First Balance*, paper held on 5 February 2003 at the IIC, New Delhi.

Mukherjee, A. (ed.), 1994, *Decentralisation of Panchayats in the 1990s*. New Delhi: Vikas.

Mukhopadhyay, A., 1995, 'Kultikri: West-Bengal's Only All-Women Gram Panchayat', in *Economic and Political Weekly*, 3 June, pp. 1283–5.

——, 1996, *Coming of Women into Panchayati Raj*. Calcutta: Jadavpur University, School of Women Studies (Occasional Paper 2).

N.N., 2000, 'Shared Experience', in *The Hindu*, 28 May 2000, at *www.indiaserver. com/thehindu/2000/05/28/stories/1328083a.htm.*

Naipaul, V.S., 1994, *India: A Million Mutinies Now*. (1990). London: Minerva.

Nanda, S., 1979, *Coalitional Politics in Orissa*. New Delhi/Jullundur/Bangalore: Sterling Publications Pvt. Ltd.

Nandy, A., 1980, 'Woman versus Womanliness in India: An Essay in Cultural and Political Psychology', in A. Nandy (ed.), *At the Edge of Psychology: Essays in Politics and Culture*. New Delhi: Oxford University Press, pp. 32–46.

Nanivadekar, M., 1998, 'Reservation for Women: Challenge of Tackling Counter-Productive Trends', in *Economic and Political Weekly*, 11 July, pp. 1815–19.

Narasimhan, S., 1999a, *Empowering Women: An Alternative Strategy from Rural India*. New Delhi/Thousand Oakes/London: Sage.

——, 1999b, 'Empowering Rural Women: An Overview of Past State Initiatives', in *Kurukshetra*, September, pp. 2–8.

Narayan, J. et al., 2000, 'Enhancing Women's Representation in Legislatures: An Alternative to the Government Bill for Women's Reservation', at *http:// www.freespeech.org/manushi/116/alterbill.html*, downloaded 1.12.2000.

Nayak, U., 1999, *Women's Development and Social Conflicts: Historical Perspectives on Indian Women*. New Delhi: Kanishka.

Nicholson L., 1986, *Gender and History: The Limits of Social Theory in the Age of the Family*. New York: Columbia University Press.

Norris, P. and J. Lovenduski, 1995, *Political Recruitment. Gender, Race and Class in the British Parliament*. Cambridge: Cambridge University Press.

——, 2001, 'Blair's Babes: Critical Mass Theory, Gender, and Legislative Life', Paper for the Women and Public Policy Program, Sept. 2001, at *www.ksg. harvard.edu/ wappp/research/BlairsBabes.pdf.*

Nussbaum, M.C., 2000, *Women and Human Development: The Capabilities Approach*. New Delhi: Kali for Women.

Oommen, M.A., 1996, *Panchayati Raj Development Report 1995*. New Delhi: ISS.

OSCARD, 1993, 'Participation of Women in Panchayati Raj in Orissa: A Status Report'. Prepared by the Institute of Panchayati Raj and Social Work, Bhubaneswar [unpubl. manuscript].

OVHA (Orissa Voluntary Health Assoc.), 1995, *Status of Health in Orissa*. Bhubaneswar: OVHA.

Padhi, A.P. (ed.), 1985, *Indian State Politics: A Case Study of Orissa*. New Delhi: B.R. Publishing Company.

Padhy, U., 1995, *Political, Social and Cultural Resurgence in Orissa*. Calcutta: Punthi-Pustak.

Pai, S., 1998, 'Pradhanis in New Panchayats: Field Notes from Meerut District', in *Economic and Political Weekly*, 2 May, pp. 1009–10.

Pal, M., 1994, 'Gap Between Availability and Requirement of Training Infrastructure Under Panchayati Raj', in *Journal of Rural Development*, 13 (2), April–June, pp. 159–79.

——, 1999, 'Empowerment of Women Through Panchayats: An Assessment and Tasks', in *Women's Link*, 5 (2), pp. 20–9.

Palriwala, R. and I. Agnihotri, 1996, 'Tradition, the Family, and the State: Politics

of Contemporary Women's Movement', in T.V. Sathyamurthi (ed.), *Region, Religion, Caste, Gender and Culture in Contemporary India*. Vol. 3, New Delhi: Oxford University Press, pp. 503–32.

Panda, S., 1990, *Determinants of Political Participation: Women and Public Activity*. New Delhi: Ajanta Publications.

——, 1992, *Women and Social Change in India*. New Delhi: Ashish Publishing House.

——, 1995a, *Gender, Environment and Participation in Politics*. New Delhi: M D Publications.

——, 1995b, 'Women in Rural Local Government', in *Kurukshetra*, April, pp. 103–7.

——, 1997, 'Political Empowerment of Women: A Case of Orissa', in *Journal of Rural Development*, 16 (4), pp. 663–72.

——, 1998, 'Decision Making in Panchayats: Role of Women', in *Yojana*, July, pp. 11–15.

——, 1999, 'Political Empowerment of Women: Case of Orissa PRIs', in *Indian Journal of Public Administration*, 45 (1), pp. 86–94.

Pandey, S., 1992, 'Women's Education and Development in Orissa: An Analysis', in *Social Change*, December, pp. 27–33.

Parija, A., S. Baral and K. Mishra, 1988, 'Women Politics in Orissa', in B.B. Jena and J.K. Baral (eds.), *Government and Politics in Orissa*. Lucknow: Print House, pp. 407–14.

Pateman, C., 1970, *Participation and Democratic Theory*. Cambridge: Cambridge University Press.

Pathy, J., 1982, 'Caste, Class and Power in Rural Orissa', in G. Omvedt (ed.), 1982, *Land, Caste and Politics in Indian States*. Delhi: Teaching Politics, pp. 51–61.

——, 1988, *Underdevelopment and Destitution: Essays on Orissan Society*. New Delhi: Inter-India Publications.

Pati, B., 1993a, *Resisting Domination*. New Delhi: Manohar.

——, 1993b, 'Face of Dowry in Orissa', in *Economic and Political Weekly*, 22 May, pp. 1020–2.

Patnaik, A.K., 1985, 'Nature of the Council of Ministers in Orissa from 1936 to 1950', in A.P. Padhi (ed.), *Indian State Politics: A Case Study of Orissa*. New Delhi: B.R. Publishing Company, pp. 27–33.

Patnaik, N., 1960, 'Kaibartta or Keuta of Puri District', in N.K. Bose (ed.), *Data on Caste: Orissa*. Calcutta: Anthropological Survey of India, Government of India, pp. 175–8.

Patra, K.M. and B. Devi, 1983, *An Advanced History of Orissa*. Ludhiana: Kalyani Publishers.

Pattanaik, B.K., 1996, 'Political Empowerment of Women and Village Development', in *Yojana*, December, pp. 24–5, 31.

Pattnaik, S., 2002, 'Orissa Bureaucracy Remains a Male Bastion', in *Hindustan Times* (Delhi edition), 18 February, p. 11.

Phillips, A., 1995, *The Politics of Presence*. Oxford: Clarendon Press.

Pintat, C., 2001, *A Global Analysis: What Has Worked For Women in Politics and What Has Not, 1975–1998*, at *www.capwip.org/resources/whatworked/pintat.html*, downloaded 12.09.2001.

Pradhan, S., 1986, *Agrarian and Political Movements: States of Orissa*. New Delhi: Inter-India Publications.

Praharaj, D.M., 1988, *Tribal Movements and Political History in India*. New Delhi: Inter-India Publications (Tribal Studies of India Series; T–127).

PRIA (Society for Participatory Research in Asia) and NCRSOs (Network of Collaborating Regional Support Organisations).

PRIA and NCRSOs, 1999, *Status of Finances of the Panchayati Raj Institutions: An Overview*. New Delhi: PRIA.

Pujari, P. and V.K. Kaushik, 1994, 'Resurgence in Orissa', in P. Pujari and V.K. Kaushik, *Women Power in India*, Vol. 1: *Women in India: Democracy to Development*. New Delhi: Kanishka, pp. 151–76.

Putnam, R.D., 1993, *Making Democracy Work: Civic Traditions in Modern Italy*. Princeton: Princeton University Press.

——, 1995, 'Bowling Alone: America's Declining Social Capital', in *Journal of Democracy* 6 (1), pp. 65–78.

Rai, S., 1999, 'Democratic Institutions, Political Representation and Women's Political Empowerment: The Quota Debate in India', in *Democratization*, 6 (3), pp. 84–99.

Rajan, R.S., 1993, *Real and Imagined Women: Gender, Culture and Postcolonialism*. London and New York: Routledge.

Rajput, P., 1993, 'Women Leadership at the Grassroot Level in Punjab', in S. Kaushik (ed.), *Women's Participation in Politics*. New Delhi: Vikas Publishing House, pp. 31–44.

Raju, R., 1996, 'Socio-economic Issues and Women Legislators of Orissa: During British Period (1936–1947)', in S.N. Tripathy, *Unorganised Women Labour in India*. New Delhi: Discovery, pp. 141–8.

Rao, B.S. and B. Parthasarathy, 1997, *Anti-Arrack Movement of Women in Andhra Pradesh and Prohibition Policy*. New Delhi: Har-Anand Publications Pvt. Ltd.

Rao, C., 1977, 'Orissa', in R.G. Reddy (ed.), *Patterns of Panchayati Raj in India*. New Delhi: Macmillan, pp. 197–223.

Rath, N., 1995, *Development Scenario of Women in Orissa*. Bhubaneswar: Nabakrushna Choudhury Centre for Development Studies (Occasional Paper No. 18).

Rath, S. and M. Panda, 1993, *Participatory Democracy and Development at Block Level in India*. Meerut: Anu Books.

Rath, S.N., 1985, 'Democratic Decentralization in Orissa', in A.P. Padhi (ed.), *Indian State Politics: A Case Study of Orissa*. New Delhi: B.R. Publishing Company, pp. 284–97.

Ray, P., 1993, 'Oriya: The Image of Women in Oriya Short Story', in Y. Bhat and Y.S. Rao (eds.), *Image of Women in Indian Literature*. New Delhi: B.R. Publishing Company, pp. 103–8.

Ray, R. and A. Basu, 1999, *From Independence Towards Freedom*. New Delhi: Oxford University Press.

Reddy, R.G., 1977, 'Introduction', in R.G. Reddy (ed.), *Patterns of Panchayati Raj in India*. New Delhi: Macmillan, pp. 1–27.

Rerrich, M.S., 1996, 'Modernizing the Patriarchal Family in West Germany: Some Findings on the Redistribution of Family Work Between Women', in *The European Journal of Women's Studies*, 3 (1), pp. 27–39.

Rothermund, D., 1993, *Staat und Gesellschaft in Indien*. Mannheim: BI-Taschenbuchverlag (Meyers' Forum; 15).

Rout, B.C., 1988, 'The Orissa Legislative Assembly: An Evolutionary Study', in B.B. Jena and J.K. Baral (eds.), *Government and Politics in Orissa*. Lucknow: Print House, pp. 100–13.

—— (ed.), 1991, *Orissa Administration*. Bhubaneswar: Panchashila.

Rout, K.C., 1988, *Local Self-government in British Orissa 1869–1935*. Delhi: Daya Publishing House.

Rowlands, J., 1998, 'A Word of the Times, But What Does It Mean? Empowerment in the Discourse and Practice of Development', in H. Afshar (ed.), *Women and Empowerment: Illustrations for the Third World*. Houndmills/London: Macmillan, pp. 11–34.

Roy, K., 1999, *Women in Indian Politics*. Delhi: Rajat Publications.

Sahu, J.K., 1997, *Historical Geography of Orissa*. New Delhi: Decent Books.

Sahu, N.K. (ed.), 1956, *History of Orissa*. Vols. 1&2, Calcutta: Sushil Gupta.

Samal, A. and B.S. Bhargava, 1999, 'Panchayati Raj Under Siege: An Analysis of Orissa's Experiment with Rural Local Government', in R. Ghosh and A.K. Pramanik (eds.), *Panchayat System in India: Historical, Constitutional and Financial Analysis*. New Delhi: Kanishka, pp. 137–58.

Samal, A.K. and M. Samal, 1998, *Panchayati Raj Laws in Orissa (Panchayat Hand Book)*. Cuttack: The Legal Miscellany.

Santha, E.K., 1999, *Political Participation of Women in Panchayati Raj: Haryana, Kerala, and Tamil Nadu*. New Delhi: ISS.

Saran, S.V., 1993, 'Women in Panchayats', in *Yojana*, 15 September, pp. 6–14, 21.

Sathyamurthi, T.V. (ed.), 1996, *Region, Religion, Caste, Gender and Culture in Contemporary India*. Vol. 3, New Delhi: Oxford University Press.

Saxena, K., 1994, 'Empowerment of Women: The Indian Context', in *Indian Journal of Political Science*, 55 (4), pp. 391–400.

Senapati, F.M., 1985, *Atma-Jivana-Carita (My Times and I)*. (1917). Translated by John Boulton, Bhubaneswar: Orissa Sahitya Academy.

——, 1998, 'The Bride-Price', in K.K. Mohapatra, L. Mohapatra and S. Mohanty (eds.), *The HarperCollins Book of Oriya Short Stories*. New Delhi: Harper Collins Publishers India, pp. 1–23.

Senapati, R.N., 1992, 'Declining Sex Ratio in Orissa', in *Orissa Review*, September, pp. 26–30.

Sharma, K., 1991–2, 'Grassroots Organizations and Women's Empowerment: Some Issues in the Contemporary Debate', in *Samya Shakti*, Vol. 6. New Delhi: CWDS.

——, 1998, *Power Vs. Representation: Feminist Dilemmas, Ambivalent State and the Debate on Reservation for Women in India*. New Delhi: CWDS (Occasional Paper 28).

Sharma, S., 1994, *Grass Root Politics and Panchayati Raj*. New Delhi: Deep & Deep.

Sharpe, E.C., 1991, 'Christianity in India', in R.D. Baird, *Religion in Modern India* (1981). New Delhi: Manohar (2nd rev. edn.), pp. 221–38.

Shiva, V. (ed.), 1993, *Minding Our Lives*. New Delhi: Kali for Women.

Siim, B., 2000, *Gender and Citizenship: Politics and Agency in France, Britain and Denmark*. Cambridge: Cambridge University Press.

Singh, V.B. and S. Bose, 1987, *State Elections in India: Data Handbook on Vidhan Sabha Elections 1952–85*, Vol. 3: *The East & North East*. New Delhi: Sage.

Skjeie, H., 2001, 'Credo on Difference: Women in Parliament in Norway', at *www.idea.int/women/parl/studies*, downloaded 12.09.2001.

Srinivas, M.N., 1987, *The Dominant Caste and Other Essays*. New Delhi: Oxford University Press.

——, 1989, *The Cohesive Role of Sanskritization and Other Essays*. New Delhi: Oxford University Press.

Stake, R.E., 1995, *The Art of Case Study Research*. Thousand Oakes/ London/New Delhi: Sage.

State Election Commission of Orissa, 1997, *Information on 3-tier Panchayat General Election 1997*. Bhubaneswar.

State Finance Commission of Orissa, 1998, *Report of the State Finance Commission*. Bhubaneswar.

Tarrow, S., 1996, 'Making Social Science Work Across Space and Time: A Critical Reflection on Robert Putnam's Making Democracy Work', in *American Political Science Review*, 90 (1), pp. 389–97.

Thomas, S., 1994, *How Women Legislate*. Oxford: Oxford University Press.

Tiwari, A.K., 1994, *State Politics in India: A Case Study of Orissa 1961–1971*. New Delhi: National Book Organisation.

Verba, S., B. Ahmed and A. Bhatt, 1971, *Caste, Race, and Politics: A Comparative Study of India and the United States*. Beverly Hills & London.

Vidya, K.C., 1997, *Political Empowerment of Women at the Grassroots*. New Delhi: Kanishka.

Visaria, P., 1971, *The Sex Ratio of the Population of India*. Monograph No. 10, Census of India 1961. New Delhi: Office of the Registrar General, India.

Vithal, C.P., 1997, 'Aspects of Panchayat Finances: An Analysis of Panchayat Acts', in *Journal of Rural Development*, 16 (1), pp. 123–34.

Wadley, S., 1999a), 'Women and the Hindu Tradition', in D. Jacobson and S. Wadley, *Women in India: Two Perspectives*. New Delhi: Manohar, pp. 111–35.

——, 1999b), 'The "Village Indira": A Brahmin Widow and Political Action in Rural north India', in D. Jacobson and S. Wadley, *Women in India: Two Perspectives*. New Delhi: Manohar, pp. 225–50.

Wängnerud, L., 2000, 'Testing the Politics of Presence: Women's Representation in the Swedish Riksdag', in *Scandinavian Political Studies*, 23 (1), pp. 67–91.

Weiner, M., 1962, 'Political Parties and Panchayati Raj', in *Indian Journal of Public Administration*, 8 (4), pp. 623–8.

XIM (Xavier Institute of Management), 1996a, *Status of Women in Orissa*, Vol. XII: *Khurda District*. Bhubaneswar: XIM.

——, 1996 b, *Status of Women in Orissa*, Vol. XV: *Nayagarh District*. Bhubaneswar: XIM.

Yeatman, A., 1993, 'Voice and Representation in the Politics of Presence', in S. Gunew and A. Yeatman (eds.), 1993, *Feminism and the Politics of Difference*. Sydney: Allen & Unwin, pp. 228–45.

Young, I.M., 1990, *Justice and Politics of Difference*. Princeton: Princeton University Press

Index

302 *Index*

Giddens, Anthony 52
Gopalbandhu Academy 207
Gram Panchayat, income of the 248; in
 Orissa 67–73, 206, 211, 247;
 participation in 152–4, 229–30, 232,
 243, 262, *see also* PRI
gram sabha 158–61, 262, 265, *see also*
 grass-roots democracy
grass-roots democracy, the workings of
 161–70, *see also* gram sabha

Hartsock, N. 44
Hindu Succession Act 1956 84
Hinduism, female role models in 21, 254

Indira Awas Yojana (IAY) 164, 168, 177,
 178, 192, 197
Integrated Rural Development Programme
 (IRDP) 77, 177

Jawahar Rozgar Yojana (JRY) 177, 178
Jharkand Mukti Morcha (JMM) 67

Kabeer, Naila 20, 42, 44, 45
Kakar, Sudhir 84–8 *passim*
Karan, Harihar 114, 183

Land Revenue and Tenure Committee 61
Lele, M.K. 38, 42
Lovendusky, Joni 19, 39
Lukes, Steven 20, 42

Mahila Mandals 56, 151, 205, 208, 220,
 221, 226, 228, 232, 233
Mahila Samakhya Programme 256
Mahila Sangatan 227, 230, 232, 234
Mahila Sansad 230
Mathew, George 64
Montagu-Chelmsford Committee 56; Report
 of the 61
MP Untied Fund 177
multi-member constituencies 30, 242, 244,
 245; introduction of 246

Naidu, Chandrababu 183
Nandy, Ashis 90
Narasimhan, S. 49 n27
Narayan, J.P. 187
National Perspective Plan for Women 58,
 59
National Plan of Action 1976 58
Non-Cooperation Movement 98
Norris, Pippa 19, 39
Nussbaum, Martha 78, 89, 270

Old Age Pension (OAP) 177, 178

Orissa, caste-structure in 102–6, *see also*
 caste; and the feature of regionalism
 100–2; a history of 96–100; State
 Finance Commission of 248
Orissa Grama Panchayat Act, 1964 61, 67,
 73–4
*Orissa Grama Panchayat (Amendment) Act,
 1991* 63, 72
*Orissa Grama Panchayat (Amendment) Act,
 1995* 71
Orissa Panchayat Samiti Act, 1959 74
*Orissa Panchayat Samiti (Amendment) Act,
 1991* 63
*Orissa Panchayat Samiti (Amendment) Act,
 1994* 74
*Orissa Panchayat Samiti (Amendment) Act,
 1995* 75
*Orissa Panchayat Samiti and Zilla Parishad
 (Second Amendment) Act, 1967* 62
Orissa Zilla Parishad Act, 1991 63
Orissa Zilla Parishad Manual, 1994 76
Other Backward Castes (OBCs) 28, 29,
 33–4, 65, 71, 75, 105, 123–7 *passim*,
 142, 143, 151, 207, 208, 212, 213,
 218, 219, 237, 239, 244, 245, 261,
 264

'palli sabhas' 69, 70, 164, 165, 166
*Panchayat Samiti and Zilla Parishad Act,
 1959* 62
Panchayat Samiti, in Orissa 73–6, 247;
 participation in 152–4, 243 *passim, see
 also* PRI
Panchayati Raj 17, 53, 60; Convention 64;
 and reservation for women in Orissa
 60–7 *see also* reservation
Panchayati Raj Institutions (PRI) 19–23
 passim, 27, 30, 38–42 *passim,* 51, 52,
 55, 57, 58, 60, *see also* Balipatna and
 Gania; and the lack of control over
 financial resources 248–51, 269; in
 Orissa 62, 63, 67–77, 83, 110, 111,
 118, 123, 128, 129, 133, 135, 138,
 139, 171, 234, 243; and the perception
 of men on female representatives 235–
 41; and the role of political parties 187,
 247–8, *see also* political parties
*Panchayats (Extension to Scheduled Areas)
 Act, 1996* 249
Panigrahi, Sukant 184
Patnaik, Biju 63, 64, 100, 106, 155, 183
Patnaik, Naveen 100, 183
Pattnaik, J.B. 63, 65, 100, 182
Phillips, Anne 19, 30–43 *passim,* 49, 242,
 243, 268–76 *passim*
Phule, Jyotiba 89
political parties, and their relationship to the